Henri Rousseau
Jungles in Paris

Edited by
Frances Morris and
Christopher Green

Catalogue by Nancy Ireson
Essays by Claire Frèches-Thory,
Vincent Gille, Christopher Green,
John House, Frances Morris
and Pascal Rousseau

Abrams, New York

Henri Rousseau
Jungles in Paris

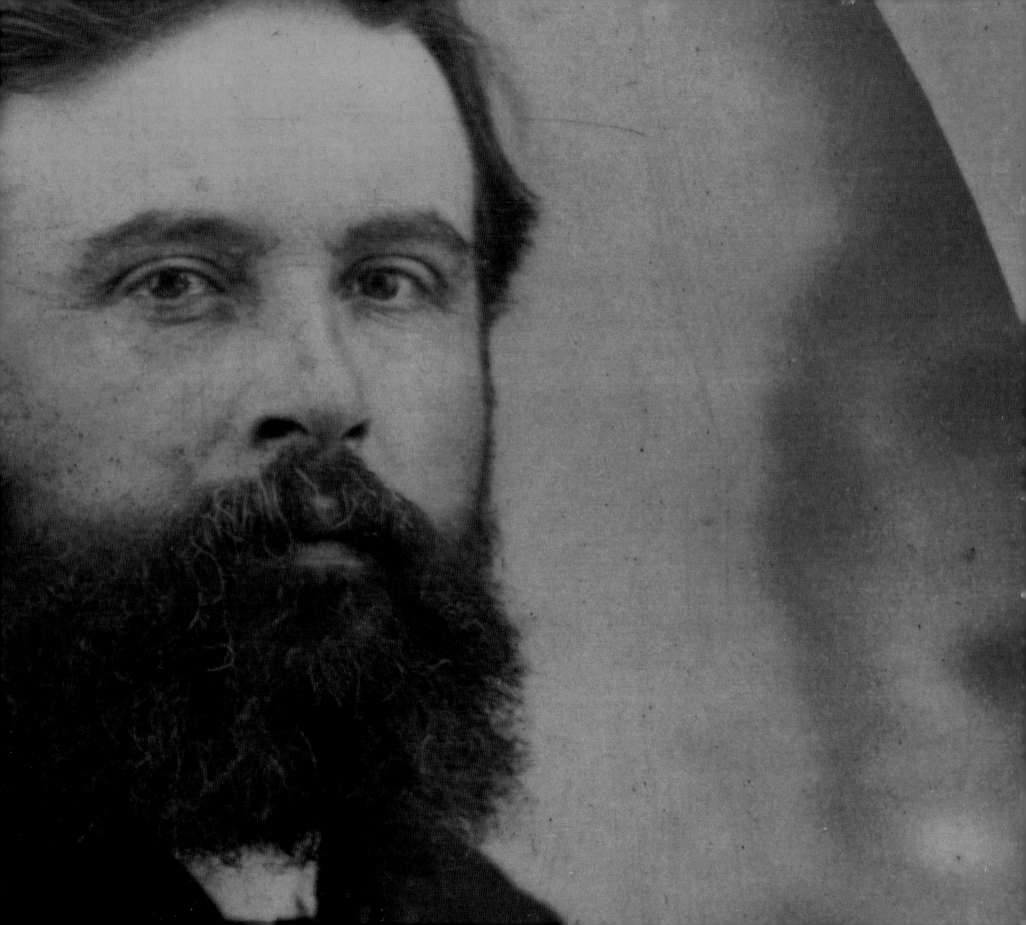

Front cover:
Tiger in a Tropical Storm (Surprised!) 1891
(detail of no. 43)
Back cover:
The Snake Charmer 1907
(detail of no. 51)
Frontispiece:
Portrait of Henri Rousseau as a young man, c. 1880
(detail of fig. 63)
pp. 10–11:
Henri Rousseau in his Rue Perrel studio, c. 1908
pp. 64–65
Pablo Picasso, *Portrait of Henri Rousseau* 1910
(detail of fig. 19)
pp. 166–167:
Henri Rousseau in his Rue Perrel studio, 1907
pp. 204–205:
Van Echtelt, *Le Douanier and Friends at his Studio* c. 1910
(detail of fig. 110)

Designed by Rose

Library of Congress Cataloging-in-Publication Data
Rousseau, Henri, 1844-1910.
 Henri Rousseau : jungles in Paris / edited by Frances Morris and
 Christopher Green ; catalogue by Nancy Ireson ; essays by Claire
 Frèches-Thory ... [et al.].
 p. cm.
 Accompanies the exhibition traveling to the Tate in London,
 Musée D'Orsay in Paris, and National Gallery of Art in Washington,
 D.C.
 Includes bibliographical references and index.
 ISBN 0-8109-5699-3 (hardcover)
 1. Rousseau, Henri, 1844-1910–Exhibitions. 2. Rousseau, Henri,
 1844-1910–Criticism and interpretation. I. Morris, Frances.
 II. Green, Christopher, 1943 June 11- . III. Ireson, Nancy.
 IV. Frèches-Thory, Claire. V. Title.
 ND553.R67A4 2006
 759.4–dc22
 2005037423

First published in 2005 by Tate Publishing, a division of Tate Enterprises, Ltd.

Published in 2006 by Abrams, an imprint of Harry N. Abrams, Inc.

Printed and bound in Belgium
10 9 8 7 6 5 4 3 2 1

HNA
harry n. abrams, inc.
a subsidiary of La Martinière Groupe

115 West 18th Street
New York, NY 10011
www.hnabooks.com

Henri Rousseau: Jungles in Paris
National Gallery of Art
July 16 – October 15, 2006

Exhibition organized by Tate Modern, London, and
Réunion des musées nationaux and Musée d'Orsay, Paris,
in association with National Gallery of Art, Washington.

Contents

6
Foreword

12
Jungles in Paris
Frances Morris

28
Souvenirs of the Jardin
des Plantes: Making the
Exotic Strange Again
Christopher Green

48
Illusion of Sources –
Sources of Illusion:
Rousseau Though the
Images of his Time
Vincent Gille

64
Rousseau's Paintings
Nancy Ireson

66
Rousseau and his World

82
The Familiar
Made Strange

96
Images of War and Peace

110
The Peaceful Exotic

124
French Landscapes

140
The Dangerous Exotic

156
Mysterious Meetings

168
From Sarcasm to
Canonisation:
Critical Fortune
Claire Frèches-Thory

182
Henri Rousseau
as an Academic
John House

190
The Magic of Images:
Hallucination and
Magnetic Reverie in the
Work of Henri Rousseau
Pascal Rousseau

206
Chronology
Nancy Ireson

211
Select Bibliography

215
Notes

222
List of Exhibited Works

228
Index

Foreword

Henri Rousseau remains one of the most popular artists of all time. He is also one of the most intriguing and fascinating artists of the early Modernist era, associated as he is with advanced aesthetic innovation, conservative tradition and with 'naive' and 'popular' painting. Tenacious will and determination propelled Rousseau to take early retirement from the Paris Customs Service to devote his time to painting. Without formal training but with considerable originality and skills in composition and as a colourist, Rousseau invented an extraordinary and unique style. This found its apotheosis in the extended series of fabulous Jungle paintings which were, for the most part, painted during the last decade of his life.

This is the first exhibition of Rousseau's paintings to take place in London for eighty years. It offers audiences a unique opportunity to see an exemplary selection of his most resolved and captivating works and to understand how the Jungle paintings can best be understood in dialogue with Rousseau's arresting work in other genres: in portraiture, landscape and allegorical painting.

We are indebted to the museums and private collectors who have agreed to part with works of great value and exceptional importance. We feel immensely privileged that private collectors have allowed us to borrow their most treasured possessions, and we thank them most warmly. It is equally difficult for public institutions, and their audiences, to lose their most precious items from their displays and we are enormously grateful to the Directors and Trustees of all the museums who have so generously allowed their treasures leave of absence for the duration of this exhibition. Their generosity is a clear demonstration of the importance and timeliness of *Henri Rousseau: Jungles in Paris*. A special mention should also be made to those institutions and individuals who have lent items to our extensive display of popular ephemera and archival material.

It has been a great pleasure for us to collaborate on this ambitious project with Musée d'Orsay, Paris. We are deeply grateful to Serge Lemoine, Président de l'Etablissement public du Musée d'Orsay, for so enthusiastically embracing this collaboration and for enabling masterpieces by Rousseau from Musée d'Orsay to occupy centre stage. Serge's colleagues, both from Musée d'Orsay and the Réunion des Musées Nationaux, have worked alongside Tate to deliver the project.

We are thrilled that the exhibition will also travel to the National Gallery of Art, Washington, home too, to an exquisite group of paintings by Rousseau. Enthusiastic endorsement by Earl A. Powell III, Director, National Gallery of Art, has led to close and fruitful cooperation between our respective institutions.

Professor Christopher Green of the Courtauld Institute, London, has long been a passionate advocate

of a major Rousseau exhibition for London. *Henri Rousseau: Jungles in Paris* has been selected by Chris and Frances Morris, Curator and Head of Displays, Tate Modern, with Claire Frèches-Thory, Conservateur Général, Musée d'Orsay. Collectively they present a formidable team, combining scholarship, curatorial expertise, skills of diplomacy and persuasion and, above all, unstinting energy and enthusiasm for their subject. *Henri Rousseau: Jungles in Paris* is more than an exhibition of paintings. It also includes over three hundred documents and images, ranging from memorabilia pertaining to Rousseau's life, illustrated source material, and items relating to notions of the 'exotic' in turn-of-the-century Paris. For taking on this huge additional project and delivering it with such panache, we are indebted to Vincent Gille, Chargé de Mission at the Pavillon des Arts. Vincent has worked closely with Nancy Ireson, one of the few younger scholars working on Rousseau today. Nancy has additionally provided important research support to many aspects of the project and publication. We are indebted to the curatorial team for realising an exhibition that will enthral huge numbers of visitors encountering Rousseau for the first time as well as one which considerably extends the grounds of Rousseau scholarship. All five curators have made significant contributions to the exhibition catalogue, which is also enriched by original and illuminating essays by Professor John House and Pascal Rousseau.

Alongside the curatorial team there are other individuals without whose support the exhibition could not have been realised. The project has been managed by two teams working in collaboration: led by Juliet Bingham, assistant curator, for Tate Modern, London, and Anne Fréling, Chef de projet, for the Réunion des Musées Nationaux in Paris. In Paris, the exhibition has been organised with dedication and professionalism by Anne Fréling with the support of RMN colleagues including Thomas Grenon, Administrateur général de la RMN; Olivier Toche, Administeur général adjoint, directeur du développement culturel; Ute Collinet, Secrétaire général; Ariane Rabenou, Chargée des contrats; Juliette Armand, Chef du département des expositions, and her predecessor, Bénédicte Boissonas; Jean Naudin, Responsable du mouvement des œuvres; Katia Cartacheff, Coordinatrice du mouvement des œuvres. The French edition of the catalogue has been co-ordinated by Catherine Marquet, Chef du département du livre; Geneviève Rudolf, responsable d'éditions; and Alain Madeleine-Perdrillat, Chef du service de la communication. At Musée d'Orsay, Serge Lemoine and Claire Frèches-Thory have worked in conjunction with Caroline Mathieu, Conservateur en chef chargé des collections; Sylvie Patin, Conservateur en chef, chargée de la restauration des œuvres; Martine Bozon and Elise Bauduin, au secrétariat de la Direction; Françoise Fur, Evelyne Chatelus, Michelle Rongus and Nathalie Mengelle, au secrétariat de la conservation; Manou Dufour à la Régie des oeuvres; and at la Direction des Musées de France, Francine Mariani-Ducray, Directrice des Musées de France and Rodolphe Rapetti, adjoint à la Directrice des Musées de France.

We are also indebted to our partner, the National Gallery of Art, who, led by Director, Earl A. Powell III, and D. Dodge Thompson, Chief, Department of Exhibitions, have embraced the exhibition with such energy and enthusiasm. Washington's considered presentation has been curated by Leah Dickerman, Associate Curator, Modern and Contemporary Art, with the dedicated help of Marcie Hocking, Assistant for Exhibitions. The tour has been expertly co-ordinated by Ann Bigley Robertson, Exhibition Officer, and with invaluable support by Jennifer Rich, Assistant for Exhibition Administration. Transport and logistics have been co-ordinated by Michelle Fondas and Melissa Stegeman, Registrars for Exhibitions. The successful delivery of the exhibition and its accompanying programmes would not have been possible without the support of key National Gallery staff, including: Mark A. Leithauser, Senior Curator and Chief of Design; Gordon O. Anson, Deputy Chief of Design; and Jamé L. Anderson, Architect and Design Coordinator; Susan M. Arensberg, Head of Exhibitions; Carroll Moore, Film and Video Producer; Lynn Matheny, Associate Curator; Elizabeth Laitman, Image Researcher; Judy Metro, Editor in Chief; and Isabelle Raval and Lara Levinson, Office of the Secretary-General Counsel. The Gallery also thanks David Nash.

Special recognition is due to Juliet Bingham at Tate Modern who has organised this immensely complex exhibition with great determination, tact and humour, steering the project with a steady hand at all times, managing the administration of loans and the delivery of all aspects of the exhibition as well as contributing to the exhibition guide. The curatorial team has been supported over time by very talented interns, primarily Tania Sidawi and Caroline Cross, with additional assistance from Renata Smialek and Erica Papernik, whose input into research and administration has been much appreciated. The Tate team has benefited hugely from the ongoing advice and support of Stephen Mellor, Exhibition Co-ordinator, who has overseen contractual and logistical matters as well as guiding the installation itself. We would also like to thank Phil Monk, Art Installation Manager, and his team, led by Senior Art Handling Technician Glen Williams, as well as Exhibition Registrar Nickos Gogolos, for their customary efficiency in getting the show up and running under pressure of time.

The whole team has benefited from the daily support and interest of the Exhibitions and Display Department at Tate Modern. Particular thanks are due to Administration Managers Rebecca Lancaster and Charlotte Merrett, Administrator Paul McAree and Administration Assistant Michele Smith, and Sheena Wagstaff, Chief Curator.

A Rousseau exhibition offers tantalising opportunities to colleagues engaged in Interpretation and Education. We are especially grateful to Stuart Comer, Curator: Events and Film, Dominic Willsdon, Curator: Public Events, Gillian Wilson, Assistant Curator: Resources, and Sophie Howarth, Curator: Adult Learning, for generating such a fulsome range of events from scholarly conferences to family film programmes. For the second time we are delighted to present the public with the possibility of a multi-media tour guide for the exhibition, supported generously by Aviva. Jane Burton, Curator: Interpretation, has had a significant role in initiating and overseeing this guide and we are very pleased that it should accompany the exhibition. Simon Bolitho, Assistant Curator: Interpretation, has contributed to an exemplary printed guide to the exhibition.

The fully illustrated catalogue which accompanies this exhibition has been designed by Simon Elliott and Terry Stephens at Rose with great style. We are also delighted with the creative vision Simon has brought to the exhibition design. Mary Richards, Project Editor at Tate Publishing, has driven the catalogue project from the start with determination and considerable insight. We are indebted to her for her commitment to the publication. The production of the catalogue has been expertly managed by Sophie Lawrence, and the picture research by Alessandra Serri and Katherine Rose.

Many other individuals and departments at Tate have contributed to this exhibition in important ways. Ruth Findlay and Jennifer Lea have led a remarkable press and media campaign. Thanks are due to Caroline Priest and Emma Clifton who have overseen a brilliant marketing campaign, as well as to the special events team led by Brad Macdonald and Billie Lindsay, and to the Development team especially Fiona Parker.

Exhibitions of this kind take many years and much dedication to put together. Pehr Gyllenhammar, Chairman of Aviva, already has a long association with Tate and has supported a number of very major projects at Tate Modern since its opening. His interest in and commitment to the Henri Rousseau exhibition was instant. His early support has made a tremendous difference to the project, and we salute Pehr as well as Aviva for this enduring friendship.

This exhibition offers a unique opportunity to introduce several new generations to Henri Rousseau's work and to reassess the nature of the experience offered by his art. Original research, undertaken in relation to this exhibition, has uncovered fascinating insights into Rousseau's working methods, into our understanding of his era, and into the meaning and message of his paintings. Such insights do nothing to diminish the astonishing visionary power of his subject matter or the perplexing enigma of his character and career. We hope visitors to the exhibition, in London, Paris and Washington, will find the experience enthralling and enriching.

Vicente Todolí
Director, Tate Modern

Essays
Frances Morris
Christopher Green
Vincent Gille

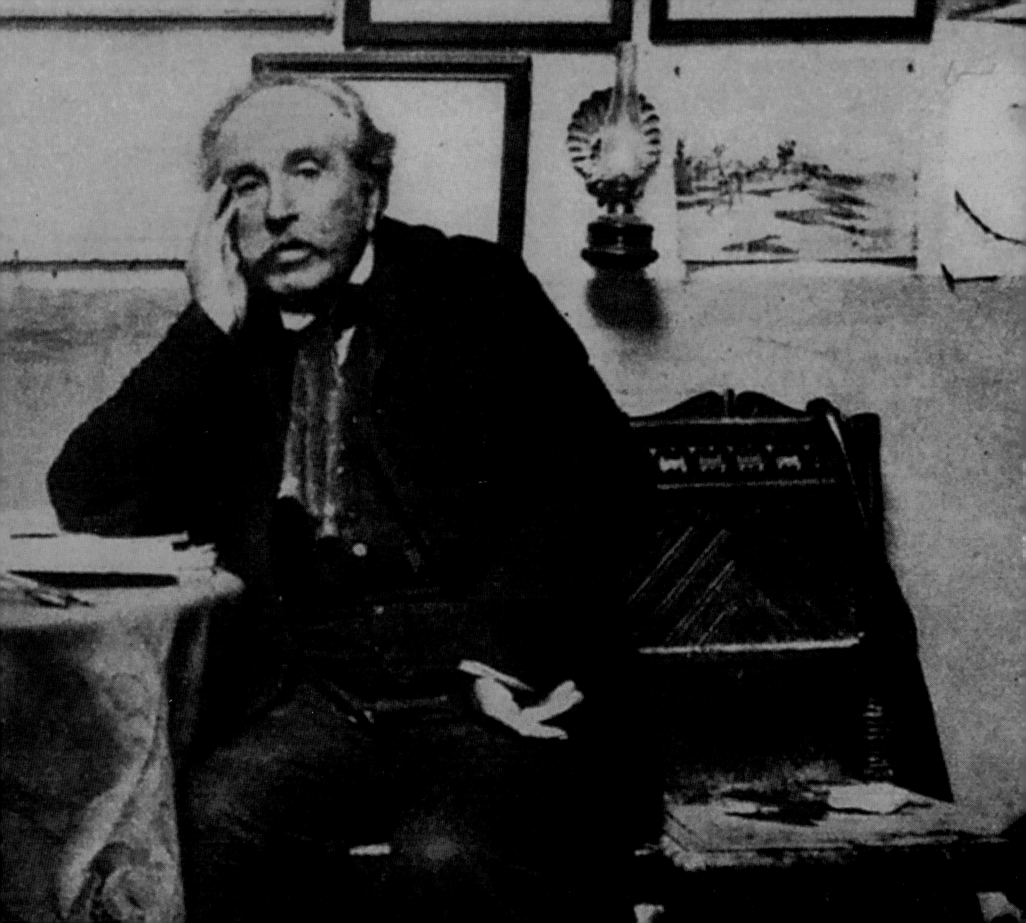

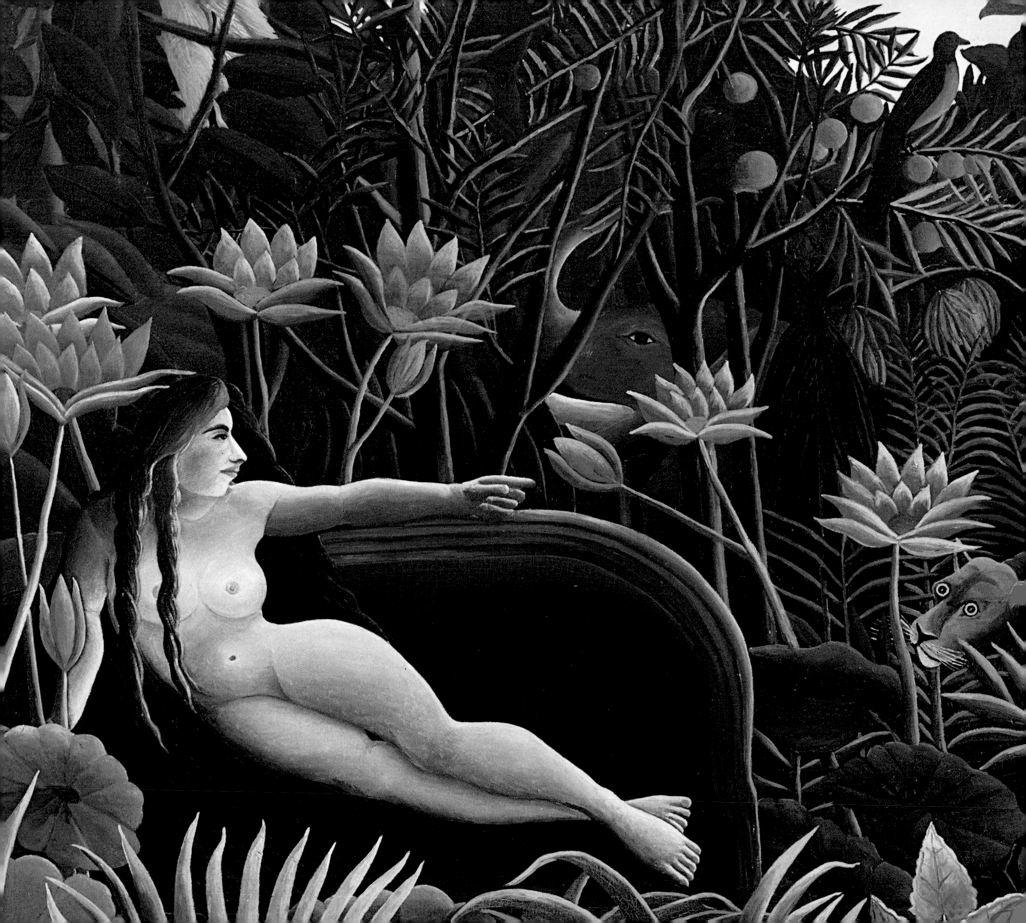

Jungles in Paris
Frances Morris

Henri Rousseau's *The Dream* 1910 (fig.1) is the largest and latest of his major Jungle paintings, the series of sumptuously coloured compositions of exotic creatures in fantastically luscious tropical settings that dominated Rousseau's late work. It is also, in scope, the most complex and resolved. The artist had suffered years of insults at the hands of the press and scornful laughter from the hordes visiting the annual Salon des Indépendants; finally, here was a painting to command respect. 'I don't believe anyone will laugh this year,' wrote the poet Guillaume Apollinaire, 'ask the painters. They are unanimous: they admire.'[1]

Surrounded by the dense, encroaching foliage of hot-house fronds and encircled by overblown lotus flowers, a voluptuous nude reclines on an upholstered divan, her nakedness swathed by the flowing tendrils of her hair. Her face, in profile, inclines towards a gathering cast of exotic creatures, as if in acknowledgement and quiet welcome. The monkey poised in suspension, the elephant lurking in the gloom, the lions caught wide-eyed and centre stage are momentarily hesitant, stilled perhaps by the dark musician's melody. Only the orange-winged bird rustles the leaves on this moonlit evening. Bands of pattern and design – like elaborately decorated stage flats – convey the distance between the quiet drama unfolding and us the audience,

a distance traversed only by the moody lion who looks out of the painting at us, engaging us as witnesses and participants. As if to set the stage and soothe our entry into the scene, Rousseau provided a poetic introduction:

> Having fallen into a gentle sleep
> Yadwigha, in a dream,
> Heard the sounds of a musette
> Played by a benevolent magician.
> While the moon shone down
> Upon the flowers, the green trees,
> The wild serpents listened to
> The instrument's merry tunes.[2]

The Dream was painted in the small studio Rousseau rented in rue Perrel in the petit-bourgeois neighbourhood of Plaisance, in Paris. This was also his home, where he lived and ate, where he gave lessons in art and music to the children of his neighbours, and where, from 1907, he entertained his acquaintances at evening soirées. 'Yadwigha', the woman on the couch that is *the* studio divan, is at one and the same time Rousseau's former Polish girlfriend, of whom we know little, and a generic nude whose reclining form had been carried through the

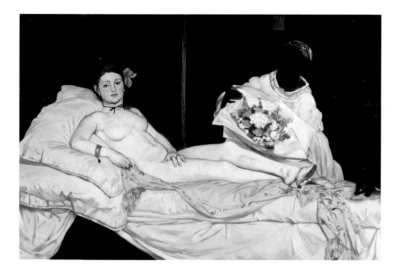

history of art by countless painters, in honour of and latterly in transgression of a great tradition – an ancient and yet thoroughly modern motif. On his journeys through the Louvre Rousseau would have encountered not only Ingres's *La Grande Odalisque* 1814, but from 1907 he would have seen it in juxtaposition with Édouard Manet's still controversial *Olympia* 1863 (fig.2). Drawing on such sources from advanced art – Manet's *Déjeuner sur l'herbe* 1863 (fig.61), also acquired by the French State in 1907, has been numbered among them[3] – as well as from his domestic milieu, and from popular imagery and urban collections of exotic flora and fauna, *The Dream* is among Rousseau's most perplexing paintings. It is also exemplary of his working process. Acutely alive to visual experiences of all kinds, Rousseau united in his technique a breathtaking democracy of vision, and disparate sources from high and low quarters. He was able to hold together a *mise-en-scène* comprising elements whose origins are so divergent that their conjunction borders on the ridiculous. That he was able to do this testifies to the strength and authenticity of his vision as well as to the powerfully coherent, if idiosyncratic, idiom he evolved as a painter.

The jungle setting of *The Dream* is not a place that Rousseau knew at first hand. Despite Apollinaire's claim that Rousseau's military service in Mexico provided him with his memories of 'tropical forests, the monkeys and the bizarre flowers',[4] we know from direct testimony that it was the splendid plantations of Paris hot houses and dusty cages of exotic creatures in the zoological gardens that more immediately generated these compelling visions.

The desire to explore and translate for a modern urban audience a vision of a strange and faraway place was not unique to Rousseau: it was shared by many others, from the Salon painters of the day to the designers of French popular illustrated magazines. Rousseau's Jungle paintings are, nevertheless, extraordinary and singular. He was self-taught and his works do not provide us with the genealogy we are accustomed to tracing in the emergence of great art. His Jungle paintings have, instead, a history and background within his own life, his circumstances and his personality. Caught between the artist's own oft-expressed ambition to achieve distinction as an Academic painter, attempts to dismiss his work as the product of folk or naive vernacular, and his subsequent appropriation by generations of avant-garde artists, Rousseau's work relates to all these readings but belongs entirely to none of them.

Rousseau's first Jungle painting, *Tiger in a Tropical Storm (Surprised!)*, of 1891, stands alone (no.43).

Fig.2
Édouard Manet
Olympia
1863
Musée d'Orsay, Paris

Completed almost twenty years before *The Dream*, and over a decade before the jungle emerged as a pre-eminent subject within his work, it was painted shortly after the great 1889 Paris World Fair. One of a number of international fairs that took place in Paris during Rousseau's lifetime, the World Fair was intended as a centennial celebration of the 1789 French Revolution, and was a notable event. With its emphasis on the strength and power of the Republic, its celebration of both technological development and colonial expansion – itself seen as a major contributing factor in French economic development – made it a popular and commercial triumph. Coinciding with France's continuing, but far distant, campaign to subjugate the kingdom of Dahomey (1877–94), it brought closer to home a vision of the colonial 'other'. Elaborate reconstructions of 'typical' domestic settlements – each with a full complement of native inhabitants – from Senegal, Gabon and Congo were staged along the Place des Invalides, beside the Seine and close to the resting place of Napoleon's remains. Overlooked by a prominent colonial pavilion, this picturesque encampment offered visitors, according to one observer, 'a magical carpet. This carpet, a simple ticket of entrance, is the talisman that admits them to the country of dreams. Here you are transported, according to your caprice, from Cairo to the Americas, from the Congo to Cochin China, from Tunisia to Java, from Annam to Algeria.'[5]

The World Fair inscribed a colonial present within the symbolic heart of Republican France, as urgent and modern as the evident symbols of industrial progress. Rousseau, like thousands of his neighbours, both visited the fair and was swept up in the collective fervour that it provoked. It was the talk of the town, extensively covered in the periodicals and newspapers of the day. Rousseau's own three-act vaudeville, his first attempt at dramatic invention, *A Visit to the 1889 Exhibition*, tells the story of the simple Breton family on a day's outing to Paris, who laud 'this great exhibition, where there is the Eiffel Tower, the Trocadero, Negroes, redskins'.[6] That Rousseau saw himself as belonging to Paris and this quintessentially modern epoch is apparent from his magnificent *Myself, Portrait-Landscape* completed in 1890 (no.2). Here he portrayed himself standing in the traditional garb of the salon painter replete with black beret and palette, against a background of modern Paris traversed by an iron bridge and framed between the Eiffel Tower and a hot-air balloon – symbols both of modernity and the World Fair. At a time when many painters of the Academy, as well as members of the avant-garde, abhorred the fact of the Eiffel Tower's construction

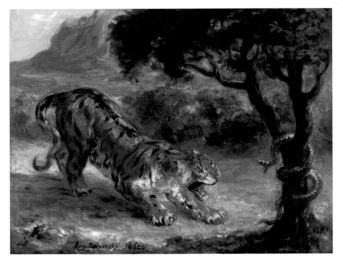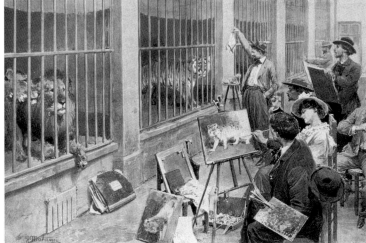

and avoided all references to intrusive modern technology in their work, Rousseau's embrace of such imagery, though not unique (Seurat had been, in 1889, the first to embrace the Eiffel Tower as a subject), was notable.

In comparison to this hybrid of landscape and portrait – a genre Rousseau claimed to have invented – *Surprised!* was perhaps less singular as a subject. Earlier in the century, exotic subjects had been a frequent source of inspiration to the Orientalist painters who specialised in North African and Near Eastern subjects, finding in the external exotic a way of expressing the interior of the self. Among them Rousseau claimed as his mentors Félix-Auguste Clément (1826–1888) and Jean-Léon Gérôme (1824–1904), well known for his desert lion compositions. The representation of animals was an especial genre during the Romantic era, with a number of 'animaliers' including both painters and sculptors specialising in themes of animals in combat or confronting the elements, and such work was still in fashion at the time.

Rousseau derived the image of the beast ready to pounce in *Surprised!* from a motif explored in a number of compositions by Eugène Delacroix (1798–1863), of tigers poised on the verge of combat (fig.4), the subject of an important exhibition at the École des Beaux-Arts in 1885.

Delacroix had visited Morocco in 1832 but, in anticipation of Rousseau, sources for his tiger paintings could be found closer to home in the wild animal collections of the Muséum d'Histoire naturelle in Paris. Rousseau may well have seen the 1885 exhibition; in the same year he produced a convincing and freely painted sketch in the style of a Delacroix pastel. Returning to the source six years later, Rousseau transcribed the motif itself, with its tensile physique, accurately, but painted it in a style quite of his own invention. The dense, exquisite surface pattern suggested, among other things, the highly worked surfaces of fifteenth-century tapestries such as *The Lady with the Unicorn*, which Rousseau would have seen at the Musée Cluny off Boulevard St Michel.

In style, if not in subject, *Surprised!* belongs to the group of paintings with which the artist first announced himself to the world. At the time, Rousseau was still in full-time employ as a clerk at the Paris Octroi, a service imposing duty on goods entering the city, but he had been contributing paintings to the recently established, jury-less Salon of the Société des Artistes Indépendants since 1886. Unlike the official Salon, the Indépendants exercised no entry qualification, so that artists like Rousseau were able to exhibit without patronage or pleading. Presented by Rousseau at that first Salon was *Carnival Evening* 1886

Fig.4
Eugène Delacroix
Tiger and Snake
1862
The Corcoran Gallery of Art,
Washington D.C., William A.
Clark Collection

Fig.5
'Artists studying animals at the
Jardin des Plantes',
L'Illustration, 2 August 1902

Fig.6
Tiger in a Tropical Storm
(Surprised!)
1891
(No.43)

Fig.7
'Attacked by a Tiger',
Le Petit Journal, 4 April
1909

(no.15). Along with *Promenade in the Forest c*.1886 (no.16) and *Rendezvous in the Forest* 1889 (no.14), these forest paintings are closer in style and technique to *Surprised!* than any of the later Jungle paintings; extraordinarily coherent and finished for an artist who had not only received no formal training but was only able to devote evenings and Sundays to the task.

 Surprised! brought Rousseau his first really considered criticism. Félix Vallotton's extended review, published in *Le Journal Suisse* on 25 March 1891, acknowledged the positive strengths of the artist's 'astonishing' style: 'His tiger surprising its prey ought not to be missed; it's the alpha and omega of painting and so disconcerting that the most firmly held convictions must be shaken and brought up short by such self-sufficiency and childlike naivety'.[7] The puzzle is that despite this accolade – and we know Rousseau treasured such comments – he chose not to return to the theme or setting for a number of years. This might be due in part to the fact that in retiring to paint full time in 1893 (on an annual pension of only 1,019 francs), Rousseau needed, more than before, to generate an income from his art. Although his ambitions to take on the grandiose genre of history and allegorical painting did not go away (witness the extraordinary and majestic canvas

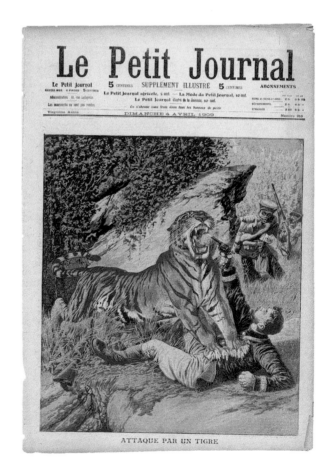

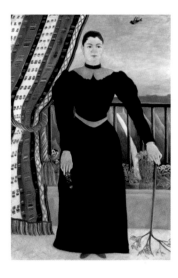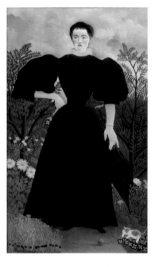

War 1894 [no.17] as well as his pursuit of public patronage in *A Centennial of Independence* 1892 [no.18]) during the last decade of the century, smaller paintings dominate his output, with landscapes and portraits to the fore, produced for the market and as commissions for neighbours and friends. Many of these are strange and compelling works, demonstrating a persistent inability to stay within the necessary – at least for an aspiring academician – bounds of convention.

The landscapes allow us to trace Rousseau's to-ings and fro-ings around and about Paris. Most are of marginal outlying districts away from the grands boulevards. Rousseau was interested in places where town and country meet, where trees coexist with more modern intrusions from the industrialising world such as electricity power lines and chimneys, places intersected by the canals and crossing places of rivers as well as places of rest, the parks and gardens of the city. Depicted from a distance, these open landscapes are dominated by their skies and animated here and there by little dark figures, sometimes strolling, sometimes fishing. What is strange about them, as Vincent Gille convincingly demonstrates in this catalogue, is that they are rarely simply of things seen. Instead these scenes are discreetly altered in the studio, or corralled from

different sources. A few surviving sketches show that it was Rousseau's habit to work in the open from the motif; he did so in a surprisingly fluent and expressive painterly style, very different to the emphasis on outline and surface that characterises the finished works. A process of transformation both in style and of the motif thus appears to have taken place in the studio.

From their apparently more finished look and their greater size, it seems likely that many of Rousseau's portraits were commissioned. Two handsome full-length portraits from 1895 and 1895–7 are particularly beguiling (figs.8 and 9). Possibly painted from photographs and visibly in the vernacular of studio portraiture, especially as disseminated in the popular *cartes de visite* of the time, the emphatic darkness and flatness of the models' fashionable gowns is either peculiar or original, depending on one's point of view. Beyond the figures themselves, the settings – the barren lunar landscape of jagged rocks in the earlier painting, purportedly a representation of the fortifications of Paris,[8] or the disjunction between the scale of the figure and its garden setting in the later portrait – make these paintings deeply strange. Both contain details that offset the familiarity of the genre: a splayed branch in place of a cane, a little kitten playing among the pansies. That Rousseau's

Fig.8
Portrait of a Woman
1895
(No.4)

Fig.9
Portrait of a Lady
1895–7
(No.3)

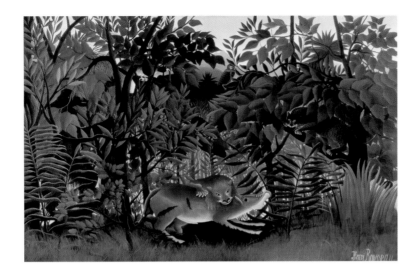

work, despite his efforts, lacked the right touch for the humdrum local market place is demonstrated by the need to augment his earnings through other means. He supplemented his income as a street musician from 1895, and worked part time as a sales rep for the magazine *Le Petit Journal* around 1900. From 1901 Rousseau gave teaching courses in porcelain painting, pastel and watercolour at an adult education institute, the Association Philotechnique, while from 1905 he offered music and drawing lessons to his neighbours.

Despite his concentration on the places and faces of his local milieu, dreams of faraway places did not leave him. In 1897, seemingly out of nowhere, Rousseau produced the vast and highly finished *The Sleeping Gypsy* (fig. 30), key elements of which – the lion, the recumbent female, the suggestion of melody – anticipate *The Dream* (no. 50), though in this earlier work the encounter between woman and beast takes place in a barren desert land. This painting is unique in Rousseau's oeuvre, particularly in its openness and the monumentality of the figures. It is also the most overt demonstration of the influence of Orientalism on his work. But there is a crucial connection between *The Sleeping Gypsy* and the later Jungle paintings: this lies in the extent of its invention and the manner in which the strangely

discordant details of this fantasy are subjected to a formal transformation which welds them into a harmonious and thus convincing narrative. This is not a narrative that convinces us of a reality seen and acknowledged on canvas, but of a dreamed reality, realised in painted form. Two years later Rousseau was inspired to write a second short play. It is here, in *The Revenge of a Russian Orphan* (1899), that the jungle itself emerges as a dreamscape, as the female persona of Yadwigha charmingly opines: 'how scorching hot it is. I feel as though I were in Senegal or in one of those exotic countries where boundless forests with coloured trees are peopled with cannibals and more or less fierce wild beasts'.[9] This is the scene that finally found direct realisation in *The Dream* of 1910.

Anticipated by two or three earlier paintings of jungle scenes, which went largely unremarked by the critics, Rousseau's late Jungle paintings drew considerable attention with the very large canvas presented at the Salon d'Automne in 1905. *The Hungry Lion throws itself on the Antelope* (fig. 10), like so many of the paintings that follow, focuses attention on a central group of animal characters but allows a high level of incident and variation to play over the whole surface of the canvas, whether provided by additional animals partaking in the scene or by the varied

plant life. The foliage is dense and seemingly impenetrable. This density is combined with a continuous clarity of focus, which is maintained in the painting regardless of imagined distance. Our awareness of the surface is further enhanced by the absence of shading. Rousseau's skies, like stage-set backdrops, act not just to provide a background but also to prevent recession. Lighting is overall and even; his suns and moons are held aloft, but they neither shed light or generate shade.

Critics conflicted in their views of the work, but several noted with admiration its decorative qualities: comparisons were made with Japanese masters, Persian miniatures and Byzantine mosaics as well as the Bayeux Tapestry. Rousseau may have felt encouraged. Over the next five years he maintained a steady production of grandiose jungle themes, ranging from images of animals in combat (occasionally wrestling with humans), monkeys at play, mythological narratives – such as *The Snake Charmer* 1907 (no.51) and *Eve* c.1906–7 (no.52), in which, like *The Dream*, the human figure plays a central role – and one or two more domestic jungle landscapes, images of peace and tranquillity.

Rousseau's Jungle paintings were dreamscapes, each one the meeting place of a principal idea with a tapestry of images culled from everyday, local sources and experiences, all of which were available to the ordinary people of Paris. Live animals themselves, displays of mounted stuffed beasts and their postcard reproductions, as well as widely disseminated and cheaply reproduced 'scientific' illustrations, furnished Rousseau with an alphabet of creatures with which to 'people' his foliated surfaces. Rousseau had always found the business of transforming three-dimensional living flesh on to the two-dimensional terrain of the canvas difficult: witness the clumsiness of his studio portraits. His apparent technical deficiencies in relation to three-dimensional transcription and the charming, if curious, solutions he invented as if to mask these shortcomings were prima facie evidence of his naivety to his detractors. It is not difficult to see how reproductions, easily transferable to another surface by copying and with the aid of a pantograph, offered Rousseau an invaluable resource.

The technique he evolved was distinctive. The use of iconographic sources has a long and distinguished history in Western art practice, as an obvious way in which artists could pay homage to their mentors and to great art of the past. But given Rousseau's often expressed ambition to be counted among the great painters of tradition, and the

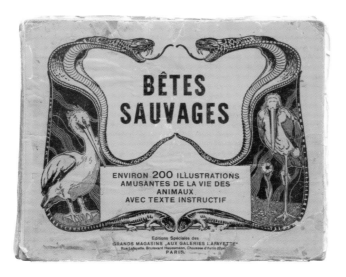

fact that from 1884 he had access to the Louvre as a 'copyist', it may be surprising, not that he drew inspiration from the plethora of visual sources available to him, but that he did not more often take on and honour the painters he revered: Gérôme, Clément or Adolphe-William Bouguereau.

Rousseau's use of multiple sources in his work and especially his predilection for popular ephemera has also elicited comparisons with the technique of collage, 'invented' only in 1912, and pivotal in the transformation of Analytical into Synthetic Cubism. It seems not implausible that Rousseau's frequent resource to popular imagery may well have fed into the melting pot of Pablo Picasso and Georges Braque's invention of papier collé and its subsequent dissemination among many artists, some of whom, such as Robert Delaunay and Fernand Léger, professed to admire Rousseau and who in homage 'collaged' references to Rousseau into their own work. But Rousseau's accumulated sources are rarely acknowledged and certainly never exist as deliberately juxtaposed fragments within the finished painting. There is no play on visual meaning, no symbolic intent as such in Rousseau's borrowings. While Rousseau never sought to disguise his use of sources from those who observed him at close hand, they *are* disguised in the finished paintings themselves; for him Delacroix's tiger

served the same function as a photographic source from *Bêtes sauvages*. Rousseau's sources are moved, by him, far away from their origins to a composite but quite unified territory, suggesting a strategy in some ways more akin to post-production processes in photography in our own times, where digitalisation enables multiple images to be transformed into a seamless whole. In the process, scale and proportion can be altered, images can be flipped, details can be enhanced, patterning can be extended and everything bound into a precise and evenly notated surface.

Rousseau did not use his sources to aid his reconstruction, in the studio, of scenes seen. He never, for example, painted the Jardin des Plantes as it was, depicted animals as they were kept there, or painted plants in their artificial environments. There are, as Vincent Gille and Christopher Green point out in their essays here, startling disjunctions between the jungles tended by Rousseau and the visual experiences open to him in Paris. In reality, the splendid beasts of Rousseau's imagination were housed in ill-kept and barren cages; despite its popularity, the Jardin des Plantes was, at this time, a 'cursed place: there harmless animals as well as magnificent cats torn from the desert, rot slowly in ridiculously cramped gaols, in the damp and muck and in revolting filthiness'.[10] Nor was Rousseau's jungle a

place of colonial exploration or conquest, as it was so frequently depicted in the popular illustrated journals of the day: native peoples feature very seldom in the series, and his works carry no references to colonial conquest or indeed to human combat. In Rousseau's paintings the wild creatures are liberated from their cages, set to roam and play, fight and devour each other in fantastic hot-house plantations, settings in which extravagant flowers bloom at dusk.

In the theme of the jungle, Rousseau found a subject that suited his style. Although he continued to be subjected to the hilarity and scorn of visitors to the annual salons, from around 1906 he was taken up by a small circle of admirers, among them distinguished and serious-minded intellectuals – painters, poets, dealers and collectors – who now found him and his work striking and relevant.

The first decade of the twentieth century witnessed a growing interest in 'art nègre'. Ethnological collections developed throughout Europe during the last quarter of the nineteenth century and, as colonial empires expanded, the number of items imported from first Oceania and then Africa increased. Around 1905–6 a small number of influential younger artists, including Picasso, Braque, Maurice de Vlaminck and André Derain 'discovered' African art for themselves. Tribal artifacts could be seen on

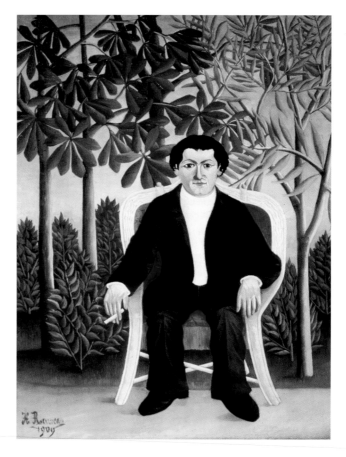

Fig.12
Portrait of Joseph Brummer
1909
Private Collection

display both at the Trocadero museum and in curiosity shops and at market stalls. Many artists began to build their own collections. A key figure in the development of this interest was the Hungarian sculptor and subsequent dealer Joseph Brummer (fig.12), who showed sculptures from Oceania and Africa alongside canvases by Rousseau at his shop at 6 boulevard Raspail. Rousseau had been introduced to him by Brummer's fellow student, the young American painter Max Weber. Other introductions followed and among those who came to admire and support Rousseau were Apollinaire, Picasso, Weber and Brummer, whose interest in his work ran side by side with an admiration for African sculpture. Early associations were made between Tribal art, Folk art and the art of children and adolescents. These associations were not particularly new, but gained added impetus at a moment in time when a younger generation of artists were hungry to push beyond the boundaries of their predecessors. Reflecting on the receptiveness of artists to the examples proffered by African sculpture in the 1900s, William Rubin, in his introduction to the controversial survey *Primitivism in Twentieth Century Art* (1988), described the generational shift away from styles based on visual perception to styles based on conceptualism that underpinned early

twentieth-century avant-gardist interest in Tribal art.[11]

The coincidence of Modernism and Primitivism was thus no accident, and helps explain how Rousseau could be co-opted as a role model in this juncture: his work had the look of Folk art, while his Jungle paintings envisaged with fantastic originality the far-off realms whence primitive artifacts originated. The appellations of 'primitive' and 'naive' were not new in relation to Rousseau, but few, aside from the young poet and playwright Alfred Jarry (who commissioned an engraved reproduction of *War* [fig.105] for his Folk-art revivalist journal *L'Ymagier* in 1893), had then seen such things as cause for celebration. From around 1905 onwards, words like 'primitive', 'naive', 'childlike' appear to take on a different tone.

For those artists and critics who no longer subscribed to a belief in bravura technique and manual skill as measures of value in art, Rousseau's work had much to offer: a sense of fantasy and invention, formal power and fabulous colour, a freedom from compositional convention, a non-naturalistic realism. In much the same way that Modernist circles looked to Tribal art for the seemingly incompatible claims of both formalism and realism, so too the early Modernist interpretations of Rousseau combined the notion of the artist as realist with a formalist view of him.

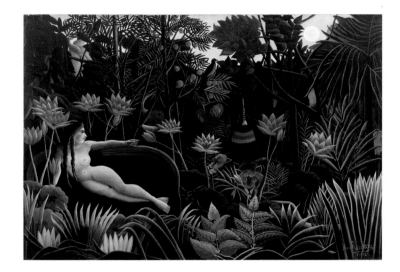

Contemporaries drew comparisons between Roussseau's style and aspects of Italian primitive painting, as well as with the art of Nicolas Poussin, finding historical analogies for Rousseau's combination of design with 'emotionally significant colour'.[12] Innovators of formal abstraction could thus appropriate him, just as his original use of colour attracted the Expressionists.

At the same time Rousseau's way of seeing was depicted as peculiarly intense, the result of an especial sensibility verging on the visionary. Apollinaire's fond yet condescending memoir of 1914 describes Rousseau's hold on reality as so strong that 'sometimes when painting a fantastic subject, he would become terrified and, all atremble, would be obliged to open the window'.[13] Rousseau's special ability to paint strangely assorted things in a tantalisingly convincing way subsequently attracted the Surrealists. Early affinities were noted, by Apollinaire for example, between Giorgio de Chirico's treatment of space and his enigmatic association of disparate objects,[14] while André Breton belatedly acknowledged Surrealism's debt to the artist in 1959: 'It is with Rousseau that we can speak for the first time of Magic Realism... of the intervention of magic causality.'[15] To others the special quality of Rousseau's work originated in part from the sense of instinctive creativity:

he painted as he did, it was felt, because he lacked training, methodology or skill. The critic Arsène Alexandre, writing in 1909, found in his work 'an impulse to express form as the artist feels it, using means he finds directly and involuntarily in himself, without thinking about them at all', implying that Rousseau would in fact have been 'incapable of *wanting* to do what he did'.[16] It made sense, to Rousseau's admirers, to see him as a case apart, unique and different from themselves. From the reminiscences of his associates – jovial, mocking and fond in turn – in the last years of his life, from the numerous accounts of the fabulous 1908 banquet held in his honour by Picasso and Apollinaire, to the first more or less serious attempts to grapple with him as an artist, all commentators dwelt on his biography and the circumstances of his life in a way that was unusual at the time. The picture that emerges of Rousseau is of a petit bourgeois innocent, whose miraculous and inexplicable art raised him above but never beyond his origins. So to Apollinaire, Rousseau, the 'poor old angel', was always the 'Master of Plaisance', his suburban home.[17] It was Rousseau's fate to remain forever outside the carapace of the establishment. Despite aspirations to the Academy, he was never accepted by those whose work he admired, but neither was he taken, on equal terms, into the cadres of the

Fig.13
The Dream
1910
(No.50)

avant garde. The fact was, as Wilhelm Uhde bluntly concluded in 1911, Rousseau 'sees men and things differently from us'.[18]

Undoubtedly Rousseau was, in some ways, different to the artists who latterly lent him support and encouragement. Having undertaken no formal training, Rousseau had never acquired rules and conventions to defy. Nor did he apparently understand, still less approve of, the formal and aesthetic innovations of early Modernism – Paul Cézanne he felt could not draw, and towards the work of Delaunay, his friend and admirer, he remained uncomprehending. At the same time, Rousseau was not blind to his own unique attributes and not unaware that his fortunes were bound up in a reading of his naivety. Rousseau never hid the fact that he had not been schooled. In a telling autobiographical note of 1895 he alluded to 'no master other than nature'. At the same time he claimed 'some bits of advice culled from Gérôme and Clément'.[19] And although Rousseau's desire was to be acclaimed as a great public artist, it seems that his mentors may in fact have encouraged him along his own, very different, path. Shortly before his death, Rousseau admitted that 'If I have kept my naivety, it is because Monsieur Gérôme always told me I should keep it'.[20]

That there was more to Rousseau's character than met the eye was apparent to a number of perceptive contemporaries. The lawyer Guilhermet, who defended Rousseau against fraud charges in 1907, recalled that 'Rousseau always remained an enigma for me. Was he a man mystified by everything, or was there something of a mystifier in him?'[21] While Ambroise Vollard, one of Rousseau's earliest dealers, 'often wondered if that simple, not to say slightly bewildered, air, that struck one in père Rousseau, was not a mask behind which he concealed himself, and whether at bottom he was not a sly dog'.[22]

From early on, interconnected critical trajectories can be traced, situating Rousseau as both a principal player in the emerging drama of Modernism and pre-eminent among popular or naive artists. Such readings are not necessarily contradictory. Uhde, for example, claimed for Rousseau a leading role in the history of new art,[23] while at the same time Uhde's practice as a dealer situated Rousseau within a context of naive and Folk art. Subsequent institutional accommodation of Rousseau had a similar duality. When, in 1936, Alfred Barr, first Director of The Museum of Modern Art in New York, drew up his famous diagram of artists and schools – tracing a genealogy of Modernism for the first time – Rousseau is one of very few 'named' artists to grace the page, albeit in a somewhat

marginal position (fig.14). Around the same time the Museum presented a trio of thematic exhibitions intended, according to Barr, 'to present some of the major divisions or movements of modern art'.[24] The first two, *Cubism and Abstract Art* and *Fantastic Art, Dada, Surrealism*, both held in 1936, have gone down in the history books as landmark shows. The third, now largely forgotten, was *Masters of Popular Painting*, in 1938. From the vantage of the present, and a still broadly uncontested canonical reading of Modernism from the vortex of mid-century artistic transformations to the emergence of post-conceptual practices, popular painting seems oddly misplaced alongside groupings that proved themselves precursors of all that followed. However, at the time, so-called popular art *was* still relevant and engaging. That this was so was, in part, due to the stature of Rousseau himself, by now enshrined in the great collections of the Louvre and The Museum of Modern Art. In his introduction to the 1938 exhibition, Barr wrote: 'It is only since the apotheosis of Henri Rousseau that *individual* popular artists have been taken seriously'.[25]

While Rousseau's relevance to his contemporaries – his stature within emerging Modernism – continues to be explored, and was the subject of the last major exhibition of his work in 2001, the case continues to be made for

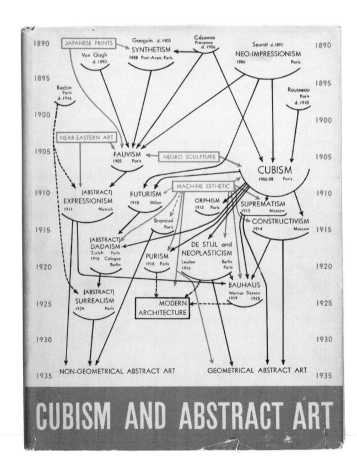

Fig. 14
Diagram of artistic movements, devised by Alfred Barr, Director of The Museum of Modern Art, New York

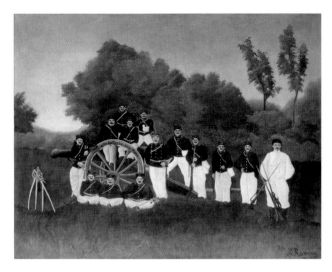 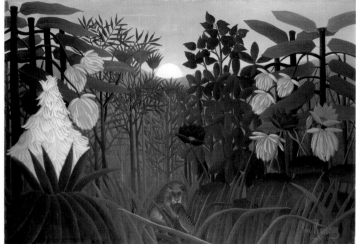

Rousseau as the 'first paradigm of untutored creativity'.[26] But were Rousseau's ambitions so naive and was his painting so inept? Clearly he was self-taught, but was he truly unable to master perspective or did he deliberately circumvent – indeed as others were doing – a convention that would have detracted from his interest in surface clarity, in colour and in pattern? Why, when observers noted the care with which Rousseau measured his models and squared up his canvases, or even more perplexing when he directly transcribed from a photograph, did he take such extreme liberties with scale and proportion? Why also, when plenty of paintings – *The Artillerymen c*.1893–5 (fig.15) for example – demonstrate an alternative, softer and more painterly manner for rendering massed trees and foliage, did Rousseau increasingly opt for the full frontal, clearly outlined and flattened profiles of plants in his Jungle paintings? Why, when the skies of his home-land paintings reveal the whole gamut of Paris weather conditions, did he seek to situate his exotic landscapes under cloudless skies uniformly lit by the moon or the setting sun? There is undoubted and ample evidence, within his oeuvre as a whole, that he was aware of other options available to him that he could have chosen.

We must presume that the choices Rousseau made were not principally motivated by the desire for conventional, public acclamation but rather by a singular drive to feed the fantasy of his visions, to capture and convey a world of familiar things reconstituted and made unfamiliar in his dreams. Whereas so many of the Modernist artists who followed Rousseau were bound up in a struggle for innovation and radical renewal in which subject matter became mere pretext in advance of abstraction, for Rousseau the subject was always pre-eminent. In the Jungle paintings, subject and style find their most satisfying symbiosis.

Rousseau and his art remain singular and enigmatic. Quintessentially a product of his era, Rousseau made paintings that can be placed in relation to his fore-bears and contemporaries, but cannot be constrained by a particular school or tendency. Nor did his example suggest a particular way forward in the avant-gardist sense of aesthetic innovation, although his life and art offered inspiration to many. But while Rousseau may have fallen off the map of art history and is so often now confined to a discursive aside in the history books,[27] the works themselves and Rousseau's vision of the jungle remain firmly embedded in collective memory and fantasy alive to this day.

Souvenirs of the Jardin des Plantes: Making the Exotic Strange Again
Christopher Green

'The strangest, most daring, and most charming of exotic painters.'[1] This was Guillaume Apollinaire's judgement of Henri Rousseau, the painter of distant lands. In 1910, the year of Rousseau's death, Picasso double-exposed a photograph of one of Rousseau's Jungle pictures (fig.17) over another of the old man himself (see figs.19–20). Accidentally or not, his photograph said something: at that moment, it was as an exotic painter overwhelmed by his jungles, that Rousseau was most indelibly making his mark. Within the circles around Apollinaire and Picasso, his discovery was 'a beautiful revolutionary act', to be aligned with their discovery of the visual cultures of Africa and Oceania.[2]

A lioness fastens its claws and teeth into an antelope, whose screams echo through the forest. A jaguar salivates in the trees above, the whites of its eyes aglow. The scene takes place in a jungle fit for every jungle story of every Western childhood. Rousseau's *The Hungry Lion throws itself on the Antelope* (no.49) has been stopping people ever since it was first shown at Paris's Salon d'Automne of 1905, and his Jungle pictures have been doing so since 1891, when he showed *Tiger in a Tropical Storm (Surprised!)* (no.43) at the Salon des Indépendants. Fourteen years later, he was embarked on a series of exotic pictures that would culminate in 1910 with his last word to his Indépendants public, *The*

Dream (no.50), and which would take in a whole cast list of animals, from the big cats to the monkeys of *The Merry Jesters* in 1906 (no.28) and the lazily unravelling constrictors of *The Snake Charmer* in 1907 (no.51). Lions, tigers and jaguars pounce, antelope, buffalo and humans succumb, serpents are charmed, monkeys play.

Between 1904 and 1910, the exotic pictures were dominant among Rousseau's crowdstoppers and, in the inter-war period, they were the pictures that, above all, gave his work modernist weight for his admirers. It was *The Dream* that André Breton imagined carried in Surrealist triumph through the streets like a Cimabue Madonna; it was *The Sleeping Gypsy* (fig.30), Rousseau's sole major exotic picture of the mid-1890s, that in 1926 topped the prices paid in Paris for Picassos and Matisses; it was with *The Snake Charmer* that Rousseau entered the Louvre.[3]

Yet, since the middle of the twentieth century, there seems to have been increasing difficulty in seeing just what made Rousseau's work, especially the Jungles, so extraordinary for Apollinaire, Picasso and Breton.[4] It has been, perhaps, too easy to leave Rousseau's Jungles somewhere in that unthreatening, enchanted space occupied in Western collective memory by children's story-books: Elmer the elephant surely lives in a Rousseau jungle.

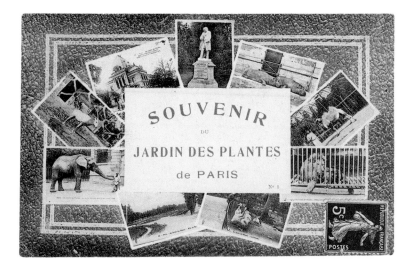

And yet it is difficult to leave *The Hungry Lion* for long in so benign a space. Rousseau showed it with a text that reads: 'The lion, being hungry, hurls itself on the antelope, [and] devours it; the panther anxiously awaits the moment when she too will have her turn. Carnivorous birds have each torn off a piece of flesh from the underside of the poor animal as it lets fall a tear! Sunset.' This is a space densely packed with horror. Rousseau feeds not merely an appetite for fantasy, but for bloodthirsty excess. There was certainly enough in such an image of violent release to make a Picasso or a Breton stop with the crowd.

My aim in this essay is to get at what was so strange about Rousseau's exotic pictures (the peaceful as well as the violent ones), and what could give them the power to challenge the givens of their society as both Picasso and Breton did. This can only be possible, I believe, if one begins to reconstruct what dominated attitudes to the faraway, in a society whose leaders preached technological 'progress' and looked to a future illuminated by the 'civilising light' of an expanding colonial France.

For Apollinaire and many others who chose to believe in Rousseau's 'revolutionary' contribution, the exotic in Rousseau's painting was more than merely strange; it was authentic, too. The story was that his Jungles were memory paintings: the irresistible resurfacing of his experiences of tropical forests in Mexico as a soldier with Napoleon III's expeditionary force against the Emperor Maximilian in the 1860s. Rousseau's own storytelling was the source for this, and Apollinaire a major reason why it gained currency before it was exposed as the fable that it was: Rousseau served as a soldier, but he never left France.[5] Robert Delaunay, the closest of his avant-garde artist friends, also believed him, and so did his first biographer, another close friend, Wilhelm Uhde.[6] And yet Rousseau himself, when pressed, was happy to confess that his Mexican stories were confabulation. In the one extensive interview published during his lifetime, the critic Arsène Alexandre writes that he obtained, 'without difficulty', confirmation that Rousseau had never 'travelled further than the glass houses of the Jardin des Plantes'.[7]

About that, at least, there has always been certainty: Rousseau was a habitual visitor to Paris's Jardin des Plantes, run by the Muséum d'Histoire naturelle, with its zoo and its impressive new Zoology Galleries (opened to accompany the 1889 Paris World Fair). Others who were close to him in the last years of his life confirm this: 'Often on Sunday' he would 'walk in the Jardin des Plantes or the Jardin d'Acclimatation', writes the Baronness d'Oettingen under

Fig. 18
Postcard, Souvenir of the Jardin des Plantes, 1900s

Fig. 19
Pablo Picasso
Portrait of Henri Rousseau
1910
Musée Picasso, Paris

Fig. 20
Pablo Picasso
Portrait of Henri Rousseau, double exposure
1910
Musée Picasso, Paris

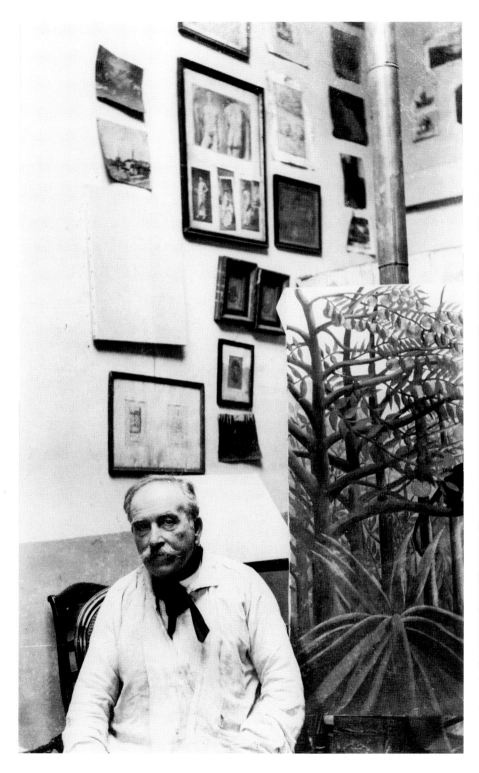

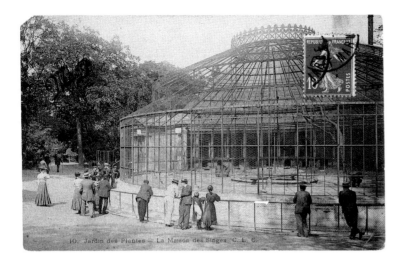

her pen name Roch Grey in the second Rousseau monograph to be published.[8] The American painter Max Weber, who introduced him to Picasso in 1908, recalls sketches of the Jardin des Plantes, and the dealer-critic Adolphe Basler remembers him going there to sketch.[9] As a painter of the 'exotic', Rousseau offered, in the end, Parisian jungles, and his sources included not only the Jardin des Plantes and the Jardin d'Acclimatation in the Bois de Boulogne (about which more later), but also the great Paris World Fairs of 1889 and 1900, and the popular literature of travel and colonial domination.[10]

Roch Grey was sceptical of Rousseau's Mexican tales, and Apollinaire, Delaunay and Uhde must have been aware of his admission to Alexandre that he had never left France. Yet for them at least, there was a need, it seems, to go along with the ageing pensioner's storytelling. I shall suggest a possible reason why at the end of this essay.

The fact is, however, that, if there is any level on which authenticity is a question relevant to Rousseau's Jungles, it is not authenticity in relation to jungles in Mexico, but to jungles in Paris. Among other things, after all, his Jungles are souvenirs of the Jardin des Plantes, though not quite in the same sense perhaps as the postcard collages of the zoo and other attractions sold as souvenirs there from the early 1900s. And what is striking when the question of authenticity is applied in the Paris context is the fact that Rousseau's Jungles not only have nothing to do with Mexico, but also were profoundly *un*like the exotica on offer in the zoos and Zoological Galleries of Paris.

The zoo of the Jardin des Plantes was hugely popular through the entire period from the 1880s to 1910. Rousseau's Sunday visits were part of a mass phenomenon.[11] Yet, through the entire period, the zoo was under severe budgetary constraints, which meant that many of its animals, especially the biggest draws, survived in scandalously deprived conditions.[12] Some at least of the exotic birds of Rousseau's paintings had been given a spacious new aviary in 1888.[13] Snakes, including two impressive pythons on the scale of the serpents bewitched by Rousseau's snake charmer, inhabited recycled hospital cabinets in a relatively new reptile house (completed in 1874), outside which stood a bronze sculpture of a snake charmer by the then highly regarded Charles Arthur Bourgeois.[14] But the animals that were given most of the lead parts in Rousseau's Jungle pictures, the big cats, the apes and the monkeys, were consigned to cages considered totally inadequate even in the 1850s.

The zoo possessed throughout the period an impressive collection of lions and lionesses, tigers, jaguars

Fig. 21
Postcard, The Monkey Palace,
Jardin des Plantes, 1900s

262. PARIS — JARDIN DES PLANTES · JARDIN D'HIVER

and panthers, because they survived the European climate well and reproduced in captivity. Only a few, however, had exposure to fresh air, in a restricted outdoor enclosure recently added to the lion house. Most dozed and paced in the twenty-one badly ventilated, unheated cages that had been constructed just after the Napoleonic Wars.[15] The monkeys quarrelled and sometimes performed as gymnasts in a domed iron cage, dubbed the Monkey Palace, in which there was no vegetation at all (fig.21). It had been thought luxurious monkey accommodation when it was built in the late 1830s, but in 1891 was described by the zoo's director, Alphonse Milne-Edwards, as so unhygienic that most enclosed in it became sad within weeks before sickening and dying.[16] Rousseau's *Merry Jesters*, surrounded by luxuriant greenery, relate to species that did survive in the Jardin des Plantes, but the picture has nothing at all to do with the barren waste of the Monkey Palace; nor do any of his other monkey pictures.[17] The survival rates of the great apes were particularly low, and so Rousseau had no chance to see chimpanzees in the zoo throughout the 1890s and the 1900s until one arrived in 1906. He could have seen an orang-utan there for only a few months in 1885, and would never have had a chance to see a live gorilla.[18]

The glass houses were as old as the Monkey Palace (they were built between 1835 and 1841), but the profusion of vegetation in the heat of the tropical house was often commented on (fig.22). There, at least, living specimens from far away could be encountered in the right conditions.[19] To see apes, monkeys and big cats outside cages, giving at least an impression of behaving naturally in their own habitats, it was necessary that they be dead: the best opportunity offered was the stuffed animal displays in the Muséum's Zoology Galleries, and from these at least Rousseau certainly drew direct inspiration. They were an attraction from the moment they opened, to a highly appreciative press, in July 1889.[20] In a long, lateral gallery beside the central hall of the new building, were the carnivores, the apes and the monkeys, among which the popular scientific weekly *La Nature* drew attention to 'magnificent new groups of panthers and tigers', as well as to a group that Rousseau would adapt in 1905 for his *Hungry Lion*, a 'Senegal Lion Devouring an Antelope' (fig.25).[21] Even here, however, it is the distance between Rousseau's big cats in their jungle and what he could see in the Jardin des Plantes that is striking. The beasts exhibited may have been 'admirably stuffed' in 'lifelike' attitudes, as *La Nature* put it, but each display was just a single example among thousands. It was calculated that, to see every gallery, visitors had to walk

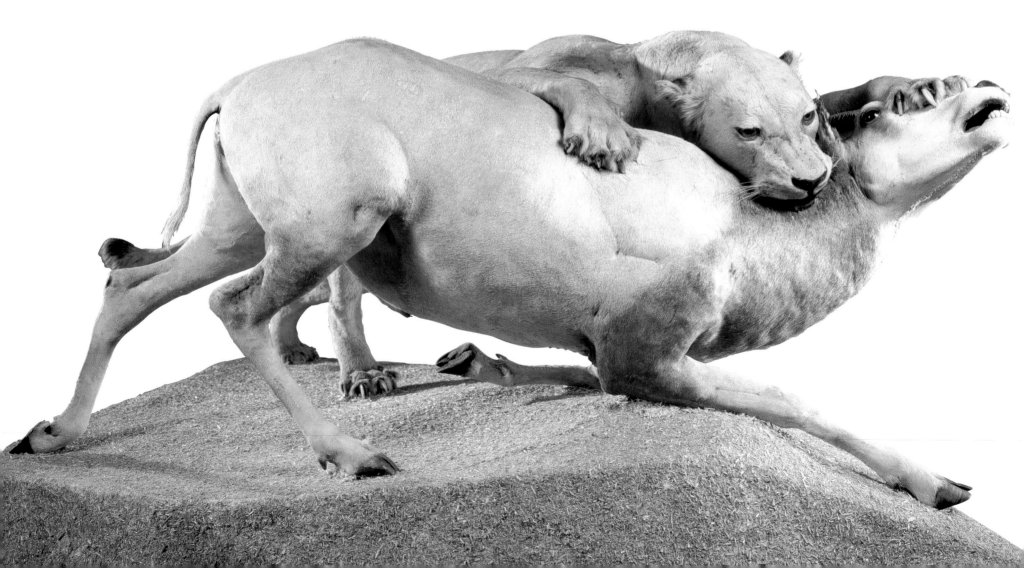

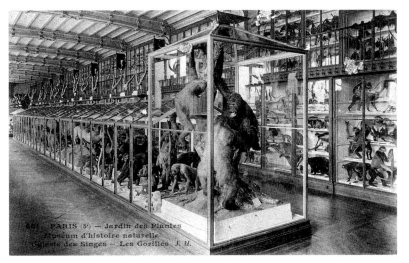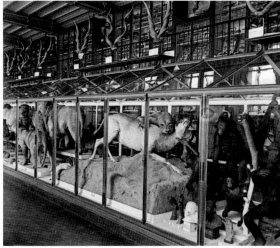

four kilometres; on the way, they passed 23,000 bird and 6,000 mammal specimens, quite apart from the reptiles and marine creatures.[22] When an ordinary visitor like Rousseau stopped in front of the *pièce montée* of the lion and the antelope, he had to detach it from an indigestibly vast mass of impressions.

Moreover, the way in which the curators of the Zoological Galleries organised that mass of material was driven not so much by the wish to feed the imagination of a half-educated, fanciful visitor like Rousseau, as by the wish above all to instruct. The Galleries, the zoo and its offshoot the Jardin d'Acclimatation in the Bois de Boulogne all existed primarily to educate and to pursue scientific research. When in 1891 Milne-Edwards unsuccessfully made the case to government for an increased zoo budget in order to fund modernisation, he pointed to its popularity as a problem not as a benefit, and built his argument on the massive scientific contributions of his predecessors – such figures as Georges and Frédéric Cuvier, Étienne and Isidore Geoffroy Saint-Hilaire. The zoo, he argued, was at the centre of a collecting and research programme that had made possible major breakthroughs in the understanding of comparative anatomy, animal behaviour, the potential of hybridisation and of the acclimatisation to European conditions of foreign species.[23] Its educational role was central, too, and indeed that decade saw it take on significantly new responsibilities. At Nogent-sur-Marne, it opened the École supérieure d'agriculture coloniale, dubbed the Jardin coloniale, to train the colonists who, in the State's ideal colonial future, were to make 'Greater France' agriculturally as rich as France herself.[24] It is worth adding that the Muséum's accent on precision in the categorisation and description of plants and animals spread right across the literature of zoology and botany in its most popular forms – the forms that reached Rousseau. The Muséum naturalists' insistence on exact distinctions and their preoccupation with orders of classification are features of many of the entries in the department-store Galeries Lafayette's publication, *Bêtes sauvages*, mostly devoted to the zoo animals of the Jardin des Plantes, which Yann Le Pichon has shown to have been one of Rousseau's most exploited Jungle-picture sources.[25]

Perhaps he read the entries as well as gazing at the photographs, but Rousseau's Jungle pictures said very little at all instructive about the animals, living or stuffed, that he actually saw in the Jardin des Plantes. It is, in fact, their sheer, impossibly fabulous *in*authenticity that was and is so extraordinary. And the importance of their inauthenticity is

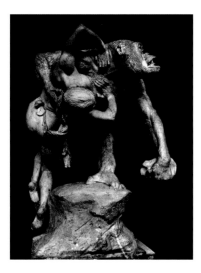

greatly enhanced by the fact that one of the fundamental aims of the Professors of the Jardin des Plantes (besides scientific research and the training of colonists) was precisely to offer public curiosity 'authentic' experiences. It was an aim they shared with the publishers of the popular literature of the exotic.

Two instances can finally underline this point: the work of the taxidermists in the Muséum, and the work of artists (other than Rousseau) there.[26] Preservation was, of course, a major priority for the taxidermists, but *the* priority for Terrier, the chief taxidermist who led the animal-stuffing campaign for the installation of the new Zoological Galleries in the 1880s, was to achieve the most lifelike results possible. His team worked as artists, using skeletons as armatures to fabricate remarkably accurate sculptures cast in plaster, before the damp skins were stretched over them.[27] *Senegal Lion Devouring an Antelope* (fig.25) was a sculpture finished in skins. The zoo of the Jardin des Plantes was, however, *the* place to observe living animals as authentically as possible, and one of its declared functions was to serve the needs of artists. Terrier's sculptor taxidermists worked in a sculptural tradition developed by artists who studied animals from the life in the zoo. One of those artists was Emmanuel Frémiet, who from 1884 until after Rousseau's death was Antoine-

Louis Barye's successor as the Muséum's official 'master of drawing'.[28] His *Gorilla* (fig.26) might now appear a brutal, near pornographic fantasy, but between its rejection by the Salon in 1859 and its triumphant showings at the 1887 Salon des artistes français and at the 1889 World Fair, he promoted the sculpture as the authentic product of his close, first-hand examination of a stuffed gorilla from the zoological collection.[29] Rousseau was almost certainly not among those who attended Frémiet's courses at the Jardin des Plantes, where he taught accurate observation of the forms and movement of the animals.[30]

The inauthenticity of Rousseau's jungles was something that his contemporary admirers saw plainly enough. The writer Philippe Soupault, while a proto-Surrealist ally of Breton, comments that the strangeness and the freshness of *The Merry Jesters* (no.28) overrides the obvious unlikeliness of the story it tells (that milk bottle in mid-air, inexplicably suspended in front of monkeys performing as if in the music hall or the zoo, except that they are in a dense tropical forest).[31] Responding to *The Dream* (no.50), the Italian painter-critic Ardengo Soffici, who had commissioned work from Rousseau, describes the 'horrible flowers', like lotuses or 'monstrous water lilies', and 'pink-veined leaves like those of the Turkish vine', brought

Fig.26
Emmanuel Frémiet
Gorilla
1887
Fonds national d'art contemporain,
Ministère de la culture et de la communication, Paris

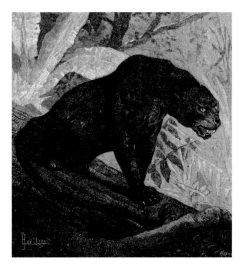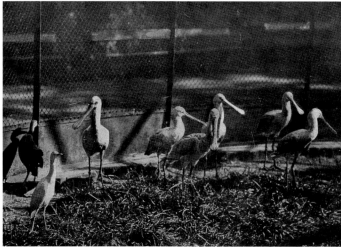

Fig.27
Anonymous
'The Black Panther, after the
living specimen in the Muséum
d'Histoire naturelle, Paris',
La Nature, 1900

Fig.28
'Jeunes Spatules (Platalea)',
illustration from *Bêtes sauvages*

together 'without the slightest truth to life' under a moon disk suspended in the 'pearl hued sky' like a railway signal. 'What,' he asks, ' does this meeting of heterogeneous things that cry out at being together... signify?' They signify, he answers, 'a vision that is personal': these are Rousseau's jungles, and Rousseau's alone.[32]

In order to endow a star attraction at the zoo, a black panther, with greater authenticity, the illustrator in 1890 of an article in *La Nature* does the obvious thing: he lifts it out of the barren emptiness of its cage and places it in a tropical forest (fig.27).[33] Rousseau, too, always makes this routine move: he gives his animals from the zoo or the stuffed animal displays jungles or deserts in which to live and die. The jungle into which he puts the lion and antelope from the Zoological Galleries in *The Hungry Lion* (no.49) is one of his most convincing, but the later Jungles especially – those of *The Repast of the Lion* (no.48) or *Jungle with Setting Sun* (no.46) – become, as Soffici saw in the case of *The Dream*, heterogeneous collections of plants, many impossibly enlarged, others more associated with deserts or even with temperate climates than tropical forests.[34] Collage-like imaginative processes are often the underpinning of Rousseau's inauthenticity-effects, as Le Pichon has shown. The jaguar in the trees above the lion and antelope in *The*

Hungry Lion is lifted from another stuffed-animal display while, in *The Snake Charmer* (no.51), zoo birds with spatula-like beaks, lifted from a photograph in *Bêtes sauvages* (fig.28), join a flute-playing figure loosely related to a Salon des artistes français success of 1899, reproduced in the popular souvenir album, *Panorama-Salon*.[35] Little is ever credible in Rousseau's collaged, exotic world: the delicate yet rich colouring of the plumage of the spatula-beaked bird (of the *Platalea* species) in *The Snake Charmer* has nothing to do with the colouring so carefully described in *Bêtes sauvages*; the side-view of the deer lifted from another photograph in that book for *The Waterfall* 1910 (no.23) is from Mongolia, and is one of a species, the entry informs us, found everywhere except in the tropics; gorillas do not live in forests where they can attack Native Americans (fig.35); the macaco monkeys he puts in his jungles (no.25) are actually mountain monkeys – and so on.[36]

Gauguin's picturing of the exotic was, it is well known, also produced by an imaginative collage process that combined a wide range of images from high and popular culture. The difference is that the results could be presented and received as coherent representations of people and places, and above all of a lost mythology, where Rousseau's collaging of the exotic resists coherent reading at every level:

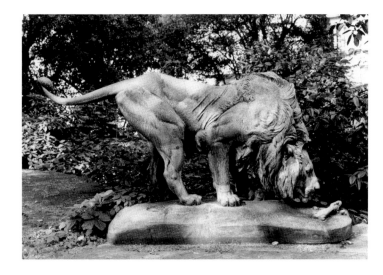

it is impossible to the point of absurdity.[37] As Soffici remarks of *The Dream*, responses to its impossible heterogeneity ranged from a shrug to bursts of laughter.[38]

Even where Rousseau does not obviously collage, but works from a dominant or sometimes a single model, it is the degree to which he renders his models inauthentic – the degree to which he re-invents them – that matters.[39] Certainly this is the case where the lion and antelope of *The Hungry Lion* are concerned. Probably working with a postcard as model, he exaggerates brutally for expressive effect: that stretching of the antelope's neck and lower jaw as it screams in agony; those bloody rips gouged from its flank by the 'carnivorous birds'.[40] The expressive strikingly takes over from the lifelike too in one remarkable instance so far unnoticed: the superb lion that dominates *The Sleeping Gypsy* 1897 (fig.30). Rousseau's model here was one of two lions sculpted by Alfred Jacquemart, cast in bronze in the 1850s and later mounted above a fountain close to the rue Cuvier entrance into the Jardin des Plantes (fig.29).[41] Jacquemart, one of those artists who studied animals from the life in the zoo, offers a remarkably closely observed reproduction in the round of leonine movement, form and musculature. His lion sniffs the bare foot of a buried human corpse, beside which is an abandoned calabash. The

confrontation is the trigger, it seems, for Rousseau's fantasy of the sleeping gypsy in mortal danger, and he keeps the essentials of the lion's posture – the slow incline of the massive head, the stiffened, virile tail – but erases all those details of stretched skin and authentically rippling muscles to produce a sculptural invention of his own, the controlling presence in the work. In 1890, writing just before Rousseau exhibited his first Jungle picture, *Surprised!*, Gauguin's admirer and follower Maurice Denis used the example of the ancient Assyrian lion reliefs in the Louvre to support his argument for form, not nature, as the key to expression in visual art: 'Compare... the lion in nature to the lions of Khorsabad,' he wrote. 'Which demands genuflection?'[42] Denis's answer would have been the lions of Khorsabad. Rousseau, however, needed Jacquemart's 'authentic' lion before he could invent his lion for *The Sleeping Gypsy*. His kind of inauthenticity depended on a rich diet of the 'authentic', supplied as much by the taxidermists as by the 'animalier' sculptors.

It is not, in the end, the inauthenticity of Rousseau's Jungles *as such* that counts for me here; it is what they could do for their spectators because of it. Put baldly, they could do two things: they could free their spectators (at least momentarily) from a scientifically ordered world (the world

Fig.29
Alfred Jacquemart
Lion and Corpse
1854

Fig.30
The Sleeping Gypsy
1897
The Museum of Modern Art,
New York. Gift of Mrs Simon
Guggenheim, 1939

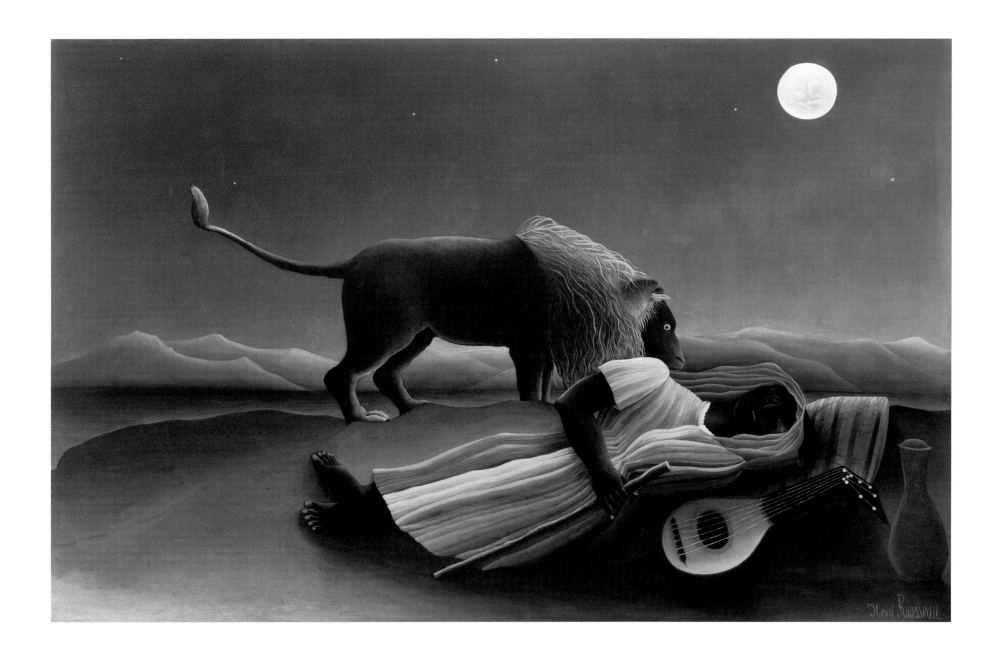

for which the Muséum stood as a dominant scientific institution in progressive Third Republic France), and they could de-familiarise the worlds of distant flora and fauna made familiar by the popular culture of the exotic under colonialism. The challenge they presented to science was something recognised early on by Robert Delaunay (the first owner of *The Merry Jesters*, and whose mother commissioned *The Snake Charmer*). Immediately after Rousseau's death, Delaunay writes of Rousseau's painting as a direct challenge to logic. Faced with Rousseau's kind of 'totality', he contends, 'scientific analysis becomes useless'.[43] The force of the challenge that the Jungle pictures presented to the familiarisation of the far away is brought home when one realises just how far the process of familiarisation could be taken in France, especially if one does so with the writer Victor Segalen's early twentieth-century idea of the exotic in mind. For Segalen, intellectual trustee of Gauguin's legacy, the exotic is the very 'notion of difference': it is that which is *least* familiar.[44]

By the period 1904–10, when Rousseau painted almost all his exotic pictures, jungles and 'wild' animals were so familiar in Paris that, in Segalen's terms, they had been effectively de-exoticised. But perhaps the most telling demonstration of the drive to familiarise the far away was the importance given to acclimatisation as a project originated and managed by the Muséum from the nineteenth into the twentieth century. The aim of the project was not merely to make exotic plants and animals familiar, but actually to Europeanise them, indeed to make them French: it was aimed at ironing out difference altogether (an aim made immediately apparent in the picturesque, distinctly European housing of the herbivores and ostriches at the zoo).[45] By 1855, Isidore Geoffroy Saint-Hilaire had drawn up a list of mammals and birds that could adapt to the French climate, and 1860 saw not only the foundation of the Jardin d'Acclimatation but the release of yaks from China to graze in the Jura and the Cantal. One of Alphonse Milne-Edwards's boasts as the zoo's director, three decades later, was that several types of antelope, along with gnus, had been released as 'new game' into the forests around Paris (are they still there?).[46]

The incoherence, the inauthenticity of Rousseau's jungles in Paris proofed them against both the analysing scientific eye and the growing monotony of the familiar. They are spaces that cannot be controlled or tamed, which are opened up to the imagination, as if they were the product not of 'authentic' spectacles at all but of dreams. When he confessed to Alexandre that he had never gone further than

Fig.31
The Snake Charmer
1907
(No.51)

the Jardin des Plantes, the journalist recalled Rousseau's depth of feeling as he said: 'I don't know if you're like me... but when I go into the glass houses and I see the strange plants of exotic lands, it seems to me that I enter into a dream. I feel that I'm somebody else completely.'[47] For many, unsurprisingly, *The Dream* (no.50) has been taken to be the key to all Rousseau's Jungles. Gauguin used texts and titles both as explanation and suggestive mystification. Rousseau used the most straightforward titles and maintained that the texts that accompanied his paintings, as in the case of *The Hungry Lion* (no.49), were there to clarify, not mystify. Greeted by mystification in response to the European nude on a red couch in *The Dream*, he patiently explained in the simplest of terms how the piper draws the nude 'Yadwigha' into her dream.[48] Yet the Jungle pictures evade explanation far more comprehensively than Gauguin's Tahitian pictures. As many have observed, their invitation to dream infantilises their spectators. Writing in 1911, Uhde puts it like this:

> It is not the virgin forest as it is in the botanical or the zoological gardens that he paints, but the virgin forest with its terrors and its beauties of which we dream in childhood, where palm woods stand under the silvered light of the moon beside broad rivers... where the night echoes with the cry of the black man that the panther devours.[49]

To be infantilised thus is not, however, to be released from the fears and desires of adulthood; it is to allow them to surface as if with the intensity of childhood fears and desires, as Breton clearly realised.

Rousseau seems to have approached every landscape that he painted – those made after outings to Ivry or walks on the Paris quais as much as his Jungles – in a dreaming frame of mind. He often lights his Paris landscapes, like the calmer of the Jungles, in a de Chirico-like but shadowless midday, sometimes under looming clouds. They are the necessary homeland counterparts of the Jungles, and when he exhibited, he showed his exotic and his homeland pictures together. But his jungle dreaming was different. In Paris in the 1900s, Rousseau the ageing Republican idealist dreamed of a perfect modern France, sometimes threatened under those clouds, perhaps, but a place of social harmony nonetheless; a France that could seem to not be far away.[50] His Jungles, where they were peaceful or comic, as in *The Waterfall* (no.23) or the monkey pictures (nos.25, 27), offered a

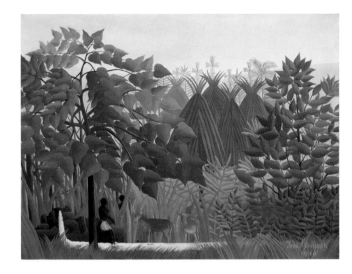

Fig.32
The Waterfall
1910
(No.23)

cloudless broad daylight – sunshine every day – but far away (and long before low-fare paradise tourism). When he confronted violence in his Jungles, where there was only terror, he bathed his scenes in especially suggestive light, which took them even further away: his fights to the death take place in a menacing half-light, either under a red sinking sun or a full moon. They take place very far away, and yet they are disturbingly immediate. Those red suns behind the trees suggest more strongly the slowly fading winter sunsets of the Bois de Boulogne than the briefly brilliant sunsets of the tropics. These are tropical forests for Northern imaginations.

So, if we return to Segalen's definition of the exotic, it becomes possible to say that Rousseau's Jungles *re*-exoticised a popular imagery of the exotic: he made it impossibly idyllic, excessively horrifying. And he took it away, far away, by making it different again, yet gave it an immediacy that could connect with the desires and fears of his European viewers. With the question posed earlier still in mind – what could the inauthenticity of his jungles do for their spectators? – it is worth taking a closer, final look at the character and functioning of the exotic as he re-invented it.

On one level, certainly, Rousseau's Jungle pictures are like the 'authentic' displays of the exotic that he knew in Paris, for those displays were inevitably inauthentic too: in a real sense, they were themselves, after all, assemblages much as the souvenir postcards of the Jardin des Plantes and Rousseau's Jungles are collages.[51] A claustrophobic density characterises Rousseau's tropical forests, the echo of the dense accumulations of plant and animal species crowded together in the Jardin des Plantes. As Tristan Tzara pointed out, Rousseau's pictorial composing was not simply a matter of construction, it was a matter of accumulation too.[52] But, for the avant-gardists who championed him, from Alfred Jarry in the mid-1890s on, it was more essentially the way that he combined the dense, dream-like accumulation of 'facts' with modernist picture-construction that made his work so compelling. It is in this that he is most obviously Gauguin's Parisian counterpart as a painter of the exotic.[53]

It is almost certainly not a mere coincidence that Rousseau's return to the exotic after years of neglect of such subjects came in 1904, the year after Gauguin's death and the first Parisian exhibitions that brought his Tahitian work back into the foreground for the modernist avant gardes.[54] Rousseau had probably known Gauguin and seen the paintings of his first Tahitian stay when he was back in Paris between 1893 and 1895, and I would argue that he hung on to his own 'naivety' as a quality to be cultivated, very much

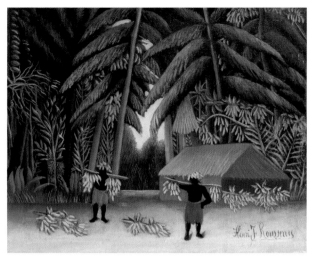

Fig.33
Banana Harvest
1907–10
Collection of Mr and
Mrs Paul Mellon

Fig.34
Georges Spitz
Banana Carriers
c.1888
Photograph from the
album of the 'croiseur'
Duquesne, Tahiti

aware of its cachet in the milieux not only around Jarry but also around Gauguin.[55] One feature of 'naive' image-making found by their contemporaries in both Gauguin's and Rousseau's work was the 'decorative': that subordination of 'nature' to expressive formal invention on which Denis insisted.[56] Those who championed Rousseau after the success of *The Hungry Lion* in 1905, championed him as a modernist master of pictorial construction, often using the word 'decorator'.[57]

Gauguin, then, the 'decorative' painter of the exotic, certainly can be paired with Rousseau the painter of 'decorative' jungles, but I stress again: Rousseau's refusal of coherence and authenticity is altogether more extreme, more 'daring', as Apollinaire put it (to accept his knowingness as a painter, rather than the myth of his 'naivety', is to realise just how daring this was).[58] Further, the dreams Rousseau opens up for us are, in their adult yet infantile simplicities, very different from the cumulative picture of a corrupted paradise that Gauguin offers. Since Rousseau never left France, he never risked the kind of disappointment with the far away that Gauguin suffered on his arrival in colonial Tahiti in 1891.[59] There is only one certain instance where he paints a scene that could be considered colonial: an unusually small canvas for a

Jungle picture, *Banana Harvest* 1907–10 (fig.33), and this, aptly but surprisingly, was based on a photograph of a Tahitian plantation taken by Georges Spitz (fig.34), a photographer whose work was, in fact, one of Gauguin's inspirations when he was in Oceania.[60] Otherwise, Rousseau's Jungles never feature, as Gauguin's Tahitian paintings so often do, identifiable indigenous peoples and can never be related to specific places or times. What Rousseau paints is the wild, imagined at a time before European culture: a dream of men and beasts in the state of nature. In this, his Jungles are more to be compared with Picasso's and Derain's attempts in 1907–8 to paint an elemental humanity before culture, than with Gauguin's self-consciously arcane and sophisticated paintings of a doomed Oceania.[61]

From the 1880s to 1910, images of the untamed wild were actually rare in the popular illustrated travel press from which Rousseau made his collection of cuttings. What dominated were images of the impact of colonisation, especially in tropical Africa: the penetration of the wild by explorers, the coming of modern construction, violent military triumph, and the dangers encountered on the way to it.[62] Perhaps Rousseau's most 'revolutionary act' as a painter of the exotic was to almost completely ignore these

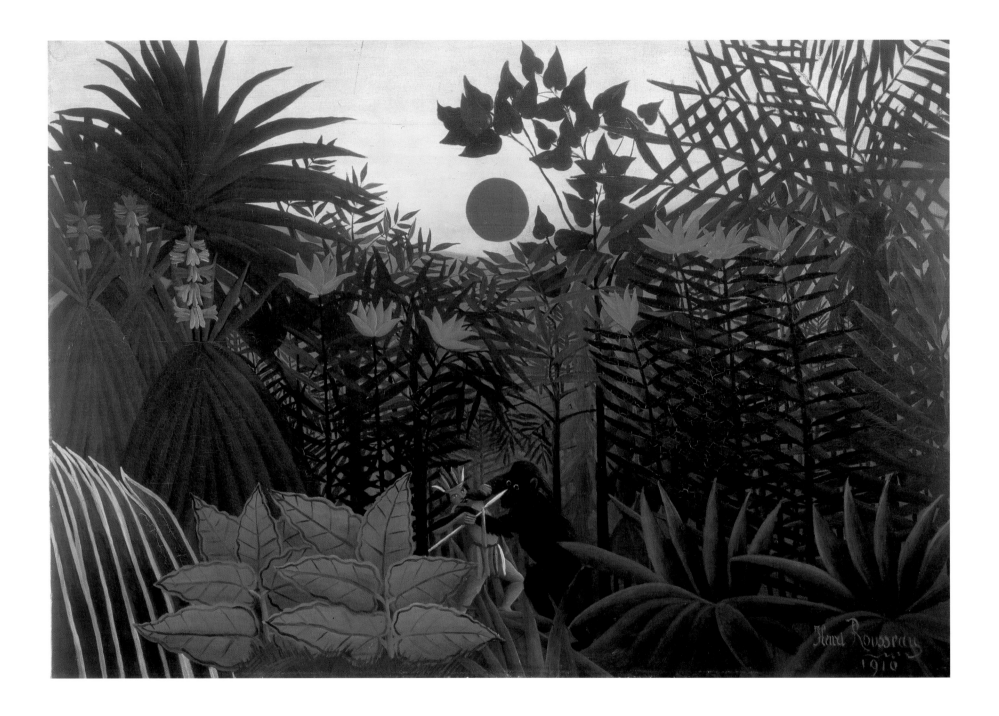

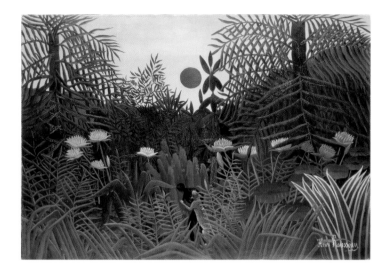

images of colonial mastery, just as he ignored the mastery of nature in the wild represented by science. What he offered instead were exotic images that could work against or at least remain outside the current mythology of mastery, including the racist dream of white European mastery of 'other' peoples.

Certainly Rousseau's 'blacks' are the 'natives' of the colonial imagination of his time: figures from a fantasy of the simple life before technological development, as in *The Waterfall* 1910 (no.23), or from a nightmare of man at the mercy of the monsters of the wild, as in *Jungle with Setting Sun c.*1910 (no.46). But, with only one certain exception, they cannot be situated ethnically except in the broadest generic terms: they are totally unrelated to the formulaic representation of other peoples as racial 'types' that was dominant in popular culture as the 'low' counterpart to the obsession with racial differentiation that had driven physical anthropology since the mid-nineteenth century.[63] The single exception, where Rousseau does give one of his natives an ethnic identity, is *An American Indian Struggling with a Gorilla* 1910 (fig.35), where he dresses his victim as a Native American with feathered headdress, and the result in this case is, of course, patent absurdity. Otherwise, his black villagers and, most strikingly of all, the victim he paints into *Jungle with Setting Sun* are mere ciphers, empty silhouettes

or shadows into which the imagination can project freely. Rousseau told Alexandre that, when he painted 'fantastic subjects', he had to open the window, so much was he overcome with fear. When he painted black victims in the wild, the implication is that he projected into them, to become 'someone else completely'. Neither Rousseau nor his work was proof against the prejudices endemic within his society – or could have been – but the natives in his Jungle pictures offer too few credible cues to invite the kind of racist stereotyping that was the common currency of his time.[64]

If the 'natives' of Rousseau's Jungles do not positively encourage stereotyping, his wild animals do the opposite, and they do so because animals never function as neutral screens for empathetic projection in his Jungle pictures but, instead, as symbols, as images in which very particular constellations of ideas are condensed. Rousseau might ignore the actual habitats of many of the animals he paints, he might be shockingly imprecise in his treatment of their colouring and their markings, he might place them in impossible forests, but the expressive forms and the roles he gives them in his Jungle pictures suggest an exacting grasp of their characters in the popular imagination.

In this at least the natural historians of the Jardin des Plantes made a positive and recognisable contribution

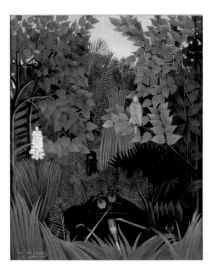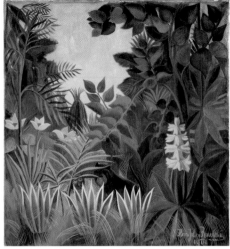

to his Jungle pictures, because it was their work on animal behaviour that laid the foundation in France for the popular stereotyping of the exotic animal world. Indeed, many of the most enduring animal stereotypes were reinforcements of those established well over a century before Rousseau's first Jungle picture by the Comte de Buffon, the celebrated *ancien régime* predecessor of the Professors of the Muséum.[65] Rousseau's painting of animals might not correlate at all with the physical descriptions and careful identifications of habitats found in the entries of *Bêtes sauvages*, but they do correspond closely with the confidently authoritative descriptions of animal character found there, as they do with the closely comparable characterisations found in the popular animal writing of the period.

Lions and tigers are given disproportionate attention in *Bêtes sauvages*, the lion narrowly the more admired of the two for its irresistible power yet its attachments to other creatures (including its keepers), and for its majesty.[66] Rousseau also gives lions and tigers in his Jungles most of his lead parts: the lion capable of a near-human magnanimity to go with its massive force in *The Sleeping Gypsy* (fig.30), and both of them inspirers of fear and awe. Jaguars are represented in *Bêtes sauvages* as they are in popular animal writing generally, as beyond taming,

the most vicious of the big cats; one entry evokes their cries at sunset when their hunting begins, much as Rousseau does in his horror picture *Jungle with Setting Sun*.[67]

Almost every species of monkey represented in *Bêtes sauvages* is anthropomorphised. The dominant monkey species in the book (for which there are three entries and photographs) is the one closest to the monkeys that perform in the Jungle picture that Picasso photographed (no.25), the 'Houlman' or *semnopithecus entellus* from the Indian subcontinent.[68] Henri Coupin, who published a popularising book on monkeys in 1907, describes them as especially vivacious: charming but also notorious thieves.[69] The different entries in *Bêtes sauvages* describe them variously as like certain 'old judges' in appearance, capable of seemingly great seriousness, but also as mischief-makers.[70] All Rousseau's monkeys are mischief-makers and games players, and pictures like *The Merry Jesters* (fig.37) and *The Equatorial Jungle* (fig.38) invite the viewer to play games as well: to play at finding the monkeys that peep, half concealed, from the dense foliage. It is a mark of Rousseau's strong sense of the appropriate that he only put together puzzle paintings of this kind when his subject was monkeys. Finally, his incredible hulk of a gorilla with black staring eyes in *An American Indian Struggling with*

Fig.37
The Merry Jesters
c.1906
(No.28)

Fig.38
The Equatorial Jungle
1909
(No.29)

a Gorilla (fig.35) is the embodiment of an entire mythology of the gorilla as monster, kept up not only by Frémiet (fig.26) and a populariser like Coupin, but also, for instance, in the popular-science magazine, *La Nature*.[71] Coupin quotes a hunter-explorer on a gorilla aroused to fury: 'It reminded me of those visions in our dreams, fantastic creations, hybrid beings, half men, half beasts, of which the imagination of our old painters have peopled infernal regions.'[72]

So, if one asks again (and finally) what the inauthenticity, the incoherence of Rousseau's Jungle pictures could do for their viewers, something fuller can be said in answer. They gave them painted dreams (in the sense that Breton, reflecting on Giorgio de Chirico or Salvador Dalí, would have understood) in which the main characters are animals that act exactly as the mythology of animal behaviour said that they always act (our mythology of animal behaviour has been tamed and domesticated where big cats and gorillas are concerned: the bloodthirsty fascination with the kill in nature is something not so easily acknowledged).[73] His Jungles turned the exotic, with its unfamiliarity restored by the strangeness of their contradictions, into a theatre of fears and desires in which the characters all have roles as pre-defined as, say, those of the Commedia dell'Arte – terrifying, bewitching, comic. They offered a spectrum of possible dreams, from the horror of violent death, to the lovely stasis of serenity, to liberation in play. They offered a parallel, parody world of excess, where all is mystery, where we can desire and fear transgressive savagery as beasts of prey or as victims, where we can believe for a moment in an immaculate beauty, and where monkeys can become surrogates of a wished-for freedom from constraint in infancy (Rousseau's monkeys in one of his Jungles are actually Europeanised, becoming blue-eyed and blond [see *Exotic Landscape* 1910, fig.83]).[74] His Jungle pictures asked to be seen as he himself saw the zoo, the glass houses and the Zoology Galleries of the Jardin des Plantes – as places that can reveal a deep psychological interior, places too wildly astonishing to be tamed.

Now, around a hundred years after he painted them, they can still be show-stoppers, as they were for Picasso and Breton. And yet they do not, in their excessiveness, impose themselves: they invite their viewers to take them over. Perhaps this was why Apollinaire, Delaunay and Uhde, in their time, needed to believe in Rousseau's stories about Mexico. They could tolerate nothing that exposed his Jungles to grown-up scepticism, because they were the places of their own dreams.

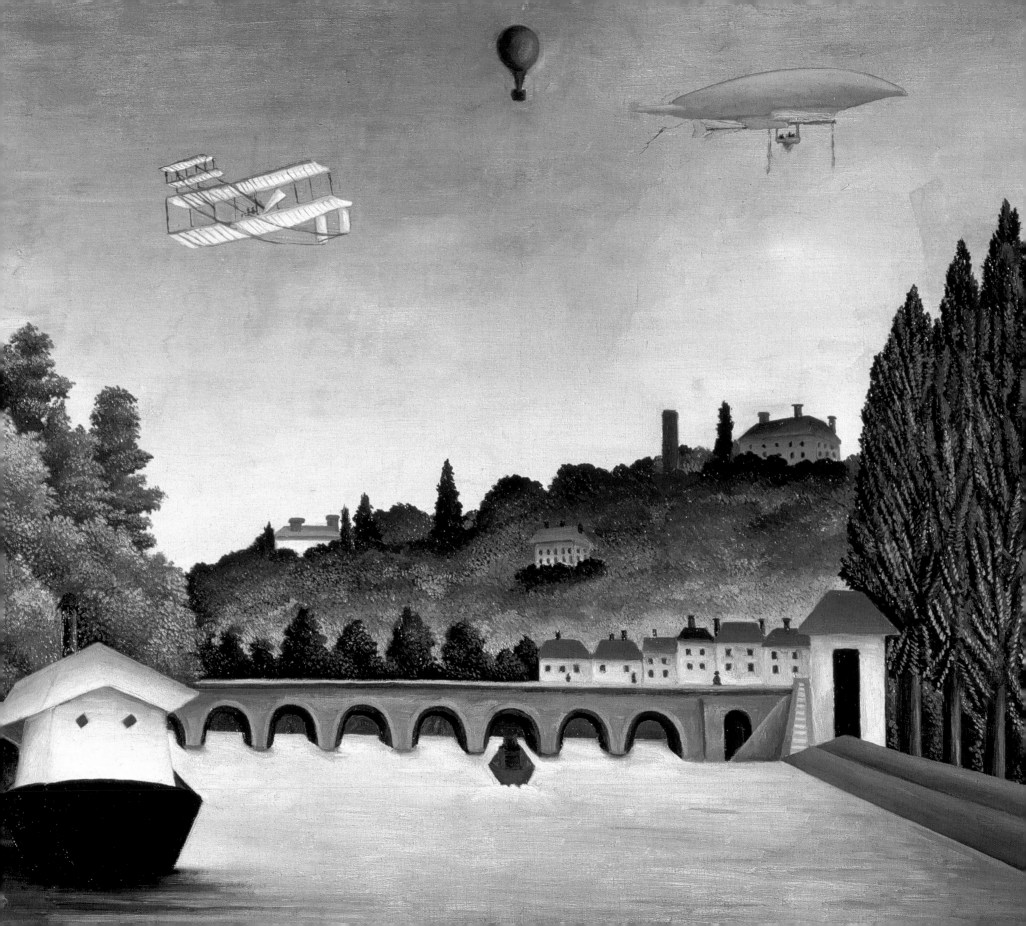

Illusion of Sources – Sources of Illusion: Rousseau Through the Images of His Time

Vincent Gille

Fig.39
View of the Bridge of Sèvres
1908
(Detail of fig.90)
The State Pushkin Museum of
Fine Arts, Moscow

'Rousseau's art... was influenced in part by postcards and poor-quality prints, by cheap weekly magazines', wrote Wilhelm Uhde.[1] Arsène Alexandre spoke of the reproductions of works by Jean-Antoine Watteau and 'certain Bolognese' painters that he saw in Rousseau's studio. Later commentators mentioned, often with good reason, the famous Medieval tapestry *The Lady with the Unicorn*, dioramas from the Muséum d'Histoire naturelle, images and illustrations from *Le Magasin Pittoresque*, *Le Tour du Monde* and *Le Petit Journal*, photographs from the *Bêtes sauvages* album published by the department store Galeries Lafayette, a work by Charles Verlat, another by Jean-Léon Gérôme, and so on. This search for precedents is perhaps an attempt to explain paintings in which there seems to be more than meets the eye. In the process, however, the artist has been buried beneath a mountain of sources.

There are, in fact, established sources for some of Rousseau's works: the *Lion and Antelope* diorama from the Muséum (fig.25) clearly provided the model for *The Hungry Lion throws itself on the Antelope* (no.49). Equally, the animal in *Jungle with Setting Sun* (no.46) was undoubtedly traced from the picture of the young jaguar in *Bêtes sauvages*. The dance featured both in *A Centennial of Independence* (no.18) and *Carmagnole* (fig.79) was

directly inspired by *La Farandole*, Fortuné Méaulle's engraving, which was published in the illustrated supplement of *Le Petit Journal* on 11 April 1891 (fig.41). When pieced together, this information has produced an image of an amusingly inventive artist, a pantographic practitioner par excellence, a creator of extraordinary collages, who made paintings by transposing his chosen motifs on to more or less elaborate backgrounds. Upon painting a portrait of the poet Apollinaire, for example, he wrote to inform his sitter that 'as a background, I shall use a corner of the Luxembourg'.[2]

No one would contest the existence of these sources. But beyond each piece of the puzzle, the paintings as a whole remain unexplained, and a number of questions arise. How do Rousseau's painting-collages reflect the time in which they were made? Are his Parisian landscapes true to the city? Should his Jungles be read within the socio-political context of colonialism? Rousseau was, in accordance with the era in which he lived, caught up in the whirlwind of a changing world. He lived in Paris but remained sensitive to nature. He painted professionally but was nonetheless inspired by postcards, colour prints and magazine images. He depicted wild animals in the middle of tropical rainforests but went no further than the

LES FÊTES A ANDORRE
(La Farandole)

greenhouses of Paris's Jardin des Plantes and the zoological galleries of the Muséum d'Histoire naturelle. He took what was around him: Paris, and the people who animated its streets, as well as its World Fairs with their colonial exhibitions and 'black villages' (reconstructions of 'primitive' settlements). In this respect, Rousseau perfectly encapsulated the *fin-de-siècle* era, where the boundaries between city and nature, old and new, near and exotic, 'primitive' and 'civilised' became blurred; an era that, like Rousseau himself, produced a collage-like aesthetic. This effect of selecting, juxtaposing and re-assembling created, in many different arenas, a strange disparity of vision, where reality was replaced with an illusion of the real. Appearing as the giddying filters of progress, science or universalism, such illusions often masked an ideological or political agenda, be it the myth of the city of light or propaganda for the growing French Empire. But they also evoked a sense of the supernatural, of the weird and wonderful, which rendered them devilishly effective.

A quick survey of Le Douanier Rousseau's work tells us that, of all the genres in which he worked – portraits, allegories, Parisian landscapes, exotic landscapes – the one he practised most, by far, was the Parisian landscape. Of the four or five paintings that he

exhibited annually at the Salon des Indépendants, at least half depicted Paris and its surroundings. Rousseau's Paris was the city he knew best. It was that of the places where he worked: the tollhouses on the banks of the Seine, the embankments and bridges from Austerlitz to Auteuil, from the port of St Bernard to the Point du Jour, the city walls. 'He didn't joke around with his colleagues,' reported Uhde, 'but would go and sit somewhere alone and paint and draw. It seems he made use of everywhere he found himself: the city walls, the Porte de Meudon.'[3] Almost as frequently, he would paint the parks in Paris, from the Jardin du Luxembourg to the Parc des Buttes-Chaumont via the Parc Montsouris (with the notable exception of the Jardin des Plantes) to the Bois de Bologne and the Bois de Vincennes. Then, beyond Paris, he captured the surrounding suburbs: Malakoff and the Bièvre valley to the south, Saint-Cloud, Sèvres and Meudon to the west, Charenton, Ivry and Alfortville to the east,[4] and still further out, the landscapes of the banks of the Oise and the Marne, where 'suburbia gives way to the countryside'.[5]

But were Rousseau's landscapes 'real'? Did he paint them directly from nature or with the help of postcards? Are these views geographically correct? It is difficult to know for sure. If indeed they are based on real

Fig.40
A Centennial of Independence
1892
(No.18)

Fig.41
'Les Fêtes à Andorre: La Farandole', *Le Petit Journal*, 11 April 1891

appearances and are, for the most part, topographically accurate, they also take huge liberties. One would search in vain, for example, for a photograph of a toll gate in Paris at the end of the nineteenth century that corresponds, tree for tree, street for street, house for house, to Rousseau's painting, *The Customs Post c.*1890 (no.8). But when we compare this view with Atget's photos of the Porte d'Arcueil (fig.43), it would appear that, minus the greenery, we are dealing with the same location. *View of the Pont du Jour, Sunset* 1886 might not show all the restaurants and bars that appear on postcards of the site, but the Seine in such images, being an important thoroughfare, is indeed crammed full of river-buses. It is unlikely that Rousseau saw such a ballet of aeroplanes, airships and hot-air balloons at the Sèvres bridge, but the plane in the painting looks exactly like the *14bis* that Santos Dumont flew for 220 metres over the Bois de Boulogne on 12 November 1906, and the airship is identical to the one from which the plane was suspended before detaching itself to carry out its victory flight. Significantly, perhaps, it was customary for postcards of that era to pepper the sky with such apparitions.

'All these paintings are, from a documentary point of view, of little interest',[6] noted Uhde. Likewise Pierre Courthion observed: 'These *Views* are not documentary,

Fig.42
Postcard, View of the
Pont du Jour

Fig.43
Eugène Atget
*Porte d'Arcueil,
Boulevard Jourdan*
1913

and they are even less picturesque.'[7] But what, then, are they? 'The soul of the city,' according to Courthion. 'Personal adventures,' explained Uhde.

Born in 1844 in Laval, in north-west France, the son of an ironmonger, Henri Rousseau, soldier, small businessman, minor civil servant and Sunday painter, clung to the Paris of Sunday strolls, fishing and siestas, a peripheral Paris, a Paris of parks and leisure time, an idle, slowed-down Paris; in short, a suburban Paris, situated somewhere between city and countryside.[8] If he painted from life – 'I make small studies from nature,' he explained to Alexandre, 'but I always rework them on a larger scale in my studio' – he selected elements and altered them to comply with his image of a city that was not too aggressive, not too noisy; that was not too *modern*. Everything here is human-scale, familiar and reassuring, with a few surprises – aeroplanes or flags, pretty dresses and parasols, rewarding those occasional passers-by with a real **sense** of occasion. These were the landscapes that Rousseau took from Paris, the fruits of a selective memory that chose locations unsullied by commercial activity, where it was still possible to make the most of nature, free from the bustle of the crowds. He painted these places so as to accentuate the aspects that he found moving; the rest he discarded. His

views of the city walls, for example, describe airy, rural shrubland, even if that area was also, in part, a dubious no man's land. He painted the Paris of his social class – artisans, small shopkeepers, workers – which was also that of his buyers. Driven out of Paris's historic centre, they emigrated to the former villages of Plaisance, Belleville and Ménilmontant, where, on the other side of the city walls, they constituted the first inhabitants of the new suburbs, characterised by 'a very distinct culture, one set apart from the urban culture all around, against which it defined itself'.[9]

Rousseau was obviously not alone in having painted the Seine, its surroundings and views of the suburbs. But the views he created at once resembled and contrasted with those produced by his contemporaries, who were similarly interested in painting the 'modern' city.[10] In this sense, Rousseau's vision of Paris more closely coincided with that of the amateur photographer Jules Girard (fig.44), or indeed of Eugène Atget, who was 'not interested in the rich, pompous, grandiose Paris of Haussmann, but rather in a crumbling piece of a wall, in a touching or unexpected detail' (fig.45).[11] Apart from the appearance of aeroplanes and airships, one or two paintings of the Eiffel Tower, or a few street-lamps that

Fig.44
Jules Girard
Village in a Valley
*c.*1900

Fig.45
Eugène Atget
Clamart, vieille rue
1901

Fig.46
Marcel Monnier
*In the Forest: Palms
and Creepers*
Binger Mission from
the Ivory Coast to the
Sudan, 1891–2 (detail)

Fig.47
Marcel Monnier
Hunters in the Forest
Binger Mission from
the Ivory Coast to the
Sudan, 1891–2 (detail)

sometimes haunt the horizon, the modern city, the living city, the luminous city is absent from Rousseau's works. The avenues are rarely lined with buildings, let alone people; there are no cars, no signs of metropolitan life, not a single monument, not one view of the World Fair, no stations or crowds. The little people who wander through Rousseau's landscapes, those tiny, furtive silhouettes, are anonymous, simple figures, interchangeable from one painting to the next. He made no reference to the major alterations that were taking place right before his eyes – the work that began on the Métro in 1898, for example – and he would go so far as to erase any trace of them. 'What pleases me the most is to contemplate nature and to paint it,' he told Alexandre.[12] In deconstructing and reconstructing landscapes to ensure that nature dominated, by closing in the pictorial space of his canvases and immobilising the figures that haunted them, by distorting perspectives, Rousseau covered the city in a veil of stillness and silence. Leaving the artist's studio, Alexandre wrote: 'I have to tear myself away from this conversation, the gentleness and sincerity of which have transported me so far from present-day Paris and even beyond the Maine.'[13] This is the conjuring trick of Rousseau's landscapes, in which he erased time. He created a sort of city that was not the city,

unknown and disquieting, populated by the occasional ghost that drifts slowly by, dressed in its Sunday best. His was a strange city, if it can be called a city, improbable, as if the essential had been conjured away in a vanishing act. Were there to exist, for a given era, a single, definitive, image of Paris, we might say that Rousseau's Paris was the opposite of that myth. Could this discrepancy be the reason why, in his lifetime, his landscapes were seldom discussed, and his reputation grew, effectively, from his tropical forests? In 1891 his show-stopping painting *Tiger in a Tropical Storm (Surprised!)* (no.43) launched his career with the reviews it excited, and he would return, in 1905, to this spectacular – and more lucrative – mode of painting.

'If the assent from Nougoua to N'Gakin was difficult, that from N'Gakin to Kokourou was terrible', wrote Marcel Monnier, describing the tropical rainforest,

I have never encountered a comparable terrain. The vegetation conceals the contours, which are of surprising proportions. There are only steep rises, deep and sunken ravines, between near-vertical walls of rock... It is chaos, in so far as it is possible to make out amid the shadows that veil all the contours. Impossible, even from one of

the summits, to get an overall view of the terrain already covered. Over the peaks as in the lowest regions the creeper-covered trees form an impenetrable curtain that obstructs any attempt to look out towards the horizon… In this shadow, imagine a phenomenal tangle of roots, fallen trees, thorny bushes; in the folds of every vale, a still and stagnant backwater; foul odours rise from layers of rotting leaves, piles of dead wood, and every kind of decomposing vegetal detritus. Add to that the ant corpses, which add their charnel-house stench to all of this, and still you have only the faintest idea of this African jungle. In reality, it is indescribable. Does one describe a nightmare?[14]

Rousseau had only to travel a few miles to sketch the bridges and embankments of Paris; in order to portray the environment described by Monnier, he had to submerge himself in the illustrations that accompanied accounts of travel and expeditions,[15] or visit the greenhouses of the Jardin des Plantes and the Jardin d'Acclimatation, where he could at once observe live animals or, at the Muséum, see stuffed examples. Hence, the method behind his exotic landscapes becomes clearer: he inserted animals haphazardly[16] into a dense and overwhelming background, adding and juxtaposing layers, sometimes sacrificing a feeling of depth. Thus, in a certain sense, these paintings acted like collages.

Consequently, they comply with their era in a number of ways: they demonstrate a contemporary taste for the exotic and for travel without the expense, or even without the trouble of moving. Zoological gardens were established all over Europe in the second half of the nineteenth century; as Victor Hugo commented of Paris's Jardin des Plantes, they provided a 'complete short cut to the wider world'. While Westerners were penetrating deeper into as yet unexplored areas of the world – the Indochina Peninsula, African jungles, Amazonia, deserts and poles – public and intellectual curiosity was beginning to focus on the 'savages' of those regions. Introducing a new exhibition of *Warrioresses and Warriors of Dahomey* at the Jardin d'Acclimatation in 1891, the 'ethnographer' Fulbert Dumonteil wrote:

Each caravan that rolls past our eyes is like a new chapter in an original, living book… in which you only need turn the page to move from the

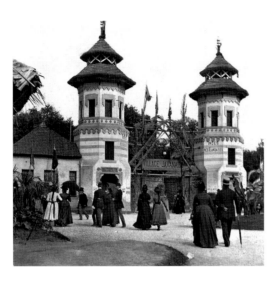

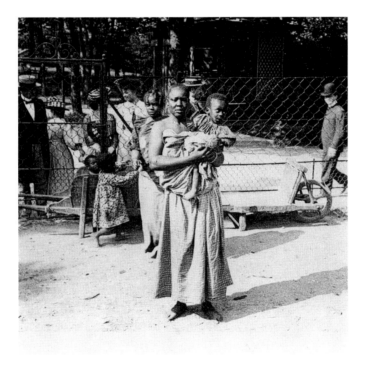

Fig.48
Javanese Village, 1889 World
Fair

Fig.49
Postcard, Achanti Woman,
Jardin d'Acclimatation (detail)

savannahs to the pampas of the New World, to
the solitary wilderness of barbaric Africa, from
the glaciers of the Eskimos to the scorched
regions of the Somalis; from the steppes
of Tartary to the lands of the Kafirs and the
Huguenots, to the magical banks of the Indian
Ocean. It knows not how to lie, this animated
book that tells its own story, in which sentences
are facts, documents are paintings, the vision
of both people and things truthful and of
incomparable charm.[17]

These exhibitions, which attracted large crowds,
were true spectacles, similar to those created by the founders
of circuses like P.T. Barnum or of zoological gardens such
as Carl Hagenbeck, and given authority for a time by science.
They consisted of planting villages on the main lawn of the
Jardin d'Acclimatation or, for the 1889 World Fair, on the
esplanade des Invalides (fig.48), where for several months
aborigines offered the public an exhibition of their lives:

The small Senegalese enclosure was made up
of no fewer than thirty people. It was necessary
to organise and build huts, where, during the

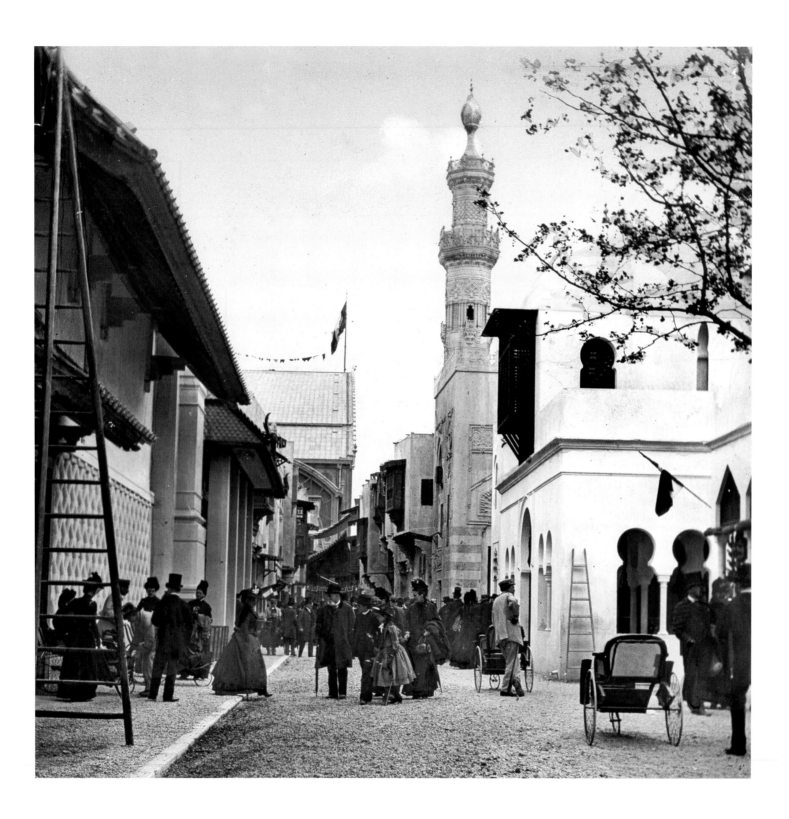

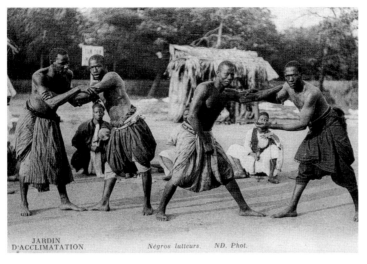

Fig.50 (left)
Rue du Caire, 1889
World Fair

Fig.51
Postcard, Warriors
in the Jardin
d'Acclimatation

Fig.52
Amazons and
Warriors from
Dahomey (now
Benin), Casino de
Paris, 1892

day they could, under the eyes of the general public, live a true Senegalese life, going about their work and domestic tasks so as to provide Europeans with an exact portrait of the lifestyles of colonised peoples that they find so mysterious and so interesting.[18]

Writing in *La Revue de l'Exposition universelle*, Pol-Neveux described the co-existence of many of these villages:

It is a quiet refuge, intimate, immersed in the caravan park of the Invalides, this New Caledonian village that seems to huddle, to nestle, under the old elms of the esplanade, its simplicity obscured by the noisy exoticism of the Tonkinese village and the West African hamlets, its silence haunted by the music from Javanese Kampong, and the jarring pandemonium of Annamese theatre.[19]

What is described here if not a collage? Juxtaposed within the same space, 'under the old elms of the esplanade', was a Kanakan village, a Tonkinese palace and Senegalese hamlets ('a delicious sheen of colours, exquisite and

disorderly confusion of silhouettes', stated the *Guide bleu du Figaro et du Petit Journal*). The 'palaces' of Brazil and Mexico, of Tonkin and of Algeria, created specially for the Fair, were designed to combine all the variations of vernacular architecture within single buildings. 'The most exact science has combined with the most popular art to make these African or Asian palaces into true monuments to the civilisations they represent', wrote E. Monot. And, with regard to the Algerian pavilion, he added: 'The unity of character that emerges from the juxtaposition of disparate architectural elements is immensely satisfying.'[20] Hence the whole set-up of the Fairs acted like a collage: from the structures themselves to the presentation and juxtaposition of the different 'villages' and their integration within the original urban setting. 'The World Fairs are successful precisely because they harmonise disparate elements, because they achieve unity out of extreme contrasts', concluded F.G. Dumas.[21] The same is true of Rousseau's exotic paintings.

His Jungles similarly partook of the collective fantasies of his era. In addition to the exoticism of being transported 'elsewhere', there was also that of watching animals fighting or being slain. Scanning the images in the illustrated supplement of *Le Petit Journal*, for example,

reveals an abundance of wild animals shown in such situations: zoo visitors being attacked; organised fights between animals; pictures of children, explorers, soldiers and settlers being massacred by wild beasts.[22]

The 'savagery' of the 'natural' world was a constant theme in this period, and one that applied as much to humans as animals: 'A group of Galihis has got all of Paris going,' wrote E. Taillebois, for example, in *La Science populaire* in 1892. 'We hardly know how to entertain all the Parisians eager to take advantage of this short visit from the Caribbean to observe the last survivors of a prehistoric race.' The attraction of these exhibitions lay in their 'primitive' and 'savage' aspects; the categories of man and beast became confused. Nubians in the Jardin d'Acclimatation, one scientist stated, 'were displayed a bit like wild animals'; 'anthropozoology' was still a fashionable term.

Bodies clothed in striking costumes or stripped naked performed frenetic dances that simulated cannibalism or combat. 'In truth, a shiver runs down your spine at the sight of these men, with their strange appearance, crawling on the ground as if about to ambush, then jumping up with remarkable agility, uttering war-cries and carrying out dizzying whirls with some kind of sword,' *Le Petit Journal* reported on 11 September 1887.

Here, exoticism acted as a veil for a thinly disguised ideological agenda. Science, politics and entertainment united to defend and promote the racist theories that accompanied and justified the colonial enterprise.[23] Following his defeat and the annexation of his territory, Behanzin, King of Abomey (fig.54), became a highly colourful figure in Paris where, with his warriors, he was the focus of spectacular exhibitions and theatrical performances.[24] The head of Rabah, a rebel finally defeated after having faced down the French army for several years, made the front page of *L'Illustration*, paraded on a stick like a trophy (fig.53).

To read Rousseau's Jungles in such a context is not to draw a literal analogy with all of the above, but the animal fights that he placed at the centre of his landscapes evoke the contemporary violence typified by such episodes. That violence produced a kind of anxiety: 'Tigers, panthers, jaguars, lions; from whence comes the effect that seeing all of this has upon me?' Delacroix asked himself.[25] The laughter of the visitor to the Salon des Indépendants before the paintings of the 'primitive' Rousseau was not so far removed from that of the spectators who laughed at the 'primitives' in the Jardin d'Acclimatation. It was an expression of incomprehension and discomfort, of

Fig.53
'Rabah', *L'Illustration*,
9 March 1901

Fig.54
'Behanzin', *L'Illustration*,
23 October 1892

uneasiness at seeing the reflections of personal fantasies. The savagery of the wild animals, both admired and feared, found its counterpart in the cannibalism and supposed sexual prowess of the black men, seen with their families, behind the bars of the Jardin d'Acclimatation. Such were the machinations of a fantasy constructed around the attraction of the unknown, of danger, of curiosity and fear. The violence of colonial conquest was thus masked – and justified – with reference to the hostility of the natural world, the cruelty of wild beasts and the savagery of 'primitives' – all of which, *mutatis mutandis*, Rousseau presented in his 'exotic paintings'.

'There is no need to cross the Mediterranean, nor to ride a horse or a mule across hundreds of miles of mountains or desert,' wrote Pol-Neveux. 'There is, not far from the Palace of the Colonies, an encampment, a real encampment of Kabyles.'[26] The Kanakan village he described was no doubt *real* to him:

These huts, devoid of any artificial ornamentation, exude a sense of sincerity, of life reproduced exactly – that is singularly agreeable in the midst of the Fair. And once we have grasped the principle of these exhibits, we may accord the Kanakan village the highest praise; it gives a frank description of a distant tribe, revealing a glimpse of a humanity lost in the vastness of the Pacific Ocean.[27]

In the same way, *Le Petit Journal* noted with regard to the exhibition of Dahomeans in the Champ de Mars that: 'Everyone makes their offerings, lives their everyday lives, which may not be unusual in Dahomey but is most fascinating here. The decor is very interesting, astonishingly precise; it is hardly surprising that the Palace of the Liberal Arts is inundated with curious visitors every day.'[28] Notably, despite awareness of the artificiality involved in these spectacles, the focus was very much on authenticity. The illusion was perfect, even though one knew that it was an illusion. This 'ability to play simultaneously with belief and disbelief; to instil, at the level of perception, an uncertainty built on acceptance and denial', seems to have been one of the characteristics of the era – one found also, for example, in the pursuit of photographing ghosts and other apparitions.[29] It is important to stress this latter point, for in addition to being one of the main themes of Rousseau's Jungles, the question of 'truth' in illusion runs right through this

era: from exhibitions to the World Fairs, from salons to panoramas. In all these cases, it was deemed essential to succeed in presenting things *as if they were true* and *as if the viewer were there*.

This illusionism was the underlying principle of the panoramas that were so popular during this era. Created in 1787 by Robert Barker in Edinburgh, the panorama was a form of entertainment that consisted of a large, circular *trompe l'œil* painting, intended to be viewed from its centre. Often, the paintings were presented in purpose-built settings. In 1822, the Frenchman Louis Daguerre perfected this technique and invented the 'diorama', the aim of which was to 'transform a painting by progressively modifying the light source, in order, for example, to pass from a nocturnal landscape to the same landscape in full daylight.'[30] Improvements followed in quick succession and soon there was a whole range of potential experiences to choose from. The 1900 Paris World Fair featured no fewer than nine different panoramas,[31] without even counting the *cinéorama* – where you could choose to be on the Trans-Siberian railway or in a hot-air balloon – or the *maréorama* – where you found yourself in the cabin of a transatlantic steamer. Here, 'there was a desire to go further still, to give the impression of movement.'[32] Like the exhibitions and the 'villages', the panoramas made it possible to travel for a paltry sum; by offering the public new and spectacular sensations, they attracted considerable crowds. Every detail had to be absolutely perfect: the ratios stringently calculated and every light-source carefully studied, in order to achieve the optimum effect. 'The effectiveness of the device is unquestionable,' wrote Bernard Comment, 'in making the viewer lose all sense of the outside world and transporting him into a new space that he believes to be reality.'[33] The illusion of truth and the truth of illusion: such could be the remit of the panorama, for incidentally, the painters who created them – Charles Castellani, Alfred Stevens, A. de Neuville – were otherwise engaged as academic painters or illustrators. The illusionism of the panorama was thus connected to the illusionism of the academic painting, for which, from Gérôme to Félix Clément, Rousseau never ceased to express his admiration. This desire for precision and truth led a number of academic painters and other illustrators to take inspiration from photographs; Atget's work was one such source. The same concern preoccupied Edouard Charton when he founded the magazine *Le Tour du Monde*:

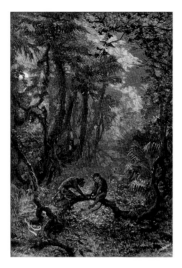

Since time immemorial, editors of travel journals have understood the undeniable need for 'illustrations'. But their good intentions have almost always been poorly served… one has hardly to go far to see how often those responsible for the drawings attached to excellent texts have attracted reproach, with good reason, for failing to see or being unconcerned with truth. Today, the art of simply observing, without preconceived ideas and without recourse to conventions old or new, has entered the public psyche. There are a growing number of travellers who can draw well enough not to need the help of professional artists. Photography, as it spreads around the globe, acts as a mirror whose material testimony cannot be contested, and which is preferable even to drawings of great merit from the moment they inspire the slightest doubt.[34]

Rousseau's virgin forests may have shared the same ambition: to push illusionism until it bordered upon truth. His attention to detail, the precision of his drawing, the exactness of his tones, all stand as evidence. Was he not proud of his greens and his blacks? It may be that he did not possess all the basic technical skills to fulfil this ambition and to equal his models but, in wanting to perfect the illusion he crossed over to the other side of the mirror. He no longer painted the greenhouses of the Jardin des Plantes or some diorama, nor traced his images; instead, from then on he painted what belonged solely to him. He made it his mission to take painting into unexplored territories.[35] 'Naively', subconsciously, or completely deliberately – no one will never know – he revolutionised the idea of what could be done in a painting: its form and ground, technique and figuration. He made paintings that no one, before or since, could have made. Against all odds, but with supreme self-confidence, he constructed his oeuvre by following his heart, supported only by his personal fantasy. In the same way that Georges Méliès travelled to the moon and Raymond Roussel discovered Africa,[36] Rousseau created people and jungles. In his works, there was no other reality than that which he imagined, no other truth than the one he invented and, as a result, the whole spectrum of art was liberated and enriched by a wonderful and fantastic new continent. Nothing there is true, and everything is real,[37] for him and for us, as we look at his works and find – with such ease –

Fig.56
Illustration from the magazine
Le Tour du Monde, 1888

Fig.57
Illustration from the magazine
Le Tour du Monde, 1891

sincere enjoyment. Pleasure and joy is what these images are really about. A shiver of excitement, a window swinging open on to the marvellous, a 'gulp of happiness', in the words of André Breton.[38]

Furthermore, wrote Breton, on the subject of Max Ernst, 'there has been a change of set: now it is simply a jungle and, furthermore, it is no human jungle.'[39] A transformation had taken place: a shift from reality, to poetry. In Rousseau's oeuvre the sites of Paris had undergone a comparable change: the bridges and the embankments of Paris, the lawns of the Jardin d'Acclimatation and the old elms of the esplanade des Invalides and, of course, the greenhouses of the Jardin des Plantes which fed his personal fantasy: 'When I enter those hothouses and see those strange plants from exotic countries, I feel like I am entering into a dream.'[40] The process continues: sure enough, the jungle dream would one day become reality, for Yadwigha would awake one day to find herself surrounded by real wild animals. Allegedly, at the Mirage Casino in Las Vegas, the magicians Siegfried and Roy used to perform a conjuring trick with tigers. In the middle of a massive cage, in which the beasts were kept during the day, hung a giant reproduction of one of Rousseau's exotic canvases. In such a way, a number of magnificent lions, Asian tigers and white tigers finally came to live at the heart of Le Douanier's jungle.

'It has been said,' reported Uhde, 'that when Rousseau was painting he was so moved by the power of his own visions that, seized by anguish and feelings of suffocation, he had to open the window to catch his breath'. Hence the exoticism of Rousseau, the stationary traveller, was born of a magic trick: a desire for enchantment that was widely pursued by his era, made manifest in panoramas, World Fairs, popular shows and a whole wealth of other imagery. Rousseau the illusionist, whose own jungles scared him, no doubt made reference to the explorer-colonisers Louis Gustave Binger and Pierre Savorgnan de Brazza, from whom he 'borrowed' the exotic pretext and argument of his paintings. But above all he echoed the words of Novalis: 'The greatest magician is he who can enchant himself at the same time, in such a way that the results of his own tricks appear to him like alien phenomena, with a force all of their own.'[41]

Rousseau's Paintings
Nancy Ireson

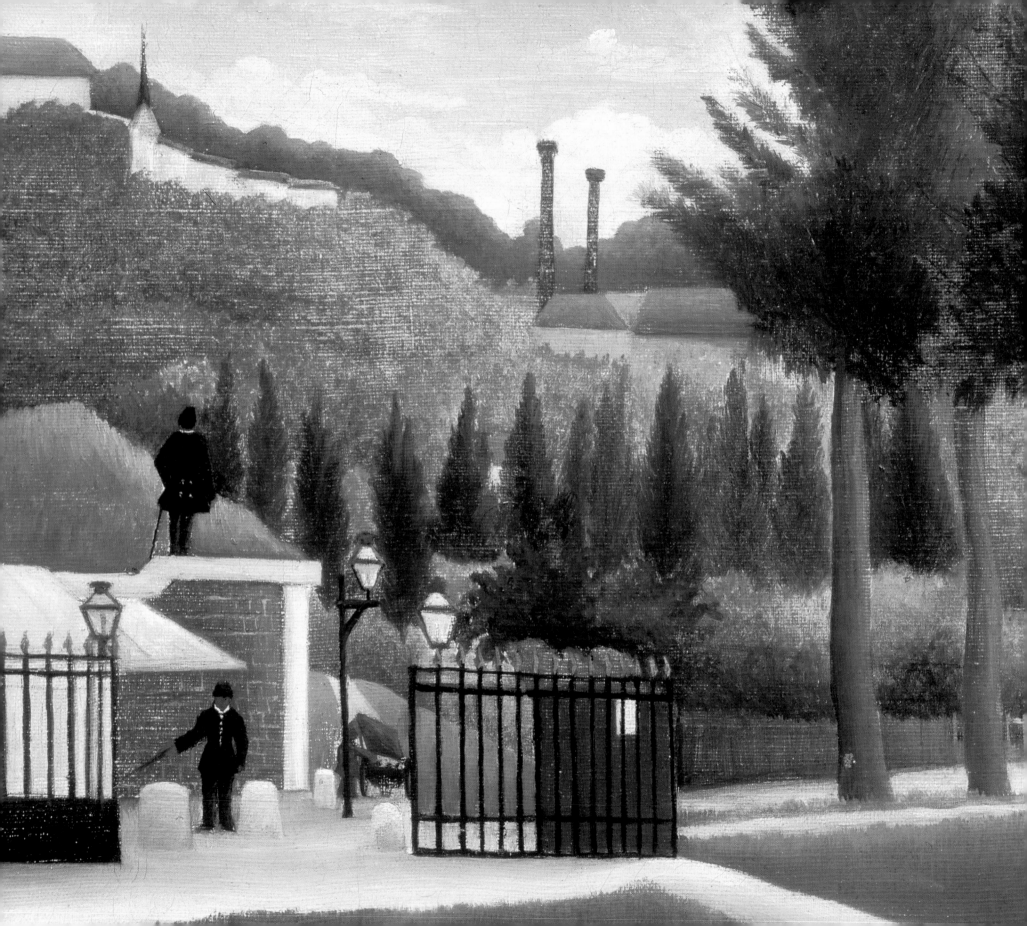

Rousseau and his World

Fig.58
The Customs Post
c.1890
(Detail of no.8)

Fig.59
Painter and Model
1900–5
(Detail of no.1)

'He painted with such an expressive realism that he made the learned laugh ... but happily he was not from their world. He escaped them through the anonymous life of his milieu.'

Robert Delaunay[1]

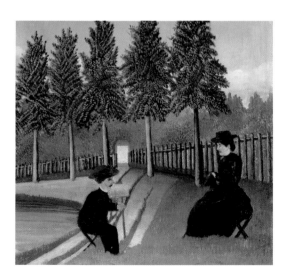

Rousseau's *Painter and Model* 1900–5 (no.1) seems a modest little picture at first appearance. It shows the artist painting a portrait of his second wife. In the formal setting of a park or public garden, at the edge of a lake, the image is one of peace and tranquillity. The artist, who wears a beret and is easily identifiable as Rousseau, works at his easel. Joséphine, his model, sits perfectly still. To an extent it is an image of absolute professionalism and, certainly, Rousseau was no amateur artist: in 1893, he had taken early retirement to concentrate on his creative efforts. Why, then, did so many of the painter's educated patrons describe him as a 'Sunday painter'? Perhaps they discerned a trace of amateurism in his stylistic peculiarities. The proportional relationship between the figures and setting in *Painter and Model*, for instance, is far from convincing. Were the figures able to stand, in all probability they would be almost as tall as the trees. But such uncanny details would have pleased avant-garde artists; they were part of the aesthetic appeal of Rousseau's painting. Their judgement of him as an amateur was, instead, shaped by the fact that they would have found the ideal of artistic life shown in *Painter and Model* completely alien. Accordingly,

were *Painter and Model* a *Déjeuner sur l'herbe*, it would be a far cry from the one that Manet – born only twelve years before Rousseau – had invented in his famous work of 1863 (fig.61). There, the artist had produced an image that was perfectly bohemian, a park landscape peopled by suited men-of-the-world and voluptuous nudes. The canvas presented an affront to the morality of the day, to the authorities, to social mores. In contrast, Rousseau's small canvas seems prim and proper, with its subjects who adhere to and embrace convention, sitting on folding picnic stools. In no way, in terms of content, does it reflect the values of the avant-garde art world at the turn of the century. Indeed, if anything, it seems entirely unconnected. Wassily Kandinsky, the painter who purchased the canvas in 1912, could hence praise the painter as the 'father of a new realism': one that was, somewhat ironically, inartistic.[2] Such readings – which albeit unintentionally mixed admiration with condescension – were born of social distance.

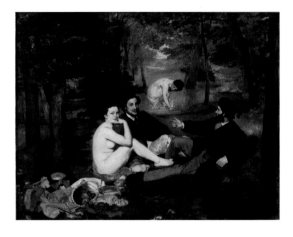

Fig.60 (left)
Anonymous
The 'Sunday' Painter

Fig.61 (above)
Édouard Manet
Déjeuner sur l'herbe
1863
Musée d'Orsay, Paris

Fig.62
Pierre Puvis de Chavannes
The Balloon
1870
Musée d'Orsay, Paris

Rousseau's image of the artist was that of a layperson, the kind of stereotype that might be entertained by a shopkeeper, a grocer or a craftsperson, the kind shown in an anonymous contemporary photograph (fig.60). Yet, since *Painter and Model* shows the painter embodying that ideal, it is anything *but* modest. Nor is his large 1890 self-portrait *Myself, Portrait-Landscape* (no.2), an image of humility. He dominates the landscape, and close examination of the canvas even reveals that, in the first instance, he had made his self-image even larger than it appears in the final composition. Even the genre in which Rousseau worked here – that of the 'portrait-landscape' – is one that he claimed to have invented.[3] In such works the background was not only decorative; it helped to explain the identity of the sitter. The scene in the backdrop here, tellingly, is the city of Paris itself. Taller than the Eiffel Tower and dwarfing the ship moored on the quayside, as a modern painter complete with brushes and palette, Rousseau aligns himself with the modernity of the metropolis.

But if Rousseau's image expressed his optimism for his own future – and the future of his city – it also acknowledged that he was mindful of the past. The ghostly hot air balloon set against the bright blue sky not only suggests the 1889 Paris World Fair where flights had featured among the attractions. It also acted as a reminder of the Siege of Paris, which the academic artist Pierre Puvis de Chavannes had commemorated with a pair of poignant allegories, one featuring the balloon that famously carried the politician Gambetta to freedom (fig.62), when the Germans had surrounded the city of Paris and cut off supply and communication lines. There is certainly a close formal resemblance between the images.[4] A parallel symbol of personal remembrance and renewal lies in the references inscribed upon Rousseau's painted palette. Originally, the names were Clémence and Marie (those of his first wife and his current love in 1890), but he later updated it upon marrying Joséphine.[5]

Thus, clearly, concerns other than his work informed Rousseau's painting practices. In his smart black suit, with his perfectly groomed moustache, *Myself, Portrait-Landscape* not only showed Rousseau as an artist. It also presented him as an upright citizen. The same is true to an even greater extent in his *Portrait of the Artist with a Lamp* (no.5), in which instead of describing himself as a painter, Rousseau depicted himself as a bourgeois gentleman. The image here is one of a faithful spouse, for the picture forms a pair with the *Portrait of the Artist's Second Wife* 1900–3 (no.6), which presents his partner in an equally sober style. Borrowing from the conventions of Enlightenment portraiture, by focusing on the head instead of the body, the image reflects the Republican belief that status lies in merit and not in genealogy. This format also resembles that of contemporary *cartes de visite*, the small photographs that could be treasured by relatives or sweethearts that were immensely popular with people of Rousseau's class.[6] There is an essential difference, however, between Rousseau's portraits and the aesthetic of the *cartes de visite*, for while sitters for conventional photographic portraits might have worn their best clothes, to do so they had to own them. In painting, aided by his imagination and improving on reality, Rousseau could describe himself as he wished. Thus, in his painted likenesses, his outfits are grander than those seen in the few known photographic portraits. The image

of the 'artist', who was at the same time an upright citizen of Third Republic France, could help in the middle-class pursuit of keeping up appearances.

For better or worse, Rousseau was a man of his time, as his attitude to his partner suggests. In the lamp portraits, unflinching and with confidently defined features, Rousseau paints himself as the stronger character. His portrayal of Joséphine, where the heavily worked contours of the face emphasise her age, suggests vulnerability. The same sense of male superiority is present in certain of his letters: 'You are charming, my little Joséphine, my love', he wrote to her in 1899. 'You are clever and I would like to develop that intelligence which is as useful to a woman as to a man. In a sense it is even more so to a woman, since she must be a man's companion, who charms him by her grace, beauty and science and on many occasions even has to help him.'[7] The conventions of the day mattered to him, as they did to the vast majority of petit bourgeois people. Interestingly, when he died in 1910, his daughter wrote to his friend the painter Robert Delaunay, to commission a posthumous portrait of her father. 'Please be so good as to depict him in his black morning coat, with an open waistcoat and black tie, as he used to dress when he came to see us,' she asked. 'That is to say, quite properly – not in the overalls that you were more used to seeing him in.'[8] The description could be one of Rousseau's own self-portrait. His painting, in its projection of an image that was a little better than reality, mirrored the aspirations of a whole section of society.

Rousseau's willingness to assume roles, together with his penchant for elaborate storytelling, complicated readings of his character. The scraps of early biography that remain are often contradictory, which is probably thanks to embroidery added both by the artist and by his critics. But it is clear that before he had given up employment to dedicate himself to painting, the painter had been a civil servant, working as a clerk for the Paris Octroi, which imposed duty on goods entering and leaving the capital. It was this job that inspired Rousseau's nickname of Le Douanier or 'the customs man'. The post, secured through the intervention of a relative, provided him with a steady (if modest) income. Later in life, though he gave up his position, he would continue to refer to it frequently. He appears to have been proud of the years of service he gave. The artist Sonia Delaunay-Terk recalled that, to her and Robert, her husband, 'Rousseau represented a typical petit-bourgeois Frenchman, properly dressed, conscious of his dignity. He didn't take pride in the fact that he was a painter and musician, but more importantly, in the fact that he was Monsieur Henri Rousseau, retired customs man'.[9] Perhaps this is the message of the *Portrait of the Artist with a Lamp* where Rousseau appears as an ordinary civil servant. But, as the other self-portraits demonstrate, her comment does not ring true in other instances.

Yet the remark does underline an important consideration: that, for Rousseau, the roles of government servant and artist were perfectly compatible. The writer Gustave Coquiot remembered that if Rousseau was in love with poetry, he liked precision equally well, often confiding to this author of the history of the Salon des Indépendants that 'I'm a civil service man.'[10] Likewise, in his frequent letters to the President requesting that the government purchase his canvases, he often mentioned his years spent working for the

Fig.63
Portait of Henri Rousseau
as a young man, *c*.1880

Fig.64
Myself, Portrait-Landscape
1890
(No.2)

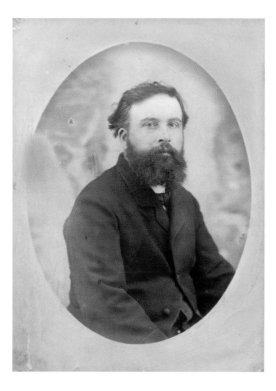
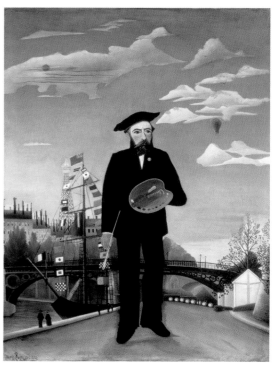

city, along with his military service, in support of his petition.[11] No written source could better express Rousseau's vision of his compatible occupations more succinctly than his painting *The Customs Post c*.1890 (no.8). It is perhaps surprising that this work, together with a rare drawing on the theme, is the only known example in his oeuvre where the Octroi features. However, according to Uhde, the artist never missed an opportunity to sketch when he was at work. Instead of joking with his colleagues, 'he would find somewhere to sit alone, to paint and draw', he wrote. 'It seems he made use of all the places he found himself, be it at the fortifications, [or] the "Porte de Meudon"'.[12] Rousseau's early retirement in 1893, it seems, was no great loss to the civil service. Reportedly, his colleagues found him lazy; they played tricks on him and they considered his artwork worthless. Nevertheless, one colleague wrote to him on his exhibition of *Tiger in a Tropical Storm (Surprised!)* 1891 (no.43), praising his friend's lyrical portrayal of the scene.[13] Rousseau himself acknowledged, much later, that the *octroi* had helped him in his early days as an artist by allocating him suitable shifts.[14]

 The Customs Post is a particularly interesting picture for, in addition to suggesting that Rousseau saw his careers as complimentary, it also shows how he considered work and leisure to overlap. The backdrop of *The Customs Post* is part of the fortifications, on the outskirts of the metropolis, which had become a recreational haven to the working people of the city. Accordingly, if this image shows the fortifications as a place of work, his *View of*

the Fortifications 1896 (no.7) describes them as a peaceful idyll peopled by mothers and children. There, as is the case in Eugène Atget's photograph of a picnic at the Porte d'Arcueil (fig.65), the fortifications are not a place in which to stand to attention but rather a place to take stock, away from the bustle of the city, far from the drudgery of day-to-day existence. This overlapping of the spaces of 'work' and 'play' may have encouraged certain admirers to develop an image of Rousseau as a particularly industrious artist. One of them, André Salmon, claimed that Rousseau was so keen to start painting in the morning that he slept fully clothed.[15] Another, the German Stanislaus Stückgold, said that he considered the money he earned through painting in terms of an hourly rate.[16]

During the Franco-Prussian War from 1870 to 1871, the fortifications had been a sight of conflict, but in his *View of the Fortifications* Rousseau created an image of peace and harmony. This suggests that he thought along the lines of the government of the day: they too, especially in official imagery, were trying to award new meaning to old sites in a spirit of Republican optimism. In a rather patronising tone, Christian Zervos observed that, like all the 'little people', Rousseau had a blind faith in grand institutions; certainly, his views often reflected those of the authorities.[17] His message in this image, if not his aesthetic, is one that would have met with their approval. While the peace of the present may depend upon the efforts of the past, for the sake of progress, it is time to look to the future. Certainly, with its trees in bud and the mother and child in the foreground, Rousseau's image is one of renewal.

The fortifications appear yet again in another of Le Douanier's paintings. On this occasion, however, they are neither sites of work nor leisure, but the backdrop to the *Portrait of a Woman* 1895 (no.4) that Picasso purchased from the small-time dealer Eugène Soulié in 1908, and which Uhde described as 'an impression of a strange and restless being'.[18] It was Fernand Olivier, Picasso's first significant muse, who recalled Rousseau telling her that the background of the work featured the location;[19] though the identity of the sitter is unknown, in the context of a 'portrait landscape', the choice was no doubt significant. From the fortifications, the view stretches beyond the city; perhaps Rousseau used the site as a metaphor for temporal distance. Maurice Raynal, who like Olivier had known the painter, suggested that it portrayed a Polish woman who had been the object of Rousseau's early affections, Yadwigha.[20] Though Rousseau used this name for a character in the play he wrote in 1899 and for the nude depicted in *The Dream* 1910 (see no.50), sadly no supporting evidence exists for the theory. However, the pansies lining the balcony could suggest an emotional connection, for in popular and sentimental picture postcards of the day the flowers were used as a play on words. In French, the word for pansies – *pensées* – is the same as the word for 'thoughts'. Later in his life, Rousseau used the device in a love letter, drawing a little pansy next to the words 'sending all my thoughts'.[21] Surely this befitted an artist whom critics attacked and celebrated for his engagement with all that was 'popular'. Indeed, for many of his admirers, Rousseau's attitudes and background made him an 'artist of the people'.

Another of his large-scale portraits, the *Portrait of a Lady* 1895–7 (no.3), also includes these flowers at the foot of the composition, which may support Uhde's suggestion

Fig.65
Eugène Atget
On the Paris Fortifications
*c.*1908

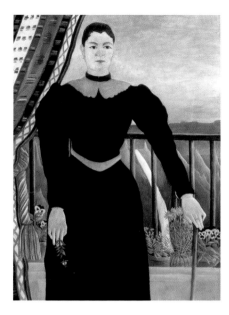

Fig.66
Portrait of a Woman
1895
(Detail of no.4)

that the unknown sitter in *Portrait of a Woman* was the artist's first wife.[22] The language of flowers was clearly important to Rousseau, for when he painted the wrong symbolic variety in his portrait of the poet Apollinaire and his girlfriend Marie Laurencin (*The Muse Inspiring the Poet* 1908–9), he made a second version to correct his mistake.[23] Alternatively, with her prominent ring finger and parasol, the woman may be the wife of a patron: Rousseau wrote a poem to accompany an unidentified portrait-landscape where he explained that these attributes – and the works' photographic format – recalled the first year of the sitter's marriage.[24]

In such ways, even if Rousseau's portraits 'borrowed' their references from the mundane petit-bourgeois world, it did not prevent their being imbued with layers of meaning. And while the artist's professional ambitions – government commissions, official decoration, glory at the Salon – must have seemed risible to his avant-garde admirers, his ability to improve on 'ordinary' things was no laughing matter. Rousseau made the everyday poetic, and this had a considerable impact. In 1947 the Dadaist Tristan Tzara identified a trajectory from 'Rousseau's petrol lamp to the playing cards and tobacco packet of Picasso and Braque'.[25] The comment was especially fitting since, in addition to the *Portrait of a Woman*, Picasso went on to purchase both the *Portrait of the Artist with a Lamp* and the *Portrait of the Artist's Second Wife* in 1938. Rousseau alerted a new generation of artists and writers to the mysteries of the familiar. He raised the possibility that, as his first biographer Wilhelm Uhde put it, beyond their world of intellectualism and theorising, 'there are other worlds with mysterious ways, hidden by closed doors and drawn curtains'.[26] The closed doors and curtains to which he alluded were, of course, those of the petite bourgeoisie. This made Rousseau 'exotic' even beyond his paintings of jungles and tigers. For the avant garde Rousseau may have been a *representative* of 'the people', but, in his art, he did much more than simply represent 'the people' on canvas.

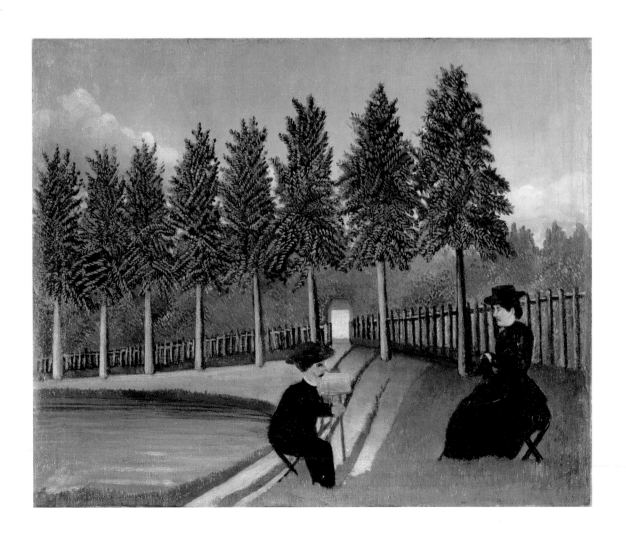

No.1
Painter and Model
1900–5
Oil on canvas 46.5 x 55.5 cm
Centre Georges Pompidou, Paris,
Musée national d'art moderne /
Centre de création industrielle.
Bequest of Nina Kandinsky, 1981

No.2
Myself. Portrait-Landscape
1890
Oil on canvas 146 x 113 cm
Národní galerie v Praze

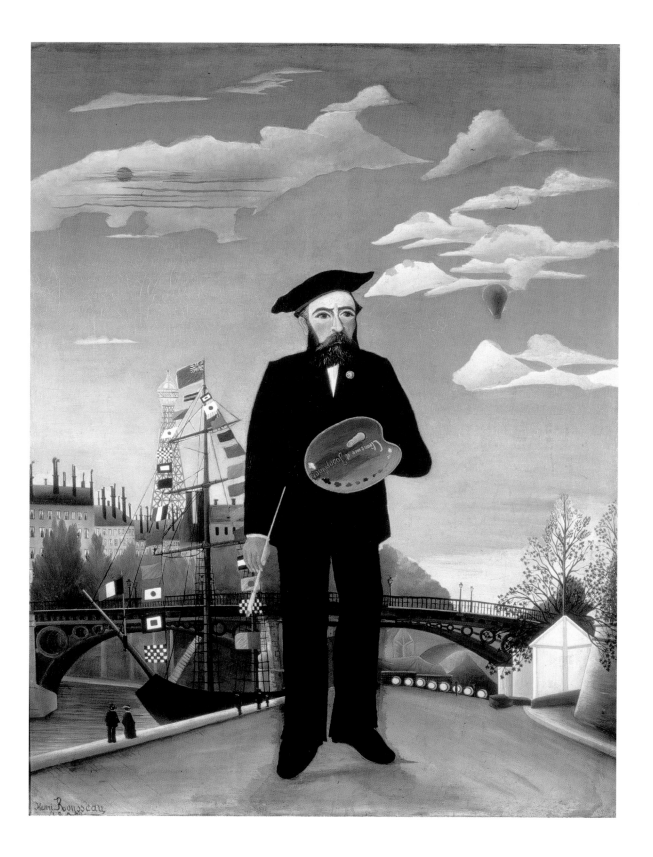

No.3
Portrait of a Lady
1895–7
Oil on canvas 198 x 115 cm
Musée d'Orsay, Paris.
Donation of Baronne
Eva-Gebhard-Gourgaud, 1965

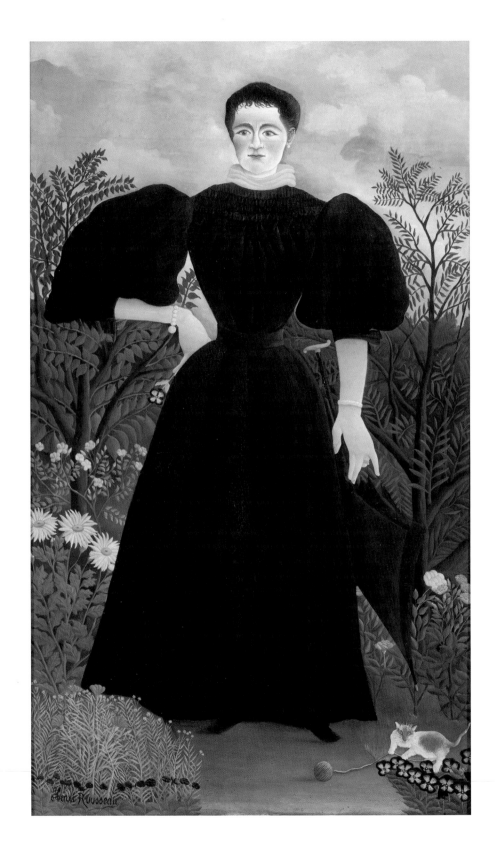

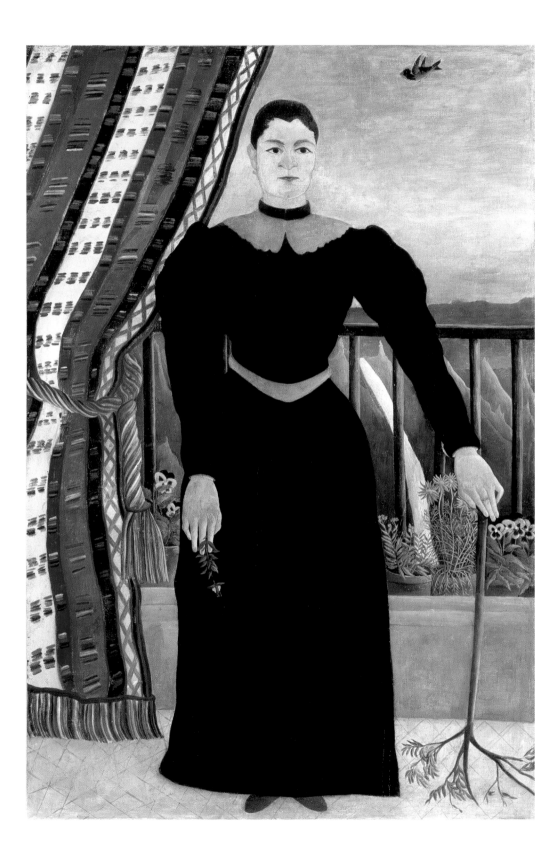

No.4
Portrait of a Woman
1895
Oil on canvas 160 x 105 cm
Musée Picasso, Paris

No.5
Portrait of the Artist with a Lamp
1900–3
Oil on canvas 23 x 19 cm
Musée Picasso, Paris

No.6
Portrait of the Artist's Second Wife
1900–3
Oil on canvas 23 x 19 cm
Musée Picasso, Paris

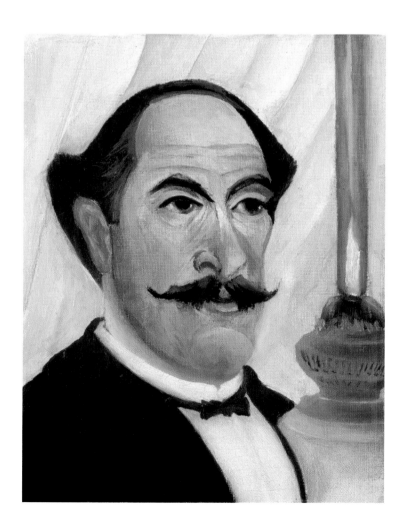
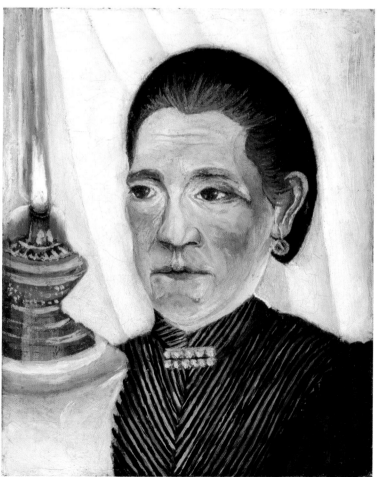

No.7
View of the Fortifications
1896
Oil on canvas
38 x 46 cm
Private Collection

No.8
The Customs Post
*c.*1890
Oil on canvas 40.6 x 32.7 cm
The Samuel Courtauld Trust,
Courtauld Institute of
Art Gallery, London

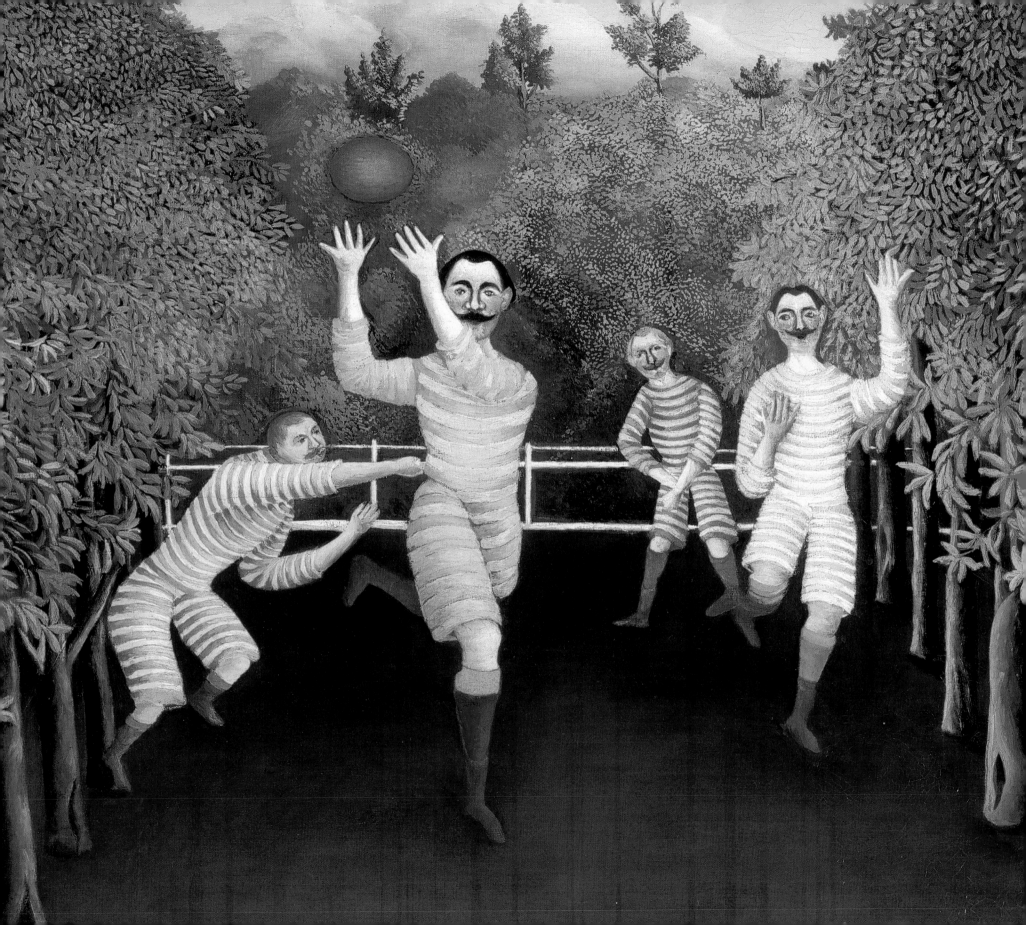

The Familiar
Made Strange

Fig.67
The Football Players
1908
(Detail of no.13)

Fig.68
To Celebrate the Baby
1903
(No.11)

'He produced a portrait of a child that is one of his most beautiful paintings. The child is standing outside, in his shirt-tails, which he lifts with one hand, there are some flowers, and in the other hand there is a puppet.'

Wilhelm Uhde on Rousseau's *To Celebrate the Baby*[1]

Some of the clearest examples of how Rousseau made the ordinary 'extraordinary' are provided by his surprising portraits of children. His *Young Girl in Pink* 1893–5 (no.10), *Boy on the Rocks* 1895–7 (no.9) and *To Celebrate the Baby* 1903 (no.11), are particularly disquieting images of what ought to be perfectly 'normal' subject matter. Child portraiture, particularly with the arrival of photography, was a popular genre in the late nineteenth and early twentieth centuries, but this does little to explain Rousseau's curious efforts. Likewise, it might be tempting to read the sober, almost sinister, look of the infants that Rousseau depicted in relation to his own experience of children. He lost most of his own offspring through illness before they reached adolescence and, when his first wife died, leaving him to care for a teenage daughter, the girl was apparently taken into care due to his persistence in 'living like a single man'.[2] But to confine readings of the child portraits to biographical information is to miss their overwhelming significance.

Stylistically, *Young Girl in Pink* shares many features with *Portrait of a Woman* and *Portrait of a Lady* discussed in the previous section. The subject dominates the foreground, while the foliage and the tiny animals at her feet, as is the case in those examples, impart

meaning. The model for the portrait was apparently Charlotte Papouin, the daughter of a Breton stonemason who lived nearby, which explains the pile of stone blocks upon which she stands.[3] But few other details are so logical. Already, the size of the sitters in Rousseau's portraits of women was disconcerting, their bodies filling almost the whole height of the canvas. The same strategy in this image of a child is all the more bizarre.

Rousseau's use of proportions elsewhere appears inconsistent. A comparison of *Young Girl in Pink* with the only other example of his work that includes both a young girl and animals, *Old Junier's Cart* 1908 (fig.70), offers ample illustration. In that instance, the dogs seem to dwarf the abnormally small girl. This is surprising, since Rousseau based the image on a photograph of the grocer Junier and his family in the same positions, which even bears traces of paint from its service in the studio. Though *Old Junier's Cart* can offer no clues to the meaning of *Young Girl in Pink*, it does suggest that the artist may have deliberately cultivated a certain eccentricity in his oeuvre. To compare the finished canvas

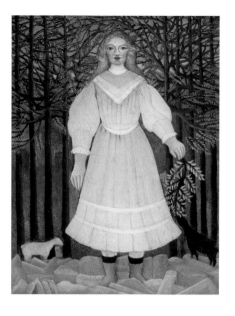

Fig.69 (above)
Young Girl in Pink
1893–5
(No.10)

Fig.70 (left)
Old Junier's Cart
1908
Musée de l'Orangerie, Paris

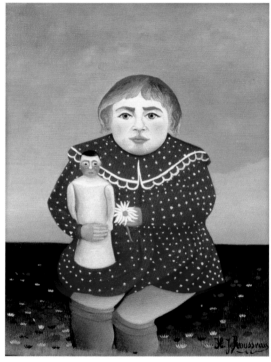

Fig.71
Still from *The Baby's Meal* by
the Lumière brothers, 1895

Fig.72
Child with a Doll
c.1904–5
Musée de l'Orangerie, Paris

of Junier's cart to the photograph of the grocer and his family is to see that Rousseau added the dogs beneath the cart to the composition during the painting process. One tiny, one unfeasibly large, they might be evidence of the artist's attempts to 'keep his naivety', as Jean-Léon Gérôme, the academic painter, had apparently advised.[4] Max Weber, who saw Rousseau painting the work, asked whether the dog was not too large for the image. The response: 'No, it must be that way.'[5]

Clearly, in *Young Girl in Pink*, there is no evident process of compositional integration at work. In other paintings by Rousseau, most notably his Jungle works, the various elements of the scene are combined to create a cohesive image. Here the effect is quite the opposite, rather like a collage, since the girl bears no spatial relationship to the stones on which she stands. This sense of dislocation is stronger still in *Boy on the Rocks*, which Roger Shattuck has likened to the kinds of fun photography found at the fairground or seaside at the turn of the century.[6] At such events, for a small fee and by placing their heads through holes cut out of painted scenes, amusement-seekers could take on different 'bodies' for the camera. But in *Boy on the Rocks*, it is not only the relationship between the head and the body that seems bizarre; the whole image is strange. Even the various parts of the boy's body seem uneasily assembled, as untenable as his precarious position on the rocks. The same sense of fragmentation is at work in *Old Junier's Cart*, which, through its leaps in scale and perspective, offers a particularly dislocated viewing experience. It is the case in *The Football Players* 1908 (no.13), too, in which, as Tristan Tzara observed, Rousseau seems to have condensed all the action of the game into one 'frame' of action.[7] It was these strange formal qualities, in part, that aroused the interest of Le Douanier's avant-garde admirers.

The idea of connecting Rousseau's images to broader visual culture is, then, an important one. These curious works are somewhat unorthodox when considered in relation to the conventions of contemporary painting, but they do share something of the visual experience offered by different kinds of media. The sense of fragmentation that Rousseau created, of composing an image through assembling various parts or frames, was not unlike the principle of film, which had recently been invented. His choice of the child subject makes the comparison pertinent, since the first film programme ever presented to the public included a short piece called *The Baby's Meal* (fig.71) by the Lumière brothers. At this early stage in cinema's history, it was the means of description (film as a medium) and not the subject matter that made *The Baby's Meal* noteworthy. Indeed, in some respects, its unremarkable focus emphasised the technical aspects of the work. The same is true of Rousseau's *Child with a Doll* c.1904–5 (fig.72), where a stout child with an almost adult face clutches her toy in an impossibly small hand. The lawn, which appears to absorb her solid legs, is dotted with flowers that echo the pattern of her dress. The artist seems to have created a visual synthesis of sorts, leaving the viewer to patch together the composite pieces. If the *Portrait of Monsieur X (Pierre Loti) c.*1910 (no.12) brings film to mind, however, it is in a slightly different way. Here both the frontal presentation of the sitter, and the way in which Rousseau has 'framed' him with other

elements of the image, bring to mind the compositional strategies of another early filmmaker, Georges Méliès.[8]

Another medium with which Rousseau's work attracted comparison in his lifetime was that of the woodcut or, more specifically, the genre of popular prints known as *image d'Epinal*. The bold lines and heightened coloration of these prints, often used for advertising, were not unlike those that Rousseau displayed in his work. Arguably the strangest of Rousseau's child portraits, *To Celebrate the Baby*, which features an imposing child manipulating the strings of an enormous jester puppet, calls to mind the poet and playwright Alfred Jarry's passionate interest in marionette theatre. It might have been inspired by the fact that, when Jarry went to stay with Rousseau in 1897, he may have brought his puppet theatre with him.[9] The only early reference to the painting that exists, however, is one left by Uhde. He wrote that *To Celebrate the Baby* was a commission from a laundress and her husband, and that they paid the sum of three hundred francs for the work.[10] This fee was, apparently, far larger than any other that the artist had secured, and has since raised doubts. For example, even at the height of his success, Rousseau sold *View of the Fortifications* 1896 (no.7) and a view of Ivry Quay for only forty francs.[11] But this may be another example of Rousseau being, as Uhde had put it, craftier than many of his contemporaries thought.[12] Perhaps he thought he could take advantage of his patron's love of the subject. On other occasions he adapted his demands to suit a particular client: it is worth noting that, when trying to sell his *Sleeping Gypsy* (fig.30) to the Mayor of Laval in 1898, he asked for considerably more than he would usually charge.[13]

If Rousseau's portraits of children appear to be collaged or 'cinematic', other examples of his works that make the familiar strange are theatrical. In a handful of early paintings – *Promenade in the Forest* c.1886 (no.16), *Carnival Evening* 1886 (no.15) and *Rendezvous in the Forest* 1889 (no.14) – the relationship established between figure and ground in the child portraits is completely reversed. These are by no means portrait-landscapes: the landscapes dominate the figures to the point of obscuring them. The characters depicted appear like players on a stage. Some of them even wear fancy, or historical, dress.

It is interesting to note that, in addition to painting, Rousseau turned his hand to other creative activities. He composed and published a waltz in 1904 (fig.73) and around 1889 and 1900 he even tried his hand at writing plays. His two complete scripts, *A Visit to the 1889 Exhibition* and *The Revenge of a Russian Orphan*, published many years after his death, reveal much about his creative processes.[14] It is the unpublished 'Student on a Spree', however, that may relate to one of these early paintings.[15] *Carnival Evening* shows the figures of Pierrot and Colombine making their way through a moonlit forest; in his play, probably created before 1889, he describes two of his characters, Jolibois Fils and Blanche, adopting those very costumes, in preparation for a night of dancing. 'Student on a Spree' has shades of autobiographical reference (the student arrives in Paris to discover sexual love) and it may be that the same is true of the painting. The work, unusually for Rousseau, appears in the catalogue of the 1886 Salon as not for sale. If *Promenade in the*

Fig.73
Title page from the Walz 'Clémence',
composed by Rousseau, 1904
Musée du Vieux-Château, Laval

Forest was equally off limits – and it does not feature in the Salon catalogues – it may also have been for private reasons. Uhde, who bought the painting from a washerwoman in 1911, described it as an image of Rousseau's wife and spoke of how, in a 'beautiful, expressive movement', the woman places her hand on her heart. It is as though, he suggests, 'she is overwhelmed by the nature that surrounds her and by her feelings. No painting could better describe the hopes of a young soul'.[16] Even so, that gesture is ambiguous, for the lone woman in the wood seems frozen as much in trepidation as in reverie.

Carnival Evening is the earliest known canvas that Rousseau exhibited in the Salon des Indépendants. In showing the work there in 1886, in the annual exhibition of this recently formed jury-free artistic society, he began an important association. He would show his works with them every year, apart from 1899 and 1900, until his death in 1910. However, it did not cause a sensation. His contributions, as was so often the case during much of his early career, attracted little attention. When one critic did commit a few lines to paper on the subject, he was clearly dumbfounded: 'A black man and a black woman, in fancy dress, are lost in a zinc forest, under a round and brightly shining moon that illuminates nothing, while stuck on to the black sky is the strangest of constellations, consisting of a blue cone and a pink cone.'[17]

Rendezvous in the Forest, though unrecorded, might also have exasperated contemporary critics. Charles Baudelaire, when he described 'the painter of modern life' in 1863, had suggested that it was retrograde for an artist to revert to the use of historic costume in painting. Such a move was, he argued, anachronistic.[18] But he voiced this concern because the use of historic dress was a frequent feature of one of the genres against which modern art defined itself: history painting. Rousseau did not make history paintings himself – descriptions of historical, mythical or biblical events hardly feature in his oeuvre – but he would surely have found connotations of the idiom pleasing. Allegory, another artistic convention that the avant garde found unappealing, was one of the artist's favourite genres.

No.9
Boy on the Rocks
1895–7
Oil on linen
55.4 x 45.7 cm
National Gallery of Art, Washington.
Chester Dale Collection

No.10
Young Girl in Pink
1893–5
Oil on canvas 61 x 45.7 cm
Philadelphia Museum of Art.
Gift of R. Sturgis and Marion
B. F. Ingersoll, 1938

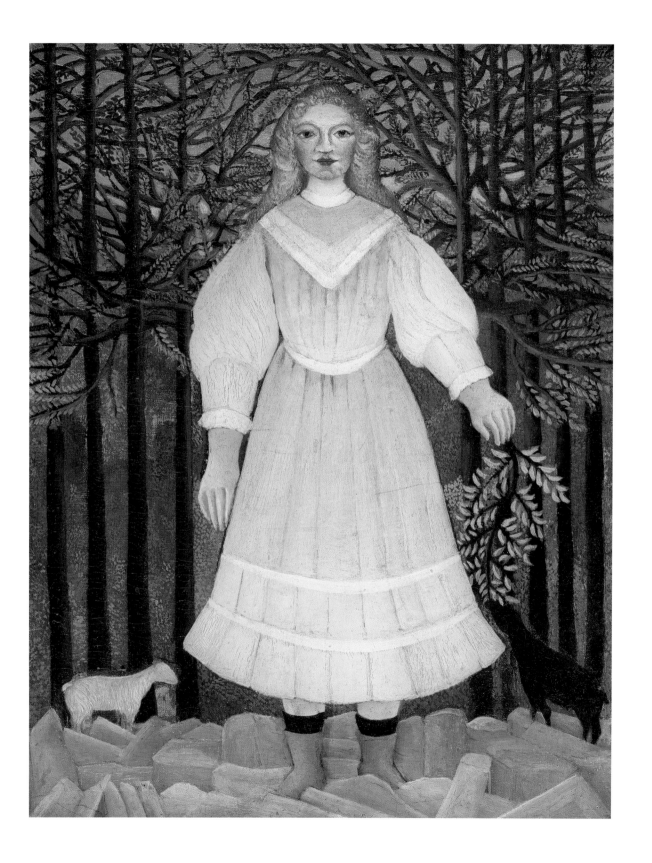

No.11
To Celebrate the Baby
1903
Oil on canvas 100 x 81 cm
Kunstmuseum Winterthur.
Presented by the heirs
of Olga Reinhart-
Schwarzenbach, 1970

No.12
Portrait of Monsieur X
(Pierre Loti)
*c.*1910
Oil on canvas 61 x 50 cm
Kunsthaus Zürich

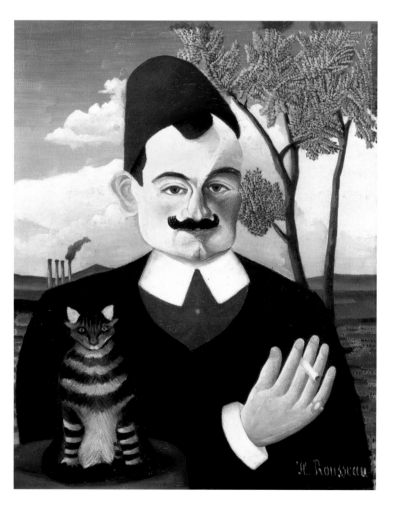

No.13
The Football Players
1908
Oil on canvas
100.5 x 80.3 cm
Solomon R. Guggenheim
Museum, New York

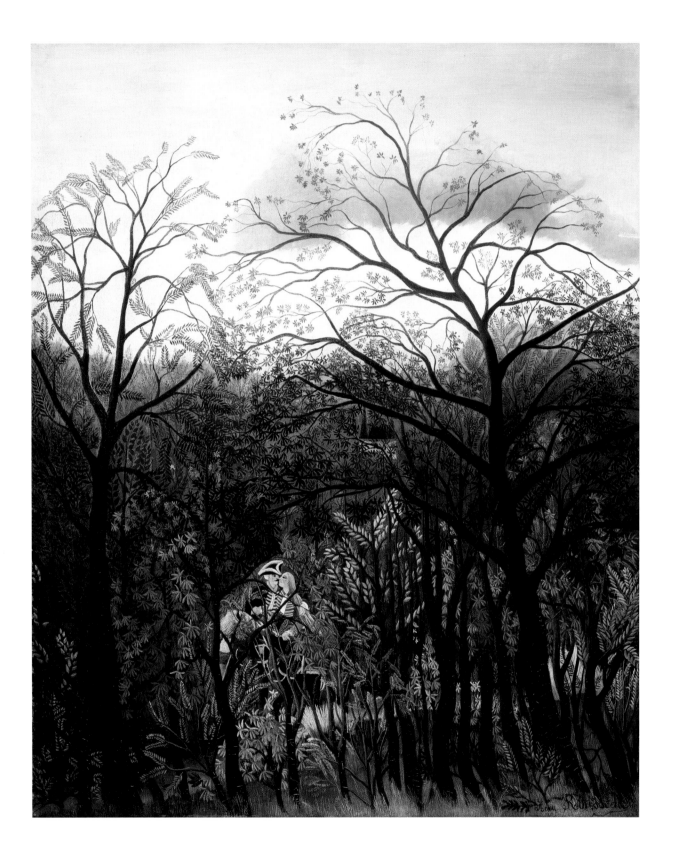

No. 14
Rendezvous in the Forest
1889
Oil on canvas
92 x 73 cm
National Gallery of Art,
Washington. Gift of the
W. Averell Harriman
Foundation in memory
of Marie N. Harriman

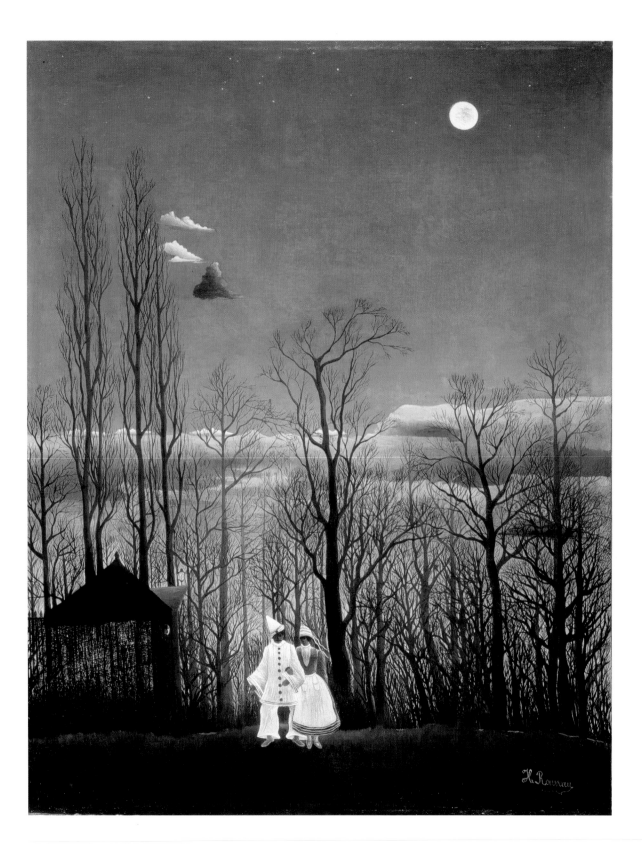

No. 15
Carnival Evening
1886
Oil on canvas
117.3 x 89.5 cm
Philadelphia Museum of Art.
The Louis E. Stern
Collection, 1963

No.16
Promenade in the Forest
*c.*1886
Oil on canvas
70 x 60.5 cm
Kunsthaus Zürich

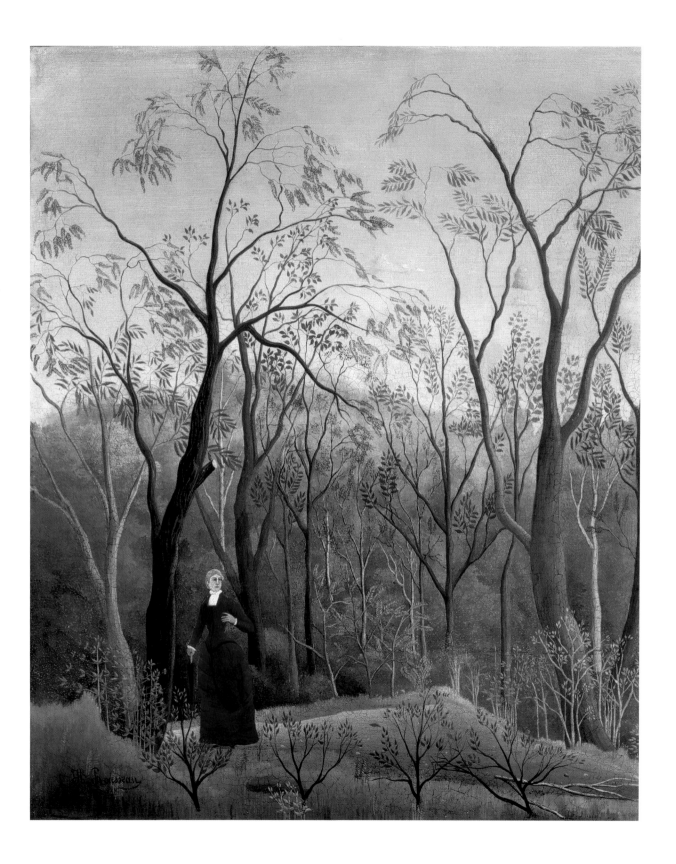

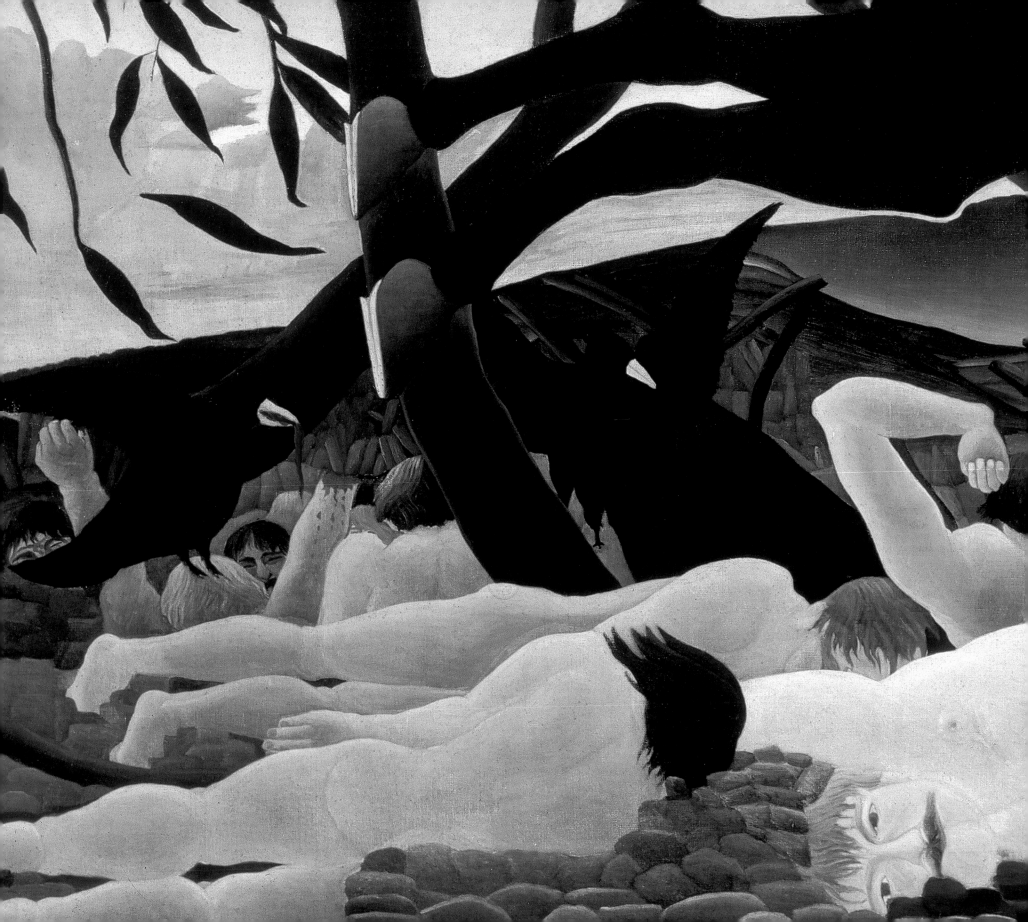

Images of War and Peace

Fig.74
War 1894
(Detail of no.17)

'Here is the famous Douanier Rousseau...
Salute! His official painting is to die for!'

Willy Rogers[1]

To contemporary viewers, Rousseau's images of war and peace must have presented something of a paradox, for they were at once the most conventional and the most revolutionary of his images. They were conventional in the sense that they borrowed from an accepted visual vocabulary of 'official' art; revolutionary in that, by doing so, they subverted that aesthetic. One of Rousseau's most accomplished early canvases, *War* of 1894 (no.17), illustrates this point eloquently. To compare that work with the academic painter Jean-Léon Gérôme's *Truth Emerging from a Well to Chastise Humanity* 1896 is to note that the female protagonists in both adhere to the same artistic category: that of the symbolic punishing woman. Indeed, not long after the Franco-Prussian War of 1870 to 1871, to paint a personification of conflict was quite unexceptional. Rousseau's idiosyncratic style, however, highlights the implausibility of the allegorical scene. Here there is no soft brushwork or blending of compositional elements to harmonise the diverse elements of the image. His terrifying woman, with bared teeth and wild hair, rides on horseback across a barren landscape littered with corpses. She seems superimposed upon that background, while the colours, a lurid riot of blue and orange, are as bold as the figure herself. It is little wonder that the canvas attracted comment when it was exhibited in the Salon des Indépendants of 1894. However, if the artist had hoped to catch the eye of the authorities with his striking canvas, the most notable attention came instead from avant-garde quarters. Crucially, it captured

the imagination of Alfred Jarry, the writer and dramatist. And although Jarry did not discover Rousseau, as some authors claimed, he was his first significant supporter.[2]

Evidently excited by Rousseau's work, in one of two reviews the young playwright wrote of 'the black leaves that populate the purple clouds; the ruins, tumbling like pine cones among the corpses, translucent with anoxia, littered with pale-beaked crows'.[3] Jarry's poetic prose suggests that his response to *War* was creative and he seems, accordingly, to have gone on to use the artist as part of his own, broad, intellectual project. He provided Rousseau with a rare commission, for a print on the same subject, to illustrate a journal on which he was working. The publication, *L'Ymagier* (fig.75), featured all kinds of visual material arranged in provocative and illuminating juxtapositions. It was within its pages that, for the first time, Rousseau's work appeared in proximity to 'other' forms of art: Jarry presented *War* in an edition that included popular prints (including *Images d'Epinal*) and fourteenth-century woodcuts.

There has been some debate as to whether Rousseau's lithograph of *War* predated his painting of the subject in 1884. However, since the composition is more unified in this instance, it seems likely that the print features a revised design. Furthermore, had the artist made a print after a painting, he would have been following the conventional academic art practices of the day. Professional printmakers often made lithographs and etchings after popular paintings from the official Salon, diffusing the original image, generating revenue and publicity. Jarry's sense of irony may well have encouraged him to commission Rousseau, an already unconventional artist, to create his own unorthodox print. In these ways both the painted and lithographic version of *War* engaged with and subverted art-world norms. Rousseau, if unwittingly, was challenging the boundaries of art.

Following *War*'s appearance in *L'Ymagier*, a young artist called Louis Roy wrote the first lengthy review that the artist received, praising his ingenuity and originality. He claimed that Rousseau was striving towards a new art. Why then, he asked, should his work attract mockery? 'It only seems strange,' he reasoned, 'because nothing like it has been seen before'.[4] The new, of course, can be shocking. Indeed, at least for Jarry, part of Rousseau's appeal was just that sense of anarchy. In a quasi-autobiographical book, *The Gestures and Opinions of Dr Faustroll*, the writer cast his friend as an *artiste-peintre*, the operator of a painting machine, who destroyed the works of his illustrious contemporaries, 'masking the impotent grimaces of the National Store [read academic artists and the Musée de Luxembourg] with a calm uniform of chaos'.[5]

Rousseau was aware that audiences found his works difficult. He kept scrapbooks into which he pasted the (mostly negative) press responses that his works attracted (fig.76).[6] But he hoped, nevertheless, to gain government recognition; when the municipal authorities of Paris announced a series of competitions to design murals for local town halls, he was quick to enter his proposals. One of these, *Carmagnole* 1893 (fig.79), a suggested decoration for the town hall in Bagnolet, was based on a composition that he had submitted to the Indépendants the previous year. That work, *A Centennial of Independence* 1892 (no.18), shows, in Rousseau's words, 'our forebears, in short trousers, dancing to celebrate the advent of liberty'.[7] Observing, on the sidelines, stand a group of usurped aristocrats. This content,

Fig.75
Cover of *L'Ymagier*
1884–5
Musée du Vieux-
Château, Laval

Fig.76
A page from Rousseau's
scrapbook of press cuttings,
1907–8
Bibliothèque Historique
de la Ville de Paris, Fonds
Guillaume Apollinaire

bearing in mind the ways in which the secular French State borrowed from traditional motifs to establish new traditions, was not entirely inappropriate. Across the country, new, invented Republican festivals were replacing celebrations of Saints' days and religious holidays. It was no doubt Rousseau's style, not the content of the picture, that caused the jury to find the design (as the artist himself explained) 'too revolutionary'.[8]

Nevertheless, in using the motif of *A Centennial of Independence* for *Carmagnole*, a positive 'official' response to that original design may have encouraged Rousseau. Indeed, on not one but two separate occasions the artist referred to the favourable critique that he claimed a highly respected 'official' artist had given to the painting. This artist, Pierre Puvis de Chavannes, was also on the panel of judges for the Bagnolet contest. 'Every time I met Puvis de Chavannes we chatted away happily,' Rousseau told the critic Arsène Alexandre in 1910, 'we were very good friends'.[9] In an open letter to a different journalist, Rousseau disclosed the compliments that the artist had supposedly paid him at the opening of the Salon des Indépendants about the canvas. 'He approached me', Rousseau claimed, to say, '"Monsieur Rousseau, I do not care for the garish colours of certain works in this Salon, but I like yours. You have overcome a great artistic challenge: you have made one red stand out against another."'[10] The artist had been referring to the Phrygian bonnets worn by the dancers, Rousseau explained, for these overlap in the movement of the dance. Thus, it appears that Rousseau was proud not only of his connection with the distinguished painter, but also of the work itself. He went on to boast to his interviewer of the 'sixty-two different tones in the Chinese lanterns!' and to tell of how, in their turn, visitors to the Salon danced in front of the painting.[11] They joined in, he added, with the song with which he captioned the image in the catalogue, the traditional French melody *Auprès de ma blonde*.[12]

Rousseau was similarly pleased with the strange allegory he produced some fifteen years later, *The Representatives of Foreign Powers Coming to Greet the Republic as a Sign of Peace* 1907 (no.22). This work was a yet more obvious attempt to meet the requirements of official art, featuring a whole host of French politicians, past and present, together with dignitaries from countries as diverse as Greece, Serbia, Ethiopia and Persia.[13] In the background, representing the 'young' French colonies, is a multi-national group of children. Celebrating secularised society, they dance around the monument to the martyred French Humanist thinker Etienne Dolet that stood in the Place Maubert, which had clear political overtones. Meanwhile, gathered on a steeply raking podium, the officials honour the Republic in great solemnity.[14]

Evidently, Rousseau's grouping of figures in *The Representatives of Foreign Powers* was fantasy, but so too was his image of France's power. The status of the Third Republic, on the world stage at this moment, was hardly so grand as the painting suggests. Thus, in *The Representatives of Foreign Powers*, Rousseau exaggerated the standing of his homeland. But he also appears to have embroidered the truth in recounting the reception of the work. On the latter subject, he told Alexandre that when he displayed the painting at the Indépendants in 1907, he could 'barely leave the galleries, so many people were coming to shake me by the hand, surrounding me, congratulating me'.[15] The reason for the surge of interest, he

explained, was that the show coincided with the Hague conference, an event of considerable international importance. However, as Certigny has pointed out, in March (the month that the Indépendants displayed their works), the conference was yet to take place.[16] Rousseau also claimed that he received letters from all over Europe in praise of the painting, but the press responses to the work suggest that this was also somewhat far-fetched. Robert Lestrange of the *Tintamarre* labelled the canvas 'the hilarious jewel in the comical box' of Rousseau's 1907 submissions,[17] while Uhde wrote that he had never heard such laughter from a crowd before a canvas. 'Anyone who wished to find qualities therein', he mused, 'would have been carted off to the madhouse'.[18]

Clearly, such responses did not deter Picasso, who bought the painting from Vollard in 1913.[19] The collage aesthetic of the image must surely have appealed to the pioneer of papier collé who, as Christopher Green has shown of late, took Rousseau very seriously.[20] Picasso had known Rousseau in the last years of his life and had held a 'banquet' in celebration of the artist at his studio on the rue Ravignon. There, legend has it, Rousseau proposed a toast to himself and Picasso, and pronounced them the two greatest painters of the day: 'You in the Egyptian style, I in the Modern.'[21] Of course, it is impossible to know what the comment meant, but it is clear that Rousseau kept an open mind when considering the painting of his contemporaries. In essence, he was a wholehearted subscriber to another idea championed by various administrations of the Third Republic, that art and artists should be free.[22] This message was one that he celebrated in his *Liberty Inviting Artists to Take Part in the 22nd Exhibition of the Société des Artistes Indépendants* 1905–6 (no.19). Exhibited in the Salon of the title in 1906, the work paid homage to the institution that allowed artists like Rousseau the opportunity to show their creations. Around the central figure of a lion – not a jungle creature, but a sleek version of the symbolic ones that represented liberty and the people on Paris's monuments – he depicted the artists waiting patiently to pay their fee and submit their works.[23] The winged figure of Liberty, hovering in the air above, reinforces the message of freedom; significantly, as Rousseau depicts her, she is also a relation of victory. Rousseau described the Indépendants as 'the fairest society, the most just, because everyone there has the same rights'.[24] It is only fitting then, that the following lines appear in the poem that Apollinaire declaimed in honour of Rousseau when they gathered in Picasso's studio: 'Oh Glorious painter of the soul of the Republic / Your name is the flag of the proud Indépendants.'[25] The words, though recited with a fair dose of irony, would no doubt have pleased their subject.

Not all of Rousseau's allegories were political. The subject of his *Happy Quartet* 1901–2 (no.20) is none other than love. Yet despite the different theme, the work operates in a similar way to *Liberty Inviting Artists*. Here too, with complimentary symbolic details, Rousseau reinforced the meaning of his image. Dora Vallier has shown that, although he borrowed from Gérôme's *Innocence* 1852 in *Happy Quartet* – thus borrowing that work's sentimental connotations – he also adapted the image to meet his own requirements. Hence, when he includes a dog instead of a fawn, a symbol of fidelity strengthens its overall message of compassion and companionship.[26]

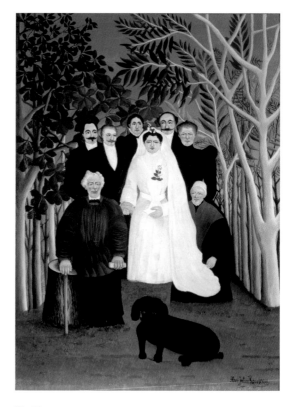

Fig.77
The Wedding
c.1904–5
Musée de l'Orangerie, Paris

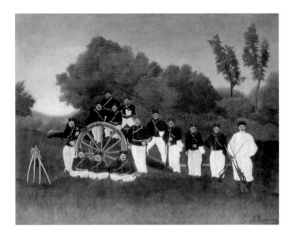

Fig.78
The Artillerymen
c.1893–5
(No.21)

But Rousseau did not always revert to allegory to express abstract values. Such ideas are also discernible in two very different works: *The Wedding c*.1904–5 (fig.77) and *The Artillerymen c*.1893–5 (no.21). These might appear as portraits, but audiences could well have read them in terms that were more general. In the first of these, *The Wedding*, the juxtaposing of the elderly couple in the foreground with the newlyweds in the centre of the image could suggest the passage of time or the notion of a lifelong commitment. Alternatively, this might be an image about harmony: in marriage, or even between the country and city. It is worth noting that the younger, cosmopolitan guests that the artist portrays wearing slick city clothes (certain of whom share Rousseau-esque facial features), are proud to stand with their rural elders. In an age of rural to urban migration – Rousseau himself came to Paris from the provinces – that sense of solidarity surely had considerable resonance.

Likewise, even if Rousseau was familiar with the company he painted in *The Artillerymen*, its message might also have been 'universal'. The scene may depict the regiment of Frumence Biche, the husband of one of Rousseau's former girlfriends, but this information was unavailable to the Salon-going public and so is of secondary importance.[27] More interestingly, the artist placed his figures in a tranquil wooded setting, not unlike that of the Bois de Vincennes, where vast sections of the French military trained. The experience of military service was very common: it was one that Rousseau himself had known. By taking such a theme, perhaps he wished once more to attract official attention, while offering a more general appeal to a good Republican like himself. This image of an artillery company, peaceful as it is, would have been attractive to those who knew that the experience itself could be much less tranquil. Far away from the colonies in which they might have to serve, these men are on 'home soil', surrounded by a French landscape and safe from the dangers of the 'unknown'.

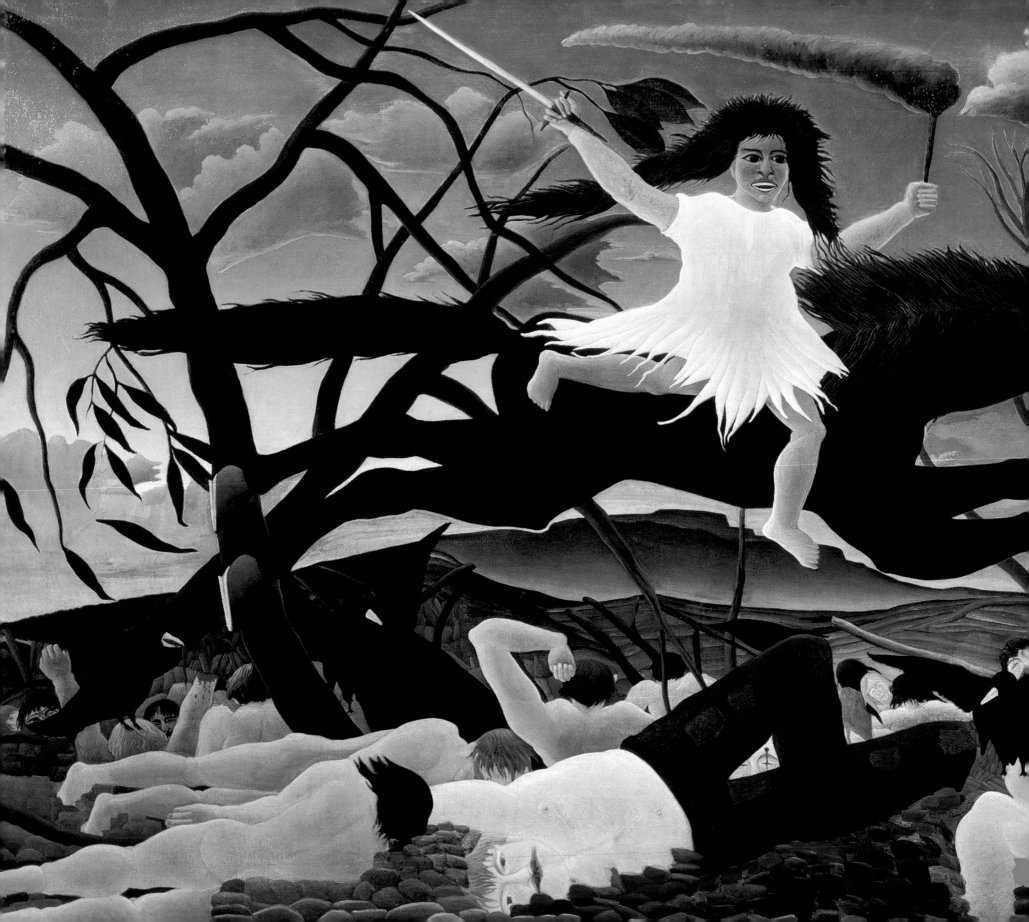

'Terrifying, she passes, leaving despair, tears and ruin all around'

No. 17
War 1894
Oil on canvas 114 x 195 cm
Musée d'Orsay, Paris

'The people dance around the two republics, that of
1792 and that of 1892, hand in hand to the tune of
Auprès de ma blonde qu'il fait bon, fait bon dormir'

No.18 (left)
A Centennial of Independence
1892
Oil on canvas 111.8 x 157.2 cm
The J. Paul Getty Museum,
Los Angeles

Fig.79 (above)
Carmagnole 1893
Harno Museum, Nagano

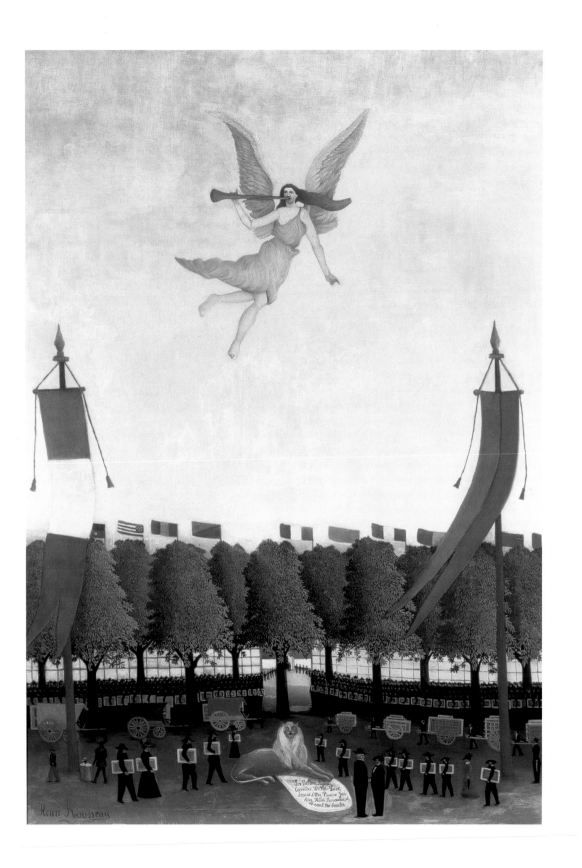

No.19
Liberty Inviting Artists to Take
Part in the 22nd Exhibition of the
Société des Artistes Indépendants
1905–6
Oil on canvas 175 x 118 cm
The National Museum of
Modern Art, Tokyo

No.20
Happy Quartet
1901–2
Oil on canvas 94 x 57.4 cm
Greentree Foundation,
New York

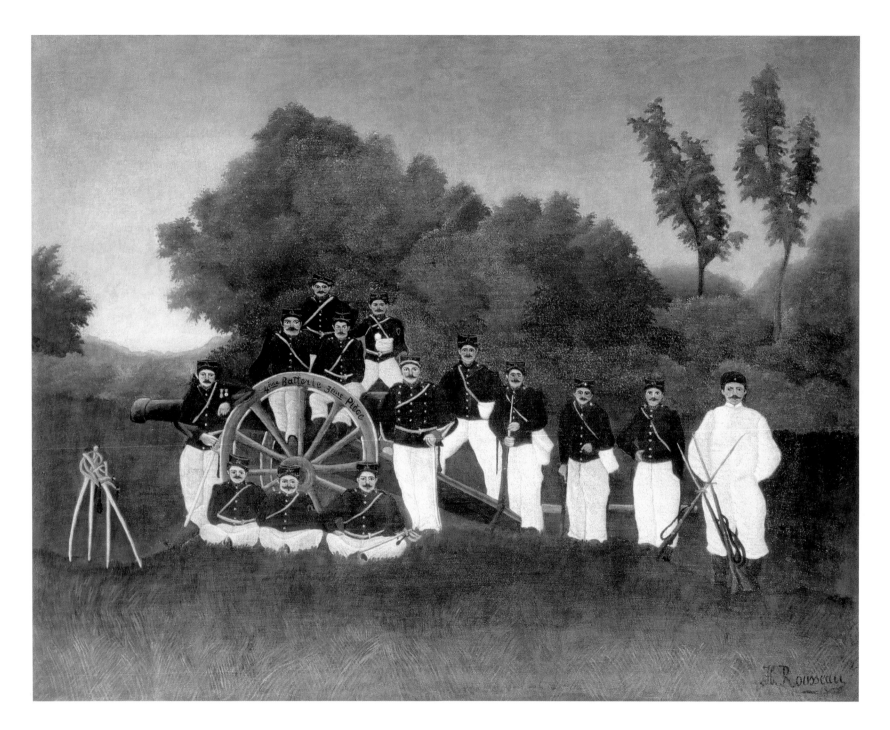

No. 21
The Artillerymen
*c.*1893–5
Oil on canvas 79.1 x 98.9 cm
Solomon R. Guggenheim
Museum, New York.
Gift of Solomon R. Guggenheim

No. 22
The Representatives of Foreign
Powers Coming to Greet the
Republic as a Sign of Peace
1907
Oil on canvas 130 x 161 cm
Musée Picasso, Paris

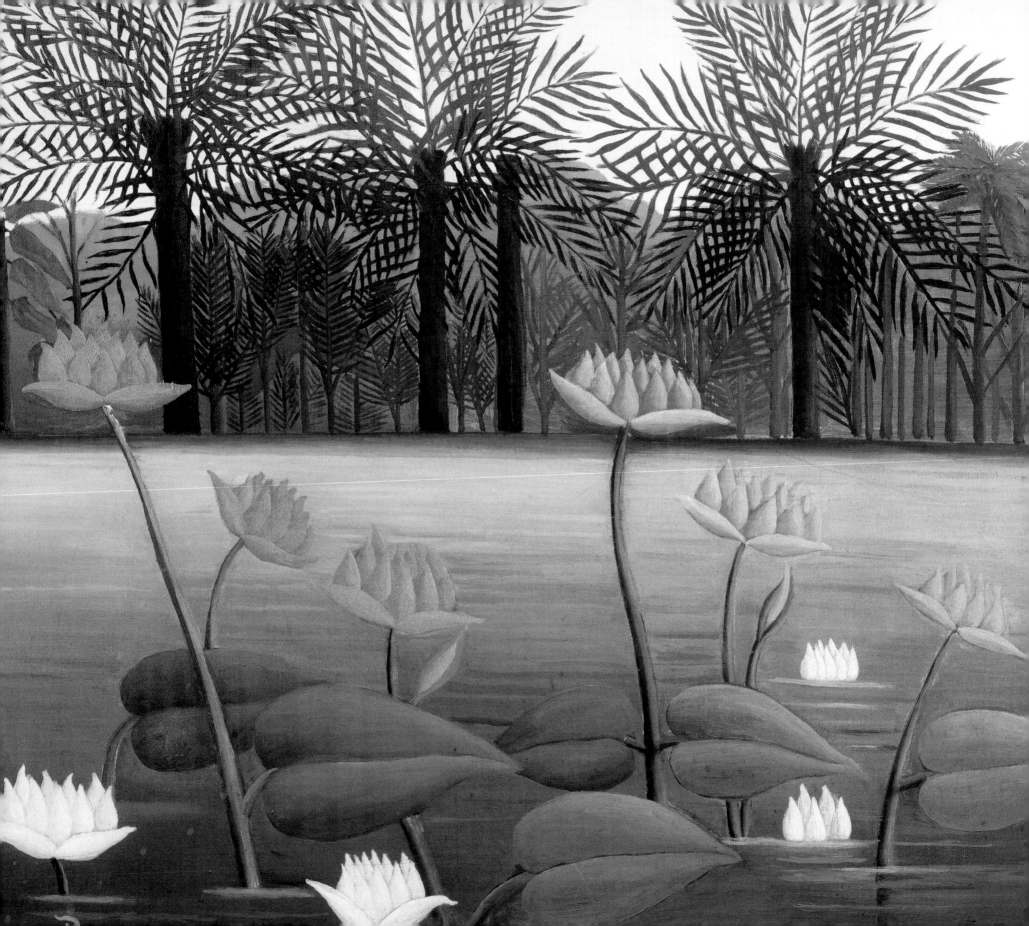

The Peaceful Exotic

Fig.80
The Flamingos
1907
(Detail of no.24)

Fig.81
Exotic Landscape
1908
Private Collection,
New York

'Come to Mexico!
On the high plains the tulip trees bloom
Tentacled creepers form the mane of the sun
The palette and brushes of a painter they say
Colours as deafening as gongs,
Rousseau has been there
There his life became dazzling'

Blaise Cendrars[1]

Like the soldiers he had depicted so carefully in *The Artillerymen c.*1893–5 (no.21), in undertaking compulsory military service, Rousseau had once worn uniform; but unlike many of his contemporaries, he never left France. There was a significant military presence in Mexico from the years of the Second Empire, well into the Third Republic, but contrary to the myth developed by Apollinaire, Salmon and many more, Rousseau did not participate. His interview with Alexandre in 1910 confirmed the fact that his voyages had gone no further than the Jardin des Plantes.[2] Perhaps, given this information, it is no surprise that his images of distant lands – including *The Waterfall* 1910 (no.23) with its small antelope and gently running water – should convey a distinct sense of the familiar.

However, as Christopher Green has shown in the present catalogue, Rousseau

did not construct such extraordinary scenes verbatim from an existing language of exoticism. The animals in his pictures are far from being faithful sketches of those in the city's zoological collections. No more are the lush plants, the exotic foliage, true to exact horticultural varieties. When The Museum of Modern Art's Daniel Catton Rich asked a Professor of Botany from the University of Chicago to identify the verdure in Rousseau's pictures, he could draw no firm conclusions. In Rousseau's work, the expert explained, 'The plants are conventionalised and most of them are difficult to identify'.[3] Thus, for example, the tent-shaped ones shown in *The Waterfall* might equally be Yucca, a 'New World' plant, or Dracena, an 'Old World' variety. Perhaps, in paintings that are outlets of fantasy, they could be both simultaneously.

Since they do relate to identifiable plant types, it is likely that Rousseau had studied tropical foliage from life, an idea that contemporary accounts support. Weber recalled that, upon a large sheet of cardboard on his studio wall, Le Douanier had mounted a whole array of drawings. Many of these featured the Jardin des Plantes, its birds, swans, animals and flowers.[4] It may be that Rousseau made sketches in the hot-houses but, unfortunately, it is impossible to know for sure. Despite the enormous number of drawings that Rousseau produced and exhibited – over forty featured in the 1911 retrospective alone – few examples of his draughtsmanship survive. There is evidence, however, that Rousseau considered nature vitally important to artistic practice. Max Weber remembered how, even when working on other subjects, Rousseau considered it important to keep some greenery close by for inspiration.[5] Likewise, in a letter, Le Douanier urged Weber to 'follow nature at every stage', while Uhde described how he collected leaves from the cemetery to take back and study in his studio for form and colour.[6]

Clearly though, this was not simply a process of recording nature, for, as he told Alexandre, he always reworked motifs in the studio. He also, as Christopher Green's essay shows with the example of *Banana Harvest* 1907–10 (fig.33), occasionally worked from photographs of jungle foliage (see p.43). In brief, in painting his exotic havens, he continued to adapt his 'sources' according to his wishes. The canvases in this section are at once a blend of the observed and the imagined, the result of primary and secondary viewing, collages of disparate information. They present a heady combination of the tangible and the fantastic.

In an age of colonial expansion, in the popular press and elsewhere, images of Western man at ease in the jungle were manifold. This was the period of large-scale expeditions; many great explorers made their names in the years spanned by Rousseau's career. However, with a few rare exceptions, only groups of animals populate Le Douanier's idyllic jungle scenes. The stars of his *Monkeys in the Jungle* 1910 (no.25), his *Exotic Landscape* 1908 (fig.81) and the *Tropical Forest with Monkeys* 1910 (no.27), are all groups of primates. However, if these animals are not human, they are as European as Rousseau's portrait sitters. Some of the creatures – such as the flamingos in the canvas of the same name of 1907 (no.24), or the pair of Himalayan 'semnopithèque' in his *Monkeys in the Jungle* – are visual quotations from the *Bêtes sauvages* album that Rousseau kept in his

Fig.82
Marcel Monnier
Camp at Dibi (Sanwi) Binger
Mission from the Ivory Coast
to the Sudan, 1891–2 (detail)

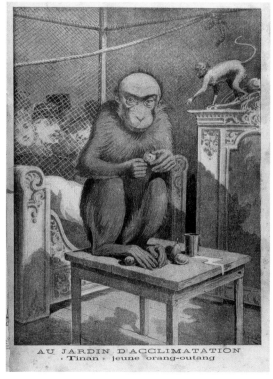

Fig.83
Exotic Landscape
1910
The Norton Simon Foundation

Fig.84
'Tinan', *Le Petit Journal*,
20 December 1896

studio.[7] The pose of the baboon, in the 1910 *Exotic Landscape* (fig.83), might similarly be that of the orang-utan in the Jardin d'acclimatation as depicted by *Le Petit Journal* (fig.84). But these 'wild animals' are Western not only in the sense of their picture-book pedigree.

Interestingly, many of the animals in Rousseau's images of the jungle at peace have human faces. This is strikingly the case in certain images – particularly the 1910 *Exotic Landscape*. If Emmanuel Frémiet's *Gorilla* (fig.26) played out an essentially human fantasy, then Rousseau's animals did likewise. In certain of these images, such as the 1910 *Exotic Landscape*, the jungle is a sanctuary. Somewhat ironically, it becomes a place of retreat, an escape from the 'jungle' of Paris; not unlike the artist's suburban landscapes. These locations offer freedom from the everyday grind of civilised life. His monkeys sit on the grass, just like the people he painted in his *View of the Fortifications* 1896 (no.7). Likewise, the group of monkeys in the 1910 *Exotic Landscape* peek out from behind the leaves, in a similar way to the courting couple in *Rendezvous in the Forest* 1889 (no.14). Hence, in these jungle scenes, the tropical forest is no more threatening than the woodland of France. To compare the serenity of *Two Monkeys in the Jungle* 1909 (no.26) with the eerie intensity of *Carnival Evening* 1889 (no.15) might even suggest that it is less so. As in his early portrait-landscapes, Rousseau had awarded his subjects with attributes, so too, in his images of the tranquil forest, he painted his animals with oranges. The 1910 *Exotic Landscape*, *Two Monkeys in the Jungle* and *Monkeys in the Jungle* are all constructed in this way and, as a device, these playthings emphasise the quasi-human appearance of the animals. Rousseau's monkeys here are not 'wild' beasts and, if they are, they are no more 'savage' than Rousseau's depictions of children with toys.

Of all the artist's animals, perhaps the most 'civilised' in appearance, if not in behaviour, are the monkeys in the 1906 canvas known as *The Merry Jesters* 1906 (no.28). Here, the artist defined the faces particularly clearly, while the relationships between the figures are equally well determined, from the two main characters to the animal they taunt with a stick, from their companion crouching in the undergrowth to a smaller animal alone in the near distance. In a forest clearing, watched by an owl, the group upset a milk bottle; the scene captures the moment as its contents empty. These are not performing animals, but they engage in some kind of strange performance.

A question arises: why are the 'Merry Jesters' playing with a milk bottle in the middle of the jungle? In the forest setting, despite the reigning calm, their presence is uncanny. It seems that there ought to be some kind of understandable logic to the scene; yet if any such logic exists, it escapes the viewer. Describing the scene, one critic asked himself in print whether he had really seen such a thing, while others were simply unimpressed.[8] Even the hanging committee at the 1906 Salon d'Automne (where the work was first shown) appears to have found the work difficult. They placed it in an obscure corner where it was hardly visible, a choice that the conservative critic Camille Mauclair praised in an ironic write-up for *Art et Décoration*. Rousseau had been set aside justifiably, he concluded, implying that the jury had been wrong to award a prominent place to his *Hungry Lion throws itself on the Antelope* the previous year. On that occasion, he explained, 'things went a bit far'.[9]

But how, in its turn, could *The Merry Jesters* go too far? Perhaps Rousseau's peaceful jungles, peopled by quasi-human animals, unsettled contemporary viewers because they blurred the boundaries between the different species. This was certainly part of their appeal for the avant garde. Many intellectuals of Rousseau's day were interested in the ideas of the philosopher Friedrich Nietzsche, who in his book *The Birth of Tragedy* (1871) had called for a return to instinctive behaviour, and Jean-Jacques Rousseau, who had aligned the instinctive with childhood. Rousseau's monkeys certainly appear to behave instinctively: a contemporary critic, with an air of both intrigue and distaste, observed how the upturned milk bottle 'allows the monkeys to give themselves up to their natural taste for face-pulling and facetiousness'.[10] Some years later, in an article in the review *Action*, other peaceful exotic landscapes by Rousseau would illustrate an article that questioned the superiority of the human race, challenging the Darwinism of contemporary science.[11] Rousseau's animals, like the fantasy his Jungle pictures prompted, encouraged viewers to identify with something other than dominant cultural norms. It was in such a way that André Salmon described Le Douanier's appeal for a new generation of painters in 1912. For them, Rousseau was 'an uncle from black-white America', who could help them to find their inner selves.[12]

With the exception of *The Merry Jesters*, few contemporary critics wrote about Rousseau's 'peaceful exotic'. Perhaps it was because the connotations those images provoked were less than relaxing. Louis Vauxcelles identified the owl in the tree as the owl of Alfred Jarry's play *Ubu Roi* (1896), one that surveyed the 'anthropomorphics who have a very nasty air about them'.[13] To Vauxcelles, Rousseau's image was one that, like Jarry's infamous play, celebrated the chaos and absurdity of the human condition.

Turn-of-the-century Western society was anxious about 'Other' kinds of culture; understanding this helps illuminate the tensions caused by Rousseau's images of the 'peaceful exotic'. The Paris World Fairs of 1889 and 1900, with their colonial villages and foreign pavilions, at once provoked nervous fascination and appeased visitor worries. At the Jardin d'acclimatation, on a more regular basis, similar displays drew great crowds. Such images cannot but shock the present-day viewer: Europeans peering into enclosures, swathed in extravagantly conservative dress, contrast sharply with the semi-naked black 'exhibits' they scrutinise. These displays, through inherent racism and the underlining of 'difference', sublimated white 'civilisation'. Rousseau's jungles, peacefully peopled by European animals, had the potential to do just the opposite.

Rousseau, himself a Parisian, was nonetheless an attentive visitor to the 1889 World Fair; there, like so many others, he must have found the sights astounding. The event even inspired him to write a play upon the theme. It would be wrong to suggest that the artist was not a participant in the lamentable ethnographic tourism of the day[14] but, notably, the comical country visitors he describes taking a tour of the attractions in his play make no mention of the African or Oceanic displays. Two other exhibits fixate them: the Annamese village and waxwork figures of Bretons like themselves in the Palais du Trocadéro. There, the characters compare appearances, noting similarities and

differences. Initially, however, they have difficulty identifying either: they compare both the Annamites and the Bretons to themselves and become confused. Perhaps this unease is comparable to that provoked by *The Equatorial Jungle* 1909 (no.29). What exactly, is the creature hidden behind the palm leaves? It is at once recognisable and strange. In such a way, Rousseau's peaceful exotic, symptomatic of an era of encounters, raised an important consideration: was there such a great difference between the French and the 'Other'?

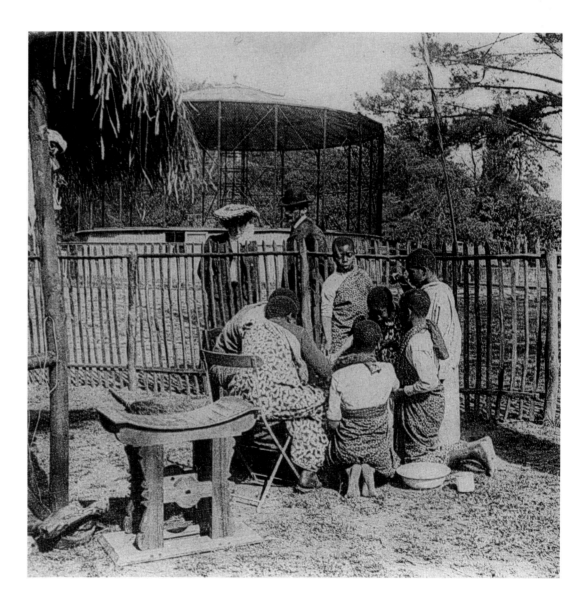

Fig.85
Postcard, 'Ashantis – The Meal'
(detail)

No.23
The Waterfall
1910
Oil on canvas 116.2 x 150.2 cm
The Art Institute of Chicago. The
Helen Birch Bartlett Memorial

No.24
The Flamingos
1907
Oil on canvas 114 x 165.1 cm
Collection of Joan Whitney Payson

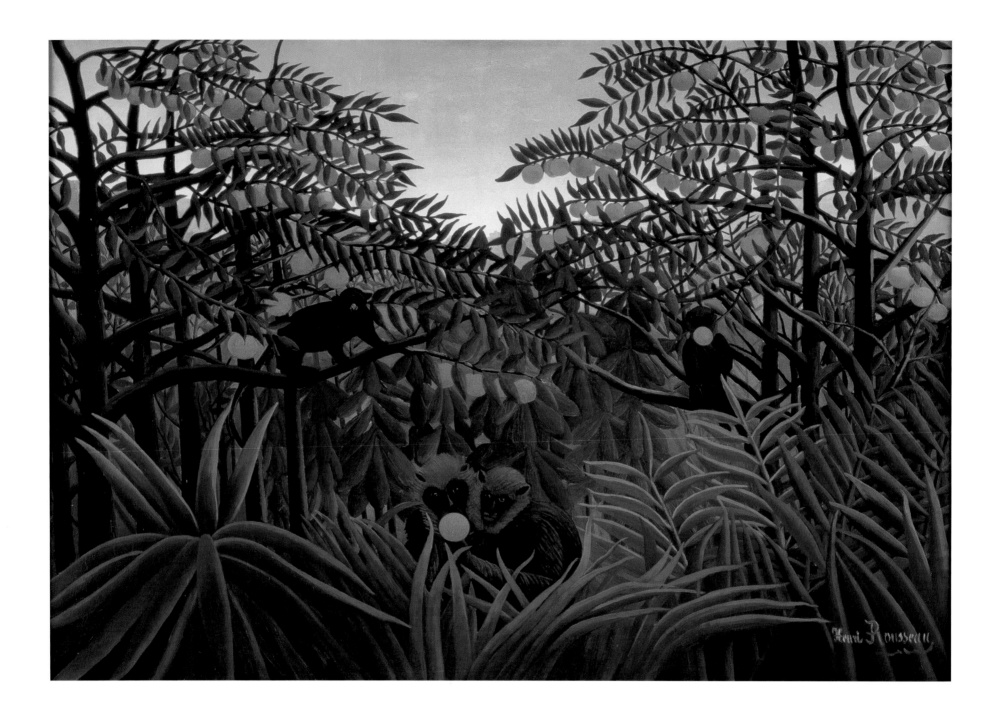

No.25
Monkeys in the Jungle
1910
Oil on canvas 114 x 162 cm
Private Collection

No.26
Two Monkeys in the Jungle
1909
Oil on canvas 64.8 x 50 cm
John Whitney Payson

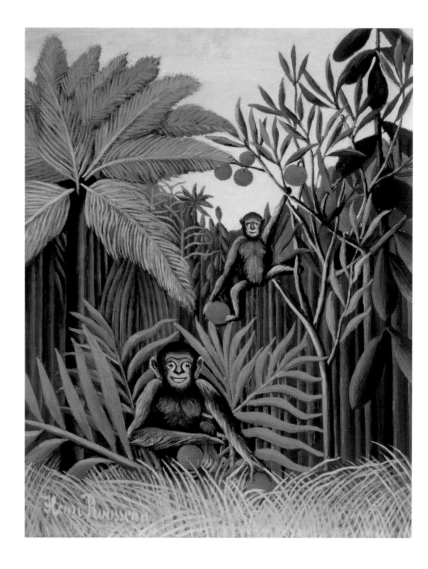

No.27
Tropical Forest with Monkeys
1910
Oil on canvas 129.5 x 162.5 cm
National Gallery of Art, Washington.
John Hay Whitney Collection

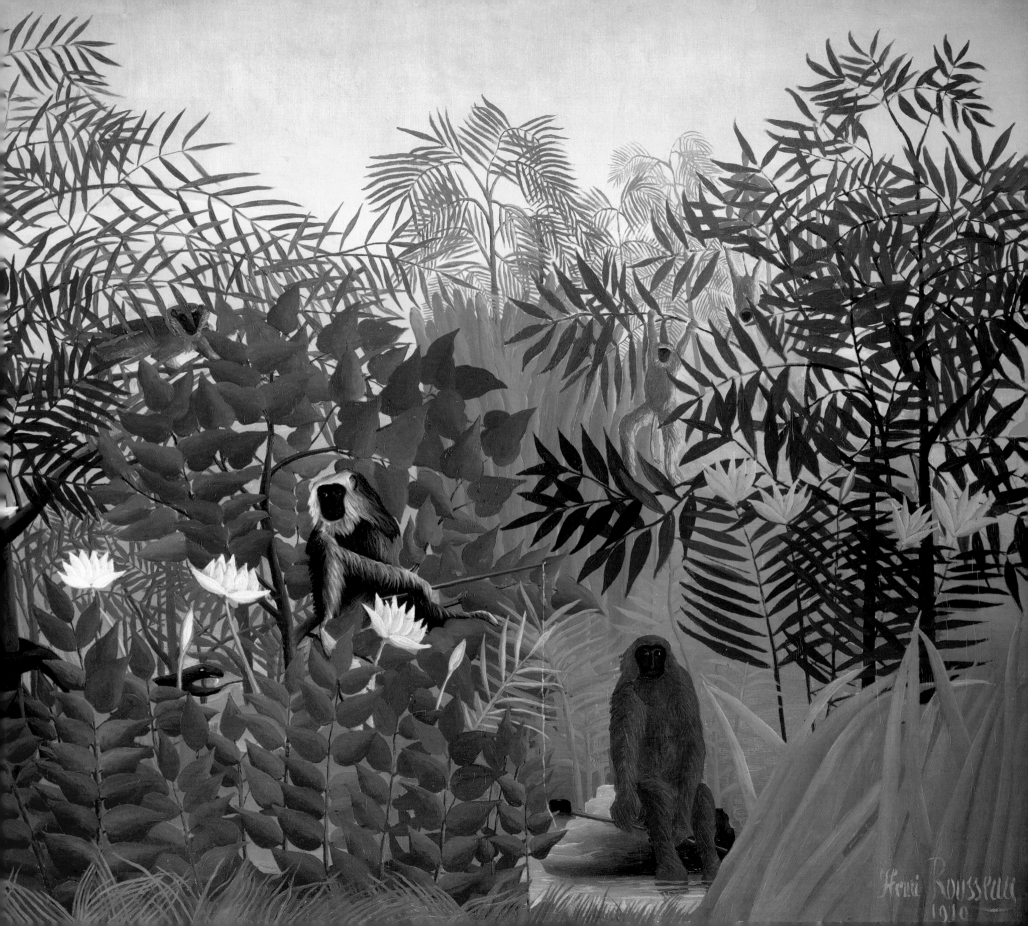

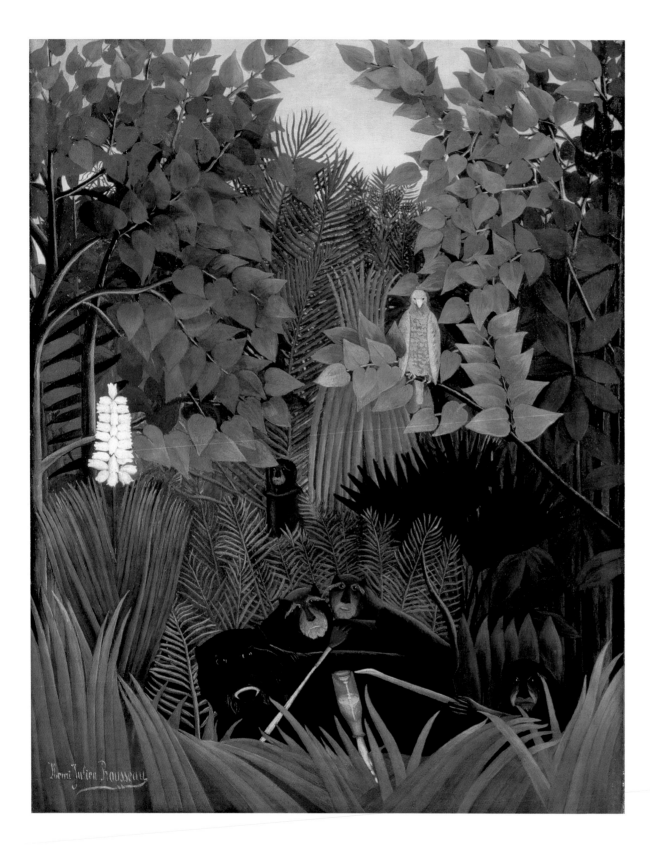

No.28
The Merry Jesters
1906
Oil on canvas 145.7 x 113.3 cm
Philadelphia Museum of Art.
The Louise and Walter
Arensberg Collection

No. 29
The Equatorial Jungle
1909
Oil on canvas
Support: 140.6 x 129.5 cm
National Gallery of Art, Washington,
Chester Dale Collection

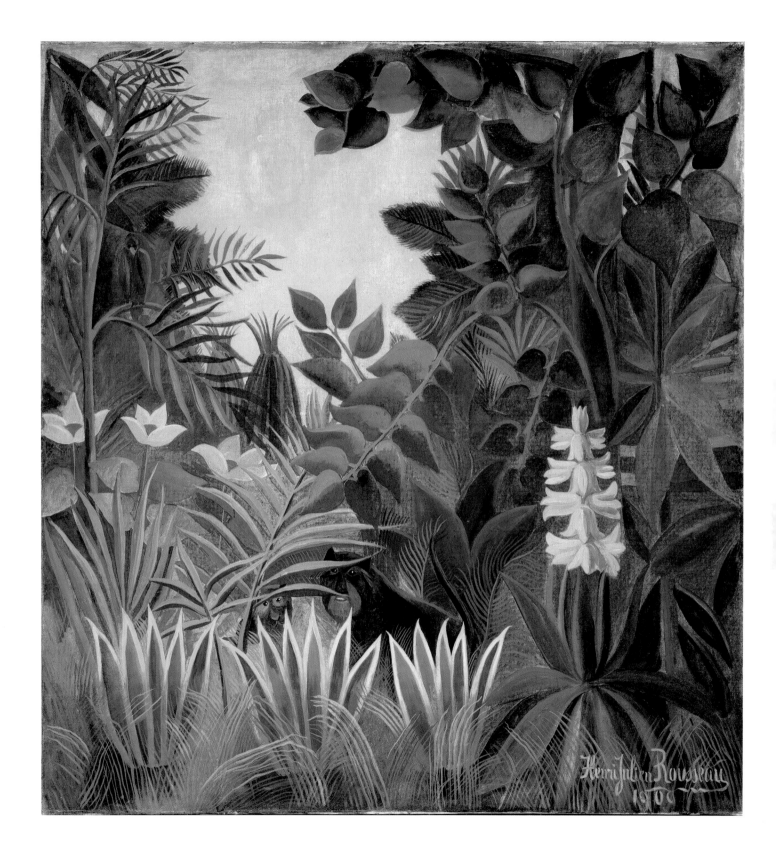

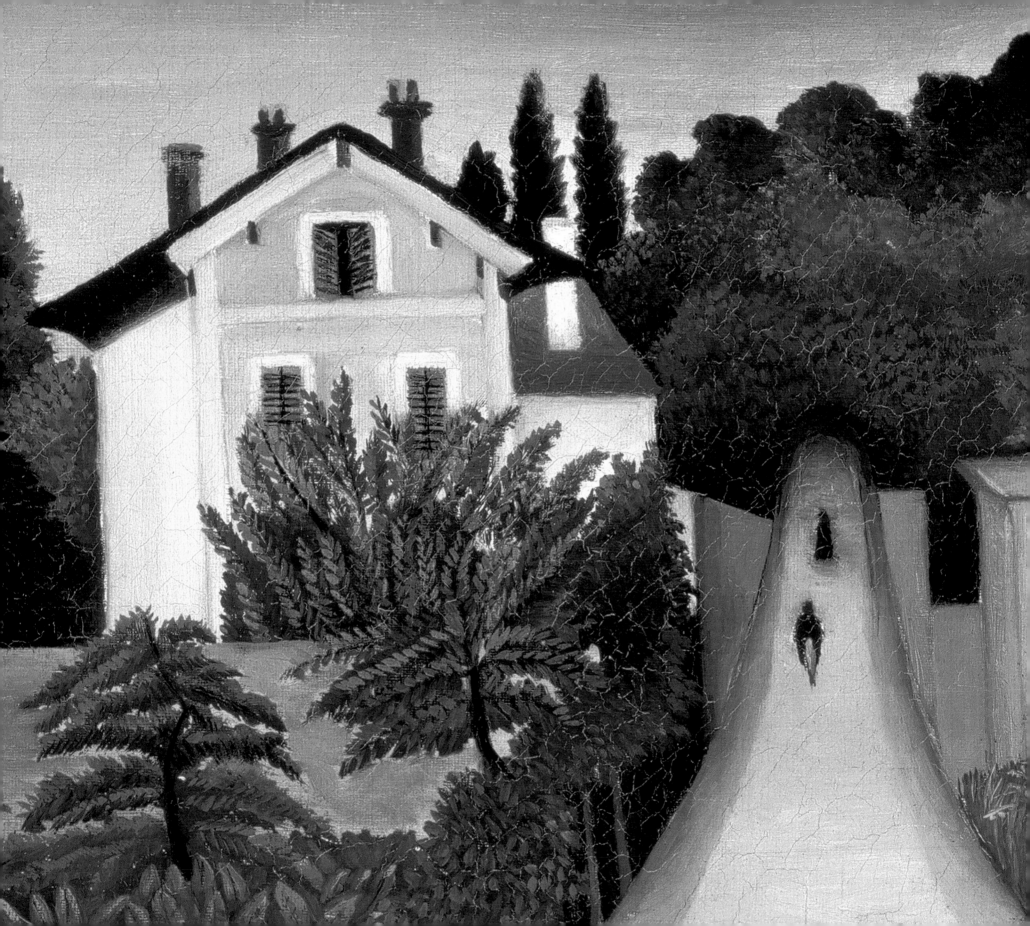

French Landscapes

Fig.86
House on the Outskirts of Paris
*c.*1905
(Detail of no.37)

Fig.87
Jardin du Luxembourg
1909
(No.32)

'If he really loved nature and painted it as he saw it, he must have been satisfied with a remarkably ill-looking mistress. It seems impossible that any man of artistic sense could have seen a villa in its grounds as Rousseau painted it; there is neither colour, form, nor atmosphere in the picture.'

Anonymous, on Rousseau's *House on the Outskirts of Paris*[1]

Landscape was, unquestionably, the dominant genre in which Rousseau worked. And, for the most part, the landscapes he painted were local. From the *Banks of the Oise* 1905 (no.38), to *Ivry Quay c.*1907 (no.40), his depictions of Paris and its outskirts were numerous. Workaday scenes, peopled by small and shadowless figures, they seldom feature the city's major attractions. When he did look to conspicuously Parisian motifs, he chose ones like the *Jardin du Luxembourg* 1909 (fig.87), that were accessible to all. Perhaps this was because the artist had little experience of the exclusive sophistication that the city had to offer. 'Rousseau knew nothing of the splendour of the marvellous Paris we love,' wrote Wilhelm Uhde. 'His world was not to be found there.'[2] Rousseau painted the minor streets and squares to which he was accustomed but, by doing so, he appeared to transform them. His imagination, Uhde claimed, raised his quotidian subjects to greater heights. Their incidental character disappeared; they became 'human documents, studies of states of

soul'.[3] These, like those images of the 'peaceful exotic', were fantastic visions. 'They transcended his reality in a strange and fascinating way,' Uhde claimed, 'to become part of his personal adventures'.[4]

But how did Rousseau's homeland landscapes provoke such a reading? They are, seemingly, the most unremarkable of the artist's paintings. It is easy for a twenty-first-century viewer to understand the faraway dream of a jungle paradise; but how could images of the outskirts of the city contribute to any kind of fantasy? If these are 'modern' images – as the factory chimneys in *View of the Quai d'Ivry near the Port à l'Anglais, Seine (Family Fishing)* 1900 (no.30) and *The Environs of Paris* 1909 (no.36) suggest – they are not a conspicuous celebration of a new age. The views that Rousseau chose are not glamorous or exciting, and they show nothing of the enormous changes that the city was experiencing. What reason, for example, for the artist to focus upon a *Saw Mill, Outskirts of Paris* c.1893–5 (fig.88)?

For avant-garde viewers, the fantasy to be found in these pictures lay in *simplicity*, a quality that they perceived in his art and his character alike. Indeed, in the 1920s, Christian Zervos would use Rousseau's *Saw Mill* to illustrate an article on that very theme.[5] Similarly, 'What made me love his work', Max Weber explained, was that in the context of 'all the intellectual hair-splitting of art then in vogue in Paris... For me to go to him, to walk into his studio, was like walking into a vineyard – fresh, no debates – here was an art without words.'[6] Accordingly, the appeal of Rousseau's landscapes was as much involved with what they portrayed as with what they omitted. 'He at no point paints impressions, episodes, ideas, experiences,' wrote Uhde. He made *paintings*; he was as 'an artist in the highest and most classical sense'.[7] In this way, Rousseau was associated with an impressive lineage of French artists, as the successor of Nicolas Poussin and Gustave Courbet. He became a painter for painters.

If the 'ordinary' subjects of *Old Junier's Cart* 1908 (fig.70) and *The Football Players* 1908 (no.13) had allowed Rousseau's extraordinarily disjunctive style to stand out, in his landscapes, composition came to the fore. 'In a Rousseau landscape nothing is overdone', wrote Delaunay. 'No one element is out of place, or fails to participate in the world he recreates.'[8] The perfectly balanced compositional elements of the *Environs of Paris* reflect as much; whether this riverside scene is true to life becomes, in a quest for a harmonious picture plane, of secondary importance. What matters instead is that a series of strong, vertical lines punctuate the canvas. From the chimney-stack to the mast of the ship, from the voluminous cluster of clouds in the background to the dense thicket that shields the factory, each element contributes to a whole far greater than the sum of its parts. It was Rousseau's ability to prioritise painterly concerns above all else – to express his personal vision – that endeared him to fellow artists. Wassily Kandinsky, who championed the freshness of Rousseau's 'childlike' vision, was desperate to buy a rural landscape by the artist in 1911.[9] It was the harmony and apparent simplicity of images like *The Orchard* c.1896 (no.33) that appealed. A canvas such as this, with its rich colour and defined outlines, could also reinforce the Folk art associations that the younger generation drew

Fig.88
Saw Mill, Outskirts of Paris
c.1893–5
(No.31)

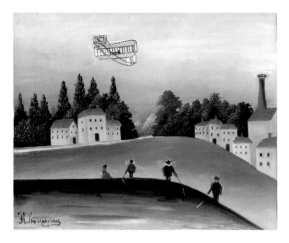

Fig.89
Anglers
1908
Musée de l'Orangerie, Paris

with Rousseau's work. What image could better illustrate Delaunay's claim that Rousseau was 'the living synthesis of an anonymous multitude of simple artisans, from the sign painter and glass painter, to the decorator of shops and village cabarets' than this early, picturesque canvas?[10]

But Rousseau was no Folk artist and nor were his images as straightforward as some of his admirers imagined. His landscapes may have been commercially and not just poetically motivated. Only a fraction of Rousseau's works in the genre featured in his annual Salon entries, a fact that reinforces the idea that they held an altogether different place in the artist's oeuvre. It is difficult to relate most of the works in this section to specific first exhibitions, and those that did appear in Rousseau's listed submissions rarely solicited press comment. *House on the Outskirts of Paris c.*1905 (no.37), for example, was present in the 1905 Salon d'Automne, but next to the artist's sensational *The Hungry Lion throws itself on the Antelope* 1905 (no.49) it passed unnoticed. Furthermore, as the few remaining traces of Rousseau's business show, the artist charged considerably less for these works than he did for his allegories or his jungle scenes.[11] When he sold *House on the Outskirts of Paris* to Max Weber, he did so together with another work, for less than thirty-five francs.[12] Though this painting is exceptional, with its strange ascending pathway that disappears into the woods beyond, the low sale prices that Rousseau commanded for his landscapes may account for the hasty execution or formulaic appearance of other examples. Throughout the course of his career, the artist would reuse the same motifs in landscape scenes, moving them around to create different compositions. *Ivry Quay* (no.40) and *Anglers* (fig.89) are, save their particular arrangements of figures and flying machines, remarkably alike. The little white houses they feature are nearly identical to those of the *View of the Quai d'Ivry near the Port à l'Anglais, Seine*, painted some eight years earlier, where the artist had similarly described the water in long, linear brushstrokes. The comparison of these works, furthermore, demonstrates that Rousseau did not just paint what he saw. Here, the section of river shown in both works is identical, yet the colours of the roofs and the sizes of the buildings vary considerably. The artist clearly altered the proportional relationships between the figures and ground in his landscapes in a similar way. *View from the Quai Henri IV* 1909 (no.39) – when compared with its preliminary oil sketch (fig.119) – reveals that Rousseau exaggerated the size of the figure to create implausible dimensions (see p.185).

One 'fantasy' that Rousseau's landscapes offered to the bohemian intelligentsia was thus the fantasy of his naivety. But they also offered a different kind of fantasy to a different audience: it may be that Rousseau intended these images for, or managed to sell certain of these landscapes to, suburban clients. He gave works in lieu of payment for grocery bills and other services; Rousseau's best works, Uhde mused, might have come to grace the walls of wine merchants or concierges.[13] As such, his pictures met with the requirements of that market. 'Did not our customs man belong with the little people from the suburbs... ? Rousseau's dream was no more than that of those humble souls. It was their vision of the landscape that he captured on canvas,' wrote Adolphe Basler.[14]

But interestingly, as Vincent Gille's essay in this catalogue suggests, the 'humility' of that vision was questionable: those familiar with the city would have realised that it was of his own invention.[15] Rousseau's landscapes were rarely faithful representations of specific areas. A few of his artworks bear labels stating exact locations, such as *The Banks of the Bièvre near Bicêtre* 1908 (no.35), but many more are quite anonymous. When Robert Delaunay organised the first Rousseau retrospective in France, at the Salon des Indépendants in 1911, he wrote to the collector Serge Jastrebzoff (who painted under the pseudonym of Férat), asking if he could lend any suitable works. Jastrebzoff returned a list, mentioning a landscape, with a note in brackets: 'I don't know the location – you told me it the other day – the Seine with an aeroplane.'[16] If, even at that early stage, the identities of these landscapes were ambiguous, it seems likely that the issue was relatively unimportant.

This, together with their small scale, might mean that Rousseau intended such images to embellish the home. A work such as the *Anglers* (fig.89), for example, would be far more suitable for a conventional domestic interior than, say, a *Happy Quartet* (no.20),

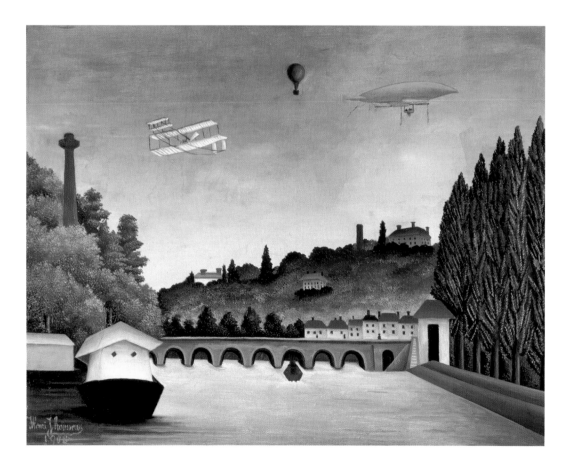

Fig.90
View of the Bridge at Sèvres
1908
The State Pushkin Museum
of Fine Arts, Moscow

obviously destined for public display. But this imprecision also suggests that if Rousseau's landscapes 'transcended his reality' they did so not just through their 'simple' appearance. Indeed, if the artist's portraits reflected petit-bourgeois aspirations, so too did his landscapes. They presented a peaceful vision of a suburban skyline that, during this period, was transforming rapidly: a reality improved. In a similar way, they are like Rousseau's images of war and peace, for they too adhere perfectly to the idealistic values expounded by contemporary government. All is peaceful in these landscapes. New developments are completely at one with the surrounding natural scene. Thus, the mounds of logs in *Saw Mill, Outskirts of Paris* echo the undulations of the natural skyline. Likewise, the chimney stack that stands among the trees on the bank to the left of the *View of the Bridge at Sèvres* 1908 (fig.90), reaches no higher than the wooded area opposite. In fact here, as in *View of the Quai d'Ivry near the Port à l'Anglais, Seine (Family Fishing)*, the natural and the man-made even rhyme: they are in perfect harmony. Similarly, there is no conflict between a church spire, a tree, or a chimney in *The Orchard*. All this reflects the way in which the Third Republic sought to promote unity, an immensely popular message in a post-war world. Rousseau's landscapes reinforced a sense of national identity. In the light of this idea, it is hardly surprising that some of his other works in this genre, such as *The Pont de Grenelle c.*1892 (no.41), feature conspicuous Republican motifs, including the tricolour. This is not to say that Rousseau's images were propagandist. It shows instead that, like so many of his contemporaries, the artist subscribed to a certain way of thinking. Consequently, his landscapes are not as timeless as might be thought, being symptomatic of a historical moment. Their construction and their content – if not their relationship to a seen reality – is indicative of the era in which they were made. Some include conspicuously new motifs such as flying machines. Others, such as his *View of Malakoff, Paris Region* 1908 (no.42), with its fragmented, collage-like composition and its bending telegraph poles, as Tristan Tzara expressed it, 'stamp the rhythm of a modernist optimism on the distant solitude of the countryside' in less obvious ways.[17] Hence, even though the relationship between Rousseau's landscapes and a contemporary, seen, reality was often tenuous, the fantastic vision they betrayed was very much of its era. It is in this way that, despite their appearance, these French scenes are rather like the artist's famous Jungle works.

No.30
View of the Quai d'Ivry near the Port
à l'Anglais, Seine (Family Fishing)
1900
Oil on canvas 24.1 x 33 cm
The Baltimore Museum of Art.
The Cone Collection, formed by
Dr Claribel Cone and Miss Etta
Cone of Baltimore, Maryland

No.31
Saw Mill, Outskirts of Paris
c.1893–5
Oil on canvas 25.5 x 45.5 cm
The Art Institute of Chicago.
Bequest of Kate L. Brewster

No. 32
Jardin du Luxembourg
1909
Oil on canvas 38 x 47 cm
The State Hermitage Museum,
St Petersburg

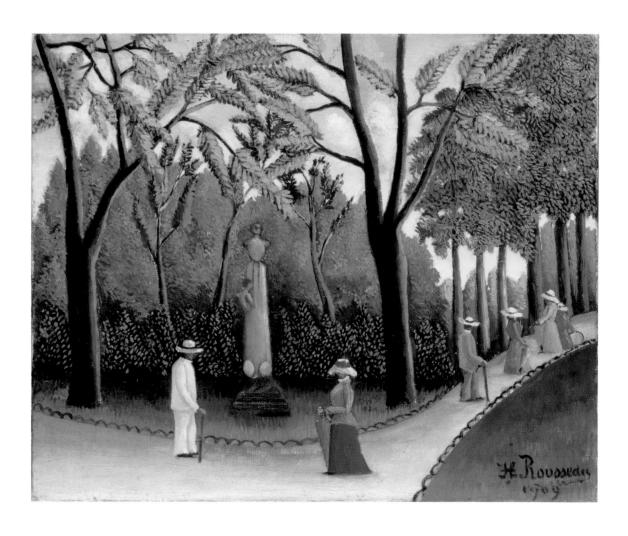

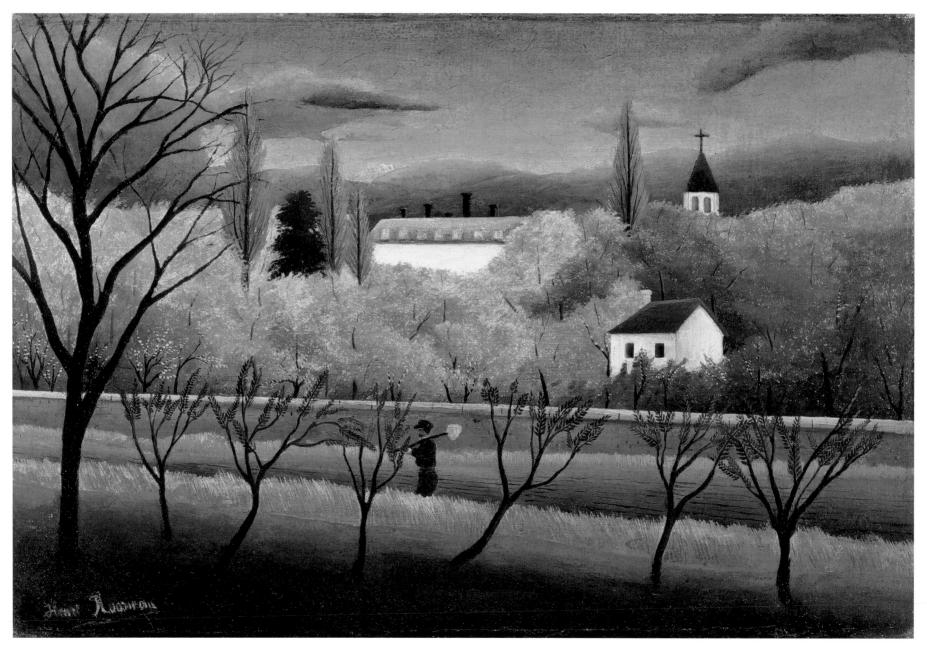

No.33
The Orchard
*c.*1896
Oil on canvas 38 x 56 cm
Harmo Museum, Nagano

No.34
Avenue in the Park
at Saint-Cloud
1908
Oil on canvas
46.2 x 37.6 cm
Städtische Galerie im
Städelschen Kunstinstitut,
Frankfurt am Main

No.35
The Banks of the Bièvre
near Bicêtre
1908
Oil on canvas 54.6 x 45.7 cm
Lent by The Metropolitan
Museum of Art. Gift of Marshall
Field, 1939

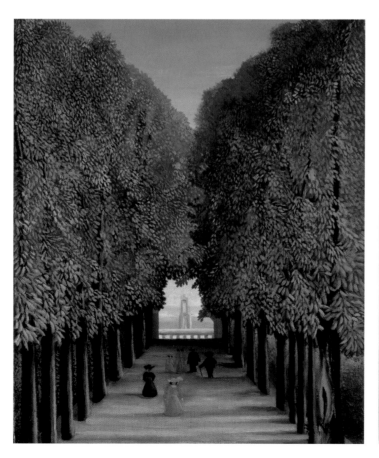
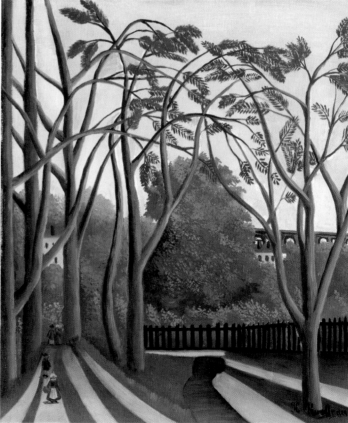

No.36
The Environs of Paris
1909
Oil on canvas 45 x 53.7 cm
Detroit Institute of Arts,
Bequest of Robert H. Tannahill

No.37
House on the Outskirts of Paris
c.1905
Oil on canvas 33 x 46.4 cm
Carnegie Museum of Art, Pittsburgh.
Acquired through the Generosity of
the Sarah Mellon Scaife Family, 1969

No.38
Banks of the Oise
1905
Oil on canvas 45.7 x 55.8 cm
Smith College Museum of Art,
Northampton, Massachusetts.
Purchased with the Drayton
Hillyer Fund

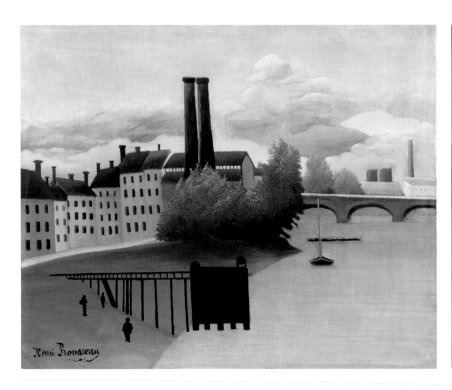

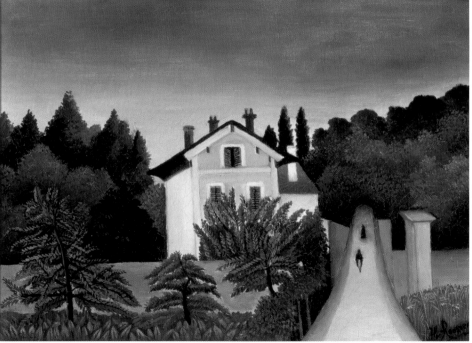

No.39
View from the Quai Henri IV
1909
Oil on canvas 32.7 x 41 cm
The Phillips Collection,
Washington, D.C.

No.40
Ivry Quay
c.1907
Oil on canvas 46 x 55 cm
Bridgestone Museum of Art,
Ishibashi Foundation, Tokyo

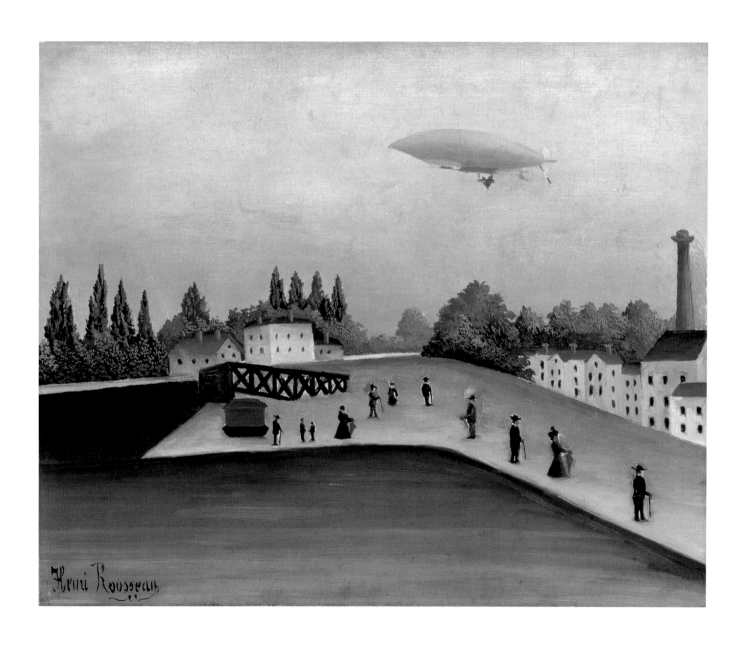

No.41
The Pont de Grenelle
c.1892
Oil on canvas 20.5 x 75 cm
Musée du Vieux-Château, Laval

No.42
View of Malakoff, Paris Region
1908
Oil on canvas 46 x 55 cm
Private Collection.
Courtesy Pieter Coray

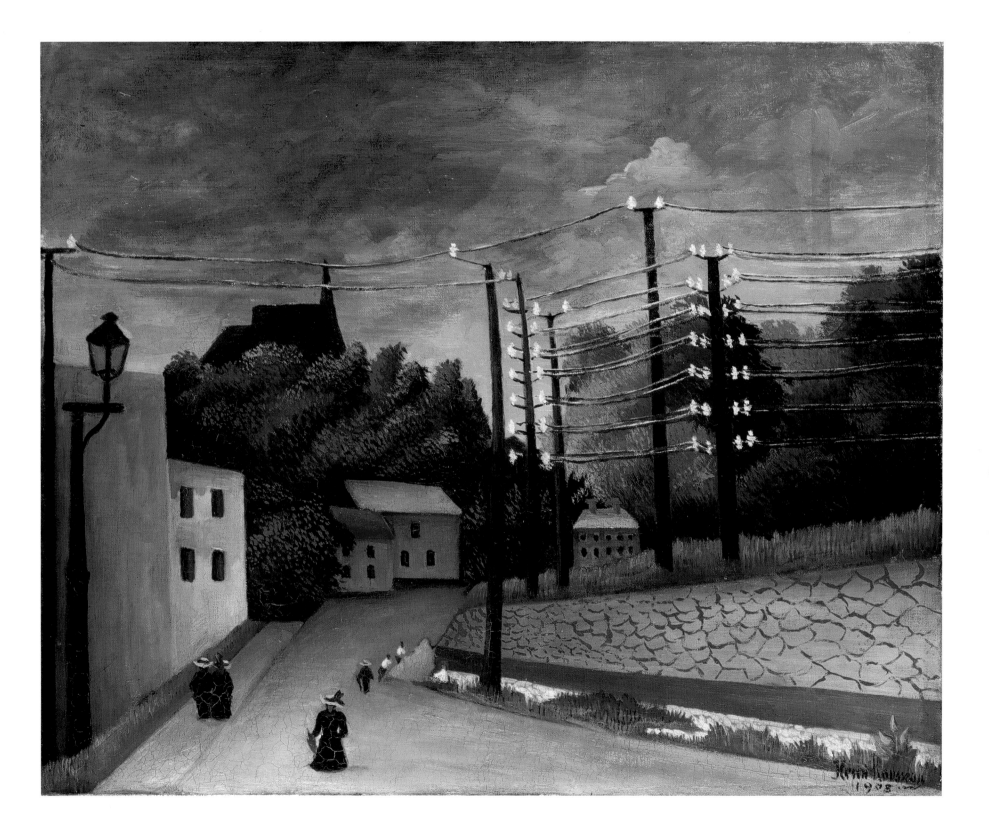

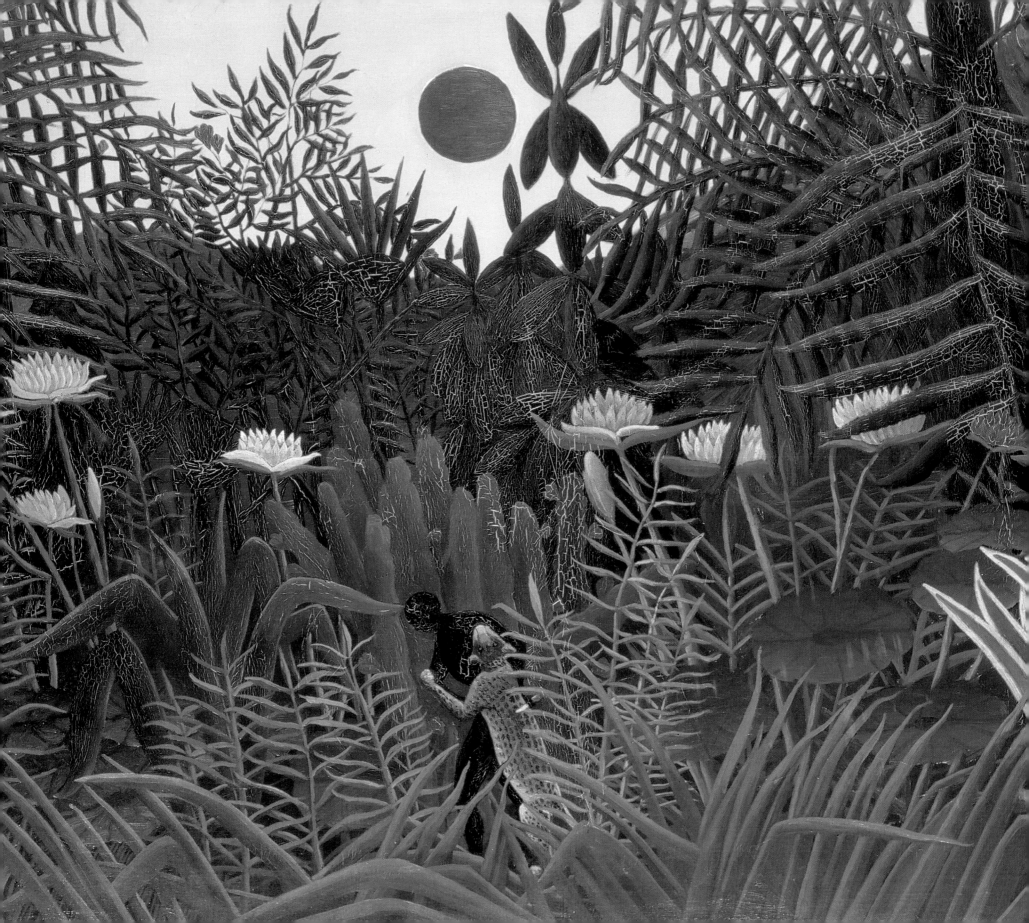

The Dangerous Exotic

Fig.91
Jungle with Setting Sun
*c.*1913
(Detail of no.46)

'I stayed, completely petrifed before your Surprise!
What fierce energy you have given your wild beast!'

M. Cotton[1]

Rousseau's first foray into painting the dangers of the jungle was isolated. He created his *Tiger in a Tropical Storm (Surprised!)* (no.43) in 1891, and several years would pass before he revisited such a theme. It is appropriate, then, that the animal he depicted in that work was itself a solitary creature. Caught in a heavy storm, a tiger prowls through the undergrowth, whipped by the wind. 'Cruel for the fun of it, ferocious, bloodthirsty… In the vast jungle, the tiger reigns as king!' described a contemporary admirer, in a poem addressed to the artist.[2] The painting also impressed one of his colleagues, a Mr. Cotton, who wrote a letter to the artist to that effect (quoted above). But if, for some, Rousseau's tiger presented a force to be reckoned with, the artist did not command a comparable respect from other quarters. 'From year to year Rousseau becomes more stupefying … The bodies accumulate before his entries and laughter rings out,' reported Félix Vallotton, painter and critic for the *Gazette de Lausanne*. 'He is a terrible neighbour: he squashes everything.' But the response was not entirely negative. The work was, Vallotton added, a 'must-see'. It was, he wrote, 'so disconcerting that, before so much competency and childish naivety, the most deeply rooted convictions are held up and questioned.' Some viewers laughed, but there were others whose approach was contemplative. This, the critic predicted, would increasingly be the case.[3]

However, if eventually admiration outweighed laughter before Rousseau's jungles, it would take longer than Vallotton might have thought. The artist would exhibit another animal combat scene, the now lost *Struggle for Life*, at the Salon des Indépendants in 1898 but, even seven years on, reactions to this new depiction of the dangers of the exotic were hardly complimentary. 'Henri Rousseau continues to express his visions on canvas,' wrote one commentator, 'in implausible jungles, grown from the depths of a lake of absinthe, he shows us the bloody battles of animals escaped from the wooden-horse-maker'.[4] It was yet another five years before the artist returned to the theme of wild beasts, when he exhibited his *Scouts Attacked by a Tiger* 1904 (fig.115), at the Indépendants. If reactions to Rousseau's canvases were still variable, on this occasion they were at least numerous. His work, even if only for comic reasons, now attracted a wide audience. As much was noted by the writer Furetières: 'In the midst of the hubbub, only a single utterance is heard: "Where are the Rousseaus?"' The painter, it seems, had finally captured the eye and imagination of the Paris public. 'In two or three exhibitions,' the report continued, 'he has become famous. Around his entries, there is a scrum, a flurry known only to masterpieces. To approach the picture you have to elbow your way through; to maintain a place you have a struggle on your hands.'[5] The success of this new combat scene surely persuaded Rousseau to create *The Hungry Lion* (no.49) to exhibit at the Salon d'Automne the following year. And his choice to do so, whatever the motivation, was astute. The committee accepted the canvas and consequently it took its place at the heart of the sensational *cage aux fauves* – alongside the works of Henri Matisse and André Derain – in a display that has since become the stuff of art-historical legend.

This exhibition would prove the most successful of Rousseau's career to date. The vociferous reception, together with the higher prices that such works attracted, no doubt informed his decision to continue to paint scenes of animal combat until his death in the autumn of 1910. Buyers were keen to secure them. Uhde even reported that one young collector wanted to take the canvas he had commissioned home fresh from the easel.[6] On at least one occasion, when an image proved particularly desirable, the artist went so far as to make a copy. Having shown his large-scale *Fight between a Tiger and a Buffalo* 1908 (fig.93) to some acclaim at the 1908 Indépendants, he made a small reproduction of the canvas (fig.92), which he then offered to Ambroise Vollard for purchase. The dealer brought the picture, though not at the elevated sum the artist proposed; a receipt shows that Rousseau received 190 francs for a consignment that included not only the small painting but also *Surprised!* and the *Jardin du Luxembourg* (no.32).[7]

But why did it take so long for Rousseau's Jungle works to gain critical acclaim? Why, when *Surprised!* had attracted so little attention in 1891, did 1905 see the renaissance of Rousseau's scenes of jungle violence? It is tempting to understand the phenomenon as a reflection not only of renewed interest in Gauguin (after his death in 1903), but also of changing attitudes towards colonial policy in France.[8] At the end of the nineteenth century, expansion had been controversial, but it had become relatively popular by the early years of the twentieth century. Exotic imagery proliferated: the

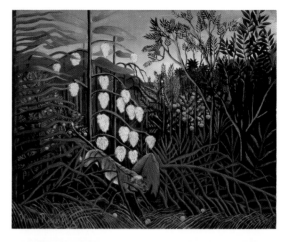

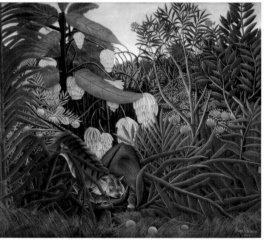

Fig.92
Jungle with Buffalo Attacked by a Tiger
1908
The State Hermitage Museum, St Petersburg

Fig.93
Fight Between a Tiger and a Buffalo
1908
(No.45)

illustrated press published gory scenes of explorers and tourists attacked by animals, while film 'transported' cinema-goers to distant 'French' shores. As this heady mixture of the real and the imagined filtered down to a popular audience, the jungle started to become entertainment, the dangers of the unknown a source of excitement. That atmosphere clearly infiltrated Rousseau's work. Some of his jungle combats, including *Tropical Landscape – An American Indian Struggling with a Gorilla* 1910 (fig.35) and *Jungle with Setting Sun c.*1910 (no.46), borrowed directly from the kind of imagery that appeared in *Le Petit Journal*. Hence these canvases had precedents: *Tiger Hunt c.*1895 (no.44) appears to have its source in an 'academic' engraving reproduced in a popular magazine (see p.186),[9] while certain other images quoted from the stuffed animal displays of the Muséum. A collective fantasy of the unknown informed Rousseau's jungles and, in turn, they contributed to that phenomenon.

But specific developments within the art world, in addition to these broader cultural changes, also affected Rousseau's reception. It was not so much content, after all, that had made Rousseau's work controversial. By 1889 Frémiet's *Gorilla* (fig.26), a more shocking portrayal of the 'dangerous exotic' than any image by Le Douanier, was perfectly acceptable. Critics found fault instead with form, or technique, in Rousseau's painting. If these vibrant jungle confrontations went largely uncelebrated until 1905, it was because their appreciation required a change in attitude towards the artist's plastic abilities, an acceptance of alternative methods of artistic expression.

What was so different about Rousseau's way of painting? Robert Delaunay, who had often watched the artist at work, described the particularities of his approach. When Rousseau created an exotic landscape, Delaunay explained, 'all is thought out, premeditated: just a few lines high up to indicate the mass of the palms or other species of plants from hot countries, some other lines for the foregrounds'.[10] Rousseau painted his images in blocks, rather like painting by numbers, completing one section before embarking upon the next. Delaunay likened this method to 'that of the ancient craftsmen, those whose paintings covered the walls of palaces, convents and churches, the illuminators who left not one detail to chance'.[11] These observations are pertinent because they point to another reason for the new popularity that Rousseau found in 1905. If there was a fresh interest in the Douanier's Jungle scenes, equally, the kinds of culture with which they could be associated were also gaining credence from artists and critics.

Many writers had, as this catalogue shows, already likened Rousseau's landscapes and allegories to 'popular' imagery. Now the subject matter of his Jungle scenes extended that comparison to the work of artists quite unlike those who exhibited beside him in the Salons. Indeed most critics, with very few exceptions, chose to discuss Rousseau's scenes of jungle combat by relating them to work produced outside of conventional artistic canons. Now Rousseau's art was not just like illustration or Folk art; it was akin to that of non-Western peoples. In other examples, the connection extended to compare Rousseau's painting with the creative products of prehistoric man, children, or even the mentally ill. There had been some hint of this in 1891, for at that point, one writer had

likened *Surprised!* to a Japanese tapestry.[12] But by 1905, and the showing of *The Hungry Lion*, such associations were common. Writing for *Le Gaulois*, the critic de Fourcard noted that the theme of *The Hungry Lion* was an old Oriental one.[13] Just one day later Camille Le Senne wrote a comparable commentary on the picture for *Événement*: 'Room Two contains a bizarre entry that holds the ground somewhere between a terracotta figurine and a fresco,' he mused. 'A cursory lion devours a rudimentary antelope in a quasi-prehistoric landscape.'[14] Another critic likened the work to 'a coloured enlargement of a wood engraving, [an] illustration for an old German Bible',[15] while yet another observed how, had this work been of Persian or Indian origin, it would have cost a fortune.[16]

Rousseau was aware of the reactions his work solicited; he must have known that, to some extent, these archaic associations were positive. After the 1908 Indépendants, where he showed *Fight between a Tiger and a Buffalo*, he wrote to his friend Max Weber about how visitors to the show were 'all agreed that I am certainly a modern primitive'.[17] The diagnosis evidently pleased the artist, though it is hard to know on quite what terms. 'Primitive' was, at that moment, a term that held yet more connotations than Rousseau's art drew. At the beginning of the twentieth century, it applied to Italian artists of the thirteenth to fifteenth centuries, as well as to African and Oceanic art or 'Outsider' art. But the references that Rousseau's critics made when discussing his animal combats, those comments about the art of Japan or cave-painting, are interesting, for they suggest that his success coincided with a growing interest in these 'other' types of art. It is hardly surprising that one of Rousseau's first dealers, Joseph Brummer, made his reputation selling and collecting African sculpture. The first work by the artist that came to his attention, thanks to their mutual friend Weber, was *Fight between a Tiger and a Buffalo*.[18] It was as if, as André Salmon claimed with anarchistic relish in 1927, the artist's success would be 'the sum of living art, coinciding expressively with the new recognition given to African and Polynesian art. A wall breaks down and the ethnographic museum is annexed to the museum of comparative sculpture.'[19]

There was something radical about appreciating Rousseau: something, no doubt, that was all the more easily expressed with reference to his brutal exotic imagery. A painting such as *Horse Attacked by a Jaguar* 1910 (fig.94) makes the confrontational aspect of his work the more evident. Though an established theme, reaching back as far as Eugène Delacroix and Peter Paul Rubens, its content – a 'Western' horse attacked by an 'exotic' tiger – could act as a metaphor for the way in which Rousseau's art challenged convention. For the implications of his technique were, potentially, unsettling in the extreme. Delaunay described their significance as follows: 'Before a Rousseau the senses are gripped with such an emotion that they sometimes abandon the desire to control the working process.'[20] Ordered analysis becomes useless; intuition is everything.

Rousseau's paintings thus offered a return to all that was instinctive and pure, an idea that was best articulated with reference to his violent Jungle scenes. But the need for that conjunction shows the unease and trepidation of this moment in Modernism. If Rousseau's works were dangerous agents of change, to some viewers, the artist himself

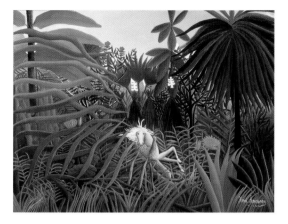

Fig.94
Horse Attacked by a Jaguar
1910
(No.47)

seemed equally threatening. Even a supporter of Rousseau, Arsène Alexandre, would note the potential dangers of admiring the artist's scenes of animal combat. In 1909 he suggested that Rousseau's works might 'exercise a dangerous fascination upon our spirits' and that, had his intentions been calculated, he would have been quite dangerous.[21] The effects of Rousseau's animal combats had thus extended to readings of the artist himself, which sometimes caused critics to describe him as an artist unlike any from the conventional worlds of art. In such a way, in 1911, *The Snake Charmer* was used to illustrate an article in *La Vie Mystérieuse* that suggested Rousseau had occult powers (see fig.126).[22] It is impossible to know whether, as the author of the piece argued, that canvas revealed the artist to possess supernatural abilities. But one thing was evident, something that his images of the 'dangerous exotic' had made clearer still: undoubtedly, there was something extraordinary about this man and his work.

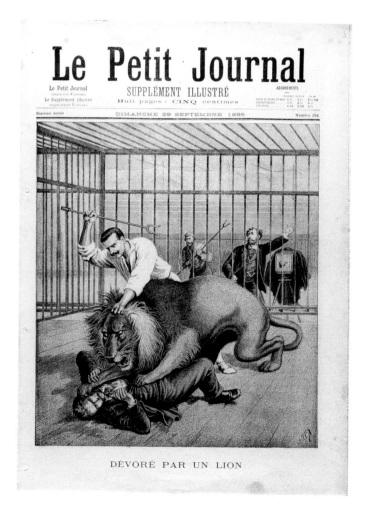

Fig.95
'Devoured by a Lion', *Le Petit Journal*,
29 Sept. 1895

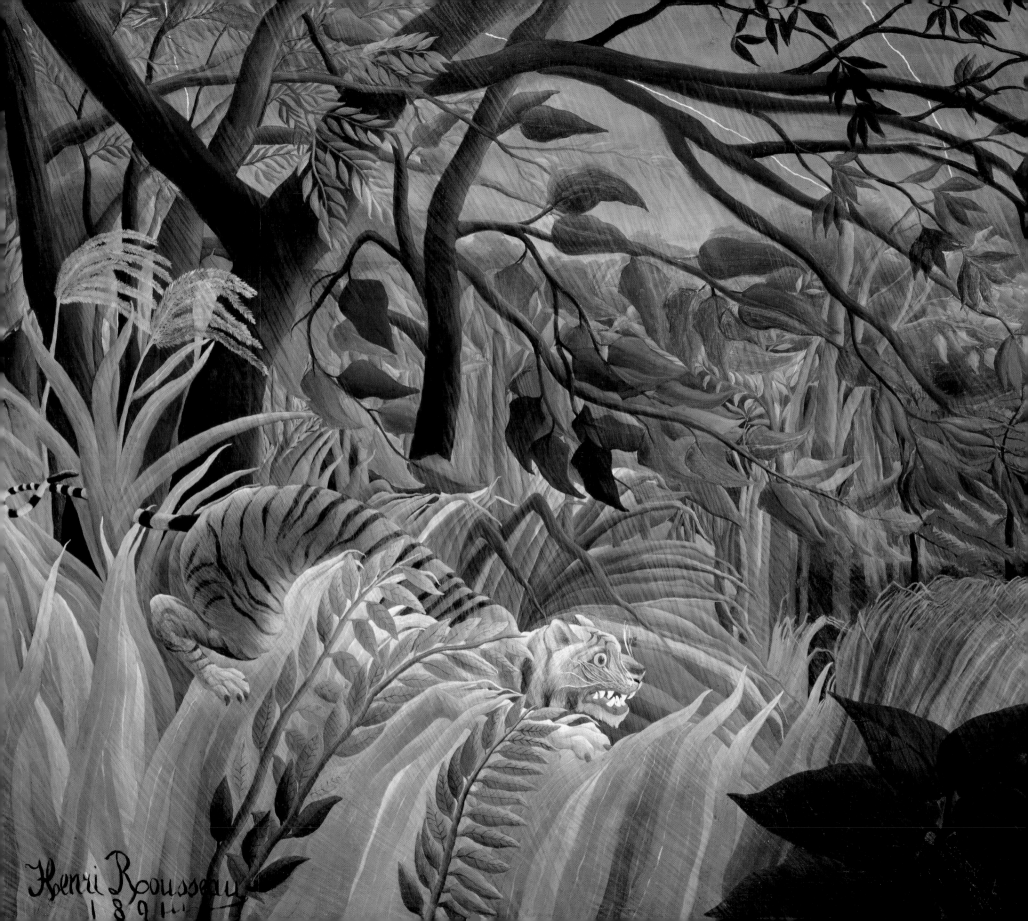

No.43
Tiger in a Tropical Storm (Surprised!)
1891
Oil on canvas 129.8 x 161.9 cm
The National Gallery, London

No.44
Tiger Hunt
c.1895
Oil on canvas 38.1 x 46 cm
Columbus Museum of Art,
Ohio. Gift of Ferdinand Howald

No.45
Fight between a Tiger and a Buffalo
1908
Oil on fabric 170 x 189.5 cm
The Cleveland Museum of Art.
Gift of the Hanna Fund

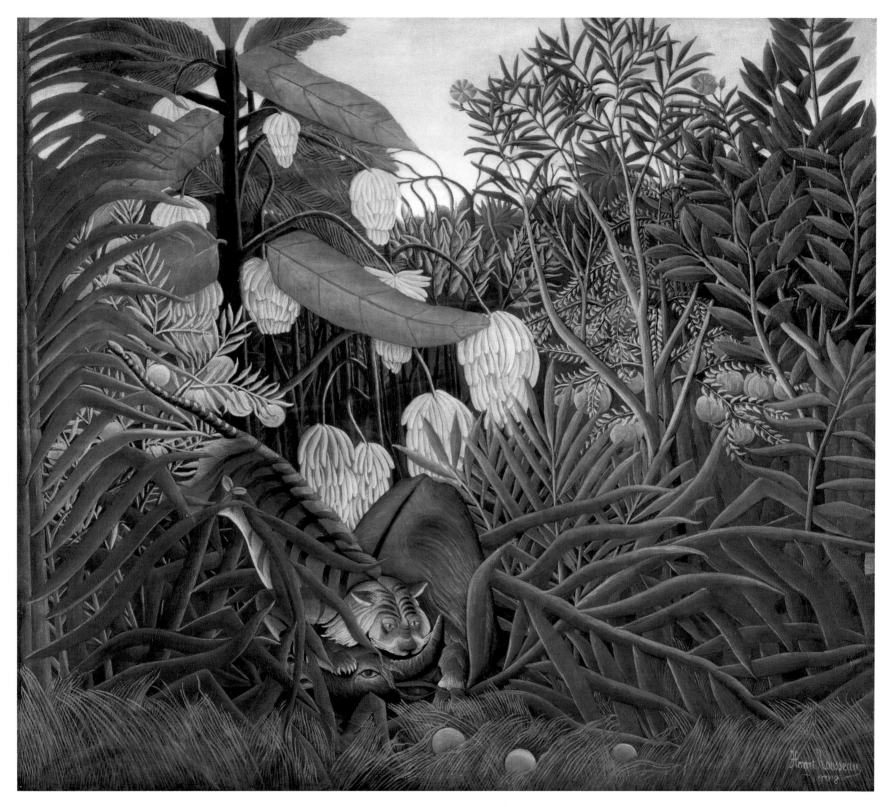

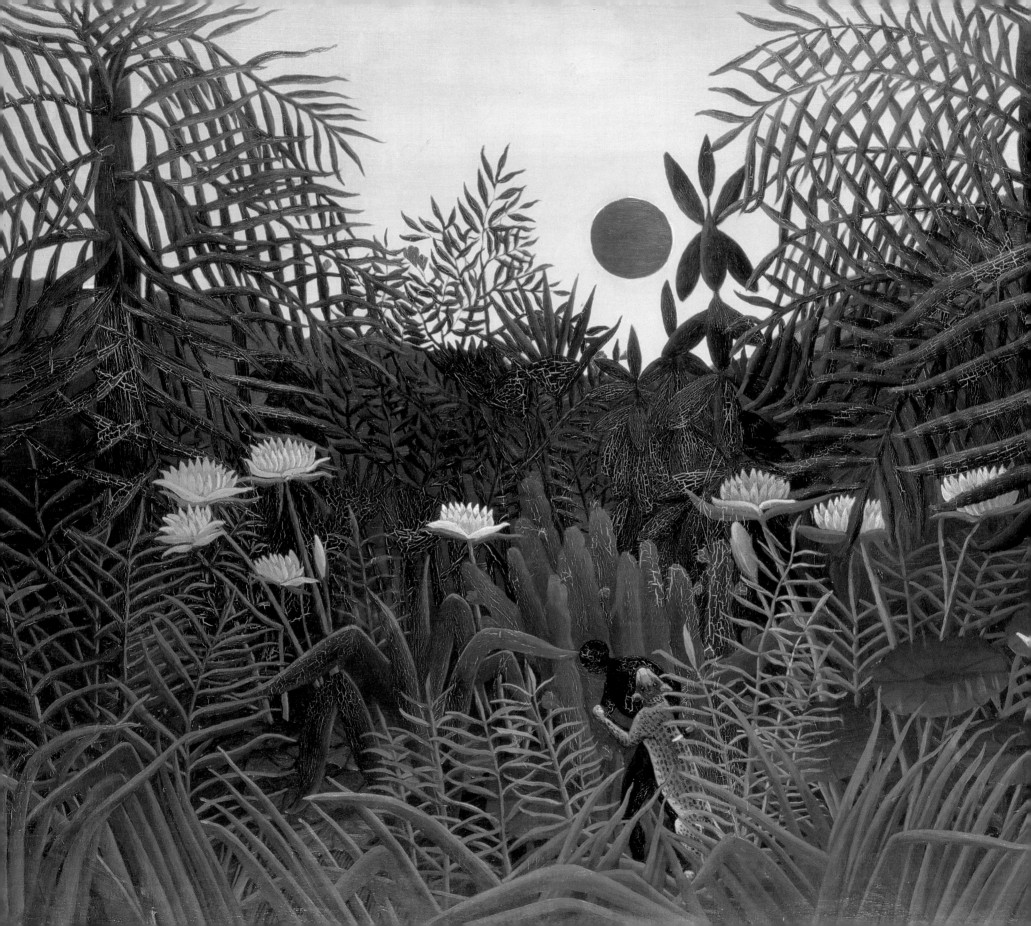

No.46
Jungle with Setting Sun
*c.*1910
Oil on canvas 114 x 162.5 cm
Öffentliche Kunstsammlung
Basel, Kunstmuseum

No.47
Horse Attacked by a Jaguar
1910
Oil on canvas 89 x 116 cm
The State Pushkin Museum of
Fine Arts, Moscow

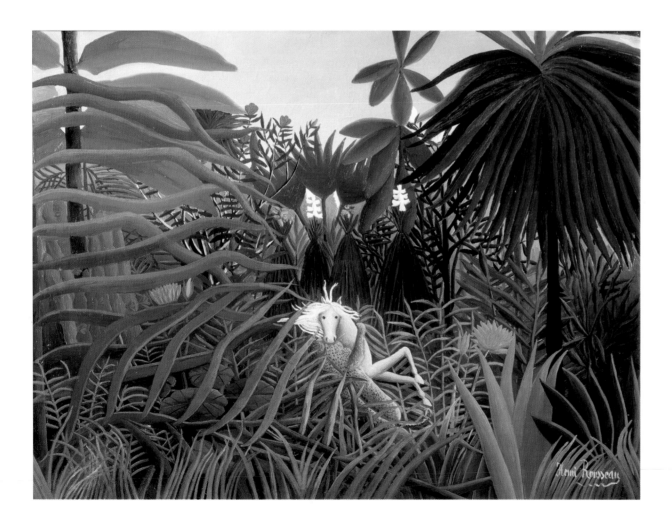

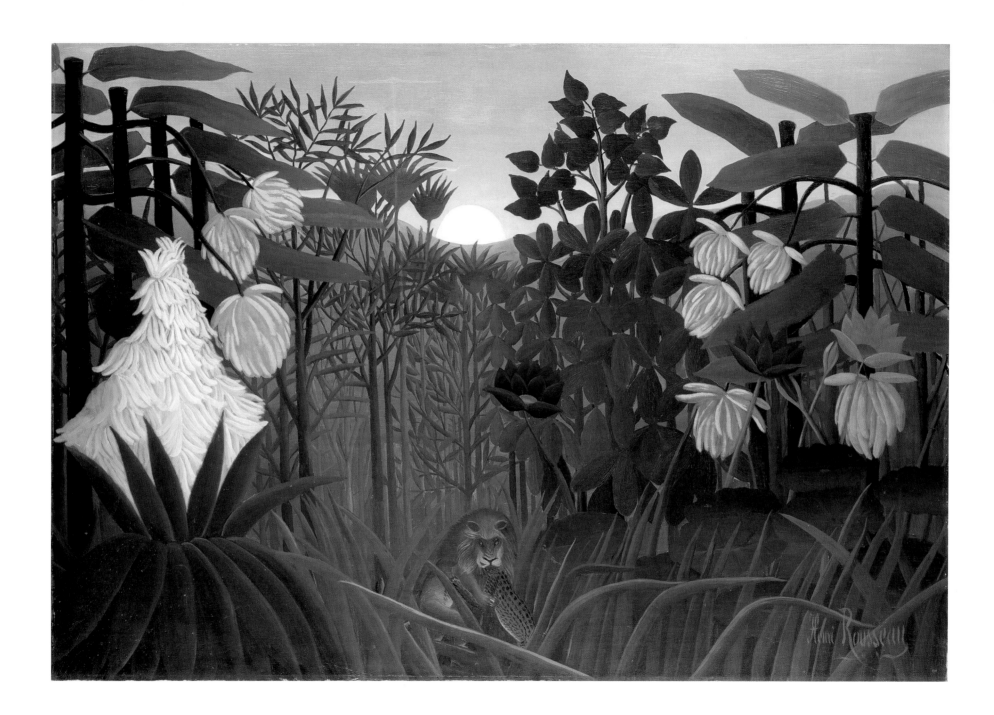

No.48
The Repast of the Lion
*c.*1907
Oil on canvas 113.7 x 160 cm
Lent by The Metropolitan
Museum of Art. Bequest of
Sam A. Lewisohn, 1951

No.49
*The Hungry Lion Throws
itself on the Antelope*
1905
Oil on canvas 200 x 301 cm
Fondation Beyeler, Riehen/Basel

'The hungry lion throws itself upon the antelope,
devours him; anxiously the panther awaits the
moment that he too can claim his share. Birds
of prey have torn a strip of flesh from the poor
animal that is shedding a tear! The sun sets'

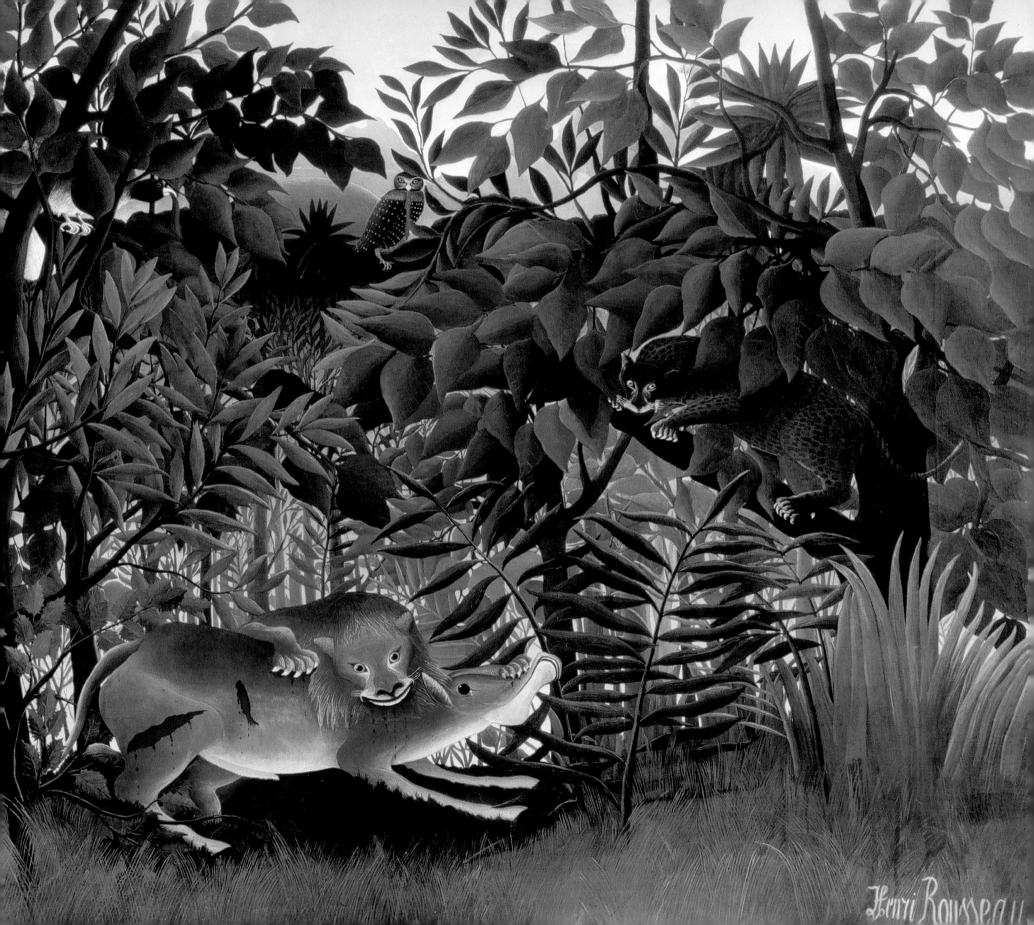

Henri Rousseau

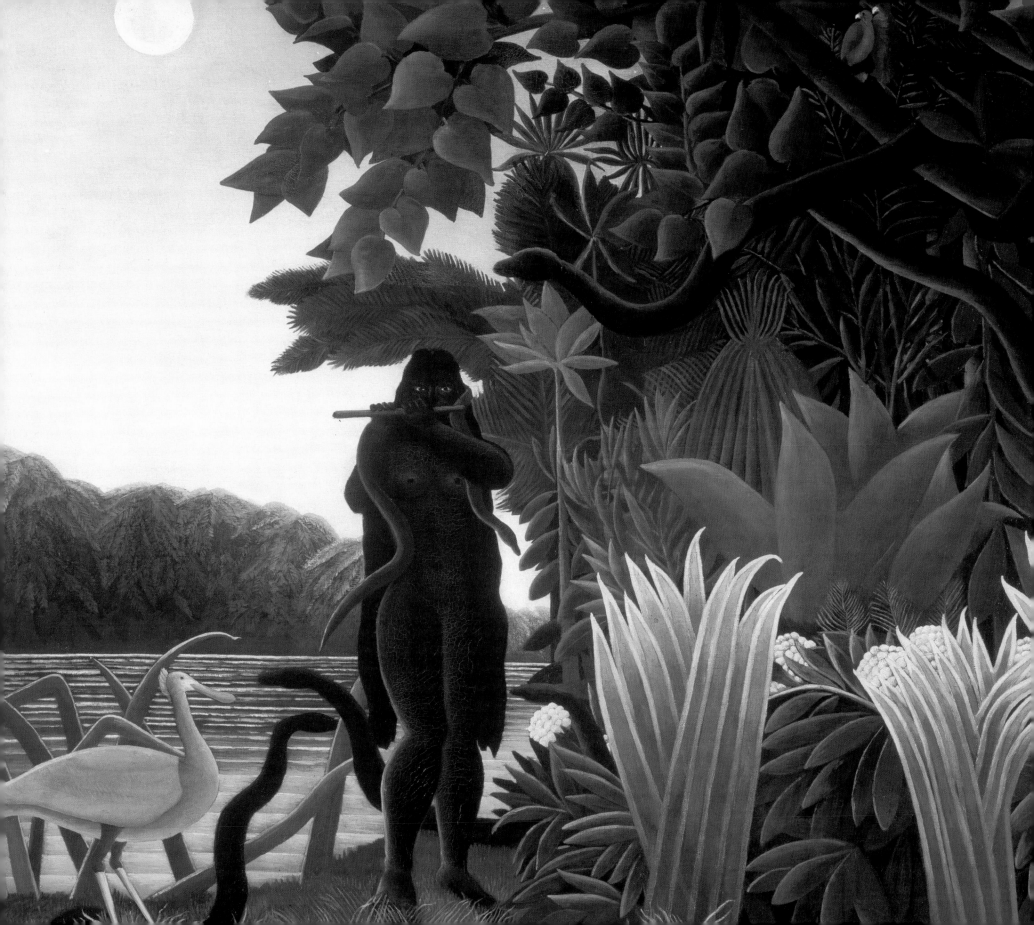

Mysterious Meetings

'And so one comes to ask oneself: what does this meeting of heterogeneous things mean, which cry out at being together?'

Ardengo Soffici[1]

Such were the reflections of the Italian Futurist Ardengo Soffici upon seeing *The Dream* (no.50) exhibited in the Salon des Indépendants in the spring of 1910. He was not the only one to be confused. This was hardly surprising: the sizeable canvas was quite unlike anything else that the Salon had to offer. 'Henri Rousseau, former customs man turned notorious and much-mocked artist, presents us with a *Dream* which is, in brief, a decorative landscape: but why, among these exotic plants, painted with a curious sense of volume, why this ugly naked woman on a velvet sofa in a style so terribly 1830?', asked *Le Petit Journal*.[2] In the newspaper *Le Gil Blas*, Louis Vauxcelles enquired whether Rousseau had been wrong to include such a strange figure in an otherwise coherent composition,[3] while elsewhere others searched in vain to classify the image. In this composition, explained a writer for *Le Démocratie Sociale*, 'there is neither modern trend, nor academic convention'.[4] Accordingly, though it drew comparisons with Ingres or with Persian tapestries,[5] it was impossible for viewers to place the work in any one particular 'category'.

The Dream was also rather different from the images that Rousseau had produced previously. Here was a statuesque European nude, surrounded by a dark jungle landscape, reclining on a red settee. In the centre of the image stands a pipe-player; wild animals

encroach from all sides. The image is, of course, one that has similarities with Rousseau's scenes of jungle combat and his idyllic exotic landscapes; but clearly it is neither. Here more than anywhere else in the artist's oeuvre, human and animal, real and fantastic, French and 'foreign', meet and share a picture plane. But in this imposing image the implications of those unions are more ambiguous than ever, leaving the viewer to draw conclusions of his or her own. Notably, Rousseau did not impose a reading on visitors to the Salon, even if he exhibited the work with a poem, because 'People don't always understand what they see'.[6] In that verse, which identifies the woman as Yadigwha, the artist explained how her dream has transported her to the forest. But besides that information, the lines are purely descriptive, giving no indication of her feelings or reactions. The look on her carefully painted face is similarly impenetrable. Does the lulling music relax or excite? Does the jungle scare her, with its disconcerting population, or does she find peace in an other-worldly paradise? The woman's dream, in brief, might prompt a range of emotional responses as startling and contradictory as the various pictorial motifs that the painting incorporated.

As *The Dream* illustrates, if Rousseau's images were curious, none were more so than those that combined the distinguishing features of his work. This is an extraordinary image because here the idiosyncrasies of his art accumulate: illogical perspective, a collage-like composition, allegory, tropical fauna... the result is the strangest of compositions. If this makes for an image that is visually exciting it is, simultaneously, quite baffling. Audiences found, and continue to find, the picture hard to interpret. Nevertheless, as Rousseau's paintings began to incite praise as often as perplexity, such canvases were soon heralded as his seminal works. The other dominant example, *The Snake Charmer* (no.51), was the first Rousseau to enter the Louvre and reside alongside the paintings of the great masters.[7]

Such a move, however, took time. The bequest did not take place until 1925, some fifteen years after the death of the painter, while the installation happened later still.[8] Meanwhile, when *The Snake Charmer* first appeared at the 1907 Salon d'Automne, it went virtually unnoticed by the press. But, even at this early stage, the young avant-garde painters were quick to see its merits. Rousseau was pleased to show his work alongside theirs and, at the time of that exhibition, both Uhde and Max Weber first met Le Douanier.

According to Sonia Delaunay-Terk, Rousseau received the commission for *The Snake Charmer* from her mother-in-law, the socialite Berthe Delaunay, renowned for her penchant for travelling. It was apparently stories of her voyage to the West Indies that provided inspiration for the image.[9] Even so, it would be difficult to connect this mysterious figure and the eerie landscape beyond identifiable physiognomic or geographic types. But if avant-garde viewers were reluctant to attempt such an exercise for themselves it was because, to them, that information was somewhat irrelevant. What mattered here was the other-worldliness of Rousseau's picture: its strangeness and its significance to their own artistic agendas. Here was something both old and new; it paved the way for creative experiment. Hence, even if the theme of the snake-charmer had appeared elsewhere, its articulation in this puzzling image, with an unusually limited palette, was none the less remarkable. Rousseau had collected a cover of April 1909 from *Le Petit Journal* showing

Fig. 97
'The Painter and the Boa',
Le Petit Journal, 18 April 1909

The Painter and the Boa (fig.97) and, in 1902, Georges Méliès had made his film *The Brahmin and the Butterfly* (fig.98). But these are quite different in appearance. In *The Snake Charmer* the impression is not comical but strange. The silhouette of the black nude stands out against the twilight backdrop. Not only snakes, but also a curious *Platalea* with a spatula shaped beak, heed the call of the music she plays. The image is supremely atmospheric. 'Like children who like to scare themselves,' wrote Philippe Soupault, 'Le Douanier could not help but paint the mysterious solitude of the forests... there one sees the sound of the branches, the scent of the grass, the freshness of the undergrowth. An invisible shiver seems to run through the veins of the trees.'[10]

After Rousseau's death, *The Snake Charmer* would quickly gain cult status. The first author to reproduce the canvas was Uhde, in his monograph on the artist, which created an image of Rousseau as a 'visionary' painter. Perhaps given this reading, it was only appropriate that the German dealer was the owner of *Eve c.*1906–7 (fig.99), an image that supported that idea. Here Rousseau adopted an age-old biblical theme, that of Humanity's fall from grace in the Garden of Eden. The motif may even relate to a print he kept in his studio (fig.100). Even so, being set in an exotic jungle and featuring apples that look more like oranges, *Eve* was far from conventional. But, as had been the case with Rousseau's

Fig.98
Georges Méliès, still from
the film *The Brahmin and
the Butterfly*, 1902

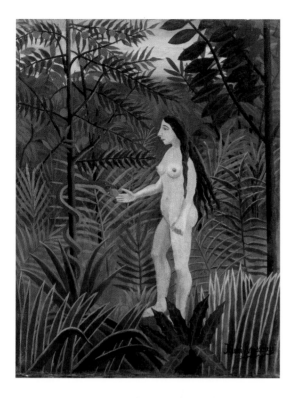

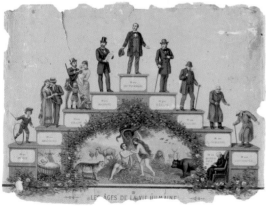

Fig.99
Eve c.1906–7
(No.52)

Fig.100
The Ages of Man
Musée du Vieux-
Château, Laval

allegories, this engagement with a recognisable, pre-existing genre, emphasised his original approach. Indeed, this theme had an added advantage in that, unlike those works, it was not Republican. Thus it could appear as something timeless and profound, as something beyond the constrictions of everyday realities. If, to some viewers, it seemed that Rousseau's art proposed a return to innocence, then this image was entirely appropriate. The subject was already one that the Nabis, led by Gauguin, had used, in rejecting artistic convention, looking to Breton and non-Western culture for artistic renewal. Rousseau now offered a combination of both precedents. In *The Cubist Painters*, the poet Guillaume Apollinaire described the artist as the 'Angel of Plaisance' and explained how, 'this Breton, long-time resident of the Paris suburbs, is undoubtedly the strangest, most audacious and most charming painter of exoticism'. The image he used as evidence? It was, of course, *The Snake Charmer*.[11]

In *Eve*, as he did so often, Rousseau truncated the extended action of the scene into a single moment. The snake has not only told the woman to eat the fruit; she takes it from its gaping fangs. Already, the forlorn look on her face anticipates the grave consequences of her dalliance, played out before a fierce red sunset. However, although the image is expectant, it embodies the moment just before its protagonist makes a decisive, and incorrect, choice. At a time when a new generation, in the words of Robert Delaunay, 'struggled against their sensibility, against their education, to liberate themselves before rediscovering the elements of simple tradition', that idea of a return must have been enormously appealing.[12] The avant garde was imbued with nostalgia for a 'paradise lost' and, as the critic Waldemar George put it, 'Rousseau came at the right moment. Born fifty years earlier he would have gone, undoubtedly, unnoticed. Appearing in and making himself known to an age that had lost faith in classical canons, to an age saturated with theoretical and experimental research, his work fulfilled a desire and offered instruction.'[13]

So if, in the early twentieth century, young painters set about rethinking artistic practice with a quasi-religious fervour, it was only natural that the works of the 'Angel of Plaisance' should assume considerable importance. This move, arguably, began in earnest with the 1910 exhibition of *The Dream*. There, gradually, not only painters but also critics had begun to contemplate the mystery of Rousseau's canvas with reverence. 'One has to laugh, for this sofa and this woman are ridiculous,' wrote one,

But, I beg you, do not laugh at the setting, do not laugh at the lions, at the elephant, the birds; do not laugh at the trees, the plants, the flowers; do not laugh at the black Orpheus who plays the flute, so chaste in his multicoloured loincloth. No, do not laugh: only smile, and look; and having seen properly, you will have the right to truly believe that M. Rousseau can offer all of the painters here an admirable lesson in sincerity and loyalty.[14]

But first, to learn that lesson, viewers had to embrace Rousseau and his painting. 'We must learn not to resist him', concluded André Salmon, 'We must learn to take full pleasure in this deeply delicious art'.[15]

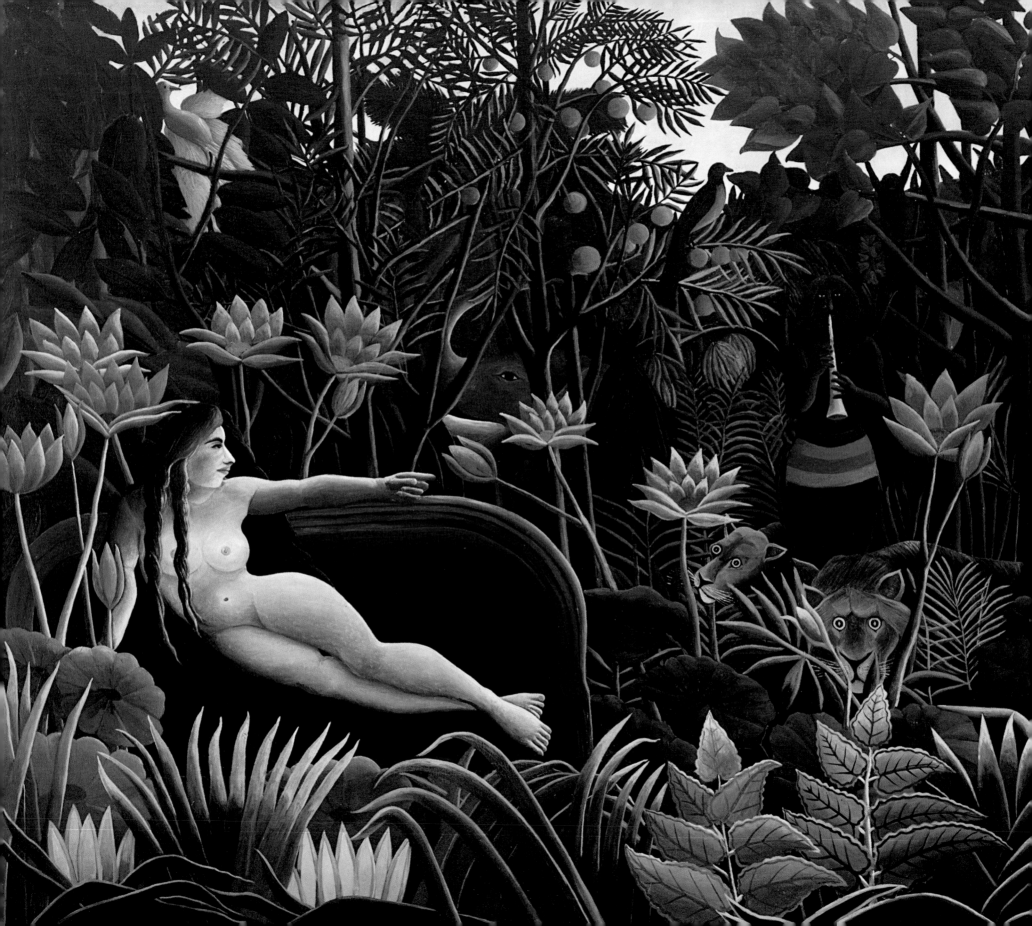

No.50
The Dream
1910
Oil on canvas 204.5 x 298.5 cm
The Museum of Modern Art,
New York. Gift of Nelson
A. Rockefeller

'Yadwigha, in a beautiful dream
Having fallen asleep softly,
Heard the sound of a musette
Played by a kindly charmer.
While the moon shone down
Upon the flowers, upon the verdant trees
The wild serpents lent their ear
To the merry tunes of the instrument'

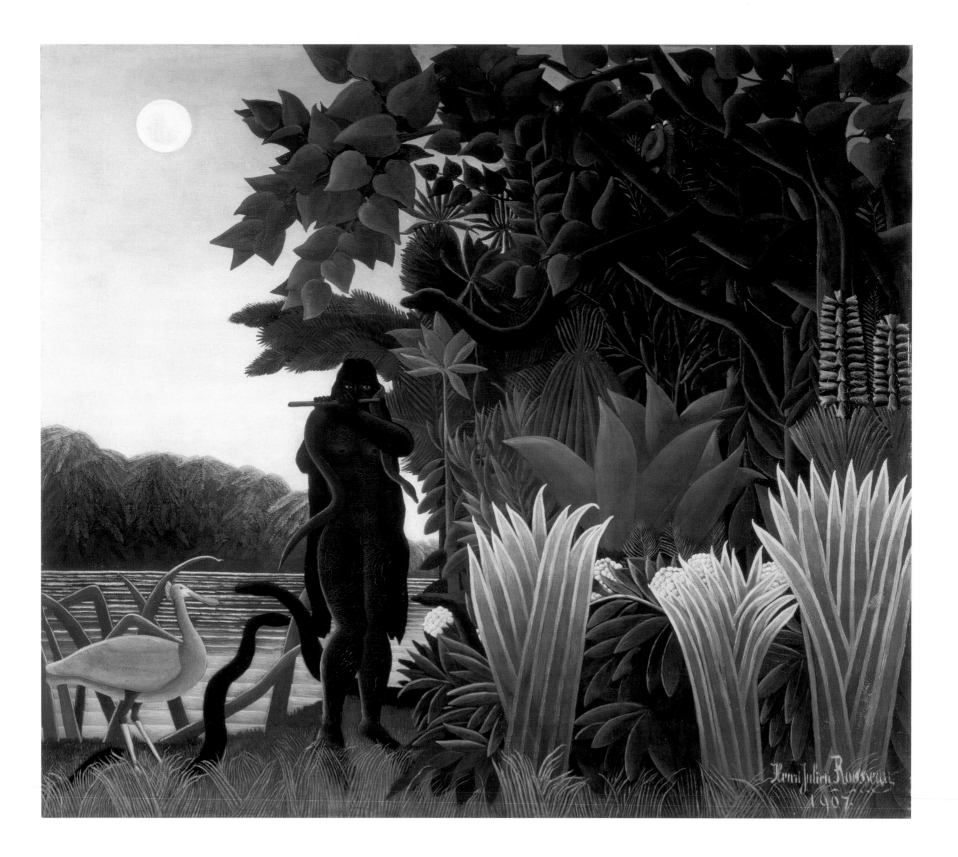

No.51
The Snake Charmer
1907
Oil on canvas 169 x 189.5 cm
Musée d'Orsay, Paris. Bequest
of Jacques Doucet, 1936

No.52
Eve
c.1906–7
Oil on canvas 61 x 46 cm
Hamburger Kunsthalle. Gift of
the Stiftung zur Förderung der
Hamburgischen

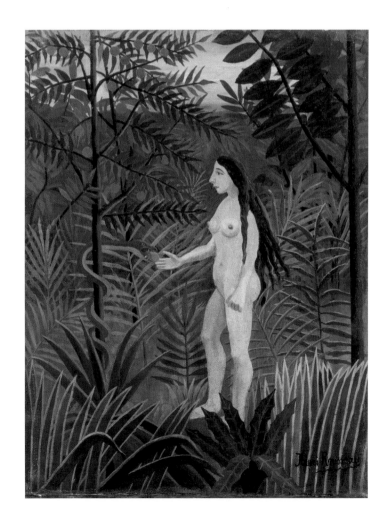

Essays
Claire Frèches-Thory
John House
Pascal Rousseau

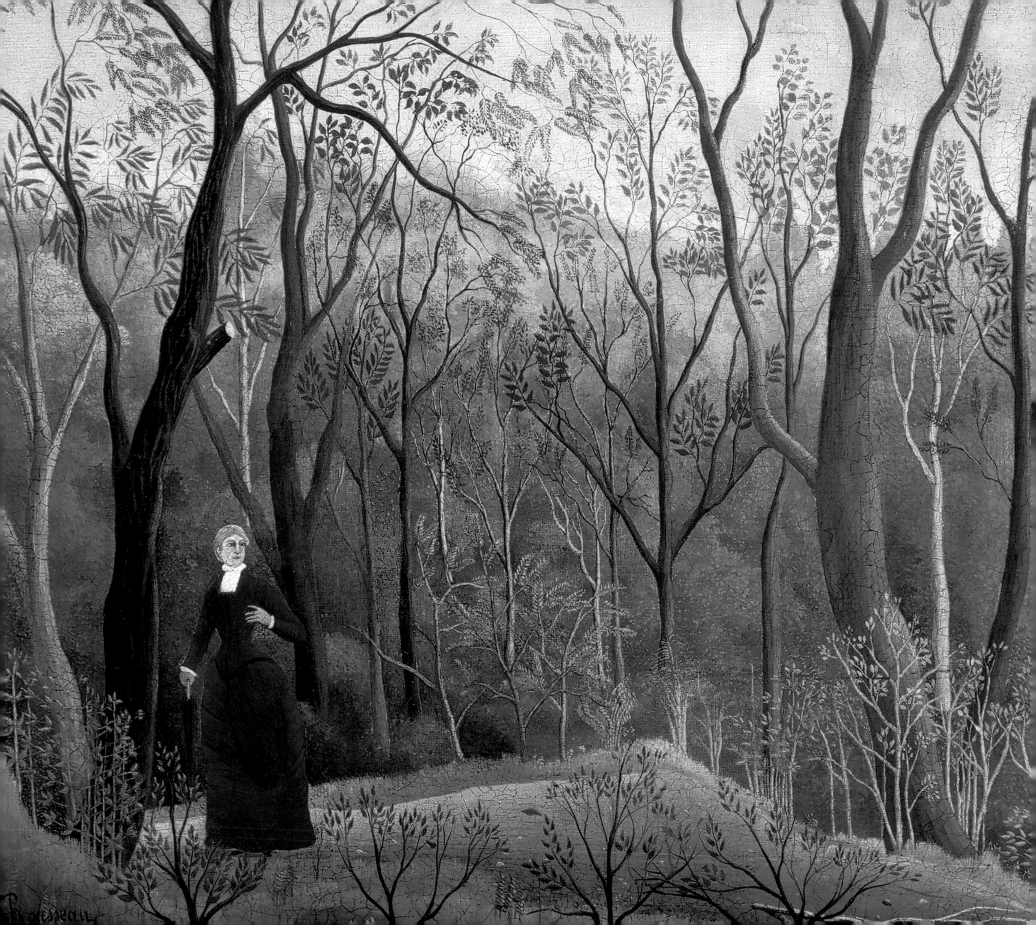

From Sarcasm to Canonisation: Critical Fortune
Claire Frèches-Thory

Fig. 101
Promenade in the Forest
c.1886
(Detail of no.16)

'Mr Henri Rousseau creates monstrosities that make people smile.'[1]

'When the history of art of this era is written, Henri Rousseau's name will appear on the first page.'[2]

Around fifteen years separate these two evaluations of Rousseau's art, which gives some idea of the critical shift regarding its reception. Few artists were so derided in their lifetime as Rousseau, the former customs officer who became a painter late in life. Nowadays, his work can be found in the most important museums and prestigious collections but from 1886 to 1910, with the exception of the years 1899 and 1900, his entries to the Salon des Indépendants provoked harsh criticism or, at best, general indifference. Critics, more accustomed to the taste of the official Salon and thus ill prepared to appreciate his baffling paintings, would respond to his work with scornful, even abusive, remarks. The artist, who dreamed of equalling the famous academic painter William Bouguereau, was attacked for his amateurism, his lack of skill and technique; a naivety, in brief, that tended to elicit general amusement among exhibition visitors.

Backed by an unshakeable self-confidence, however, Rousseau continued to work independently and in a style that, from the beginning, was very much his own. Self taught, free from the burden of academia, and eschewing membership of any artistic movement of his time, in 1895 he respected only the lessons of nature and of the painters Jean-Léon Gérôme and Félix-Auguste Clément.[3] As Götz Adriani has rightly observed, during his trial for fraud in 1907, fearing that he would be found guilty, Rousseau did nothing less than to align himself with art and with France.[4]

Rousseau's passage towards acceptance was helped by the fact that he received support from an insightful fringe of the artistic and literary avant-garde, first from the writer Alfred Jarry, and shortly afterwards from the poet and critic Guillaume Apollinaire and the artists Pablo Picasso, Wassily Kandinsky and Robert Delaunay. It is no small paradox that a customs official, who turned to painting late in life, should have won the support of these distinguished pioneers of twentieth-century art; his tomb (fig. 102), transferred in 1947 to the Jardin de la Perrine in his modest birthplace of Laval, bears witness to this fact. He had died, destitute, on 2 September 1910, and was given a bleak funeral in the

Fig.102
Henri Rousseau's
tomb in the Jardin
de la Perrine, Laval

fosse commune. Delaunay and Picasso later provided him with a decent tomb, buying a thirty-year concession on the site. Apollinaire wrote the now-famous epitaph, which the sculptor Constantin Brancusi engraved on the stone.[5]

From the first positive reviews at the Salon des Indépendants in his lifetime, to a posthumous success marked by major exhibitions in France and abroad; from important acquisitions of his work by leading museums and collectors, to innumerable publications, the present exhibition adds a new chapter to the story charted by this essay: that of Rousseau's progression from vilification to 'canonisation'.

Echoes of the Indépendants

In 1886, notable as the year that saw the last Impressionist exhibition and the debut of Georges Seurat's *Grande Jatte*, Rousseau sent four paintings to the Salon, including his poetic work *Carnival Evening* (fig. 103). His remarkable handling of the canvas and its astonishing evocative power completely escaped the critic de la Brière, who wrote in *Le Soleil* on 20 August 1886: 'A black man and a black woman, in fancy dress, are lost in a zinc forest, under a round and brightly shining moon that illuminates

nothing, while stuck on to the black sky is the strangest of constellations, consisting of a blue cone and a pink cone.'

Into one of the notebooks in which he conscientiously collected all his press cuttings,[6] Rousseau pasted the following review of his masterpiece *Myself, Portrait-Landscape* 1890 (no.2), which appeared in *Le XIXe Siècle*: 'The *Portrait de M. Rousseau par lui-même*, for example, is of an exquisite naivety. The artist, no doubt due to excessive modesty, has painted himself dwarf-height, with an oversized head, perhaps weighed down by thoughts... any comment would be cruel and unnecessary.'

In *Le Petit Caporal* of 24 March 1897, another critic wrote of *The Sleeping Gypsy* (fig.30), exhibited at the Salon des Indépendants that same year:

> I cannot help feeling a mild delight at the imperturbable artistic innocence of Mr Rousseau... This feline, which the author tries to render ferocious, is petrified in a substance that defies analysis. Is it cardboard, glass, concrete? I could not decide, but his mane, styled with curling tongs, is miraculous. As for the black woman, the object of the animal's desire, wrapped in an accordion, she is simply exquisite.[7]

Rousseau Acknowledged by his Peers

While these examples of sarcastic incomprehension before Rousseau's work are plentiful, it is important to temper them with accounts left by some of his artistic contemporaries, who counted among the precious few who appreciated his work. In 1886, for example, Camille Pissarro was especially sensitive to the 'precision of... values and the richness of tones' in *Carnival Evening*,[8] a flattering comment from this patriarch of Impressionism, himself on the eve of his Divisionist experience. This high regard for the colour in Rousseau's works, one of the key qualities of his paintings, was also expressed by Pierre Puvis de Chavannes, twenty years his senior, and by Le Douanier's exact contemporary, Paul Gauguin. At a time when Georges Seurat and his followers were making headlines at the Salon du Champ de Mars, Puvis de Chavannes said to him: 'Monsieur Rousseau, I do not care for the garish colours of certain works in this salon, but I like yours.'[9] The admiration that Gauguin – a man not known for his compliments – had for

Rousseau's use of black is well known.[10] Paul Signac, for his part, enthusiastically welcomed Rousseau to the Salon des Indépendants and was one of the few mourners at his funeral.[11]

Again, it was two painters who, in 1891 and 1895 respectively, were to defend in the press the striking originality of two of Rousseau's masterpieces, *Tiger in a Tropical Storm (Surprised!)* 1891 (no.43) and *War* 1894 (no.17). In *Le Journal Suisse* on 25 March 1891 the Swiss-born artist Félix Vallotton, who followed the Parisian scene attentively and was about to join the Nabi movement, praised the sensational exhibition of Rousseau's first Jungle, challenging its detractors with: 'Mr Rousseau becomes more amazing every year... Moreover, he's a terrible neighbour: he quashes everything around him. His tiger in the jungle is a must-see; it's the alpha and omega of painting.' With their ambitious formats, *Surprised!* and *War* both demonstrate a burst of imagination, drawn from the depths of the unconscious, and share a mastery of form and colour. Having seen *War* at the Indépendants in 1894, the painter Louis Roy, Gauguin's follower in Brittany, wrote an enthusiastic piece about the artist in *Le Mercure de France* in March 1895: '*La Guerre* by Mr Rousseau was without doubt the most striking painting... It is the same with Rousseau as it is with all innovators. He follows his own lead; he has the quality – rare in this day and age – of being a one-off. He is moving towards a new art.'

In 1891, thanks to Vallotton,[12] the term 'childish naivety' no longer had the pejorative connotations it had carried in the negative press responses. If some continued to see Rousseau as a simple joker lacking in skill,[13] over time his profoundly original vision would become linked to that of the artists of pre-Renaissance Italy who, before the invention of linear perspective, prioritised colour and the juxtaposition of forms in space. This relationship, established during Rousseau's lifetime, tied him to the Primitives and would be perceived in the twentieth century, with its eagerness to look to different kinds of art for source-material, as an eminently positive quality.[14] The inspiration that the self-taught Rousseau drew from popular art – prints, newspapers, calendars, postcards – gradually made him the archetypal naive painter and, eventually, an object of fascination for those who see Jean Dubuffet as the father of Art Brut.

Fig.104
War
1894
(Detail, no.17)

Fig.105
Lithograph for
War L'Ymagier,
January 1895

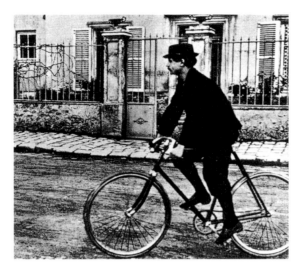

Fig. 106
Alfred Jarry,
c.1895

From Alfred Jarry to Robert Delaunay:
Rousseau Recognised by the Avant-garde

From the mid-1890s to his death in 1910, Rousseau's painting would attract the attention of the young literary and artistic avant-garde. Thus he found himself included in such cutting-edge publications as *L'Ymagier* in 1895, launched by the Symbolist writer Rémy de Gourmont and Alfred Jarry (fig. 106), or the *Blaue Reiter Almanac* of 1912, published by Kandinsky and Franz Marc. Apollinaire wrote numerous articles about him, while Picasso and Delaunay bought his paintings. It has been said that Jarry and Apollinaire (fig. 108) were the true 'inventors' of Rousseau, and it was Jarry who nicknamed him 'Le Douanier'. The meeting between the painter and the young man of letters,[15] who was also from Laval and nearly thirty years his junior, must have taken place around 1894, the year in which Jarry mentioned *War*, on view at the Indépendants, in two articles written in his idiosyncratic style.[16] The poet's admiration for this painting triggered a friendship that led Rousseau to put the young man up in his studio on the avenue du Maine when he was short of money in 1897.

The friendship that grew between the two men should be understood in the context of a contemporary revaluation of the popular arts.[17] Jarry, soon to shake up the literary world and to challenge the traditional conventions of time and space in the theatre with his *Ubu* cycle, saw the self-taught Rousseau as an exemplary artist, whose inspiration was in total synergy with *L'Ymagier*.[18] He commissioned Rousseau to make a lithograph based on *War* for the second issue of the publication in January 1895 (fig. 105), a large part of which was given over to Epinal prints and anonymous lithographs. Three years later, in his *Gestes et Opinions du Dr Faustroll, pataphysicien* (a text that was not published until 1911), Jarry cast Rousseau as a great renovator of painting, entrusting him with the running of a 'painting machine', intended to transform the high academic horrors of the 'National Store' – the canvases, in other words, hanging in the Musée du Luxembourg.

The creation of the myth, corroborated by Rousseau himself and retracted only later, that the brave Douanier had joined Napoleon III's expedition to Mexico in the 1860s, was the work of Apollinaire. Memories of this distant journey, he claimed, had been the source of the lush vegetation in his Jungle paintings. The poet and the painter probably met through Jarry in the spring of 1906, as suggested by a letter from Jarry to Apollinaire in April of that same year, published in *Les Soirées de Paris* on 15 May

1914: 'I hope to see you soon, and then we can take the fantastic trip to see Rousseau.'[19] It would not take long for Apollinaire, the non-conformist critic for *L'Intransigeant*, to share Jarry's enthusiasm for Le Douanier's paintings; his first words on Rousseau were printed in 1907 on the occasion of the Salon d'Automne, and many more would follow before his death in 1918. At first he was uncertain about the painter's work. Of Rousseau's submission to the Indépendants of 1908, for example, which notably featured *Fight between a Tiger and a Buffalo* (no.45) and *The Football Players* (no.13), he wrote that Rousseau 'sorely lacks general culture', that he 'knows neither what he wants nor where he is going', and that he 'should have stuck to being an artisan'.[20] Two years later, however, he would praise *The Dream* at the 1910 Indépendants: 'This painting exudes beauty, without question... I think that no one will dare laugh this year... Ask the painters. Their agreement is unanimous: they admire him... and so they should.'[21]

In 1908, the poet commissioned Rousseau to paint his portrait. The artist made two versions (Kunstmuseum, Basel, and The State Pushkin Museum, Moscow). In both, Apollinaire is represented accompanied by his muse, the artist Marie Laurencin, who cuts an imposing figure.

After Rousseau's death, Apollinaire played a key role in the posthumous recognition of his friend. In 1911, the Salon des Indépendants brought together a group of forty-seven works by the 'Maître de Plaisance' (the Master of Plaisance, the Parisian suburb in which he lived), providing the poet with the occasion to write a eulogistic article entitled 'The Triumph of Rousseau'. At last, glory was duly bestowed on him. Apollinaire highlighted his unusual personality and his stubborn determination, praising the painter of *The Snake Charmer* 1907 (no.51) as 'this Breton, long-time inhabitant of Parisian suburbs... the strangest, boldest and most charming of painters of exoticism.'[22] Reworking some of his earlier writings on the artist, he dedicated the entire issue of *Les Soirées de Paris* of 15 January 1914[23] to Rousseau, an issue packed with biographical documents that shed light for the first time on his complex psychology, and that was illustrated with reproductions of his works, including *Myself, Portrait-Landscape* and his own portrait, complete with sweet williams.

The recognition of the literary world was soon augmented by that of several avant-garde artists. In November 1908, a young Picasso, who had arrived in Paris in 1901 and who had just completed his *Demoiselles*

Fig.107
Copy of *Les Soirées de Paris* containing Rousseau's letter to Apollinaire of April 1906 and the portrait of Apollinaire, *Muse Inspiring the Poet* 1909

Fig.108
Pablo Picasso
Apollinaire in Picasso's studio, boulevard de Clichy c.1911

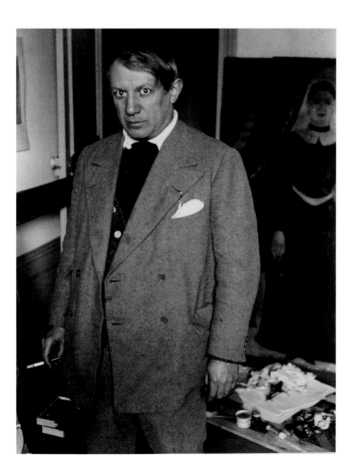

Fig.109
Brassaï, *Picasso in the rue la Boétiée studio, Paris* 1932. Rousseau's *Portrait of a Woman* 1895 can be seen in the background

d'Avignon 1907 (fig.132), stopped in his tracks upon seeing Rousseau's large *Portrait of a Woman* (no.4) in the shop of the bric-a-brac merchant Père Soulié, on the rue des Martyrs in Montmartre. He bought it on the spot for the modest sum of five francs and never parted with it: 'The first work by Le Douanier that I had the occasion to buy grew inside me with an obsessive power... It is one of the most truthful French psychological portraits,' he later told Florent Fels.[24] It is widely accepted that Picasso, who since moving to Paris had never missed a Salon, was at this time familiar with Rousseau's painting, especially after the exhibition of *The Hungry Lion throws itself on the Antelope* 1905 (no.49) in the *cage aux Fauves* of the Salon d'Automne of 1905.[25] According to Christopher Green, the Picasso-Rousseau encounter took place in November 1908 through the intermediary Max Weber, an American painter and acquaintance of Apollinaire.

To celebrate his acquisition, Picasso organised a 'banquet' in honour of Rousseau in his Bateau Lavoir studio. The evening went down in the history of modern painting, recorded in various, sometimes contradictory, accounts, left by Maurice

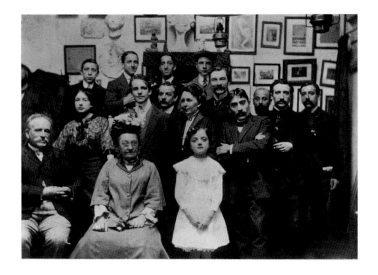

Raynal, André Salmon, Gertrude Stein and Fernande Olivier.[26] The drink flowed freely for the artists, poets, amateurs, critics and dealers who gathered around *Portrait of a Woman*. While some of the guests may have treated the event with a certain amount of mockery, this was none the less a real tribute to Le Douanier. The poem that Apollinaire wrote for this occasion is evidence enough:

> We are gathered together to celebrate your glory,
> These wines that in your honour Picasso pours,
> Let's drink them then, since it's the hour for drinking
> Crying in unison: 'Long live! Long live Rousseau!'[27]

Five years later, in 1913, Picasso bought from Ambroise Vollard one of Rousseau's finest allegorical paintings, *The Representatives of Foreign Powers Coming to Greet the Republic as a Sign of Peace* 1907 (no.22), and in 1938 he was again seduced, this time buying a pair of paintings, *Portrait of the Artist with a Lamp* 1900–3 (no.5) and *Portrait of the Artist's Second Wife* 1900–3 (no.6). Moreover, Hélène Seckel-Klein has found evidence supporting the existence of another painting by Rousseau in Picasso's personal collection, a small landscape of the Parc Montsouris, bought before 1942.[28]

Another pioneer of modern art, Kandinsky, became interested in Rousseau before 1910 and played a key role in his posthumous recognition in Germany. According to William Rubin and Carolyn Lanchner,[29] Kandinsky, who lived in the Paris area between 1907 and 1908 with Gabriele Münter, would have been familiar with his work from this time. With the help of Delaunay and, after having seen the first monograph on Rousseau by the German writer and art-lover Wilhelm Uhde, published in Paris in September 1911, he acquired two paintings by the Maître de Plaisance: *The Farmyard* 1896–8 (fig.111) and *Painter and Model* 1900–5 (no.1). In 1912, he reserved a prime spot for Rousseau in his famous *Blaue Reiter Almanac*, which he published with Franz Marc in Munich. No fewer than seven works by Rousseau were reproduced in this art manifesto for the twentieth century, including *The Wedding c.*1904–5 (fig.77), the two portraits of the artist and of his second wife with a lamp, as well as *The Farmyard*. The publication proposed a new form of presentation, where the connections between juxtaposed articles, reviews and various reproductions would be self-explanatory. 'We place an Egyptian work next to a little Zeh (the name

Fig.110
Van Echtelt
Le Douanier and Friends in his Studio c.1910
The artist can be seen on the far left

of two talented child-artists), a Chinese work next to a Douanier Rousseau, a popular drawing next to a Picasso, and so on.'[30] In this collection, popular art, children's drawings and naive paintings rubbed shoulders with conventional artworks, and from this point of view Rousseau found his natural place at the heart of this *Ymagier* for the twentieth century.

The main intermediary between Rousseau and Kandinsky, Delaunay probably met him in 1906; he became one of his most loyal supporters and a vocal champion of his work after 1910.[31] He assembled a significant collection of his paintings, including *The Merry Jesters* 1906 (no.28) and *The Pont de Grenelle c.*1892 (no.41), and presented the artist to his mother, who commissioned *The Snake Charmer* in 1907. *Myself, Portrait-Landscape* 1890 (no.2) and *The Football Players* 1908 (no.13) found echoes in Delaunay's *The City of Paris* and *The Cardiff Team*, painted *c.*1910–2 and 1913 respectively. Close enough to Rousseau to visit him in hospital in 1910, Delaunay nonetheless wrote: 'I saw Rousseau regularly; we were friends. I was mainly attracted by his art. But the man was so mysterious to me, so inscrutable, that I could not be sure that he was suffering.'[32]

Anxious to honour the memory of his friend, Delaunay asked Rousseau's daughter, Julie Bernard, to give him documents, 'so as to avoid rumours that might harm Rousseau's memory in any way'.[33] In 1920, he published an article in issue seven of *L'Amour des Arts* praising Rousseau, who, in addition to being a great colourist, was 'the popular genius of the French people', distinguished heir to the printmakers of old. It is to Delaunay that we owe this new appreciation of Rousseau's art, backed up in 1937 by the Paris exhibition *Maîtres populaires de la réalité* (Popular Masters of Reality). Revisiting one of his old texts for his *Du Cubisme à l'art abstrait* (From Cubism to Abstract Art), Delaunay placed Rousseau in the context of the Indépendants, seeing him as 'the godfather of the artistic revolution in modern painting', and comparing him to Paul Cézanne, the 'bourgeois, the first breaker, the first saboteur'.[34]

Posthumous Recognition
In the wake of Rousseau's death, numerous initiatives were launched to ensure the canonisation of his oeuvre and inscribe his name in modern painting's hall of fame. In 1911, Delaunay was the main instigator of the retrospective held in his honour at the Salon des

Indépendants, bringing together forty-seven paintings. From 1908, Uhde, who had moved to Paris in 1904 and who met Rousseau through Delaunay, organised the first exhibition of his works in Paris, but it was a failure, due to the omission of an address on the invitation card. In 1911, deeply convinced that 'in Rousseau's painting, the humble facade of the *petit bourgeois* conceals the qualities of a very great and original art',[35] Uhde published the first monograph on the artist in Paris. Containing many observations on his personality, which until then had not been explored, it deliberately placed his oeuvre in the context of new developments in twentieth-century painting:

> In his paintings, whose rigorous stylisation recalls Italian primitive art, he was the forerunner for what is happening in painting today, where his name has become a maxim. Leave naturalistic study behind and return to the 'painting'. There is no longer a desire to reproduce a slice of reality by means of all sorts of colours, but rather to create with vivid lines something that suggests a stronger representation of objects.[36]

This declaration was followed in 1912 by the organisation of a Rousseau retrospective at the Galerie Bernheim-Jeune, which featured twenty-seven paintings, including three Jungles and two drawings. The celebratory preface in the exhibition catalogue was written by Uhde, who would later dedicate many more texts to the painter.

Earlier we saw the effect of Uhde's monograph in Germany via Kandinsky, but it is important to add that from 1910 Le Douanier's reputation spread across the Atlantic, thanks to the young American artist Max Weber, who had come to Paris to study painting. Having met Rousseau at the home of Delaunay's mother, he bought works from the artist and was a regular guest at his parties in rue Perrel. When he returned to New York in 1910, he showed his collection at Alfred Stieglitz's Photo-Secession Gallery and, three years later, Rousseau featured in the seminal chapter of the story of modern art that was the Armory Show.

It was not until 1926 that Rousseau's work gained recognition in England, in the form of an exhibition at London's Lefevre Gallery, organised by Roch Grey, the pseudonym of the Baroness of Oettingen. Sister of the Cubist painter Serge Jastrebzov, alias Serge Férat, she had known the artist and collected his works, including

Myself, Portrait-Landscape 1890. Before bringing out two books on him in 1922 and 1943, in which she highlighted how, for Rousseau, painting functioned as an escape from petit-bourgeois life, she published her memoirs on the artist in a special issue of *Les Soirées de Paris* on 15 January 1914. From these we learn, notably, that Le Douanier hated Matisse's work: 'If at least it were funny! But it's sad, my dear, it is horribly ugly!'[37]

In the 1920s, it was the turn of the Surrealists to take an interest in Rousseau, hardly surprising given the nature of his art, produced as it was from novel collages and subtle shifts between dream and reality. The year 1927 saw the simultaneous publication of two monographs by the poet Philippe Soupault and the writer André Salmon, who was a friend of Apollinaire. The presence of several Surrealists, including Antonin Artaud, André Breton and Benjamin Perret, in Mexico in the 1930s, all of whom were familiar with Le Douanier's work, explains his influence on Mexican painting, evidence of which can be found in the gigantic, 79-metre-long mural that Diego Rivera created in 1947 for the restaurant of the Prado Hotel in the city's historic centre (fig. 112).

From this period onwards Rousseau enjoyed an international reputation and, with their prices soaring, some of his key works entered major museums like the Louvre and The Museum of Modern Art in New York, while important private collections of his work, such as those of Paul Guillaume (fig. 114) in Paris and Dr Albert C. Barnes (fig. 113) in Philadelphia, were established. Indeed, *The Snake Charmer* 1907 (no. 51) had been in the outstanding collection of the couturier Jacques Doucet before being accepted in 1925 and entering the Louvre in 1937 thanks to the generous donor's bequest to the museum in 1936. Ten years later, the Louvre bought *War* 1894 (no. 17) from the dealer Étienne Bignou.

There was great excitement at The Museum of Modern Art in 1940 when the Director Alfred Barr announced the acquisition of *The Sleeping Gypsy* 1897 (fig. 30), thanks to a gift from Mrs Simon Guggenheim. This painting, refused by the town of Laval during Rousseau's lifetime, had been part of John Quinn's distinguished collection before being sold to the Hôtel Drouot on 28 October 1926. Jean Cocteau wrote an enthusiastic preface to the catalogue for this exceptional sale, announced as follows by *L'Intransigeant* on 23 October of the same year: 'Le Douanier Rousseau's painting, which would have fetched a few hundred francs before the war, is going on public sale. It is expected

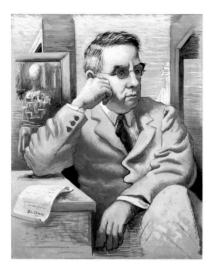

to reach the million mark.'According to Henri Certigny,[38] the painting was knocked down to 520,000 francs, which nonetheless represented a third of the total income from the sale.

The two most extensive Rousseau collections on view today, at the Musée de l'Orangerie in Paris[39] and at the Barnes Fondation in Merion, Pennsylvania,[40] were established, respectively, shortly after the First World War by the young Parisian dealer Guillaume and by Dr Barnes of Philadelphia, in all likelihood after 1914. They consist of nine and seventeen Rousseaus respectively.[41] A shared passion for African art brought Guillaume and Barnes together; the latter had translated into English Guillaume's book *Primitive Negro Sculpture*, which was co-written with Thomas Munro. From 1914 the Parisian dealer bought paintings by Rousseau from Georges Courteline, Serge Férat, Delaunay and the dealer Joseph Brummer.[42] In 1931, he bought *Boat in the Storm* 1890–3, *Anglers c.*1908 (fig.89) and *Strollers in a Park* 1907–8 from Ambroise Vollard, who had built up a stock of Rousseaus during the latter's lifetime. *Old Junier's Cart* 1908 (fig.70), bought from the painter Antoine Villard, also originally came from Vollard's stock, while *Child with a Doll c.*1904–5 (fig.72), acquired in 1927, had been in the collection of John Quinn.

Guillaume introduced Barnes to Rousseau's art and would become one of his main art consultants. The relationship between the two men was well established from 1921 to 1923,[43] from which point the Parisian dealer became the main supplier of Rousseau's paintings for the American collector. On 25 October 1924, Barnes acquired *Unpleasant Surprise* 1901 from Guillaume, and this was followed on 29 March 1926 by the acquisition of a batch of six Rousseaus, including *Scouts Attacked by a Tiger* 1904 (fig.115) and *The Present and The Past* 1899 (fig.128).[44] Other paintings in the Barnes collection were bought from the dealer Paul Rosenberg, very active in the art market at this time, or had been in the possession of Vollard.

Since the 1960s, a new approach to Rousseau has sought to debunk the myths that have persistently surrounded his oeuvre. In 1927, Philippe Soupault and André Salmon were still perpetuating the story that Le Douanier had been on the Mexican expedition. Over the last forty years, art history has demystified the figure of the Maître de Plaisance, with key publications by Dora Vallier, Henry Certigny and Yann Le Pichon.[45] This period has also seen the publication of three catalogues raisonnés, whose authors, Jean Bouret, Vallier and Certigny, have each attempted to re-establish the authenticity of Rousseau's

Fig.113
Giorgio de Chirico
Dr Albert C. Barnes
1926
The Barnes Foundation, Pennsylvania

Fig.114
Paul Guillaume in his gallery apartment, 16 avenue de Villiers

Fig. 115
Scouts Attacked by a Tiger
1904
The Barnes Foundation,
Pennsylvania

oeuvre, backed by historical evidence.[46] The number of missing paintings or works known only through scant documentation, and the increased circulation of suspected fakes explains the discrepancies between these works of reference.

Two recent large Rousseau retrospectives (Paris/New York, 1984–5; Tübingen, Germany, 2001) have, by their own admission, deliberately focused on the modernism of an art that has since enjoyed a new lease of life. As a naive artist, the subject even of a song (he inspired a hit single by the Compagnie Créole), as a symbol of exoticism and strangeness, it is unsurprising that Rousseau has 24,000 entries on the Internet, of which 17,000 are Francophone. At the time of writing, there are more than 730 websites dedicated to him, a number of which make mention of the museums of naive art in Laval, Nice and Vicq in the Yvelines, and the Halle Saint-Pierre in Paris. Is this not a sign that the artist, so mocked during his lifetime, has evidently moved beyond the boundaries of painting to become the symbol of popular art?

Henri Rousseau as an Academic
John House

Fig. 116
A Centennial of Independence
1892
(Detail of no. 18)

Henri Rousseau would have been surprised by his posthumous reputation – not by the fact that he has been celebrated, for he was surprisingly confident of his worth as an artist, but by the values that have been found in his work, and by the company he has posthumously kept. He received his apotheosis in the Paris/New York exhibition of 1984–5. The principal essay in the catalogue of the exhibition, by Carolyn Lanchner and William Rubin, was devoted primarily to his influence on vanguard artists of the twentieth century, from Picasso to the Surrealists, while Michel Hoog's essay 'Rousseau in His Time' focused exclusively on comparisons with artists such as Claude Monet, Paul Cézanne and Gustav Klimt. Rousseau would have had little understanding and still less sympathy of such artists: on seeing Cézanne's work, he reportedly said that he 'could have finished' it.[1]

Throughout his career, it was his links with French academic painters that Rousseau invoked to legitimise his status, and even his practice, as a painter. In 1884, he wrote to the Minister of Fine Arts claiming that his work had been 'seen and appreciated' by Jean-Léon Gérôme and Félix-Auguste Clément;[2] in 1907, writing during his imprisonment on a fraud charge, he stated that Gérôme and Léon Bonnat had encouraged him to continue as a painter. More ambitiously, a few days later, he wrote: 'I was encouraged by painters who were already celebrated, such as M. Gérôme, Cabanel, Ralli, Valton, Bouguereau etc. Even M. Fallières, when he was Minister of Public Instruction and who is now President of the French Republic, was requested by his friend the late lamented painter Clément to help and encourage me.'[3] Maurice de Vlaminck recorded that it was Adolphe-William Bouguereau, of all the modern masters, for whom Rousseau had the greatest admiration.[4] This essay will seek to re-place Rousseau in the context to which he aspired – amid the academic and official art of the early Third Republic.

Unlike many of the other stories that Rousseau told about his life, there seems little doubt that, at the outset of his career as a painter, he had some contact, at least, with Clément. Around 1884 the two were close neighbours on the Rue de Sèvres in Paris, and perhaps it was through him that Rousseau met at least some of the other Salon masters whose names he invoked in his letters.[5] Writing at the end of his life to the critic Henri Dupont, Rousseau stated: 'If I have preserved my naivety, it is because M. Gérôme, who was a professor at the École des Beaux-Arts, and M. Clément... always told me to preserve it.'[6] They may, indeed, have encouraged him to retain his naivety, but it is open to us to ask whether or not this was the compliment that Rousseau liked to believe it had been. In the later nineteenth century,

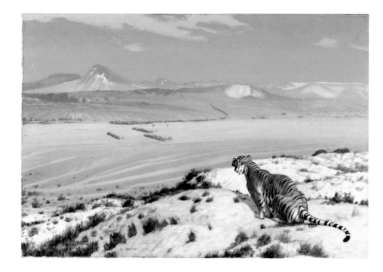

'naivety' was a term of approbation within avant-garde circles, signalling a fresh personal vision untrammelled by academic convention, but for Gérôme and Clément it would not have been an unequivocal virtue. At best, it would have meant that they recognised a distinctive personal vision in Rousseau's work that they were urging him not to lose; at worst, and more plausibly, they were laughing behind their hands at the artistic pretensions of this wholly uneducated toll booth keeper. Likewise, the comment from Gérôme that Rousseau cited in his interview with Arsène Alexandre, that he had 'a very bold brushstroke', is all too likely to have been double-edged.[7] Gérôme's liking for practical jokes and double-entendres was well known.

Rousseau's working methods throughout his career were fundamentally academic. In academic precept and practice, the conception of the painting, down to its detailed planning, was worked out in various types of preparatory study, and preceded the execution of the final canvas. Effectively, the execution of the work itself was a mechanical process, of implementing previously laid plans, involving skill but not creativity. Rousseau himself declared that he followed just such a procedure: 'I always see a painting before executing it.'[8] A number of surviving descriptions and photographs show how he implemented this process,

filling in his pre-prepared canvases zone by zone – or, indeed, colour by colour.[9] There was no room in such a practice for the improvisatory, open-ended approach to picture-making that we associate with the late nineteenth-century avant garde, most notably with Édouard Manet.

Nor can we use the surviving preparatory sketches for his landscapes (e.g. fig. 119) as evidence for a more spontaneous creative process. They are notations, strictly pragmatic in their attempt to map the basic elements in the scene before him. Although it has been claimed that the academic sketch was a medium in which spontaneity was sought and valued,[10] recent research has conclusively shown that academic theorists placed absolutely no value on the impromptu qualities of sketches, treating them simply as a rapid and practical means of jotting down a preconceived idea.[11] Likewise, in the light of the punctilious execution of the finished landscapes, there is no reason to suppose that Rousseau himself saw any value in the sketchiness of his sketches;[12] nor did he accord them any value by exhibiting them.

Rousseau's attitude to picture-making also reflected academic values in his use of copying. Within early Modernism, copying generally signified either plagiarism or parody.[13] In academic practice, by contrast, it played

Fig. 118
View from the Quai Henry-IV
1909
(No.39)

Fig. 119
Sketch for View from the Quai Henry-IV
1909
Musée du Vieux-Château, Laval

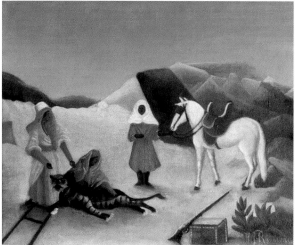

a fundamental role in the learning process;[14] and, beyond that, the borrowing of forms and motifs from canonical works of art could be viewed as the artist's acknowledgement of the authority of the canon. Here, Ingres's example was crucial, as the 'Notes' of the master published by Henri Delaborde in 1870 made clear:

> One should have no scruples about copying the *anciens*. Their productions are a shared treasure from which anyone can take what pleases him. They become our own when we know how to use them: Raphael, though ceaselessly imitating, was always himself... [The painter] may, without being a cold plagiarist, take from [Greek] vase painting whole compositions and translate them on canvas.[15]

In 1884, at the moment that he seems to have decided to take up painting seriously, Rousseau registered, as a dutiful student should, as a copyist in the Louvre and other Parisian museums, perhaps on the recommendation of Clément.[16] However, the overall patterns of his copying did not follow orthodox academic precept. In one sense, his persistent borrowings can be seen to follow Ingres's precepts

closely: without doubt he made his borrowings his own. His direct re-workings of recent Salon paintings, too, may be seen as tributes to the forms of art to which he aspired:his *Tiger Hunt* c.1895 (fig.121), derived directly from Rodolphe Ernst's *Soirée Triomphale*, shown at the Paris Salon of 1895, or more probably from a print after it (fig.120),[17] and his *View of Brittany*, copied from a print after a Breton landscape by Camille Bernier.[18] However, Rousseau appears to have felt that he could legitimately use any visual source, whatever its status or original purpose, as raw material in his compositions. His transposition of motifs for his Jungle scenes from *Bêtes sauvages*, published by Galeries Lafayette, is just one of the many examples that have been traced: clearly he had no need to persuade himself that the images he adapted had any sort of canonical status. Likewise, as Ardengo Soffici noted, Rousseau encouraged his 'students' – two elderly friends of his – to copy from the most humble visual materials, such as coloured postcards.[19]

Rousseau's artistic ambitions emerge especially clearly in the exceptionally wide range of his subject matter. Viewed in the context of academic practice and the expectations of the Paris Salon, his subjects spanned all the traditional genres of painting, and adhered closely to the established hierarchy that placed history painting at the

Fig.120
Rodolphe Ernst
Soirée Triomphale, published in
Le Monde Illustré, Sept. 1895

Fig.121
Tiger Hunt
c.1895
(No.44)

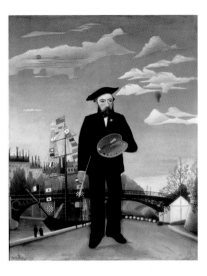

Fig.122
Myself, Portrait-Landscape
1890
(No.2)

summit, and viewed landscape and still-life as subordinate genres. Rousseau's landscapes and still-lifes are consistently small, as befitted their genre. His portraits run the gamut from modest, domestic-scale, bust-length images to life-size full-lengths, whose format is clearly based on the Salon portraits of artists such as Carolus-Duran and, beyond them, on the conventions of court portraiture.

Rousseau's acute awareness of the genres as a mode of classification for works of art and as defining characteristics for an artist emerges in his self-portrait on the banks of the Seine, exhibited in 1890 with the title *Myself, Portrait-Landscape* (no.2). The title itself demonstrates his awareness of genre classification; seventeen years later, seeking to establish his credentials in his letters from prison, he cited the fact that he was recognised as the inventor of the *portrait-paysage* form as one of his claims to recognition.[20]

Most significant, though, are the types of painting to which he accorded greatest importance by treating them on the grandest scale. The large size and ambition of the Jungle paintings place them firmly in this category; clearly he saw them as something quite distinct from his modestly scaled landscapes. Although the raw material out of which he drew them was quite humble – books like *Bêtes sauvages*, and the gleanings from his visits to the Jardin des Plantes – the resulting pictures are evidently highly ambitious, and have of course been the key to Rousseau's subsequent reputation. Loosely, their status may be associated with that of Orientalist painting at the Salons (to which *The Sleeping Gypsy* of 1897 (fig.30) and the Ernst-derived *Tiger Hunt* paid direct tribute), and to the significance attributed to the displays from across the globe at the Paris World Fair of 1889, subject of the artist's comedy in three acts *A Visit to the 1889 Exhibition*. More significant, though, as the research for the present exhibition has demonstrated, was the material that he drew from the Jardin des Plantes and the Muséum d'histoire naturelle situated within it. It was the scientific and historical dimension of this material that gave it its status – a status intimately linked with the secular, progressivist and empiricist ethos of the public culture of the Third Republic after 1879.[21] The imagery of his landscapes reflects his belief in progress in a rather different way, in their emphasis on factories within the landscape, seemingly in serene coexistence with the natural world, and the inclusion of balloons, as in *Myself, Portrait-Landscape* or, later, airships and aeroplanes (e.g. fig.89, 90).

More obviously within the category of 'high art' was *War* 1894 (no.17), Rousseau's one monumental allegorical canvas, whose subject was treated in a generalised, timeless manner. When he exhibited it in 1894, he further stressed

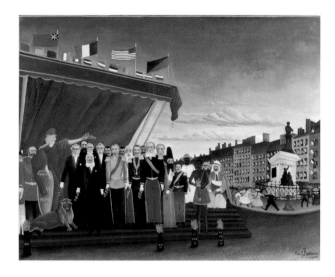

its significance, and at the same time his awareness of the conventions of exhibiting allegorical subjects, by appending a brief text to the title in the exhibition catalogue: 'terrifying, it passes by, leaving everywhere despair, tears and destruction.'[22] Rousseau added extra texts to the titles of a number of his other most significant paintings, among others *A Centennial of Independence* 1892 (no.18), *The Sleeping Gypsy* 1897 (fig.30) and a brief poem to *The Dream* 1910 (no.50); he justified this, talking to Arsène Alexandre in 1910, with the remark that pictures needed an explanation, because people did not always understand what they saw.[23]

A Centennial of Independence introduces the final group of Rousseau's most ambitious projects, those devoted to modern history. Between 1892 and 1907 he executed a sequence of major canvases devoted to the politics and ideology of the Third Republic. These range from wholly allegorical images such as *The French Republic c.*1904 (Los Angeles County Museum of Art)[24] to canvases that freely mix allegory with ostensible images of actuality. In *Liberty Inviting Artists to Take Part in the 22nd Exhibition of the Société des Artistes Indépendants* 1905–6 (no.19), a winged Liberty blowing a trumpet flies above an assembly of artists, while a version of Auguste Bartholdi's bronze *The Lion of Belfort*,

mysteriously transmuted into lifelike colours, holds a banner listing the principal exhibitors at the Indépendants. A version of the same lion puts in an appearance alongside a figure of the Republic on the podium in the foreground of *The Representatives of Foreign Powers Coming to Greet the Republic as a Sign of Peace* 1907 (fig.123), while in the background a group of children dance round the monument to the sixteenth-century humanist martyr Étienne Dolet.[25] Rousseau emphasised his patriotism through his repeated use of the image of the Lion of Belfort, the monument erected in 1875 as a defiant gesture near the post-1871 frontier between France and Germany, after the cession of Alsace in the wake of the Franco-Prussian War.[26]

These canvases are the most overt declaration of Rousseau's ambitions to establish himself as a significant Republican artist. At the same time, he pursued another path to the same goal, by submitting designs to the competitions for the decoration of several of the town halls in the Paris region – those of Bagnolet, Vincennes and Asnières, as he claimed in one of the letters that he wrote from prison in 1907, seeking to vindicate his reputation.[27] It seems likely, from its format, that *The Pont de Grenelle c.*1892 (fig.124), with its miniature version of the Statue of Liberty, is one of these designs.[28] The town-hall decorations of the late nineteenth century were

Fig.123
The Representatives of Foreign Powers Coming to Greet the Republic as a Sign of Peace
1907
(No.22)

Fig. 124
The Pont de Grenelle
*c.*1892
(Detail of no.41)

perhaps the single most significant form of public-art patronage in France during these years, devoted as they were to finding forms of imagery appropriate to the values of the Third Republic.[29]

Rousseau consistently presented himself as a staunch Republican; indeed, he reportedly told Robert Delaunay that he was an anarchist.[30] In his letters from prison in 1907, he reiterated his Republican credentials as well as his patriotism and, in 1895, he associated his political beliefs with his commitment to the jury-free exhibitions of the Société des Indépendants in the autobiographical statement that he prepared for a never-published volume of 'Portraits du prochain siècle': 'He has been a part of the Indépendants for a long time, believing that the initiator whose thought aspires to the beautiful and the good should be accorded all freedom to produce.'[31]

The existence of the jury-free exhibitions of the Indépendants was the single essential precondition for Rousseau's emergence as an artist. Fortuitously, the launching of jury-free exhibitions in 1884[32] immediately preceded his first attempts – unsuccessful, of course – to exhibit at the Paris Salon in 1885;[33] from 1886 onwards he consistently showed with the Indépendants. Speaking to Alexandre in 1910, he disarmingly stated that the foundation of the Société des Indépendants had enabled him to 'renounce' the Salon, because it was 'the finest Society, the most legal Society, since everyone has the same rights in it'.[34] Without such an outlet, there was no way in which Rousseau could have found a public for his art. Although, initially at least, his canvases were reportedly hung in the most remote corners of the exhibitions,[35] the Indépendants gave Rousseau one crucial thing: exposure. With his works regularly on view in the French capital, he was able to pursue his vision of himself as an exemplary public artist of the French Third Republic.

Fernande Olivier famously recorded a comment that Rousseau made to Picasso: 'We are the two greatest painters of the era, you in the Egyptian genre, I in the modern genre.'[36] This remark has been variously interpreted as revealing Rousseau's naivety[37] or his position among the avant garde.[38] The argument of this essay is that it can be understood in yet another way: Rousseau saw himself, with some reason, as the quintessential public artist of the Third Republic, deploying academic procedures in the quest for a contemporary form of public-exhibition painting that expressed the freedoms and technical advances that the Republic had won for France.

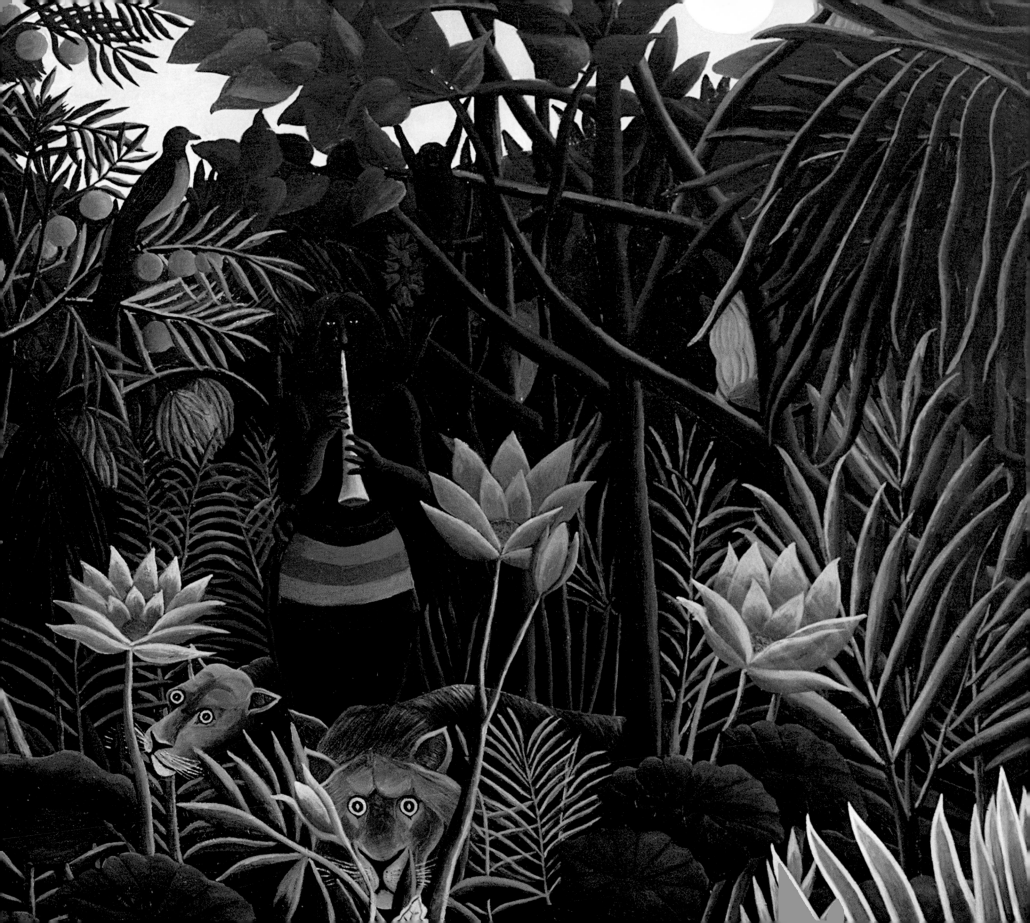

The Magic of Images: Hallucination and Magnetic Reverie in the Work of Henri Rousseau
Pascal Rousseau

Fig.125
The Dream
1910
(Detail of no.50)

'He had', Guillaume Apollinaire tells us of Henri Rousseau, 'such a strong sense of reality that when he painted a fantastic subject, he was sometimes terrified and, trembling, obliged to open the window'.[1] Earlier, he had presented a portrait of Rousseau as a man subject to hallucinations and 'frightened by his own imaginings'.[2] The term 'imaginings' is apposite: it referred at the time to 'mental visions',[3] and with reference to Le Douanier's Jungles, it identifies the suggestive power of the image, its ability to plunge the viewer into a primitive knowledge of the world, an archaic vision haunted by ghosts, revenants, spectres. Far from being purely fantasist in nature, this conception of representation as 'inhabited' responded to a *fin-de-siècle* cultural context keenly marked by the revival of spiritualist or more generally idealist positions. In his famous book *De l'intelligence* 1870, Hippolyte Taine provocatively described external reality itself as a 'true hallucination'. This reflected the growing belief in the subjectivity of vision, notably through memory and persistent images. According to this theory, vision is marked by the indelible imprint of a relic, the vestige of a reality that can subvert sensation. This mnemonic paradigm, which found its way into turn-of-the-century literature, moulded subsequent ideas of the processes of perception, no longer seen as blank (the Impressionist fantasy of the 'innocence of the eye'), but rather as being wholly informed by a series of déjà-vu images. The oneiric scenes presented to us by Rousseau join this residual field of 'hallucination', in which the painter's purpose is to reveal the magical aspect of the sense of reality, while the image is henceforward nothing but the intensified mode of memory.

It is with this clinical approach to perception, and the fantastical aspect of the influence of the gaze, that we can find a connection between the somnambulant figures that people Rousseau's jungles and suburban landscapes. As we shall see, far more than merely possessing a regressive naivety, they act within a properly hypnotic relationship towards the image, shaped by the subversive force of unrequited love, which can only be resolved through an intensified and almost fetishistic experience of representation. This grants the viewer access to a more primitive zone of consciousness, which Rousseau called, in anticipation of the Surrealists, 'magnetic love'.

Between Dream and Reality: The 'Other World' of Spirits
In a recent, highly convincing article,[4] Nancy Ireson has demonstrated the extent to which the 'naive' mystification

Fig. 126
'Le Mediumisme et L'Art,
La Vie Mystérieuse, 10 Nov.
1911

of Rousseau's character reveals a close link between the artist and the spiritualist culture of the turn of the century. Drawing on the writings of Arsène Alexandre, Wilhelm Uhde and Apollinaire, she sheds light on the occult aspect of the work of a Douanier who believed in angels, ghosts and revenants. Notably, she unearths an article published in 1911 in the journal *La Vie Mystérieuse*, by Fernand Girod, Secretary General of the International Society of Psychical Research. Girod, a relative of Eugène Figuière, the publisher of the first monograph on Rousseau, by Uhde,[5] interprets the singularity of the artist's style with reference to a gift of mediumistic vision, showing, in passing, the extent to which the idea of primitivism that the painter is saddled with is linked to the supernatural, even magical, dimension of its relationship with the image. What might have looked like mere naive faith (belief in ghosts), and has fed the popular myth of Le Douanier, is in fact a posture, a witty riposte to modernity.

This magical relationship with the image notably explains Rousseau's fascination with noble savages, the true 'primitives' with whom he rubbed shoulders in the Kanakan, Moroccan or Senegalese villages set up for the 1889 World Fair. To him, these last representatives of the archaic age are the relics of a humanity of primal religion, opposed not to civilised man but to the disbeliever. The triumphant 1889 Fair offered some staged illusionistic scenes in which the 'savage', presenting himself to the *eye*, reveals himself to be ontologically alien to the modern image's regime of distinctions.[6] There, in the very heart of the capital, beneath the Eiffel Tower, the citizens of Paris strolled among 'indigenous' people who still believed in the ability of images to act on being and consciousness, to capture not their attention, but their spirit, their *anima*.[7] Rousseau was one of those who had faith in the active intimacy of dialogue between the spirit of the living and that of the dead, what Ernest Bosc, in his popular *Glossaire raisonné de la divination, de la magie et de l'occultisme* (reasoned glossary of divination, magic and occultism) of 1910, interpreted as the possible magical re-enchantment of the world through the new technologies of vision.

Uhde, lays great stress on this 'magical' side of Le Douanier,[8] while Apollinaire portrays him as an 'enlightened one', reminding us that:

> everyone who knew Rousseau remembers his liking for ghosts. He had met them everywhere, and one of them had tormented him for over a year, when he was working in the customs

Fig.127
'La Photographie des fantômes',
La Vie Mystérieuse, 25 Nov. 1909

house. Whenever the good Rousseau was on duty, his familiar ghost stayed ten paces away from him, teasing him, thumbing his nose at him and breaking wind in a way so foul that it made the functionary feel quite ill.'[9]

Apollinaire's tone is facetious, but it finds curious echoes in the journal *La Vie Mystérieuse* when, some months before taking an interest in *The Snake Charmer* 1907 (no.51), it put the possibility of 'capturing the image of ghosts' on its front cover (fig.127).[10] This gothic ambiance is emphatically confirmed by Apollinaire when he gives an account of Rousseau's visit to the house in the rue Saint-Jacques of a 'dying man whose soul was floating in the room in the form of a glowing, transparent worm'. This was an explicit allusion to the post-mortem exhalations prized by those involved in spirit photography (Hippolyte Baraduc, Louis Darget, Édouard Buguet)[11] who were, during this period, exploring the possibility of extending the field of the visible to some still unknown dimensions of the electromagnetic field. The discovery of the visual properties of new 'vibrating waves' would, it was contended, lend visual acuity to an eye that had remained in the 'archaic' age. Since X-rays could penetrate bodies, there was nothing to keep people from

hoping for the possibility of a hyper-performing vision, penetrating the inside of the skull to reveal the visual form of thought to the naked eye. This was the ancestral fantasy of *l'idéoplastic*, the physical materialisation of thought, revisited with the help of new graphic technologies so as to appear objectively on the light-sensitive plate. The project was developed, from 1893 onwards, by Baraduc in his images of mental exhalations, the famous *psychicônes* (fig.130), revised and corrected by Darget and his 'psychic photographs' ('thoughtography').[12] In the many discussions opened up by these experiments, which, although marginal, attracted a great deal of attention, we can see the spread of the hypothesis that the capturing of ghosts in emulsion might represent the images of the dead preserved in the memories of the living, mentally projected into the ether and captured on the plate like so many forms of 'crystallised thought'.

As Ireson has suggested, it is possible to reread, in this technognostic context, the iconographic montage of a painting such as *The Present and the Past* 1899 (fig.128), now at the Barnes Foundation. The two lovers, Rousseau and Joséphine, are shown standing hand in hand, with two faces from the past floating above their respective heads in little clouds borrowed from Saint-Sulpician imagery,

on the right that of the painter's first wife, Clémence, and on the left, that of Joséphine's first husband. 'It's a little bit spiritualist, isn't it?' Rousseau commented to Arsène Alexandre,[13] thus himself broaching the similarity to fluidic photographs. The painting, made in about 1899, would not be shown to the Parisian public until the 1907 Salon des Indépendants, where it appears in the catalogue with the title *Pensée philosophique* (philosophical thought). This quite clearly links the painting with the possibility of visualising thought.

Spirit photographs did not merely purport to show mental images, but also invoked the imagination's ability to subvert our sense of the real simply by calling up the 'snapshots' sedimented in our affective memory. To put it another way, the degree of emotional intensity of the 'memory image' is seen to give objective form to thought, and passionate love manages to multiply the suggestive tangibility of the image. The popular literature of the *fin de siècle* brims with stories extending the metaphor of amorous hallucination – what certain authors call *magie passionnelle* (passionate magic). This was the title of a collection of fantastic stories by Jules Lermina, a genuine platform for Parisian occultist circles. One of these stories, the most gothic, is called *La Deux fois morte* (the twice

Fig.128
The Present and the Past
or *Philosophical Thought*
1899
The Barnes Foundation,
Pennsylvania

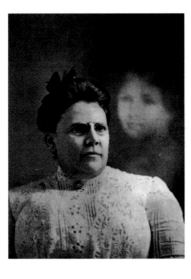

PSYCHICONE
formé au centre d'un
nimbe odique.

(Avec électricité, sans appareil,
avec la main.)

Fig.129
Spirit photograph,
c.1900

Fig.130
'Psychicone', photograph
reproduced in Hippolyte
Baraduc, *L'Ame humaine*,
Paris 1911

dead), in which the protagonist, Paul, suffering from 'excess of nerves', converses each evening with his young fiancée, Virginie, who died some months previously. Here Lermina is proposing a whole idealistic physiology of the hallucinatory phenomenon in which 'reality' and 'suggestive image' are physically confused at the level of the degrees of attention of the 'visual memory'.

In *The Present and the Past*, Rousseau, obsessed by the vivid memory of his first wife Clémence, makes her spectre 'reappear'. If we are to believe the comments reported by Uhde, he even believed that it was the hand of his late wife that guided his brush,[14] in a form of mediumistic automatism whose most rational explanation would be found in the 'externalisation of memory'.[15]

'Memory Images'
Between Archaic Memory and Melancholia
Within this set of beliefs it is the 'subliminal ego', embedded deep in the strata of the memory,[16] that subverts the relationship between imagination, perception and sensation. This idea, which is certainly not confined to spiritualist circles, ran through the cognitive theories of the nineteenth century that emerged from the rise to power of cerebral physiology, and then in particular from the

hypotheses put forward by Hippolyte Taine in *De l'Intelligence*, which were in turn picked up by Alfred Binet, one of the leading lights of French psychology. Taine[17] comments on this 'extreme resemblance between image and sensation',[18] basing his ideas on the 'law' of Dugald Stewart, according to which 'imaginary objects, when they absorb the attention, produce at that moment the persuasiveness of their real existence'.[19] Binet, in his wake, suggests that sensation be described as a pure 'state of consciousness', allowing us to establish a graded scale between sensation and image. The twenty or so articles that he published between 1880 and 1889 on the links between memory, hallucinatory hypnosis and the reality of sensation supply many clues for the interpretation of what, in Rousseau's work, is embodied in the fear of painting's hyperreality.[20] For it is the model of auto-suggestion that becomes, with Binet, the true paradigm of hypnosis[21] and its peak in oneiric ecstasy that permits the realisation of a genuine permeability between reality and ideation.[22] This hallucinatory tangibility of images, which André Breton was shortly to term the zone of 'Surreality', is one of the crucial points discussed in *fin-de-siècle* theories of suggestion, which shape the hypnotic influence exercised on the subject, and his ability to 'bring images into being'.

In the early nineteenth century, Alexander Bertrand had put forward the hypothesis that the hypnotist's thought is reflected in the mind of the hypnotised subject, according to an unfamiliar form of intersubjective communication that would feed, years later, into the Surrealist fantasy of the common sharing of automatic writing while in a trance.[23]

In 1889, the year of the famous Paris World Fair that so fascinated Rousseau, the 'First International Congress of Physiological Psychology' was held in Paris at the instigation of Jules Ochorowisz. He was one of the founding fathers of Polish psychology, and clearly wished to give scientific and experimental credence to the study of occult and parapsychical phenomena such as hypnosis. An organising committee had been set up under the aegis of Professor Jean-Martin Charcot, the leading light of French neuropsychiatry and head of the Salpêtrière Clinic. One of the vice presidents was none other than Hippolyte Taine. The papers were divided into three sections, one of which was devoted to hallucinations, and another to hypnotism. It was here that the two schools of the psychological interpretation of hypnosis confronted one another for the first time, and in spectacular fashion: the École de la Salpêtrière and the École de Nancy, Professor Charcot against Professor Bernheim from Nancy. On the one hand, there was the analysis of fluidic channels, and on the other interpretation by verbal suggestion. The point they had in common was their concern with cerebral subjection and all the fantastic notions of dispossession of the self that flow from it. The idea of hypnosis thus became engaged in a drift towards 'spirit' domination and the 'world of shadows'. In the eyes of the broader public, Professor Charcot was as much a Prince of Darkness as a Mandarin of Science, a dark, almost satanic savant, as is revealed by the gothic cover devoted to him in the journal *Les Hommes du Jour*. Bernheim was also popularly linked by the Nancy press to practices of enchantment and 'black magic'. This bringing together of a rational culture of the elucidation of the psyche and the more obscure idea of immersion in the mystery of influences forms the very soil of Rousseau's spiritualist universe.

As Jonathan Crary has shown in *Suspension of Perception*, the mood of this first Congress of Hypnotism in 1889, in the middle of the World Fair, was far from anodyne.[24] The Paris of the *belle-époque*, discovering the primitive trance states of the Aïssouas villagers, likened the public dissemination of the Salpêtrière sessions to a kind of refutation of the magical and religious character of ecstasy: rationalistic and anti-religious,[25] but also, and

paradoxically, a contemporary redefinition of reason and religion. The stagings of Rousseau's Jungles, populated by creatures involved in operations of charm and bewitchment, refer to this subtle shifting between magic and the world or, more technically, they suggest that it was Rousseau's intention to re-inject a magical dimension into art while acknowledging that the means of enchantment might have a more clinical mechanism. This would mean moving from the figure of the sorcerer (exorcism) to that of hypnotist (magnetism), from an ancestral conception of the magician (a religion of incantation) to that of the enchanter (a psychology of suggestion). Rousseau was deliberately becoming a 'modern primitive' by maintaining a clear gap between animistic belief and unanimous fascination. This inflection came into effect at the very moment when Western thought and its new anthropological tools were openly posing the question of the disenchantment of the modern world with the disintegration of primitive faith. In 1904, Marcel Mauss had just presented his 'Sketch of a General Theory of Magic', in which he showed how 'magic is, by definition, an object of collective belief': 'Belief in magic is always *a priori*. Faith in magic always precedes experience... Magic is believed in and not perceived'.[26] What would

'perceived magic' be, if it were no longer, as in the contemporary world, 'believed' magic? It is, Mauss would reply, a magic of the senses in an opticalist rereading of ecstasy, the rule of hypnotic fascination as a securalised version of a sorcerer's enchantment.

'Illuminated': The Inspired Gaze of the Ecstasy of Love
Picasso's *Les Demoiselles d'Avignon* 1907 (fig.132), provides ample illustration of this process of modern magic, and in this context its early title, *Le Bordel philosophique* (philosophical brothel), is an invitation for comparison with the painting *Philosophical Thought* (fig.128) presented by Rousseau at the Salon des Indépendants in the same year. On the one hand there is carnal and venal love, on the other courtly and cerebral love with, in each case, a composition articulated around a dialogue between the two different worlds (the beyond and the 'down-here', the dead and the living), which subtly replays this shift from exorcism to fascination. The composition of the *Demoiselles* is at the very least demonstrative. On one side, placed on the peripheries of the painting, are the African masks discovered by Picasso in the unsettling ambience of the ethnographic collections of the Trocadero. They are vestiges of the magical age of the world, as Picasso

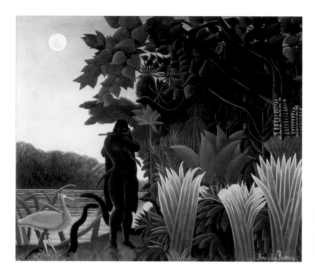

himself pointed out in his conversations with André Malraux[27] or with Françoise Gillot:

> [these masks] had been made with a sacred, magical purpose, to act as intermediaries between themselves and the unknown, hostile forces that surrounded them... And then I understood that this was the very meaning of painting. It isn't an aesthetic process; it's a form of magic interposed between the hostile universe and ourselves, a way of grasping power, by imposing a shape on both our terrors and our desires.[28]

Here Picasso was exorcising his own fear of fleshly vertigo, at the moment when he had just lost his closest friend, the Catalan painter Carles Casagemas – who killed himself after a broken love affair – and had himself possibly contracted syphilis by frequenting brothels. Eros and Thanatos are brought together in this painting in a dramatic reverse of Rousseau's intellectualised and more melancholic meditation. The masks supply the presence of black sorcery, of enchantment in its magical form, but at its centre the composition very quickly topples towards magnetic attraction. The masks are worn by only three of

the *demoiselles*, on the margins of the painting, while the two figures at the heart of the composition have an expression that recalls the bug-eyed gaze of the cataleptic figures (re)produced by Professor Charcot in the lecture-theatres of the Salpêtrière.[29] In the stylistic montage of the *Demoiselles d'Avignon* we witness the same encounter as that orchestrated in Paris in the summer of 1889, in the prevalence of primitive trance (the village of the Aïssouas, in the 'colonial' enclosure of the Fair, with snake charmers, scenes of anaesthetisation, swallowing of pebbles, broken glass or swords) and the spectacle of the new psychology (the hypnosis on display in the boulevard theatres, or the more medical form displayed at the Congress), where hypnosis is no longer the rational reverse of magic, but its contemporary aspect, the newly authentic means of achieving an 'archaic consciousness', which Rousseau was trying to find through his 'magical realism'.

The case of *The Snake Charmer* is symptomatic in this respect. The painting was made in 1907 at the request of Berthe de Rose, the mother of Rousseau's friend the painter Robert Delaunay, who had just returned from a major tour of the East Indies and Egypt. From these traveller's tales Rousseau particularly remembered the episode concerning snakes, a theme that recurs in

Fig. 133
The Snake Charmer
1907
(No. 51)

Fig. 134
Engraving showing a group of Aïssaouas at the 1889 World Fair, from Foveau de Courmelles, *Hypnotism*, Paris 1890

the works specifically devoted to the connections between hypnosis and magical practices. In *Hypnotisme et croyances anciennes* (hypnotism and ancient beliefs, 1891), Dr Régnier, an intern at the Salpêtrière, considered that the techniques of snake enchantment, known from ancient Egypt and widespread in India, are the prefiguration of modern techniques of hypnosis. We find a similar analysis in the classic work of Foveau de Courmelles, published in 1890 in the *Bibliothèque des merveilles* series of the publishers Hachette. One chapter is devoted to 'sleep provoked in animals', with a whole disquisition on the 'Aïssouas or snake charmers of Morocco', who took part in the 1889 World Fair. The author dwells upon the paralysis of animals, devotes a number of passages to the fear that some wild animals have of being struck down by the fixity of a human gaze, and opens up a discussion of 'animal somnambulism', poetically referred to as 'mesmeric sleep in animals'. He offers many different clues that shed a singular light on the frozen expressions of a number of the wild animals in Rousseau's jungle, notably those in his testamentary work, the famous *The Dream* of 1910.

Those bug-eyed animals are metaphorical references to the painter's own tetanisation under the charm of woman (from 'animal magnetism'[30] to 'the petrification of love'). Dreams of jungles are also nocturnal dreams of submission: Yadwigha, the young Polish woman with whom Rousseau had fallen in love, lying on her Louis-Philippe sofa with her paralysed lover at her feet. But also, as Cornelia Stabenow suggests,[31] Yadwigha herself is under the charm of the flute-player with whom the painter here identifies. The dream is no longer that of the young odalisque, but the more fantastical one of the painter imposing his seductive power over the woman of his dreams, the inaccessible woman brought under his control by a pictorial exorcism. This ambiguous play of reversibility had already been encountered in the libidinal device of Picasso's *Demoiselles* and in Rousseau's *The Muse Inspiring the Poet* 1908–9. In Rousseau's picture he expands not so much the bucolic metaphor of inspiration as the more electric one of amorous influence. This is illustrated by the magnetic channel of force provided by Marie Laurencin, the laying-on of hands over the stupefied eyes of Apollinaire, the subjugated poet. It follows the iconographic codes of the *fascinés* (mesmerised subjects) of the Charité or the Salpêtrière.[32] Rousseau thus meets, in the occult figure of the magnetist, not only a model for the laicisation of the 'illuminated' gaze, but the actual

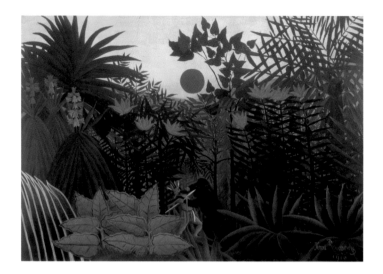

paragon of an instinctual perspective in which the eye, whether active or captive, is both the instrument of sexual (dis)possession and the tool of its exorcism.

The whole history of hypnotism is permeated with this libidinal ghost of the loving relationship. From the beginning of mesmerism, sexual authority over the female subject by the fluidic impulse of the gaze was the object of theoretical speculations developed by Charles de Villers in *Le magnétiseur amoureux* (the amorous magnetist) of 1787.[33] The relationship with the therapist is thus very quickly eroticised, and its explanation employs analogies that are male chauvinist at the very least, and which flourish in the many novels devoted to the ambient eroticism of the Salpêtrière from *Amours d'un interne* (loves of a houseman) of 1881 by Jules Claretie to the *Théâtre d'épouvante* (theatre of terror) of 1909 by André de Lorde. For if in the sexual distribution of roles within hypnotic sessions the subject is almost always female, the woman is not always an automaton and a victim, not always defenceless prey. Some authors analyse cases of doctors who have fallen in love with their female patients, but also of subjects, much less passive than one might expect, who simulate hysteria to get closer to the young doctors. It is the mystery of the enchantments of profane love, in which the woman is both the fantasy image and an actor exerting a magnetic influence.[34] Surrealism, rereading the *fin-de-siècle* iconography of hysteria, would actively return to this theme.[35] And for Breton, as in Rousseau's work, it is the vertigo of the 'hypnotic hallucination' that allows the modern individual to enter an archaic state of consciousness.[36]

It is from this angle that we can interpret the visual devices that Rousseau adopts in his dream landscapes, in particular the Jungles. Not only is the hieratic attitude of the figures, close to cataleptic tetanisation, a *mise-en-abyme* of the influence of the gaze, but the whole montage of the composition contributes to the hypnotic conditioning of the viewer. Le Douanier deliberately places a fixed luminous point, a moon or a setting sun, in the middle of his nocturnal *An American Indian Struggling with a Gorilla* 1910 (fig. 136), for example, or *Jungle with Setting Sun* c. 1910 (no. 46). The eye wanders the labyrinth overgrown with shady tropical vegetation, flies over the most picturesque zones (the devoured native, the enchanted lions), before being engulfed in the only perspectival vanishing-point, a luminous *punctum*. The intense contrast in values contributes to the creation of this visual shock, comparable with the shock that the clinicians

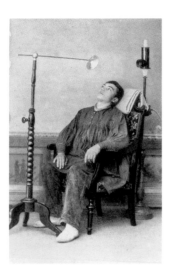

Fig. 137
'Hypnotism using a hypno-
genic mirror', from Dr E.
Bertran Rubio, *Hypnotism
and Suggestion*, Barcelona
1900

of the Salpêtrière obtained through the violent exposure of their patients to the glare of electric sparks. The vertigo of the eye fastened on a fixed point of light is in fact the fundamental, if not the founding, technique of hypnotism as defined in the mid-nineteenth century by James Braid in his *Neurhypnologie*. More generally, it is the luminescent richness of the varnish that gives Rousseau's Jungles their centripetally radiant force: 'the wave of sublime shivers (that) spreads from centre to centre',[37] to quote Blaise Cendrars' fine description.

This idea of fluidic radiation from the work is not new. It appears very early in critical literature, if we are to believe an article in *Charivari*, published in 1863, a now forgotten fantastic text that is highly revealing of a new way of thinking about the magnetism of the work of art. In a review of the 1863 Salon, entitled 'Magnetised Paintings',[38] the critic Louis Leroy recounts the adventure of a fairground hypnotist who, visiting the Salon and 'placing himself a good distance from the painting, began to look at it with singular fixity', thus charging it with such a force of suggestion that it immediately began to speak to him. The degree to which the nascent discourse of the psychological aesthetic, and its reflection upon the phenomenon of empathy, was based on the magnetic model of fascination that Rousseau (among others) reactivated at the turn of the century, is indicated by the painter's comments reported in 1913 by Stanislaus Stückgold in the journal *Der Sturm*: 'For Rousseau, the artist is a magician who becomes a living magnetic or electromagnetic field for the viewer.'[39]

The 'Fixed Vision': On Delight in the Hypnotic Space

There was one author who, alongside Henri Bergson, wrote theoretically about this specifically hypnotic conception of the work of art. This was Paul Souriau, Professor at Nancy University who, in a book entitled *La Suggestion dans l'art* (suggestion in art) of 1893, applied Bernheim's theories literally, in the service of an aesthetic reading of empathy: 'between this state of hypnosis and ecstasy over the beautiful, between the effects of suggestion and those of art, there is a singular resemblance which provides food for thought'. The development of Souriau's argument is instructive, in that it seems to foresee the mechanisms combined by Rousseau in his Jungles: 'When we look at a painting, particularly a painting that is poetic in character and which encourages day-dreaming, we forget ourselves over an insignificant detail in the canvas... Gradually, beneath our fixed gaze, the figures

blur... we look without seeing: we are in ecstasy, gripped by the painting.'[40] Souriau gives a name to this kind of 'distracted concentration': 'fixed vision', which through a simple shift of attention allows one to reach the productive layers of the unconscious, where 'new combinations of images' are possible. A scene of hypnotic sleep will engage, through a simple imitative phenomenon, a reflex of suggestibility that propels the gaze into an ecstatic relationship with the image. Or, according to a process on which Salvador Dalí was later to comment, 'certain images provoke ecstasy which in turn provokes certain images... Sometimes the images provoked by ecstasy repeat images transfigured by ecstasy.'[41]

Very soon, those who responded favourably to Rousseau absorbed this clinical approach. For Arsène Alexandre, borrowing the vocabulary of the theory of crowd suggestion (Gustave Le Bon, Gustave Tarde), 'Rousseau is an example of the attraction that an *idea* approximately rendered by visual means can exert. How can painters have abdicated this force which politicians know and employ to such great effect?'[42] As regards *The Muse Inspiring the Poet*, Apollinaire speaks of 'collective suggestion', Uhde of the 'power of suggestion', a term taken up in 1957 by Breton in his book on *l'Art magique* (magic art), which contains reproductions of two of Rousseau's most 'hypnotic' works, *The Snake Charmer* and *The Dream*. Breton speaks of the magnetic channels that envelop *The Customs Post c.*1890 (fig.138), *The Snake Charmer* or *The Dream*.[43] This is because, for him, the possible survival of a magical psyche in the modern world, the only 'way of enchanting the universe' without 'making any concessions to the spiritualist postulate',[44] passes precisely through the magnetic, subversive force of the gaze. Many Surrealist works would exploit this vein, from the self-hypnosis of Joan Miró's paintings to the *Chimères* of Victor Brauner, the Surrealist painter who was probably closest to Le Douanier's universe. Brauner's work *La rencontre du 2 rue Perrel* 1946 (fig.139) returns to the composition of *The Snake Charmer*. Haunted by the spectral presence of Rousseau, whose studio he had taken over, Brauner replays the mediumistic, automatist states[45] of his spiritualist precursor: the doubling of the self in a schizophrenia assumed under the creative form of 'permanent self-hypnosis'[46] in which Brauner, like Rousseau, associates the residual imprint of the image ('the memory image', its auratic exhalations, its ghosts) with the opticalist vertigo of fascination (the mesmeric gaze of the chimera).

According to Brauner, paintings 'almost always

Fig.138
*The Customs Post
c.*1890
(Detail of no.8)

Fig. 139
Victor Brauner
La recontre du 2 rue Perrel
1946

possess a sense of enchantment, of counter-enchantment, of magic, attraction or protection'.[47] Subjugated, enchanted, the viewer inhabits a suspended presence; he is immersed in the consciousness of the Other, as he was in his mother's womb. Libido *in utero* is the primal mirror of magnetic Eros, as though the fascination of the gaze constantly replays the repressed, pre-linguistic desire of a return to origins.[48] The psychedelic generation was not far off. Revisiting the territories of oneirism measured against the benchmark of a new clinical treatment of the gaze, this vision, accelerated under the erotomaniac influence of LSD, notably recurs in the canvases of the American artist Isaac Abrams – hyper-opticalist, acid-inspired versions of Rousseau's Jungles, a new form of immersion in the forest of dreams.

Chronology
Bibliography
Notes
List of Works

Chronology

Compiled by Nancy Ireson and Vincent Gille

Date	Rousseau	Politics	Colonies/ Explorations	Arts/Entertainment/ Communications
1844	Birth of Henri Rousseau in Laval, a market town in north-west France, to petit-bourgeois parents. His father is an ironmonger.			*The Three Musketeers* by Alexandre Dumas (1844).
1848–1860	Enters local school. Despite his reputation as a 'naive', Rousseau was reasonably educated, studying until the age of seventeen (1849).	Republican Revolution in France: the 'June Days' (1848). Start of the Second Republic (1848). Start of the Second Empire (1852). General Faidherbe's Expedition to Sénéral (1852). Baron Haussmann is named Prefect of the Seine (1853). The Crimean War (1854–6). Paris World Fair (1855). Paris boundaries expanded (1860). Abraham Lincoln becomes President of the United States (1860).	Richard Burton's expedition to the equatorial lakes of Africa (1857–9). Indian mutiny against the British (1857–8).	Herman Melville's *Moby Dick* (1851), Harriet Beecher Stowe's *Uncle Tom's Cabin* (1852). Charles Darwin's *On the Origin of Species* (1859). The review *Le Tour du Monde* founded (1860).
1861–1870	Rousseau's family moves to Angers (1861). Drawing lots, Rousseau avoids compulsory military service. He finds work as a scribe for a local solicitor. Having cheated his employer out of a small sum of money and some stamps, he has to enrol in the military. No doubt in the hope of avoiding justice, he joins the 51st infantry regiment for seven years' service (1863). Spends a month in prison for his crime (1864). Two battalions from his regiment return from the war in Mexico (1867). Death of his father. Rousseau moves to Paris (1868). Marries Clémence Boitard, his landlord's daughter (1868). Birth of first son, who dies within months (1870).	Start of the war in Mexico (1861–6). Start of the Secession war (1861–5). Abolition of Slavery in America (1865). Start of the Meji era in Japan (1868). Start of Franco-Prussian war (1870). Napoléon III abdicates (1870).	France takes control of Saigon, Mytho and Bien-Hoa (1862). France colonises Cambodia (1863).	The review *Le Petit Journal* founded (1863). *Five Weeks in a Balloon* by Jules Verne (1862). Édouard Manet's *Olympia* (1863). Invention of the game of rugby (1863). *Alice's Adventures in Wonderland* by Lewis Carroll (C.L. Dodgson) (1865). Leo Tolstoy's *War and Peace* (1869).

Date	Rousseau	Politics	Colonies/Explorations	Arts/Entertainment/Communications
1871–1880	Rousseau secures a job as clerk in the Paris Octroi, imposing duty on goods entering the city (1871). It is this job that is to earn Rousseau his nickname 'Le Douanier'. Birth of son Antoine (1872) and daughter Julia (1876). Though no exact date has been established, it is likely that Rousseau started painting in his early forties.	Siege of Paris (1870–71). The Commune and the 'Bloody Week' (1871). Formation of the German State (1870). Indian Empire proclaimed (1875). Birth of the Third Republic (1875). Paris World Fair (1878). Native American uprisings in the United States (1876–81). Construction begins on the Panama canal (1880).	H.M. Stanley and Livingstone meet on the banks of Lake Tanganyka (10 November 1871). Expeditions into the Congo by Stanley (1874–7), Savorgnan de Brazza (1875 and 1879–82). First 'living' exhibition in the Jardin d'Acclimatation (1877). Gallieni conquers the Sudan (1879–81). Zulu Wars (1879).	First Impressionist exhibition in Paris (1874). Claude Monet's *Gare St Lazare* (1874). Arthur Rimbaud's *Illuminations* (1875). Georges Bizet's *Carmen* (1875). The Facteur Cheval (1879–1912) begins building his *Palais idéal* (1879). *Journal des Voyages* founded (1876). The academic painter Bouguereau is appointed professor at the Académie Française. Böcklin's *Island of the Dead* (1880).
1881–1885	Rousseau meets the painter Félix Clément and, perhaps through him, obtains a permit to make copies at the Louvre (1884). The artist makes his debut. Rejected by the official Salon, the artist shows his works for the first time with the 'Groupe des Indépendants'. Rousseau rents his first studio, in the Impasse du Maine (1885).	Significant education reforms in France (1880–2). First of the two Boer War conflicts (1881) Formation of the Triple alliance (Austro-Hungary, Italy, Germany). Berlin conference (1884–5) to divide Africa between the European powers. Laws passed on the press (1884) and on freedom of association (1885).	The Bardo Treaty (1881): the French colonise Tunisia. Savorgnan de Brazza sets out on his third mission (1883). China renounces its hold on Vietnam (1884).	First performance of Jacques Offenbach's *Tales of Hoffmann* (1881). The Musée Grévin wax museum opens in Paris (1882). *Treasure Island* by Robert Louis Stevenson (1883). *A Rebours* by J.K. Huysmans (1884). *La Seine à Asnières* by Georges Seurat (1883). Monet begins work on his *Nymphéas*. First Salon des Indépendants (1884).
1886–1890	Rousseau begins exhibiting with the recently established Salon des Indépendants (1886). He does so almost every year, until his death. Clémence dies (1888). Rousseau visits the 1889 Paris World Fair and paints *Myself, Portrait-Landscape* 1890 (no.2). He also writes a play on the theme, *A Visit to the 1889 Exhibition*. Writes another play, *Revenge of a Russian Orphan* (1889).	Decazeville strikes (1886). Boulanger becomes Minister of War (1887), then deputy (1888), before fleeing to Brussels. Meiji Constitution established in Japan (1889). Paris World Fair (1889).	Colonial and Indian Exhibition in London (1886). Britain takes control of Somalia (1886). French Indochina created (1886). Italian occupation of Erythrée (1886–7). Binger's mission from the Niger to the Gulf of Guinea (1887–89). Clément Ader's first flight (1890).	Symbolist manifesto (1886) and exhibition (1889). Last Impressionist Salon (1888). Seurat's *Un dimanche à la Grande Jatte* (1886), Van Gogh's *Vue de Montmartre* (1886), Cézanne's *Garçon au Gilet rouge* (1888). Puvis de Chavannes participates in the decoration of the Hotel de Ville (1888–93). New displays at the Muséum (1889).

Date	Rousseau	Politics	Colonies/ Explorations	Arts/Entertainment/ Communications
1891–1895	Rousseau exhibits *Tiger in a Tropical Storm (Surprised!)* 1891 (no.43) and *A Centennial of Independence* 1892 (no.18) at the Salon des Indépendants, provoking both astonishment and sarcasm. Enters a competition to decorate the town hall in Bagnolet (1893). Retires early from the *Octroi* to paint full time (1893). Paints and exhibits *War* 1894 (no.18). Paints the portrait of the playwright Alfred Jarry, also from Laval, who publishes a lithograph of *War* in his review *L'Ymagier* (1895). Jarry lodges with Rousseau for a few months (1897).	The anarchist Ravachol is arrested (1892). Panama scandal (1892). Chicago World Fair (1893). Sadi Carnot is assassinated by the anarchist Caserio (1894). Capitan Dreyfus is denounced (1894). Ministry of Colonies established (1894). Sino-Japanese war (1894–5). Foundation of the the CGT (worker's union) (1895). Large-scale miners' strikes at Carmaux (1895).	Binger's mission to the Ivory Coast (1892–3). The Ivory Coast, Dahomey and Guinea become French colonies. Italy enters into war against Abyssinia (1894). The French enter Timbuktoo (1894). French West Africa is established (1895). French protectorate established in Madagascar (1895).	Arthur Conan Doyle's *Adventures of Sherlock Holmes* (1892), Rudyard Kipling's *The Jungle Book* (1894). Seurat's *Le Cirque* (1891) and Monet's first works of his Cathedrals series. Gauguin's first trip to Tahiti (1891). Edvard Munch's *The Scream* (1893). Antonin Dvorak's *New World Symphony* (1893) and Claude Debussy's *Prélude à l'après-midi d'un faune* (1894). First public film projection, by the Lumière brothers, in Paris (1895). First mass-produced petrol car (1891). First metal-framed building constructed in Chicago (1895).
1896–1900	Financial problems. Rousseau runs up debts with the supplier of artist's materials Paul Foinet. Moves to 14 avenue du Maine (1896). Death of his son Henri-Anatole (1897). Offers *The Sleeping Gypsy* 1897 (fig.30) to the Mayor of Laval for purchase at a considerable price, just one of many letters he sends seeking official patronage (1898). Enters a competition to decorate the town hall in Vincennes (1898). Hires a studio in the rue Vercingétorix, opposite that of Gauguin (1898). Marries his second wife, the widow Joséphine Noury (1899). Enters another competition, to paint the town hall at Asnières. Yet again, he is unsuccessful (1900). Works part time as a sales rep for the magazine *Le Petit Journal* (1900).	Zola publishes 'J'accuse' in *L'Aurore* (1898). King Ménélik II defeats Italian troops in Adoua (1896). Dreyfus's retrial begins (1899). Spain and America at war over Cuba (1897–8). Second of the Boer War conflicts (1899).	France annexes Madagascar (1896). Severe tensions between England and France due to conflicting colonial interests in the Sudan lead to the Fachoda incident (July 1898). The rebel leaders Samroy (1898) and Rabah are captured (1900). Colonial Exhibition in London (1899). Agreement made in Paris with the Sultan of Morocco gives France sovereignty in the Sahara (1900).	First exhibitions for Pierre Bonnard, Vincent Van Gogh and the Nabis at Ambroise Vollard's gallery. *The Invisible Man* by H.G. Wells, André Gide's *Les Nourritures terrestres* (1897). Colette begins writing *Claudine*. *La Nuit transfigurée* by A. Schönberg, *Maple Leaf Rag* by Scott Joplin. *The Interpretation of Dreams* by Sigmund Freud (1900). Georges Meliès builds his first studio in Montreuil. Eugène Atget begins photographing Paris. Ferdinand Zeppelin constructs his first dirigible. First metro line in Paris (Vincennes–Porte Maillot).

Date	Rousseau	Politics	Colonies/ Explorations	Arts/Entertainment/ Communications
1901–1905	Rousseau's name appears in the handbook of a city adult educational centre, the Associate Philotechnique, as a teacher of drawing and ceramic painting (1901). Death of his second wife (1903). Rousseau returns to the Jungle painting genre with his *Scouts Attacked by a Tiger* 1904 (fig.115). His debts with Foinet continue to mount (1904). Rousseau participates in the Salon d'Automne (1905). *The Hungry Lion throws itself on the Antelope* (no.49) is reproduced in *L'Illustration*. Becomes a music and drawing teacher for his neighbours (1905).	Death of Queen Victoria (1901). Theodore Roosevelt elected President in the United States (1902). Mount Pelée erupts (1902). Russia and Japan at war (1904–5). Socialist Party established. Laws passed separating the Church from the State in France (1905). Start of the Russian Revolution (1905).	Charcot Antarctic expedition (1902–5). Entente Cordiale between France and England (1904). Hereros revolt against the Germans in Namibia.	Vollard holds Picasso's first exhibition (1901). Gauguin dies (1903). First Salon d'Automne (1903). Matisse paints *Luxe, calme et volupté* (1904). *Die Brücke* formed in Dresden (1905). The 'Fauves' cause a sensation at the Salon d'Automne (1905). Picasso moves to the Bateau Lavoir. Death of Bougereau (1905). First Tour de France (1903). The first flights by the Wright brothers. The Brazilian Santos-Dumont makes a round flight from Saint-Cloud to the Eiffel Tower in less than thirty minutes.
1906–1911	Rousseau moves to his final studio, 2 bis rue Perrel. Apollinaire asks Jarry to introduce him to Rousseau (1906). Wilhelm Uhde meets Le Douanier. Rousseau exhibits at the Salon d'Automne include *The Snake Charmer* 1907 (no.51), a commission from Delaunay's mother, Berthe de Rose. Meets Max Weber (1907). A musician friend, Louis Sauvaget, persuades Rousseau to collaborate in a bank fraud. The crime is soon discovered and announced in the press. Rousseau writes letters to the judge from prison, protesting his innocence. 'I need to work on my paintings for the Salon,' he explained, 'and I need to collect my pension on the first of January'.	Tragic mining accident at Courrières (1906). Dreyfus is pardoned and reinstalled in the army (1906). San Francisco earthquake (1906). Clemenceau suppresses social movements in Paris and the southern wine-growing regions (1907). Colonial exhibition in the bois de Vincennes (1907) Léopold II hands over his African interests to the Belgium parliament (1908). Anarchist rebellion in Barcelona (1909). Major flooding of the Seine (1910). Death of Edward VII and coronation of George V (1910).	Charcot Antarctic mission (1908–9). Robert E. Peary reaches the North Pole (1909).	Death of Cézanne (1906). Jarry dies (1907). First performances by the Ballets Russes. Picasso paints *Les Demoiselles d'Avignon* 1907 (fig.132). Pathé's cinema, Le Métropole, opens (1908). Apollinaire publishes *L'Enchanteur pourissant* (1909). First Futurist Manifesto (1909). Francis Picabia's *Caoutchouc* (1909). Georges Signac becomes President of the Salon des Indépendants (1909). Raymond Roussel's *Impressions d'Afrique* (1910). Kandinsky's *Improvisations*. Delaunay's *La Tour Eiffel*. Matisse's *La Danse*. Giorgio de Chirico's *L'Enigme de l'oracle* (1910).

Date	Rousseau	Politics	Colonies/ Explorations	Arts/Entertainment/ Communications
1906–11 continued	Rousseau's naivety, demonstrated in court using his pictures as 'evidence', is his major defence (1907). Picasso and Apollinaire hold a banquet in his honour at the Bateau Lavoir, Picasso's studio in the rue Ravignon, perhaps in celebration of his eventual acquittal (1908). Rousseau paints Apollinaire and Marie Laurencin, twice, in *The Muse Inspiring the Poet* (1909). Exhibits *The Dream* 1910 (no.55) at the Salon des Indépendants, to general aclaim. Sells works to Soffici, Serge Férat and Hélène d'Oettingen, Delaunay, Vollard *et al*. The artist falls in love with Léonie, a middle-aged shop assistant, who rejects him despite his elaborate efforts to impress (1910). Heartbroken and impoverished, and suffering from an infected leg wound, Rousseau dies in September 1910. Only a few friends attend his funeral at the fosse commune (1910). The first documented Rousseau exhibition, organised by Max Weber, opens in New York (1910). The Salon des Indépendants pays homage to Rousseau with an exhibition of over forty works (1911).			Apollinaire works as an arts correspondent for *l'Intransigeant* (1910). Braque has his first exhibition at Kahnweiler's gallery; Vlaminck and Derain have their first shows with Vollard. Start of the Five Nations tournament (1910). Wilhelm Uhde holds Picasso exhibition (1910). Sonderbund exhibition in Düsseldorf brings together works by French and German artists (1910).

Select Bibliography

Books

The following bibliography focuses
on monographs and articles that
engage directly with Rousseau and his
contemporaries. In addition, it lists
more recent general scholarship that
has developed understanding of the
artist, or period works that include
significant passages. It is not exhaustive;
instead it acts as a compliment to the
bibliographies compiled for the 1984
exhibitions in Paris and New York. The
list of exhibitions mentioned, likewise,
is directed. It is limited to those that
had the most significant effects in
shaping Rousseau's reputation, in
particular, in the first half of the
twentieth century.

Maurice Aghulon
*Marianne au Pouvoir:
L'imagerie et la symbolique
républicaines de 1880 à 1914*
Paris 1998

Roland Alley
*Portrait of a Primitive:
the Art of Henri Rousseau*
Oxford 1978

Guillaume Apollinaire
Les Peintres Cubistes
Paris 1913

Guillaume Apollinaire
Chroniques d'art 1902–1918
Paris 1960

Adolphe Basler
Henri Rousseau, Le Douanier
Paris 1927

Adolphe Basler
*Henri Rousseau: Les peintres
français nouveaux*
no. 34, Paris 1929

Antony Bertram
*Henri Rousseau Le Douanier
1844–1910*
London and New York 1936

Albert Bonniers Förlag
Paris der mya konstens halle – Ank…
Stockholm 1915

Jean Bouret
Henri Rousseau
Neuchâtel 1961

André Breton
Le Surréalisme et la peinture
Paris 1965

Henri Certigny
La Vérité sur le Douanier Rousseau
Paris 1961 (Addenda no.1, 1966,
Addenda no.2, 1971)

Henri Certigny
*Le Douanier Rousseau
et Frumence Biche*
Paris 1973

Henri Certigny
*Le Douanier Rousseau et son temps:
Biographie et Catalogue Raisonné*,
vols.1 and 2, Tokyo 1984

Gustave Coquiot
Les Indépendants 1884–1920
Paris 1920

Pierre Courthion
Henri Rousseau le Douanier
Geneva 1944

Robert Delaunay
Du Cubisme à l'art abstrait
Paris 1957 (compiled by Pierre
Francastel)

Cecilia Fajardo-Hill
'Henri Rousseau and "naivety"'
Unpublished MA thesis, Courtauld
Institute, London 1994

Jill Fell
'Jarry: An Imagination in Revolt'
Unpublished PhD thesis,
Bristol 1997

Roger Fry
Vision and Design
London 1920

Maurice Garçon
Le Douanier Rousseau, accusé naïf
Paris 1953

Maximilien Gauthier
Henri Rousseau
Paris 1949

Christopher Green
Art in France: 1900–1940
New Haven and London 2000

Christopher Green
Picasso. Architecture and Vertigo
New Haven and London 2005

Roch Grey
Henri Rousseau
Rome 1922

Nancy Ireson
'Henri Rousseau: Republicanism and
Reception', Unpublished MA thesis,
Courtauld Institute, London 2000

Nancy Ireson
Interpreting Henri Rousseau
London 2005

Alfred Jarry
*Exploits and Opinions of Doctor
Faustroll Pataphysician* (1911)
Trans. and annotated by Simon Watson
Taylor, in Shattuck and Taylor (eds.),
Selected Works of Alfred Jarry,
London 1969

Alfred A. Knopf
*Great French Paintings from
the Barnes Foundation*
New York 1993

Sandra E. Leonard
Henri Rousseau and Max Weber
New York 1970

Yann Le Pichon
Le Monde du Douanier Rousseau
Paris 1981

André Lhote
*La peinture: Le Coeur et l'esprit /
Parlons peinture: essais*
Paris 1933

Fernande Olivier (ed. Hélène Klein)
Picasso et ses Amis (1933)
Paris 2001

Uta Protz
'Henri Rousseau and the relativity
of reality: From "artiste peintre
to maître populaire"'
Unpublished MA thesis, Courtauld
Institute, London 2004

Articles

Henri Rousseau
(Preface Tristan Tzara)
Une Visite à l'Exposition de 1889
Geneva 1947

Henri Rousseau
La Vengeance d'une orpheline russe
Geneva 1947

André Salmon
Henri Rousseau dit le Douanier
Paris 1927

André Salmon
Henri Rousseau
Paris 1962

Charles Schaettel
Henri Rousseau à Laval: archives et souvenirs d'atelier du Douanier
Laval 1984

Werner Schmalenbach
Henri Rousseau: Dreams of the Jungle
Munich 1998

Roger Shattuck
*The Banquet Years:
The Arts in France 1885–1918: Alfred
Jarry; Henri Rousseau, Erik Satie,
Guillaume Apollinaire* (1955)
London 1958

Kenneth Silver
*Esprit de Corps: The Art of the Parisian
Avant-garde and the First World War*
London 1989

Philippe Soupault
Henri Rousseau, Le Douanier
Paris 1927

Virginia Spate
*Orphism: The evolution of non-
figurative painting in Paris 1910-1914*
Oxford 1979

Cornelia Stabenow
Henri Rousseau 1944–1910
Cologne 2001

Jérome and Jean Tharaud
Le Gentil Douanier et un Artiste Maudit
Paris 1929

Wilhelm Uhde
Henri Rousseau
Paris 1911 (Düsseldorf 1914)

Wilhelm Uhde
Cinq Maîtres primitifs
Paris 1949

Dora Vallier
Tout l'oeuvre peint de Henri Rousseau
Paris 1970

Dora Vallier, trans. S.M. Rowe
Henri Rousseau
Bergamo, Italy 1979

Ambroise Vollard
Souvenirs d'un Marchand de tableaux
Paris 1937

Klaus Werner
Henri Rousseau
Berlin 1976

R.H. Wilenski
Modern French Painters
London 1940

Christian Zervos
Rousseau
Paris 1926

Arsène Alexandre
'Le Salon des Indépendants'
Comoedia, Paris, 3 April 1909

Arsène Alexandre
'La vie et l'oeuvre d'Henri Rousseau,
peintre et ancien employé de l'Octroi'
Comoedia, Paris, 19 March 1910

Guillaume Apollinaire
'Le Douanier', *Les Soirées de Paris*,
no.20, Paris, 15 Jan. 1914
(incorrectly dated 1913)

Adolphe Basler
'Le Douanier Henri Rousseau'
L'Art vivant, Paris, 15 Oct. 1926

Adolphe Basler
'Recollections of Henri Rousseau'
The Arts, no. 11, June 1927

Germain Bazin
'La Guerre du Douanier Rousseau'
Bulletin des Musées de France, no.2,
Paris, 1946

Jeanne Bernard-Rousseau
'La petite fille de Rousseau raconte
la vie de son grand-père' *Arts*,
17 Oct. 1947

Jeanne Bernard-Rousseau
'Rélévé par Jeanne, sa petite-fille,
le secret du Douanier Rousseau'
Elle, Paris, 10 Feb., 1961

Davin Bryers
'Berners, Rousseau, Satie:
3 peintres musiciens'
Studio International, vol.192, no.984,
Nov.–Dec. 1976

Pierre Cabanne
'Le procès en mystification d'
un naïf de Génie' *Arts*, 15-21 Feb., 1961

Blaise Cendrars
'Le Douanier Rousseau'
Der Sturm, no.178–9,
Berlin, Sept. 1913

Henri Certigny
'Aspects inconnus du Douanier
Rousseau', *Galerie des Arts*,
no.57, Paris, Oct. 1965

Henri Certigny
'Une source inconnu du Douanier
Rousseau', *L'Oeil*, no.291,
Paris, Oct. 1979

Henri Certigny
'Le Douanier Rousseau et la source
du Centenaire de l'independance',
L'Oeil, no. 309, Paris, April 1981

Henri Certigny
'Le Stratageme Oriental'
Beaux Arts, hors-serie, 1984

Charles Chassé
'Les fausses gloires: d'Ubu Roi au
Douanier Rousseau', *La Grande
Revue*, no.111, Paris, April 1923

Charles Chassé
'Les défenseurs des fausses gloires: d'Ubu Roi au Douanier Rousseau'
La Grande Revue, no.114, Paris, May 1924

Pierre Courthion, 'Henri Rousseau', *L'Oeil*, no.46, Paris, Oct. 1958

Robert Delaunay
'Henri Rousseau, dit le Douanier'
L'Amour de l'art, no.7, Paris, Nov. 1920

Robert Delaunay
'Mon ami Henri Rousseau'
Tous les Arts, Paris, 1952 (serialised)

Sonia Delaunay-Terk
'Images inédites du Douanier Rousseau'
Tous les Arts, Paris, 31 July 1952

Bernard Dorival
'Robert Delaunay et l'oeuvre du Douanier Rousseau'
L'Oeil, no.267, Paris, Oct. 1977

Ingeborg Eichmann
'Five Sketches by Henri Rousseau'
Burlington Magazine, London, June 1938

Maximilien Gauthier
'La maison natale du Douanier Rousseau'
Beaux Arts, 3 Dec. 1937

Maximilien Gauthier
'Henri Rousseau and Alfred Jarry'
Beaux Arts, 11 Feb. 1938

Waldemar George
'Le Miracle de Rousseau'
Les Arts à Paris, no. 18, Paris, July 1931

Fernand Girod
'Le Mediumisme et l'art'
La Vie Mysterieuse, Paris, 10 Nov. 1911

Roch Grey
'Souvenir de Rousseau',
Les Soirées de Paris, no.20, Paris, 15 Jan. 1914 (incorrectly dated 1913)

Nancy Ireson
'Le Douanier as Medium?
Henri Rousseau and Spiritualism'
Apollo, London, June 2004

Nancy Ireson
'Tristan Tzara and the plays of Henri Rousseau'
Burlington Magazine, London, Sept. 2004

Anatole Jakovsky
'Le Douanier et les contrebandiers'
Jardin des Arts, no.79, June 1961

Anatole Jakovsky
'Le Douanier Rousseau, savait-il peintre?'
Médicine de France, no.218, Paris, 1971

Simone Kapferer
'Adieu de Paris aux cendres du Douanier Rousseau'
Arts, Paris, 14 Feb. 1947

Yves Le Diberder
'Rousseau s'inspirait-il des photos et des gravures?'
Arts, 26 Dec. 1947

Yann Le Pichon
'Les sources de Rousseau révélées' *Arts*, no.809, Paris, Feb. 15–21, 1961

André Lhote
'Exposition Henri Rousseau'
Nouvelle Revue Française, Paris, 1 Aug. 1923

Maurice Raynal
'Le Banquet Rousseau'
Les Soirées de Paris, no.20, Paris, 15 Jan. 1914 (incorrectly dated 1913)

André Salmon
'L'Entrée au Louvre du Douanier Rousseau'
L'Art Vivant, Paris, Nov. 1925

Eveline Schlumberger
'Jungle de Rêve'
Connaissance des Arts, Paris, Sept. 1984

George Schmits
'Apollinaire, le Douanier Rousseau et l'art naif'
La Revue Général, Dec.1971

Richard Shone
'Noble Savage: Analysing the work of Henri Rousseau'
Artforum, New York, Jan. 2001

Philippe Soupault
'La prétendue naiveté du Douanier Rousseau rejoint la vision des maitres du XVe siècle'
Connaissance des Arts, no.77, Paris, July 1958

Max Terrier
'Le Portrait du Douanier Rousseau par Robert Delaunay au Musée du Laval' *Bulletin des Musées*, Paris, May 1949

Jan Thompson
'Painting and the Creative Imagination'
Unpublished lecture, IMA Dublin, 22 Nov. 2001

Jules Tronel
'Origines mayennaises du Douanier Rousseau Notes et Documents artistiques'
La Mercure de France, no.723, 1 Aug. 1928

Tristan Tzara
'Le rôle du temps et de l'espace dans l'oeuvre du Douanier Rousseau'
Arts de France, no.2, 1962

Masaomi Unagami
'Le Japon du Douanier Rousseau'
UNAC, Tokyo, 1987

Dora Vallier
'Le canapé rouge du Douanier'
XX siècle, no.25, Paris, June 1965

Dora Vallier
'L'Emploi du pantographe dans l'oeuvre du Douanier Rousseau'
La Revue de l'art, no.7, Paris, 1970

Germain Viatte
'Henri Rousseau dit le Douanier'
Arts de France, no.2, Paris 1962

Max Weber
'Rousseau as I Knew Him'
Arts News, vol. 41, 15 Feb. 1942

Christan Zervos
'Henri Rousseau et le sentiment poétique'
Cahiers d'art, no.9, Paris, 1926

Exhibition Catalogues/
Publications linked to Exhibitions

Entries are listed in chronological order

Max Weber
Introduction to Rousseau Exhibition
'291' Gallery, New York,
18 Nov.–8 Dec. 1910

Ed. Wassily Kandinsky and Franz Marc
The Blaue Reiter Almanac (1912),
trans. H. Falkenstein, London 1974

Wilhelm Uhde (preface)
Henri Rousseau
Bernheim-Jeune et Cie gallery, Paris,
28 Oct.–9 Nov. 1912

Roger Fry ('The French Group')
Second Post-Impressionist Exhibition
Grafton Galleries, London,
5 Oct.–31 Dec. 1912

International Exhibition of Modern Art Association of American Painters and Sculptors
69th Infantry Armory, New York,
15 Feb.–15 March 1913

Cent ans de la peinture française: exposition au profit du Musée des Beaux-Arts de Strasbourg
Hôtel de la Chambre syndicale de la curiosité et des Beaux-Arts, Paris,
15 March–20 April 1922

Paintings by Henri Rousseau 'Le Douanier'
Lefèvre Gallery, London, Oct. 1926

Peintres naïfs: Henri Rousseau, Camille Bombois, Adolf Dietrich
Kunsthalle Basel, 1933

Exposition Henri Rousseau (1844–1910)
Galerie Paul Rosenberg,
Paris, 3–31 March 1937

Chefs d'oeuvre de l'art français
Palais National des Arts,
Paris, summer–autumn 1937

Les Maîtres de l'art independant 1895-1937
Petit Palais, Paris, June–Oct. 1937

Les Maîtres Populaires de la réalité
Arthur Tooth and Sons Ltd.,
London, 17 Feb.–12 March 1938

Masters of Popular Painting: Modern Primitives of Europe and America
The Museum of Modern Art,
New York, 1938

Daniel Catton-Rich
Henri Rousseau
The Art Institute of Chicago and The Museum of Modern Art, New York,
1942 (revised edn 1946)

Henri Rousseau, Le Douanier: Exposition organisée par le Front National des Arts pour commémorer le centenaire de la naissance de Henri Rousseau
Musée d'art moderne de la ville de Paris, 22 Dec.–21 Jan. 1945

Henri Rousseau (preface by Tristan Tzara)
Sidney Janis Gallery, 15 East 57th Street, New York, 1951

Henri Rousseau dit 'le Douanier': Exposition de son cinquantenaire
Galerie Charpentier, 76 Rue Faubourg Saint-Honore, Paris, 1961

Henri Rousseau
Galeries Nationale de Grand Palais,
Paris 14 Sept. 1984–7 Jan. 1985;
The Museum of Modern Art, New York,
5 Feb.–4 June 1985; pub. New York 1985

Götz Adriani
Henri Rousseau. Der Zoller: Grenzänger zur Moderne
Kunsthalle Tübingen, Tübingen,
Cologne 2001; pub. New Haven and London 2001

Notes

References to The Museum of Modern Art, New York, have been abbreviated to MoMA, New York.

Any translations from French and other languages have been produced by the author of the chapter under discussion.

Frances Morris
Jungles in Paris
pp.12–27

1 Guillaume Apollinaire, 'Watch Out for the Paint!', *L'Intransigéant*, 18 March 1910, reprinted in LeRoy Breunig (ed.), *Apollinaire on Art: Essays and Reviews, 1902–1918*, New York 1972, p.68.

2 Henri Rousseau in the pamphlet of the Salon des Indépendants, Paris 1910.

3 Carolyn Lanchner and William Rubin, 'Henri Rousseau and Modernism', in *Henri Rousseau*, exh. cat., Galeries nationale du Grand Palais, Paris, 1984–5; MoMA, New York 1985; pub. New York 1985, p.76.

4 Guillaume Apollinaire, 'Le Douanier', *Les Soirées de Paris*, no.20, 15 Jan. 1914, repr. in Breunig 1972, p.340.

5 G. Lenotre, *L'Exposition de Paris 1889*, vol.1, no.19, p.15.

6 Henri Rousseau, *Une Visite à L'Exposition de 1889*, Geneva 1947, p.77.

7 Félix Vallotton, *Le Journal Suisse*, 25 March 1891.

8 Fernande Olivier, *Picasso et ses amis*, Paris 1933, p.83.

9 Henri Rousseau, *La Vengeance d'une orpheline russe 1899*, Geneva 1947, p.27.

10 Paul Escudié, Journal, 21 March 1911, quoted in Eric Baratay and Elisabeth Hardouin-Fugier, *Zoo: A History of Zoological Gardens in the West*, London 2002, p.194.

11 William Rubin, 'Modernist Primitivism: An Introduction', in *Primitivism in Twentieth Century Art: Affinity of the Tribal and the Modern*, exh. cat., MoMA, New York 1984, p.11.

12 Roger Shattuck, *The Banquet Years*, New York 1955, p.84.

13 Apollinaire, 'Le Douanier', in Breunig 1972, p.349.

14 Apollinaire, cited in MoMA 1985, p.77.

15 Andre Breton, *L'Art magique*, Paris 1959, p.37. Cited in MoMA 1985, p.79.

16 Arsène Alexandre, 'La Vie et l'oeuvre d'Henri Rousseau, peintre et ancien employé de l'Octroi', *Comoedia*, Paris, 19 March 1910.

17 Apollinaire, 'Le Douanier', in Breunig 1972, p.350.

18 Wilhelm Uhde, *Rousseau (Le Douanier)*, Bern 1948.

19 Henri Rousseau, autobiographical note, Paris, 10 July 1895, reprinted in MoMA 1985, p.256.

20 Alexandre in *Comoedia* 1910.

21 Cited in Shattuck 1955, p.61

22 Ambroise Vollard, *Recollections of a Picture Dealer*, London 1936, p.215.

23 Uhde 1948.

24 Alfred Barr, 'Preface and Acknowledgment', in *Masters of Popular Painting*, exh.cat., MoMA, New York 1938, p.9.

25 Ibid.

26 Roger Cardinal, 'Toward an Outsider Aesthetic', in Michael D. Hall and Eugene W. Metcalf, Jr. (eds.), *The Artist Outsider: Creativity and the Boundaries of Culture*, Washington 1994, p.21.

27 For example, Rousseau's contribution, 'a special case', is dealt with in a separate entry devoted to 'The exotic and the naïve', outside the main text, in the recently published mega-volume, Hal Foster, Rosalind Krauss, Yve-Alain Bois and Benjamin Buchloh, *Art Since 1900: Modernism, Antimodernism, Postmodernism*, London 2005, p.66.

Christopher Green
Souvenirs of the Jardin des Plantes
pp.28–47

1 Guillaume Apollinaire, 'Le Douanier', *Les Soirées de Paris*, no.20, Paris, 15 Jan. 1914, p.25.

2 André Salmon uses the phrase 'a beautiful revolutionary act', in his *La jeune peinture française*, Paris 1912, pp.12–13. Both he and Adolphe Basler underline the parallel between the emergence of Rousseau and that of African art. See Salmon, *Henri Rousseau dit Le Douanier* (1927), Paris 1929, p.26, and Basler, *Henri Rousseau (sa vie – son oeuvre)*, Paris 1927, pp.8–9.

3 André Breton's passage on *The Dream* appears in his *Le Surréalisme et la peinture*, Paris 1965, pp.293–4. *The Sleeping Gypsy* made 520,000 francs at the John Quinn sale in 1926, a price made much of in the press at the time, despite what seems to have been blatant manipulation. *The Snake Charmer* was offered by the collector Jacques Doucet to the Louvre as a promised gift in 1922 and accepted in 1925. The picture entered the museum in 1935. For further material on Rousseau's major exotic pictures, see Nancy Ireson's contribution to this catalogue, and also the notes in *Henri Rousseau*, exh. cat., Galeries nationales du Grand Palais, Paris 1984–5; MoMA, New York, 1985; pub. New York 1985; and Götz Adriani, *Henri Rousseau*, exh. cat., Kunsthalle Tübingen 2001; pub. New Haven and London 2001.

4 Very little serious analysis has been applied to Rousseau's work for over thirty years apart from contributions to the catalogues of the major exhibitions of 1984–5 and 2001. See note 3.

5 The facts of Rousseau's military service were established by Henri Certigny. He served as a 'second-class soldier' for four years. His regiment is recorded to have sent 500 troops to Veracruz for the Mexican expedition in 1865, but he was certainly not among them. Certigny, *La Vérité sur le Douanier Rousseau*, Paris 1961, pp.63–4.

6 Robert Delaunay fell for the stories in the monograph he drafted on Rousseau shortly after his death, which was partially published in Delaunay, 'Mon ami Rousseau', *Arts et lettres*, Paris, Aug.–Sept. 1952. Wilhelm Uhde remembered Rousseau's 'beautiful voice' as he told his Mexican stories. Uhde, *Henri Rousseau*, Paris 1911, pp.23–4.

7 Arsène Alexandre, 'La Vie et l'oeuvre d'Henri Rousseau, peintre et ancien employé de l'Octroi', *Comoedia*, Paris, 19 March 1910.

8 Roch Grey, 'Henri Rousseau', *L'Action*, no.7, Paris, May 1921, pp.1–3; also *Henri Rousseau*, Rome 1922.

9 Sandra E. Leonard uses Max Weber's unpublished memoirs as evidence that Rousseau pinned up drawings made in the Jardin des Plantes in his studio. So far as I know, none of these have been found. Leonard, *Henri Rousseau and Max Weber*, New York 1970, pp.39–40. See also Adolphe Basler, 'Le Douanier Henri Rousseau', *L'Art vivant*, Paris, 15 Oct. 1926, p.777.

10 For more on the impact of material from the French colonies, especially in the 1889 Paris World Fair and in the popular travel literature of the period, see the contributions of Vincent Gille and Nancy Ireson to this catalogue. For French colonial expansion, see Charles-Robert Ageron, *France coloniale ou parti coloniale*, Paris 1978, and Robert Aldrich, *Greater France: A History of French Overseas Expansion*, London 1996.

11 In 1904, the popularising science magazine, *La Nature*, reported that on a good summer Sunday, there could be up to 50,000 visitors to the zoo at the Muséum, of which 8,000 took in the Zoological Galleries in the Muséum d'histoire naturelle, within the Muséum complex, too. Already in 1891, there was official anxiety at the crowds that piled up in the narrow corridors between the cages on such days. See 'x', 'Le Jardin des Plantes. Autrefois et aujourd'hui, Part VII', *La Nature*, no.1644, Paris, 26 Nov. 1904, p.414. Also, Alphonse Milne-Edwards, *Musée d'histoire naturelle. La menagerie. Rapport au ministre de l'instruction publique*, Paris 1891, p.13.

12 Critical official reports on conditions at the zoo in 1849 and 1856 were followed in 1891 by the zoo's Director Alphonse Milne-Edwards's report to the Ministre de l'instruction publique pleading for an increase in funding; there had been none since 1868 (see note 11). He failed. Two decades later, the Paris deputy, Paul Escudié, published 'L'enfer des bêtes' on the front page of the mass-circulation newspaper, *Le Journal*, 21 March 1911, writing of 'superb wild animals' in 'the mud and revolting filth' slowly rotting in 'ridiculously confined jails'. No significant reconstruction was actually achieved until the 1930s. For the history of the zoo, see especially Yves Laissus, 'Les Animaux du Jardin des Plantes, 1793–1934', in Laissus and Jean-Jacques Petter, *Les animaux du Muséum, 1793–1993*, Paris 1993; and Yves Laissus, 'Adieu à la galerie de zoologie', in Pierre Béranger and Michel Butor, *Les Naufragés de l'arche*, Paris 1994.

13 Milne-Edwards used his own budget, rather than capital funding, to finance the building of the aviary in 1888, so vital did he think the need. See Laissus 1999, p.160.

14 An early historian of zoos reported in 1912 on a 'reticulated python' that had survived fourteen years, and an Indian python sixteen years in the zoo at the Muséum. Gustave Loisel, *Histoire des menageries de l'antiquité à nos jours*, Paris 1912, p.145. For the construction of the Reptile House and the sculpture by Bourgeois, see Laissus 1999, p.147, and Loisel 1912, p.142.

15 Crucial evidence of the animal populations in the zoo is found in animal inventories now in the archives of the Muséum d'histoire naturelle for the following years: 1885, 1887, 1890, 1897, and 1904–10. The cages for the big cats were built 1818–21, and remained in use until 1931. The limited outdoor enclosure was added in 1866, but the only big cat given real outdoor freedom in Paris during the period was a single panther which, in the 1900s, could be seen in a large, open-air cage in the Jardin d'Acclimatation; the 'freedom' of this animal was made much of in the department store publication owned by Rousseau, *Bêtes sauvages*, Galeries Lafayette, Paris, c.1900, p.181.

16 Milne-Edwards 1891, p.22.

17 The paired monkeys in the foreground are vague approximations of 'dog-faced' species like the mandrills and the baboons, of which examples are recorded in the zoo's inventories (see note 15) for 1906 and 1907. Their performance, however, brings to mind performing chimpanzees more than such species. There are reports of a crowd-pulling performing chimpanzee called Consul at the Folies-Bergère in 1903; he wore a top hat and rode a bike. Henri Coupin, *Singes et singeries. Histoire anecdotique des singes*, Paris 1907, p.20.

18 One or two chimpanzees are recorded in the zoo inventories (see note 15) for each year between 1906 and 1910, none between 1885 and 1905. No other orang-utan is recorded. No gorilla is recorded at all in the inventories of the period.

19 The glass houses were already mentioned as a success in M. Boitard, *Le Jardin des Plantes. Description et moeurs des mammifères de la menagerie et du Muséum d'histoire naturelle*, Paris 1842, p.liii.

20 The project got underway in 1877, and installation took place in the 1880s. The galleries opened on 22 July 1889. See Laissus and Petter 1993, pp.185–8. In the play Rousseau wrote shortly after the 1889 Paris World Fair, he has his leading man visit the Louvre and the Jardin des Plantes (in that order) before he took his wife and maid to the Eiffel Tower. Henri Rousseau, *Une Visite à l'Exposition de 1889, Vaudeville en 3 actes et 10 tableaux Avec 2 illustrations'*, Geneva 1947, Act 2.

21 Gaston Tissandier, 'Nouvelles Galeries de zoologie', *La Nature*, no.854, Paris, 12 Oct. 1889, pp.311–4.

22 Figures from Laissus and Petter 1993, pp.186–8.

23 Milne-Edwards 1891.

24 For the new importance given to the colonial role of the Muséum in the 1880s, see Laissus and Petter 1993, pp.186–8. The stress that Milne-Edwards placed on this role is clear in Milne-Edwards, 'Les relations entre le Jardin des plantes et les colonies françaises', *La Revue des cultures colonials*, Paris 1899. See also Dr A. Loir, 'Le Jardin coloniale de Nogent-sur-Marne', *A Travers le Monde*, no.6, Paris, 11 Feb. 1905.

25 It is important to acknowledge Yann Le Pichon's fundamental contribution to the study of Rousseau, in making available the extraordinary material now housed in the archives of the Musée du Vieux-Château at Laval. Le Pichon, 'Les source de Rousseau révélées', *Arts*, no.809, Paris, 15–21 Feb. 1961, and *Le Monde du Douanier Rousseau*, Paris 1981. See also *Bêtes sauvages c.1900*.

26 Another instance is the stress placed on the first-hand sources for the illustrations in the travel magazines from which Rousseau formed his cuttings collection. Before the advent of half-tone photographic reproduction in the early twentieth century, even the distinctly romantic engravings, often signed 'Riou', that appeared in *Le Tour du Monde*, for instance, were routinely captioned to stress the fact that they were based either on sketches made on the spot, on photographs or, at worst, on verbal accounts from witnesses. Diary-like forms of presentation reinforced the authentic effect of many texts. A particularly telling example of such a text is the translation of H.M. Stanley's *In Darkest Africa*, which was serialised in *Le Tour du Monde* in 1890.

27 Milne-Edwards 1891, p.11, boasts about the 'perfect exactitude of the proportions and carriage of the animal' achieved. Key developments in preservation techniques were the invention of Bécoeur's arsenic soap in the late eighteenth century and the publication of Boitard's *Manuel du naturaliste préparateur* in 1835. For developments in taxidermy, see Laissus and Petter 1993, p.177.

28 Frémiet left his mark on the Jardin des Plantes with a series of sculptures installed there from 1885. For this, see Luc Vezin, *Les artistes au Jardin des Plantes*, Paris 1990, pp.84ff, and Philippe Dagen, *Le Peintre, le poète, le sauvage. Les voies du primitivisme dans l'art français*, Paris 1998, pp.12–13.

29 For *Gorilla*, see Vezin 1990 and Dagen 1998 (in which it is called *Gorilla Abducting a Woman*), and the entry on Frémiet's *Orang-utan Strangling a Native of Borneo*, in Anne Pingeot et al., *Sculpture française XIXe siècle*, Paris 1982.

30 There is no record either that he obtained one of the cards that allowed artists special admittance to the zoo from 6 a.m. every day. For the card system for artists, and for Frémiet as a teacher at the Jardin, see Vezin 1990, pp.94, 106.

31 The species to which the two main performers are related, mandrills and baboons, were not known as performers in circuses and music halls. Performing monkeys were also usually in costume. See also note 17.

32 Ardengo Soffici, in *La Voce*, no.40, Florence, 15 Sept.1910, cited in Soffici, 'La France à l'étranger. Le peintre Henri Rousseau', in Lucile Dubois (ed.), *Le Mercure de France*, Paris, 16 Nov. 1910, p.750.

33 E. Oustalet, 'Les Modifications de couleur chez les animaux. Le merle blanc et le panthère noir', *La Nature*, no.913, Paris, 29 Nov. 1890. The unsigned engraving is captioned: 'The black panther, after the living specimen in the Muséum d'histoire naturelle in Paris.'

34 Among the cuttings Rousseau kept were images of the lotus and of yuccas from back numbers of *Le Magasin Pittoresque*; both were published by Le Pichon. See Le Pichon 1981, pp.154, 168. Rousseau's giant blooms far exceed the scale of any known flower, and often evoke cactus flowers as strongly as any other. Louis Vauxcelles, incidentally, saw cactus flowers in *The Dream*. Vauxcelles, *Le Gil Blas*, Paris, 20 March 1910. Something of the fascination that threatening or dangerous plants could exert is conveyed by Henri Coupin's popularising *Les Plantes originales*, Paris, 3rd edn 1904, which has chapters on 'vampire plants', 'giant plants' and so on.

35 Le Pichon picks out the bird source for *The Snake Charmer* and suggests the Salon painting connection, which he illustrates. See Le Pichon 1981, p.203.

36 The deer species is 'David's deer'; it is accompanied by a specimen of 'Ducker's antelope'. The deer's habitat is established, like that of macaco monkeys, in *Bêtes sauvages c.1900*, pp.20, 50.

37 Clearly, Gauguin's Tahitian work is not necessarily to be thought of as presenting a unified picture of a people, a place and a mythology, but both his texts and his titles could allow such a thing. It is possible for Roger Marx, in 1903, to write that Gauguin was 'an ethnographer eminently capable of deciphering the enigma of faces and attitudes', cited in Charles Morice (ed.), 'Quelques opinions sur Paul Gauguin', *Le Mercure de France*, Paris, Nov. 1903, p.418.

38 Soffici in *La Voce* 1910. Rousseau himself, it seems, did not care about such absurdities, or at least did not bother to avoid them. Writing to the dealer Ambroise Vollard, 26 Sept. 1909, offering *Fight Between a Tiger and a Buffalo* (no.45) for sale, he titles the picture 'The Combat of a Tiger and an American Buffalo', obviously unconcerned that there were no tigers in America to attack buffalos. Cited by Germain Viatte, 'Henri Rousseau dit le Douanier', *Arts de France*, no.2, Paris 1962, p.333.

39 An example of a work with a single model is *Tiger Hunt c. 1895* (no.44), which Le Pichon has shown was directly based on an engraving of a work of 1895 by Rudolph Ernst, published in the mass-circulation *Le Monde illustré*. See Le Pichon 1981, p.159.

40 Dora Vallier has convincingly established that Rousseau used the pantograph to scale up images like this from small-scale sources like postcards and book illustrations. This certainly helps explain the glaringly unconvincing way in which his animal groups relate to the forest setting around them in many of the Jungle pictures. Vallier, 'L'Emploi du pantographe dans l'oeuvre du Douanier Rousseau', *La Revue de l'art*, no.7, Paris, 1970.

41 The bronze that Rousseau used as a model was cast in 1854, its companion placed on the fountain in 1856. I am grateful to Philip Ward-Jackson who photographed the bronzes in situ.

42 Maurice Denis, 'Définition du néo-traditionnisme', *Art et critique*, nos.23, 30, Paris, Aug. 1890; as cited in Dagen 1998, p.101.

43 'Rousseau, all sensibility, produces the greatest possible contrast to an epoch in which dead scientific analysis has diverted intuition', Delaunay in *Arts et lettres* 1952.

44 Victor Segalen, *Essai sur l'exotisme*, Paris 1904–18, reprinted in Segalen, *Oeuvres complètes*, Paris 1995, p.749: 'The sensation of exoticism: which is nothing other than the notion of the different; the perception of the diverse.'

45 This area of the zoo was nick-named the 'vallée Suisse', significantly enough.

46 Milne-Edwards 1891, p.10.

47 Alexandre 1910.

48 Most famously he did so in his response to the literary critic A. Dupont's doubts regarding the couch, dated 1 April 1910, and published by Apollinaire in Apollinaire 1914.

49 Uhde 1911, p.43.

50 I discuss Rousseau the Republican in relation to dominant notions of the 'People' in Third Republic France, in 'The Great and the Small: Picasso, Henri Rousseau and "The People"', in Christopher Green, *Picasso. Architecture and Vertigo*, New Haven and London 2005.

51 Milne-Edwards's installation of the great hall of the Zoological Galleries was attacked precisely for its lack of clear scientific logic by his colleague Georges Pouchet, Professor of Comparative Anatomy at the Muséum. In his 1889 annual report, Milne-Edwards openly took pleasure in the fact that he had grouped specimens 'artistically'. See Laissus in Béranger and Butor 1994, pp.186–8.

52 Tristan Tzara, preface, in Rousseau 1947, p.24.

53 For the conjunction of the 'decorative' (as pictorial construction) with the 'naive' in the milieu of Gauguin, Albert Aurier and Denis, see Dagen 1998, pp.100–1.

54 Gauguin died on the island of Atuona in the Marquesas Islands on 8 May 1903. By 31 Oct., a room had been dedicated to him at the Salon d'Automne. On 4 November, Vollard opened an exhibition of fifty paintings and twenty-eight drawings.

55 It would be precisely Gauguin's 'vigorous naivety' that Denis would celebrate at his death. Maurice Denis, 'L'Influence de Paul Gauguin', *L'Occident*, Paris, Oct. 1903. For the cult of naivety centred on Jarry's and Rémy de Gourmont's periodical *L'Ymagier* (in which Rousseau's *War* lithograph was published), see Dagen 1998, pp.100–1.

56 For Albert Aurier, Gauguin is both 'a decorator' and 'a painter of ideas' ['peintre idéiste']. Aurier, 'Le symbolisme en peinture', *Le Mercure de France*, Paris, March 1891.

57 Apollinaire, in 1914, calls him both 'a decorator' and 'a painter' (by which he means a producer of 'pure painting'). Apollinaire 1914, p.25. At the time of the picture's showing at the Salon d'Automne, *The Hungry Lion* itself was seen to have brought out the qualities of Rousseau as 'a decorator'. Michel Hoog refers to pieces published in *Le Soleil* and *Le Temps*. See MoMA 1985, p.175. For telling passages on Rousseau as pictorial constructor, see Uhde on the 'virgin forests' and Poussin, and Delaunay on Rousseau's control of the picture surface. Uhde 1911, p.50, and Delaunay, 'Henri Rousseau dit le Douanier', *L'Amour de l'art*, no. 7, Paris, Nov. 1920, p.28.

58 I join those from Uhde to Rubin and Lanchner who have accepted Rousseau as a painter who chose what came to be called his 'naivety', who understood how his work related to that of Gauguin and others who fit the Modernist grand narrative. See Uhde 1911, and Carolyn Lanchner and William Rubin, 'Henri Rousseau and Modernism', in MoMA 1985.

59 For an analysis that brings out the degree to which Gauguin's Tahitian work was concerned with the corruption of 'the primitive', see Dagen 1998, pp.78–9. For Gauguin's disappointment on arriving in Tahiti, see Claire Frèches-Thory, 'Premier séjour à Tahiti, 1891–1893', in *Gauguin, Tahiti*, exh. cat., Grand Palais, Paris, 2003–4, p.69.

60 According to Leonard, Max Weber in his unpublished memoir recalls 'a little "Banana Carriers" in the tropics' at the Salon d'Automne of 1907, where Rousseau showed *The Snake Charmer*; Leonard 1970, pp.15–16. For Georges Spitz's photographs and Gauguin's Tahitian paintings, see Elizabeth C. Childs, 'Paradise Redux: Gauguin, Photography, and Fin-de-Siècle Tahiti', in Dorothy Kosinski, *The Artist and the Camera, Degas to Picasso*, New Haven and London 1999; and Françoise Heilbrun, 'La Photographie "service des arts"', in Grand Palais 2003–4, pp.43–61. It is possible that Rousseau either saw or even bought a print of the source for his picture when Spitz exhibited his Tahitian photographs at the 1889 World Fair, before Gauguin's first departure for Oceania. Interestingly, Tahitians retained ownership of the land, and so, exceptionally, Tahiti did not become a plantation colony. See Peltier 2003–4, p.24.

61 Most relevant in my view are Picasso's *Three Women* 1908, and Derain's 1908 *Bathers*.

62 This is certainly clear from a close look at *Le Tour du Monde* between 1904 and 1910, and around the date of Rousseau's *Surprised!* (no.43). Progress was certainly the watchword in the periodical's presentation of the Marseille Exposition coloniale of 1906. For more on this, see Vincent Gille's and Nancy Ireson's contributions to this catalogue.

63 I discuss such images of ethnic 'types' in 'Looking for Difference: *Les Demoiselles d'Avignon* again', in Green 2005. Picasso made a collection of postcards of West African 'types', which are good examples of the genre. They have been published in Anne Baldessari, *Picasso and Photography. The Dark Mirror*, exh. cat., The Museum of Fine Arts, Houston, and Paris 1997.

64 There is clear enough evidence that Rousseau was not immune to the normal racist opinions of his time in *Une Visite à l'Exposition de 1889*, though the play makes fun of the ignorance of the Bretons whom it follows around the exhibition.

65 Publication of Buffon's *Histoire naturelle générale* began in 1749.

66 The authors express their fascination with the idea of a combat between the two, noting, however, that their habitats in the natural world never overlap, and so such a thing could not happen in the wild.

67 *Bêtes sauvages* c.1900, p.152. The model for the jaguar in this painting is taken from the illustration to this entry on a 'Young Jaguar', where the creature is shown jumping up at its keeper (the black victim in the painting is the evacuated silhouette of the keeper). Despite the way in which the entry dwells on the fierceness of the jaguar, and its readiness to attack men, the scene photographed could be taken as playful. Rousseau uses it to create an uncompromisingly violent image.

68 *Bêtes sauvages* c.1900, pp.10, 37, 131.

69 Coupin 1907, pp.92–3.

70 See note 68.

71 C.f. E.-T. Hamy, 'Un Gorille géant de la rivière Sangha (Congo)', *La Nature*, no.1679, Paris, 29 July 1905. A detailed account, with measurements, of a huge specimen.

72 The hunter-explorer is named as de Chaillu (no source is given), Coupin 1907, pp.59–62.

73 When the stuffed animal display featuring a lion and antelope (fig.25) was restored recently, the curators of the Muséum decided that current attitudes would not tolerate the bloodiness of the scene, so the gore, painted on faithfully for a more bloodthirsty clientele in 1889, has been cleaned off.

74 *Tropical Forest with Monkeys* 1910. The Norton Simon Foundation, Pasadena, California.

Vincent Gille
Illusion of Sources–Sources of Illusion
pp.48–63

Text translated by Jennifer Thatcher.

1 Wilhlem Uhde, *Cinq Maîtres primitifs*, Paris 1949, pp.23–4.

2 Henri Rousseau, letter to Apollinaire, 14 Aug. 1908, reprinted in *Les Soirées de Paris*, no.20, Paris, 15 Jan. 1914.

3 Wilhelm Uhde, *Henri Rousseau*, Paris 1911, reprinted in Uhde 1949, pp.38–9.

4 We may well ask, in so much as these works depict locations along their route, if these choices were not suggested, in the east and the west particularly, by the four boat-bus lines – Tuileries–Suresnes, Charenton–Auteuil, Austerlitz–Auteuil and Louvre–Ablon – that were managed, from 1890, by the General Parisian Boat Company.

5 Ibid.

6 Uhde 1911, reprinted in Uhde 1949, p.52.

7 Pierre Courthion, *Henri Rousseau le Douanier*, Geneva 1944, p.30. Rousseau knew precisely where to find the pittoresque Paris: in his play *Une visite à l'Exposition universelle*, after the Eiffel and the Trocadero, he led his merry band of Breton 'savages' on a Vaudeville tour through the boulevards, from the Madeleine to the Bastille.

8 Montparnasse and Plaisance, where he lived, are examples of districts that had not yet been unified, where a calm, rich area (Notre-Dame des Champs) rubbed shoulders with the bustling and lively area of the rue de la Gaîté; whereas the north (now the 14th arrondissement) was still very much countryside: wheatfields, meadows, stables and large farms.

9 Bernard Marchand, *Paris, histoire d'une ville, xix-xxe siècles*, Paris 1993, p.102.

10 If, like many painters, he was attracted by the sights of the Seine and certain suburban landscapes, Rousseau, on the other hand, never presented the boulevards, streets and stations of central Paris, nor its inhabitants. To take only two examples: when, like Rousseau, Edvard Munch painted the bridge of Saint-Cloud, he allowed a large advertisement for *Le Petit Journal* to appear on the side of a house, an element of the modern city that Rousseau would never have reproduced in any of his canvases. Camille Pissarro, in his extensive series of 1898–1903, focused on the boulevards of Montmartre and the Italiens, the avenue de l'Opéra, the Tuileries gardens , the Vert-Galant and the Pont Neuf.

11 Laure Beaumont Maillet, *Atget's Paris*, Paris 2000, p.17.

12 Arsène Alexandre, 'La Vie et l'œuvre d'Henri Rousseau, peintre et ancien employé de l'Octroi', *Comoedia*, Paris, 19 March 1910.

13 Ibid.

14 Marcel Monnier, *France noire*, Paris 1894, pp.105–6. Writer and journalist Monnier travelled extensively: in South America, from Peru to the mouth of the Amazon in 1886, then in 1891–2 to the Ivory Coast and Sudan, as a photographer on the Binger expedition. He was one of the first, thanks to his 'Photosphere', to have photographed the tropical rainforest. These images were exhibited in 1892 at the l'Ecole nationale des Beaux-arts, where Rousseau might have seen them.

15 Essentially, *Le Tour du Monde*, created in 1860 by Edouard Charton, previous founder of *Le Magasin pittoresque* in 1833. Biannual and with a rather scientific bent, *Le Tour du Monde* became *A Travers le Monde*, a more popular weekly, in 1896. The *Journal des Voyages et des Aventures de terre et de mer*, a weekly magazine, was also launched by Charton in 1877. These magazines published illustrated accounts of travel and exploration. It should be noted, however, that in them, as in *L'Illustration*, images depicting tropical rainforests were scarce. Illustrations featuring animals and/or animal fights, on the other hand, were widespread.

16 He often ignored plausibility in doing so: lions and antelopes, for example, live in the savannah and it is highly unlikely that a Siberian tiger would cross paths with an American buffalo.

17 Jean-Camille Fulbert Dumonteil, *Guerrières et guerriers du Dahomey au Jardin zoologique d'acclimatation*, 1891, booklet published by the Zoological Gardens at the Muséum to coincide with this exhibition.

18 Ernest Renan, 'L'Exposition universelle', in *Le Magasin pittoresque*, 1889, pp.159–60.

19 Pol-Neveux, 'Le Village canaque', in Ludovic Baschet (ed.), *La Revue de l'Exposition universelle de 1889*, vol.I, Paris 1889, p.250.

20 E. Monot, *L'Exposition de 1889*, Paris 1890, pp.223, 226, quoted by Sylvaine Leprun in 'Paysages de la France extérieure', la mise en scène des colonies à l'exposition du centenaire', in 'L'Exposition de 1889', *Le Mouvement social*, no.149, Oct.–Dec. 1989. By the same author, see *Le Théâtre des colonies*, Paris 1986.

21 F.G. Dumas, 'La Décoration de l'Exposition universelle', in *La Revue de l'Exposition universelle de 1889*, vol.II, pp.100–1.

22 If one takes, for example, the 1909 illustrated supplement of *Le Petit Journal*, of which, according to Salmon, Le Douanier would have been 'sales inspector', one notes that, of the 104 reproductions that year, twenty-eight were devoted to political events and social figures (official visits, the military, etc.); twenty-five to human-interest stories and natural disasters; sixteen to animals (mostly deadly); fourteen to picturesque images of the world; twelve to cars, airships and other aeroplanes; and nine to the colonies (battles, executions and barbaric activities).

23 See Nicolas Bancel, Pascal Blanchard, Gilles Boetsch, Eric Deroo and Sandrine Lemaire, *Zoos humains*, Paris 2004. See also Pascal Blanchard et al., *L'autre et nous*, Paris 1995.

24 In Paris, no fewer than four performances – plays, reviews and pantomimes – plus an exhibition on the Champ de Mars for Behanzin, the Dahomeans and Amazonians between 1891 and 1893.

25 Quoted by Elisabeth Hardoin-Fugier in *Le Peintre et l'animal en France au xixe siècle*, Paris 2001, p.159.

26 'Ce qu'on voit à l'Exposition', *Le Petit Français illustré*, 20 July 1889, p.263.

27 Pol-Neveux, 'Le Village canaque', *La Revue de l'Exposition universelle de 1889*, vol. 1, Paris 1889, p.250.

28 'Les Dahoméens au champ-de-Mars', *Le Petit Journal*, 22 April 1893.

29 Max Milner, quoted by Clément Chéroux in 'La Dialectique des spectres, la photographie spirite entre récréation et conviction', in Chéroux, Andreas Fischer et al., *la photographie et l'occulte*, Paris 2004, p.53.

30 Bernard Comment, *Le xixe siècle des panoramas*, Paris 1993, p.31.

31 The *Battle of Rezonville* by E. Detaille and A. de Neuville, the *Siege of Paris* by Charles Castellani, *Reichshoffen* by Stephen Jacober and Théophile Poilpot, *Panorama of the century* by Henri Gerveix and Alfred Stevens, *Tout Paris* by Charles Castellani, *Monde antédéluvien* by Charles Castellani, *View of Rio de Janeiro at Sunset* and, finally, two panoramas installed in the Oil Pavilion and the Pavilion of the General Transatlantic Company, both by Théophile Poilpot.

32 G. Mareschal, 'Les Panoramas de l'Exposition', *La Nature*, 1900, p.399. The arrival of cinema rapidly replaced the vogue for moving panoramas.

33 Comment 1993, p.68.

34 Edouard Charton, introduction to issue no.1 of *Le Tour du Monde*, 1860.

35 Recall here that Alfred Jarry had entrusted him with his 'Painting machine'.

36 This, of course, foreshadowed *L'Afrique fantôme* by Michel Leiris. See Leiris, *Roussel & Co*, ed. Jean Jamin, introduction and notes by Annie Le Brun, Paris 1998.

37 Apollinaire understood this well, spinning countless yarns about Rousseau, each more fantastic than the last, but nonetheless containing many grains of truth.

38 André Breton, *Le Surréalisme et la peinture*, Paris 1965, p.367.

39 Ibid., p.165.

40 Alexandre 1910.

41 Novalis, *Fragments*, trans. Armel Guerne, Paris 1973, p.103.

Rousseau's Paintings
Nancy Ireson

Rousseau and his World
pp.66–81

1 Robert Delaunay, 'Mon ami Henri Rousseau', *Tous les Arts*, Paris, 7 Aug. 1952, p.9.

2 Wassily Kandinsky, 'On the Question of Form', *The Blaue Reiter Almanac*, ed. Kandinsky and Marc (1912), trans. H. Falkenstein, London 1974, p.178.

3 Letter from Henri Rousseau to the *Juge d'Instruction*, 6 Dec. 1907: 'Je suis l'Inventeur du portrait-paysage', reprinted in Maurice Garçon, *Le Douanier Rousseau, accusé naïf*, Paris 1953, p.16.

4 In the autumn of 1889, the authorities had erected a monument in the courtyard of the Louvre to commemorate the balloon ascent taken during the siege of Paris by the politician Gambetta. Reported in *L'Illustration*, no.94, 10 Oct. 1889, p.332.

5 Henri Certigny, *La vérité sur le Douanier Rousseau*, Paris 1961, pp.82-5.

6 Christopher Green discusses Rousseau's portraiture in relation to the conventions of the *cartes de visite* photograph in 'The Great and the Small: Picasso, Henri Rousseau and "The People"', in *Picasso, Architecture and Vertigo*, New Haven and London 2005.

7 Henri Rousseau, letter to Joséphine, 21 June 1899, 'Lettre inédite à la bien-aimée', *Arts de France*, 1962, p.320.

8 Letter from Mme Rousseau to Robert Delaunay, cited by Max Terrier in 'Le Portrait du Douanier Rousseau par Robert Delaunay au Musée de Laval', *Bulletin des Musées*, no.IV, May 1949, pp.103–4, now in Fonds Delaunay, Bibliothèque Kandinsky Research and Documentation Centre, Musée national d'art moderne (MNAM)/CCI, box 61, 9.

9 Sonia Delaunay-Terk, 'Images inédites du Douanier Rousseau', *Tous les Arts*, Paris, 31 July 1952, p.8.

10 Henri Rousseau, cited in Gustave Coquiot, *Les Indépendants 1884–1920*, Paris 1920, p.132.

11 See 'Documents', *Henri Rousseau*, exh. cat., Galeries nationale du Grand Palais, Paris, 1984–5; MoMA, New York 1985; pub. New York 1985, pp.255–61.

12 Wilhelm Uhde, *Henri Rousseau*, Paris 1911, p.12.

13 This letter, or at least a transcript of it, is now kept in the Fonds Delaunay, box 61, 2.

14 Rousseau explained this in a letter to the *Juge d'Instruction* during his 1907 imprisonment, dated 13 Dec. 1907. Reprinted in Garçon 1953, p.16.

15 André Salmon, *Henri Salmon dit le Douanier*, Paris 1927, p.10.

16 Certigny reprints a French translation of this article in the appendices of *Le Douanier Rousseau et son temps: Biographie et Catalogue Raisonné*, vol. I, Tokyo, 1984, with the reference Stanislaus Stückgold, 'Henri Rousseau', *Der Sturm*, Berlin 1913; but this does not correspond with the original journal.

17 Christian Zervos, *Rousseau*, Paris 1927, p.16.

18 Uhde 1911, p.47. Uhde describes the picture as '*L'impression d'un être bizarre et neurasthénique*'.

19 Fernand Olivier, *Picasso et ses Amis* (1933), ed. Hélène Klein, Paris 2001, p.99.

20 Maurice Raynal, 'Le Banquet Rousseau', *Les Soirées de Paris*, no. 20, Paris, 15 Jan. 1914, p.69.

21 Delaunay, 'Mon ami Henri Rousseau', *Tous les arts*, Paris, 4–11 Sept. 1952, p.10. The expression Rousseau used is 'à toi toutes mes pensées'.

22 Uhde 1911, plate 49.

23 See Claire Frèches-Thory's essay in this catalogue, pp.168–81.

24 Henri Rousseau, 'Inscription pour un portrait dans un paysage', *Les Soirées de Paris*, 15 Jan. 1914, p.65.

25 Tristan Tzara, preface to Henri Rousseau, *Une Visite à l'Exposition de 1889*, Geneva 1947, p.17.

26 Uhde 1911, p.6.

The Familiar Made Strange
pp.82–95

1 Wilhelm Uhde, *Henri Rousseau*, Paris 1911, pp.20–21.

2 Ibid. p.19.

3 Henri Certigny, *Le Douanier Rousseau et son temps: Biographie et Catalogue Raisonné*, vol. I, Tokyo, 1984, pp.518–19.

4 Letter from Henri Rousseau to the critic André Dupont, reproduced in *Les Soirées de Paris*, Paris, Jan. 1913, p.57. The artist explains: 'Si j'ai conservé ma naïveté, c'est parce que M. Gérôme … m'a toujours dit de la conserver.'

5 Anecdote recalled by Weber and recorded in Daniel Catton Rich, *Henri Rousseau*, exh. cat., The Art Institute of Chicago and MoMA, New York (1942), 1946 edn, p.52.

6 Roger Shattuck, *The Banquet Years: The Arts in France 1885–1918*, London 1955, p.69.

7 Tzara used *The Football Players* to describe Rousseau's 'simultaneity' in his preface to Rousseau's *Une Visite à l'Exposition de 1889*, Geneva 1947. See Nancy Ireson, 'Tristan Tzara and the plays of the Douanier Rousseau', *Burlington Magazine*, London, Sept. 2004, pp.616–21.

8 The film historian Richard Abel has likened other aspects of Mélié's compositional strategy, rooted in theatrical display and magic tricks, to the look of Rousseau's canvases. Abel, *The Ciné Goes to Town: French Cinema 1896–1914*, Berkeley, California 1994, p.72.

9 In a letter from Rousseau to Jarry dated 26 June 1894, a copy of which exists in the Fonds Tristan Tzara, Paris, TZR.C.3 545, 'Letter from Rousseau to an unknown correspondent', Rousseau alludes to collecting Jarry's belongings to move into his home.

10 Uhde 1911, pp.20–21.

11 For details of this transaction and others, see Germain Viatte, 'Lettres inédites à Ambroise Vollard', *Arts de France*, 1962, pp.330–6.

12 Uhde 1911, p.21.

13 This letter is now conserved in the archives of the Musée du Vieux-Château, Laval.

14 Ireson in *Burlington Magazine* 2004.

15 Henri Rousseau, 'L'Etudiant en goguette', unpublished typescript (made by Tzara), Bibliothèque Jacques Doucet Littéraire, Fonds Tristan Tzara, Paris, T2R 762, n.p.

16 Uhde 1911, p.46.

17 L. de la Brière, *Le Soleil*, 20 Aug. 1886. cited by Certigny, *Le Douanier Rousseau et son temps: Biographie et catalogue raisonné*, vol. 1, Tokyo 1984, p.32.

18 Charles Baudelaire, 'The Painter of Modern Life', *The Painter of Modern Life and Other Essays*, London 2001, p.12.

Images of War and Peace
pp.96–109

1 Willy Rogers, reporting on *The Representatives of Foreign Powers Coming to Greet the Republic as a Sign of Peace*, 'Au Salon des Indépendants', *La Presse*, no.54000, 22 March 1907, p.2.

2 For example, Philippe Soupault, *Henri Rousseau, Le Douanier*, Paris 1927, p.9.

3 Alfred Jarry, 'Les Indépandants', *Essais d'Art Libre*, May–July 1894, pp.124–5.

4 Louis Roy, 'Un Isolé: Henri Rousseau', *Le Mercure de France*, March 1895, p.350.

5 Alfred Jarry, 'Comment on se procura de la toile' in Jarry, *Gestes et opinions du Docteur Faustroll*, Paris 1898.

6 Most of Rousseau's scrapbooks, save the one illustrated, are now lost, but a photocopy of a more comprehensive example, made by Henri Certigny, is available in the Fonds Wildenstein, Paris.

7 Henri Rousseau, cited by Arsène Alexandre in 'La vie et l'oeuvre d'Henri Rousseau: peintre et ancient employé de l'Octroi', *Comoedia*, no.901, Paris, 19 March 1910, p.3.

8 Robert Delaunay, 'Mon Ami Henri Rousseau', *Tous les Arts*, Paris, 21 Aug. 1952. Delaunay recalls that 'On avait trouvé son projet trop révolutionnaire'.

9 Alexandre in *Comoedia* 1910.

10 Anon., 'Le Douanier Rousseau précise', *Paris-Journal*, 19 Aug. 1910: Rousseau wrote that Puvis de Chavannes addressed him thus:'Monsieur Rousseau, je n'aime pas le coloris criard de certaines toiles qui figurent dans ce Salon, mais j'aime le vôtre, et vous avez vaincu une grande difficulté dans l'art: c'est que vous avez fait ressortir l'un sur l'autre deux rouges". C'était à propos de deux bonnets phrygiens. Les danseurs, que je représentais à l'époque de 1789, dans les costumes tels, étaient coiffés de ces bonnets, et dans le mouvement les deux têtes se touchaient.'

11 Alexandre 1910.

12 Wilhelm Uhde, *Henri Rousseau*, Paris 1911, p.61.

13 For a full cast list see the catalogue entry by Michel Hoog in *Henri Rousseau*, exh. cat., Galeries nationale du Grand Palais, Paris, 1984–5; MoMA, New York 1985; pub. New York 1985, p.178.

14 The statue in the canvas was identified in Yann Le Pichon, *Le Monde du Douanier Rousseau*, Paris 1981, p.200.

15 Alexandre in *Comoedia* 1910.

16 Henri Certigny, *Le Douanier Rousseau et son temps: Biographie et Catalogue Raisonné*, vol. I, Tokyo, 1984, p.498.

17 Robert Lestrange, *Tintamarre*, 31 March 1907, cited in Certigny 1984, p.500.

18 Uhde 1911, p.21. Uhde discusses a work entitled *Sovereigns*; this does not appear in the author's list of Rousseau's Salon submissions and thus it is probably an alternative title for *Representatives*: 'On aurait mené à Charenton celui qui aurait voulu y trouver des qualités.'

19 Hélène Seckel-Klein, *Picasso Collectionneur*, Paris 1998, pp.212–15.

20 Christopher Green, 'The Great and the Small: Picasso, Henri Rousseau and "The People"', in Green, *Picasso, Architecture and Vertigo*, New Haven and London 2005.

21 Fernande Olivier, *Picasso et ses amis*, (1933), Paris 2001 edn, p.126.

22 For an in-depth discussion of the French government's line on art and artists, see Pierre Vaisse, *La Troisième République et les peintres*, Paris 1995, pp.55–8.

23 Michel Hoog identified the lion here as the Lion of Belfort in MoMA 1985, p.170. Maurice Agulhon discusses Rousseau's 'Republican' lions in *Marianne au Pouvoir: l'imagerie et la symbolique Républicaines de 1880 à 1914*, Paris 1989, p.146.

24 Alexandre in *Comoedia* 1910.

25 Guillaume Apollinaire, cited by Maurice Raynal, 'Le Banquet Picasso', *Les Soirées de Paris*, no.20, Paris, 15 Jan. 1914, p.71.

26 Dora Vallier, *Henri Rousseau*, Paris 1979, pp.31–2.

27 Henri Certigny 1984, p.158. The number of the regiment on the cannon does not comply with the soldier's own: but Certigny argues that this was because such numbers were not painted on weapons.

The Peaceful Exotic
pp.110–123

1 Blaise Cendrars, *Prose du Transsibérien et de la Petite Jeanne de France* (1913), Paris 1947 edn, pp.37–8.

2 Arsène Alexandre, 'La Vie et l'oeuvre d'Henri Rousseau, peintre et ancien employé de l'Octroi, *Comoedia*, Paris, 19 March 1910.

3 Professor Charles E. Olmsted of the Department of Botany of the University of Chicago, cited in Daniel Catton Rich, *Henri Rousseau*, exh. cat., The Art Institute of Chicago and MoMA (1942), revised edn 1946, New York, p.64.

4 Max Weber, 'Rousseau as I Knew Him', draft manuscript of unpublished book, c.1942, p.51. Courtesy of Joy Weber.

5 Sandra E. Leonard, *Henri Rousseau and Max Weber*, Richard L. Feigen & Co., 1970, p.42.

6 Wilhelm Uhde, *Henri Rousseau*, Paris 1911, p.54.

7 These sources were identified in Yann Le Pichon, *Le Monde du Douanier Rousseau*, Paris 1981, pp. 168–9 and p.167 respectively.

8 Réne-Marc Ferry, 'Le Salon d'Automne II' *L'Eclair*, no.6527, 11 Oct. 1906, p.2.

9 Camille Mauclair, *Art et Décoration*, Paris 1906, vol.XX, second semester catalogue raisonnée. p.486.

10 Charles Etienne, *La Liberté*, 8 Oct. 1906, catalogue raisonnée, p.486.

11 Schulte Vaerting, 'Etat humain ou état animal?', *Action*, no.7, Paris, May 1921, pp.42–9.

12 André Salmon, *La jeune peinture français*, Paris 1912, p.12. Salmon describes Rousseau as 'Un oncle d'Amerique nègre-blanc'.

13 Louis Vauxcelles, supplement to *Le Gil Blas*, Paris, 5 Oct. 1906, p.2. Vauxcelles describes the work as 'Une tapisserie picturale où il y a des feuillages verts, des anthropopithèques qui ont l'air très méchant et le hibou de *Monsieuye* Ubu'.

14 Henri Rousseau, *Une Visite à l'Exposition de 1889*, Geneva 1947.

French Landscapes
pp.124–139

1 Mr H.P. Stephenson, *The Evening Post*, New York, vol.109, 26 Nov. 1910, p.9.

2 Wilhelm Uhde, *Henri Rousseau*, Paris 1911, p.41.

3 Ibid.

4 Ibid. p.39.

5 Christian Zervos, 'Henri Rousseau et le sentiment poétique', *Cahier d'art*, no.9, Paris, 1926.

6 Max Weber, cited in Sandra E. Leonard, *Henri Rousseau and Max Weber*, New York 1970, p.19, taken from *Memoir of Max Weber*, transcript of tape-recorded interviews, conducted by Mrs Carol S. Gruber, Jan.–March 1958, the Oral History Collection of Columbia University, New York.

7 Uhde 1911, p.36.

8 Robert Delaunay, 'Henri Rousseau, dit le Douanier', *L'Amour de l'art*, no.7, Paris, Nov. 1920, p.229.

9 Wassily Kandinsky, unpublished letter to Robert Delaunay, 20 Oct. 1911, BNF Manuscripts, microfilm 7025, p.75.

10 Delaunay in *L'Amour de l'art* 1920, p.228. Delaunay describes Rousseau as 'la synthèse vivante d'une multitude anonyme de simples artisans, depuis le peintre d'enseignes et le peintre verrier, jusqu' au décorateur de boutiques et de cabarets de villages'.

11 Delaunay reproduced a selection of entries from Rousseau's account book in 'Mon ami Henri Rousseau', *Tous les Arts*, 21–28 Aug. 1952, p.9.

12 Letter from Rousseau to Max Weber, Leonard 1970, p.29.

13 Uhde 1911, p.8.

14 Adolphe Basler, 'Le "Douanier" Henri Rousseau', *L'Art vivant*, Paris, 15 Oct. 1926, p.778.

15 See Vincent Gille's essay in this catalogue, pp.48–63.

16 Serge Férat, unpublished letter to Robert Delaunay, April 1911, BNF Manuscripts, microfilm 7025, p.53.

17 Tristan Tzara's preface to Henri Rousseau, *Une Visite à l'Exposition de 1889*, Geneva 1947, pp.16–17.

The Dangerous Exotic
pp.140–155

1 Unpublished letter to Rousseau from M. Cotton, following his visit to the 1891 Salon des Indépendants, Fonds Delaunay, Fonds Delaunay, Bibliothèque Kandinsky Research and Documentation Centre, Musée national d'art moderne (MNAM)/CCI, box 61.

2 Anon., unpublished poem addressed to Rousseau after his exhibition of *Tiger in a Tropical Storm (Surprised!)* (no. 43) in 1891, featured in the artist's scrapbook. Transcribed from photographs in the Fonds Delaunay, Photothèque CGP, nos. 96–88/96–595, verse two.

3 Félix Vallotton, *Le Journal Suisse*, 25 March 1891.

4 Octave Uzanne, *Visions de notre heure*, Paris 1899. Original report, under the pseudonym la Cagoule, in *Echo de Paris*, 20 April 1898; Henri Certigny, *Le Douanier Rousseau et son temps: Biographie et Catalogue Raisonné*, vol. I, Tokyo, 1984, p.318.

5 Furetières, *Le Soleil*, Paris, 21 Feb. 1904, Certigny 1984 p.425.

6 Uhde 1911, p.11.

7 Germain Viatte, 'Lettres inédites à Ambroise Vollard, *Arts de France*, Paris, 1962, p.332.

8 See Christopher Green's essay in this catalogue, pp.28–47.

9 The engraving, after a painting by Rudolph Ernst entitled *Soirée Triumphale*, appeared in *Le Monde Illustré* in 1895. Yann Le Pichon, *Le Monde du Douanier Rousseau*, Paris 1981, p.159.

10 Robert Delaunay, 'Mon ami Henri Rousseau', *Tous les Arts*, Paris, 7 Aug. 1952.

11 Delaunay, 21–28 Aug. 1952.

12 Anonymous, 'Le Salon Indépendant', *Le Courier du Soir*, Paris, 22–23 March 1891.

13 M.L. de Fourcaud, 'Le salon d'automne', *Le Gaulois*, no.10230, Paris, 17 Oct. 1905, p.2.

14 *L'Événement*, 17 Oct. 1905.

15 *Le Mercure de France*, 1 Dec. 1905, describes the paintings as 'l'agrandissement colorié d'une gravure sur bois, illustration d'une vieille Bible allemande'.

16 *Le Soleil*, 17 Oct. 1905.

17 Henri Rousseau, letter to Max Weber, 20 March 1908, in Sandra E. Leonard, *Henri Rousseau and Max Weber*, New York 1970, pp.45, 86. Rousseau reports that visitors were 'tout d'accord à dire que je suis primitif moderne bien entendu'.

18 Leonard 1970, p.36.

19 André Salmon, *Henri Rousseau dit le Douanier*, Paris 1927, p.26.

20 Delaunay, 21–28 Aug. 1952.

21 Arsène Alexandre, 'La semaine artistique', *Comoedia*, Paris, 3 April 1909. Alexandre claims that Rousseau's works might 'exerceraient sur nos esprits une dangereuse fascination'.

22 See Nancy Ireson, 'Le Douanier as Medium: Henri Rousseau and Spiritualism', *Apollo*, June 2004, pp.80–87.

Mysterious Meetings
pp.156–165

1 Ardengo Soffici, 'La France à l'étranger. Le peintre Henri Rousseau', *Le Mercure de France*, 16 Oct. 1910, p.46; original article in Italian, *La Voce*, no. 40, Florence, Sept. 1910.

2 Unknown author, *Le Petit Journal*, no.17249, 19 March 1910, Paris, p.2.

3 Louis Vauxcelles, *Le Gil Blas*, 20 March 1910.

4 *Le Démocratie sociale*, 23 April 1910, Paris. This press clipping is in the collection in the Fonda Tristan Tzara, Paris.

5 *The Dream* attracted comparison with Persian tapestries in a piece by an anonymous writer in the *Gazette de France*, 19 March 1910, and with Ingres in an article by Edouard Sarradin in *Le Journal des Débats*, 19 March 1910, Fonds Tzara.

6 Arsène Alexandre, 'La Vie et l'oeuvre d'Henri Rousseau, peintre et ancien employé de l'Octroi, *Comoedia*, Paris, 19 March 1910.

7 This event was celebrated in an article by André Salmon, 'L'Entrée au Louvre du Douanier Rousseau', *L'Art Vivant*, Paris, Nov. 1925, pp.29–30.

8 Michel Hoog in *Henri Rousseau*, exh. cat., Galeries nationale du Grand Palais, Paris, 1984–5; MoMA, New York 1985; pub. New York 1985, pp.189–90.

9 Sonia Delaunay-Terk, 'Images inédites du Douanier Rousseau', *Tous les Arts*, Paris, 31 July 1952.

10 Philippe Soupault, 'La légende du Douanier Rousseau', *L'Amour de L'Art*, vol.7, no.10, pp.333–7, Oct. 1926.

11 Guillaume Apollinaire, *Les Peintres Cubistes*, Paris (1913), 1986 edn, p.64.

12 Robert Delaunay, typed draft manuscript of 'Mon ami Henri Rousseau', Fonds Delaunay, Fonds Delaunay, Bibliothèque Kandinsky Research and Documentation Centre, Musée national d'art moderne (MNAM)/CCI, box 61, p.3. In a handwritten correction to the text, Delaunay writes how his generation are 'obligés de lutter au hasard de leur sensibilité, de leur éducation pour se liberer avant de retrouver les elements de la simple tradition'.

13 Waldemar George, 'Le Miracle de Rousseau', *Les Arts à Paris*, no.18, Paris, July 1931, p.4.

14 Sarradin in *Le Journal des Débats* 1910.

15 André Salmon, *Henri Rousseau dit le Douanier*, Paris 1927, p.38.

Claire Frèches-Thory
From Sarcasm to Canonisation
pp.168–181

Text translated by Jennifer Thatcher.

I am very grateful to Gwendoline Lorique for her precious help in researching the documentary material in the preparation of this essay.

1 Press cutting inserted by Rousseau into one of his notebooks, reproduced in Gilles Plazy, *Le Douanier Rousseau, un naïf dans la jungle*, Paris 1992, p.2.

2 Wilhelm Uhde, *Henri Rousseau*, Paris 1911, p.56.

3 See the unpublished text by Rousseau sent to the publisher Girard Coutances for his *Portraits du Prochain Siècle*; cf. Philippe Soupault, *Henri Rousseau, Le Douanier*, Paris 1927, p.11.

4 Götz Adriani, *Henri Rousseau*, exh. cat., Kunsthalle Tübingen, Cologne 2001, p.15.

5 Epitaph by Guillaume Apollinaire engraved on Rousseau's tomb at Laval:

'Gentil Rousseau tu nous entends
Nous te saluons
Delaunay sa femme Monsieur
 Queval et moi
Laisse passer nos bagages en
 franchise à la porte du ciel
Nous t'apportons des pinceaux
 des couleurs et des toiles
Afin que tes loisirs sacrés dans
 la lumière réelle
Tu les consacres à peindre comme
 tu tiras mon portrait
La face des étoiles'

[Hear us gentle Rousseau
We hail you
Delaunay his wife Monsieur Quével and I
Allow our baggage through freely
 at heaven's gate
We will bring you brushes colours canvases
So that your sacred spare time in the
 one true light
May be devoted to painting as you
 did my portrait
The face of the stars]

6 Article reproduced in Plazy 1992, p.4.

7 Ibid, p.6.

8 Gustave Kahn, *Le Mercure de France*, 1 Aug. 1923.

9 'Monsieur Rousseau, je n'aime pas le coloris criard de certaines toiles qui figurent dans ce Salon, mais j'aime le vôtre, et vous avez vaincu une grande difficulté dans l'art: c'est que vous avez fait ressortir l'un sur l'autre deux rouges". C'était à propos de deux bonnets phrygiens. Les danseurs, que je représentais à l'époque de 1789, dans les costumes tels, étaient coiffés de ces bonnets, et dans le mouvement les deux têtes se touchaient". Puvis de Chavannes, 'Le Douanier Rousseau précise', *Paris-Journal*, 19 Aug. 1910.

10 On Gauguin and Rousseau, see Carolyn Lanchner and William Rubin in *Le Douanier Rousseau*, exh. cat., Galeries Nationale de Grand Palais, Paris, 1984–5; MoMA, New York 1985; pub. Paris 1984, pp.43–5.

11 Signac's archives do not provide any information on the relationship between Signac and Rousseau. I am grateful to Françoise Cachin for this information.

12 See Félix Vallotton, *Le Journal Suisse*, 25 March 1891, p.62.

13 See Jean Ajalbert, 'La leçon du douanier', *Beaux-Arts*, 1 Oct. 1937.

14 This is also Philippe Soupault's opinion in 'La prétendue naïveté du Douanier Rousseau rejoint la vision des Maîtres du XVe siècle', *Connaissance des Arts*, no.77, Paris, July 1958.

15 Alfred Jarry, born Laval, 1873; died Paris, 1907.

16 Alfred Jarry, *L'Art Littéraire*, May–June 1894; *Essais d'Art libre*, May–June 1894.

17 On Jarry and Rousseau, see Dora Vallier, *Henri Rousseau* (1911), Paris 1961 edn, pp.48–56; and Henri Béhar, 'Jarry, Rousseau et le populaire', in Grand Palais 1984–5, pp.25–9.

18 On *L'Ymagier*, see Emmanuel Pernoud, 'De l'image à l'Ymage, les revues d'Alfred Jarry et Rémy de Gourmont', *Revue de l'Art*, no. 115, 1997, pp.59–65.

19 Letter quoted in Vallier 1961, p.81; according to this author, the meeting would have taken place between April 1906 and November 1907, when Jarry died. Henri Certigny, on the other hand, dates it no earlier than 1907; see Henri Certigny, *La Vérité sur le Douanier Rousseau*, Paris 1961, pp.263, 279–81.

20 Guillaume Apollinaire, *Chroniques d'art, 1902–1918, textes réunis avec préface et notes par L. Breunig* (1960), Paris 1981, p.68.

21 Ibid. pp.96–7.

22 Ibid. pp.206–10.

23 Issue wrongly dated 1913.

24 Florent Fels, *Propos d'artistes*, Paris 1925, p.144.

25 See William Rubin and Carolyn Lanchner in Grand Palais 1984, p.52; and Christopher Green, *Picasso: Architecture and Vertigo*, New Haven and London 2005, chap. 4. I am grateful to Christopher Green for sending me the text prior to its publication.

26 Maurice Raynal, 'le "Banquet"Rousseau', *Les Soirées de Paris*, no. 20, 15 Jan. 1914, wrongly dated 1913; André Salmon, 'le Douanier dîne chez Picasso', *Souvenirs sans fin, 1908–1920*, Paris 1956, pp.48–58; Gertrude Stein, *Autobiographie d'Alice Toklas*, Paris 2000, pp.111–16; Fernande Olivier, *Picasso et ses amis* (1933), Paris 2001, pp.95–8.

27 'Nous sommes réunis pour célébrer ta gloire,
Ces vins qu'en ton honneur nous verse Picasso,
Buvons-les donc, puisque c'est l'heure de boire
En criant tous en chœur: 'Vive! Vive Rousseau !'

28 Hélène Seckel-Klein, *Picasso collectionneur*, Paris 1998, p.220. The stylistic relationship between Picasso and Rousseau is explored in further depth in the writing of William Rubin and Carolyn Lanchner in Grand Palais 1984, pp.51–70; Kunsthalle Tübingen 2001, pp.35–8, nos. 16, 29, 30, 41; and Green 2005.

29 Grand Palais 1984, p.76.

30 Letter from Kandinsky to Franz Marc, 15 June 1911, quoted in Kandinsky and Franz Marc, *L'Almanach du Blaue Reiter, Le Cavalier Bleu*, edited and with notes by Klaus Lankheit, Klincksieck 1981, p.7.

31 See Bernard Dorival, 'Robert Delaunay et l'œuvre du Douanier Rousseau', *L'Oeil*, no. 267, 10 Oct. 1977, pp.18–27.

32 Quoted in Vallier 1961, p.92.

33 Undated letter from Robert Delaunay to Julie Bernard, Rousseau archives, Musée du Vieux-Château, in Laval. I am grateful to Estelle Fresneau for granting me access to these archives.

34 Robert Delaunay,'Extraits de H. R., Le Douanier, le génie populaire de Rousseau …', *Du cubisme à l'art abstrait*, Paris, S.E.V.P.E.N., collection bibliothèque générale de l'école pratique des hautes études, secn. 6, 1957, pp.193–4.

35 Uhde 1911, p.7.

36 Ibid. pp.55–6.

37 Roch Grey, 'Souvenir de Rousseau', *Les Soirées de Paris*, no. 20, Paris, 15 Jan. 1914, wrongly dated 1913.

38 Henry Certigny, *Le Douanier Rousseau et son temps: Biographie et catalogue raisonné*, vol. I, no. 140, Tokyo 1984, p.286.

39 The Musée de l'Orangerie is due to reopen in spring 2006, when the entire collection will be on view.

40 The Barnes Foundation does not allow outside loans of its collection; the exhibition of selected works at the Musée d'Orsay, Paris, in 1993 remains an exception.

41 The paintings at the Orangerie were a gift from Mrs Jean Walter, widow of Paul Guillaume, who had married the architect and art-lover in 1941. With the documentation currently available, it is difficult to establish with certainty whether certain Rousseaus were bought by Jean Walter.

42 Colette Giraudon, *Paul Guillaume et les peintres du XXe siècle*, Paris 1993, p. 91.

43 Anne Distel, 'Le Docteur Barnes est à Paris', *De Cézanne à Matisse, Chefs-d'œuvres de la Fondation Barnes*, Paris 1993, p.38.

44 I am grateful to Christopher Green for providing this information.

45 Vallier 1961; Certigny 1961;Yann Le Pichon, *Le Monde du Douanier Rousseau*, Paris 1981. Le Pichon is currently working on a new catalogue raisonné.

John House
Henri Rousseau as an Academic
pp.182–189

I am most grateful to Christopher Green for inviting me to participate in the Rousseau project, and to him and Nancy Ireson for sharing their material with me.

1 On this comment and its sources, see William Rubin in *Henri Rousseau*, exh. cat., Galeries Nationale de Grand Palais, 1984–5; MoMA, New York, 1985; pub. New York 1985, pp.52 (note 55), 53.

2 Letter from Rousseau to the Ministre de l'Instruction publique et des Beaux-Arts, 25 June 1884, Paris, 1984–5, pp.262–3: 'fort heureusement pour moi, mon oeuvre a été vue et appréciée, par Monsieur Gérôme, le peintre illustre de nos jours, par Monsieur Clément, prix de Rome, et par Monsieur Pélissier, professeur de dessin.'

3 Letters from Rousseau to M. Boucher, Juge d'Instruction au Tribunal de la Ire Instance de la Seine, 5 Dec. and 13 Dec. 1907, as published in Henri Certigny, *La Verité sur le Douanier Rousseau*, Paris 1961, pp.297–8, 302: 'Je fus encouragé par des peintres déjà célèbres, tels que M. Gérôme, Cabanel, Ralli, Valton, Bouguereau etc. même M. Fallières alors qu'il était Ministre de l'Instruction publique; et qui est aujourd'hui Président de la République Française, fut sollicité par le regretté peintre Clément son ami de m'aider et de m'encourager.'

4 Götz Adriani, *Henri Rousseau, der Zoller*, exh. cat., Kunsthalle Tübingen, Cologne 2001, p.18, quoting Vlaminck, *Portraits avant décès*, Paris 1943, p.209: 'Il aimait beaucoup Bouguereau et m'en parlait avec une admiration sans bornes. C'était, pour lui, le plus grand des peintres et personne ne pouvait l'égaler.'

5 On this, see Certigny 1961, pp.83–7.

6 Letter from Rousseau to Henri Dupont, 1 April 1910, as published in Certigny 1961, p.412: 'si j'ai conservé ma naïveté, c'est parce que M. Gérôme, qui était professeur à l'école des Beaux-Arts, ainsi que M. Clément, directeur des beaux-Arts de l'Ecole de Lyon, m'a toujours dit de la conserver.'

7 Arsène Alexandre, 'La Vie et l'oeuvre d'Henri Rousseau, peintre et ancien employé de l'Octroi, *Comoedia*, Paris, 19 March 1910: 'Vous avez un coup de pinceau très hardi.'

8 Alexandre in *Comoedia* 1910: 'Toujours, dit-il, je vois un tableau avant de le faire.'

9 The clearest description of his methods is by Ardengo Soffici, quoted in Certigny 1961, pp.410–11; cf. also Alexandre in *Comoedia* 1910, and Delaunay's reminiscences, quoted in Jean Bouret, *Henri Rousseau*, London 1961, p.41; the second version of *The Poet and his Muse* can be seen behind the artist in the picture reproduced in Le Pichon 1981, p.76, and MoMA 1985, p.234, its background seemingly finished, but the figures only summarily outlined.

10 See Albert Boime, *The Academy and French Painting in the Nineteenth Century*, London 1971, especially sections IV and V.

11 See Kathy McLauchlan, 'French Artists in Rome, 1815–1863', unpublished PhD. dissertation, Courtauld Institute of Art, London 2001, pp.256–92.

12 For a similar conclusion, see Kunsthalle Tübingen 2001, pp.114–16.

13 Gauguin's use of visual source material is the exception here; see for example, Richard Field, 'Plagiaire ou créateur?', in *Gauguin*, exh. cat., Grand Palais, Paris (1961), Paris 1986 edn, pp.115–130.

14 See for example, Louise d'Argencourt, 'Bouguereau et le marché de l'art en France', in *William Bouguereau*, exh. cat., Musée du Petit Palais, Paris 1984–5, p.102, discussing the rental of paintings by Bouguereau for students to copy.

15 Henri Delaborde, *Ingres, sa vie, ses travaux, sa doctrine*, Paris 1870, pp.140–2.

16 The permit is reproduced in Kunsthalle Tübingen 2001, p.50; no copies by Rousseau from any of these museums have survived.

17 See Kunsthalle Tübingen 2001, pp.88–90.

18 See Le Pichon, *Le Monde du Douanier Rousseau*, Paris 1982, p.127.

19 Soffici, as quoted in Certigny 1961, p.410.

20 Letter from Rousseau to the Juge d'Instruction, 6 Dec. 1907, as published in Certigny 1961, p.300: 'Je suis l'Inventeur du portrait paysage telle que m'a cité la presse.'

21 In this respect, the secularisation of primary education, implemented in 1880, and the final separation of church from state in 1905, were of fundamental importance.

22 'Elle passe effrayante, laissant partout le despoir, les pleurs et la ruine.'

23 Alexandre in *Comoedia* 1910: 'Il faut … une explication aux tableaux. Les gens ne comprennent pas toujours ce qu'ils voient.'

24 It is suggested in Le Pichon 1982, p.256, that this may be the canvas exhibited in 1893 as Liberté, with the attached text: 'Oh! Liberté sois toujours le guide de tous ceux qui par leur travail, veulent concourir à la gloire et à la grandeur de la France' (as quoted in Certigny 1961, p.123).

25 On the imagery of this canvas and its political contexts, see Kunsthalle Tübingen 2001, pp.196–201.

26 The version of this that Rousseau would have known is the reduced-scale version in the Place Denfert-Rochereau, close to many of Rousseau's homes, but he would without doubt have been aware of the significance of the monument.

27 Letter from Rousseau to the Juge d'Instruction, 5 Dec. 1907, as published in Certigny 1961, p.298.

28 Perhaps for the town hall of Bagnolet, as suggested in Kunsthalle Tübingen 2001, p.61; although the Pont de Grenelle is on the opposite side of Paris from Bagnolet, the Statue of Liberty gives it an obvious generalised Republican relevance.

29 On the town-hall decorations of the Paris region, see *Le triomphe des mairies: Grands décors républicains à Paris, 1870–1914*, exh. cat., Musée du Petit Palais, Paris; for a wider discussion of the town-hall decorations of this period, see Claire O'Mahony, 'Municipalities and the Mural: the decoration of town halls in Third Republic France', unpublished PhD. dissertation, Courtauld Institute of Art, London 1997.

30 Cited in Jean Bouret, *Henri Rousseau*, London 1961, p.20.

31 Autobiographical notice, dated 10 July 1895, published in Certigny 1961, p.157 and MoMA 1985, p.262: 'il … fait partie des Indépendants depuis longtemps déjà, pensant que tout liberté de produire doit être laissée à l'initiateur dont la pensée s'élève dans le beau et le bien.' Rousseau's use of the phrase 'le beau et le bien' shows his awareness of the language of academic theory, in its reiteration of the terms in the title of Victor Cousin's much-reprinted lectures on aesthetics, *Du vrai, du beau et du bien*.

32 A jury-free Salon des Indépendants was held in May–June 1884. Later that year, the Société des Indépendants was formed; this held its first exhibition in December 1884, and then mounted annual exhibitions from 1886 onwards; for details, see Pierre Angrand, *Naissance des artistes indépendants 1884*, Paris 1965.

33 On the confusion over his exhibits in 1885, see Certigny 1961, pp.86–9.

34 Alexandre in *Comoedia* 1910: 'c'est la plus belle Société, c'est la plus légale, puisque tout le monde y a le même droit.'

35 Kunsthalle Tübingen 2001, p.22, quoting Gustave Coquiot, *Les Indépendants 1884–1920*, Paris 1920, p.131.

36 Fernande Olivier, *Picasso et ses amis* (1933), Paris 1954 (as quoted in Certigny 1961, p.350): 'Nous sommes les deux plus grands peintres de l'époque, toi dans le genre égyptien, moi dans le genre moderne.'

37 For example, Olivier 1954.

38 For example, Kunsthalle Tübingen 2001, p.38.

Pascal Rousseau
The Magic of Images
pp.190–203

Text translated by Shaun White.

1 Guillaume Apollinaire, 'Le Douanier', *Les Soirées de Paris*, no.20, Paris, 15 Jan.1914, collected in Apollinaire,*Oeuvres en prose complètes (II)*, ed. Pierre Caizergues and Michel Décaudin, Paris 1991, p.638.

2 Guillaume Apollinaire, 'Quelques artistes au travail', 16 April 1911, *La Vie anecdotique*, collected in Apollinaire, *Oeuvres en prose complètes (III)*, ed. Pierre Caizergues and Michel Décaudin, Paris 1993, p.56.

3 Alfred Binet, 'La vision mentale', *Revue philosophique*, vol. 27, 1889, pp.337–73.

4 Nancy Ireson, 'Le Douanier as Medium: Henri Rousseau and Spiritualism', *Apollo*, June 2004, pp.80–87.

5 Wilhelm Uhde, *Henri Rousseau*, Paris 1911.

6 Timothy Mitchell, 'The World as Exhibition', *Comparative Studies in Society and History*, vol. 31, no. 2, April 1989, pp.217–36.

7 It is this collusion of beliefs, between triumphant technology (Eiffel Tower, Palace of Electricity) and the primitive scene (villages of the colonial Empire) that Rousseau comments on in a little theatrical sketch written shortly after the 1889 World Fair. The play, which remained unpublished until 1922, when some extracts were included in the *Bulletin de la vie artistique*, is soberly entitled *Une Visite à l'Exposition de 1889*. It tells the picaresque adventure of two Breton tourists from Ploërmel, M. and Mme Lebozeck, who have come to visit the 1889 Paris World Fair with their maid Mariette, wearing her big wooden clogs. Thus it can be read as the story of three crazed people plunged into the heart of the technological forest of the New World. With its hints of anthropology (Rousseau uses the exotic vocabulary of the local dialect), the play could appear anodyne were it not for the fact that it voiced the aesthetic issues of the moment, when the Nabis group of painters were gathering around the tutelary figure of Gauguin (who also wore wooden clogs on the avenues of the Champ de Mars).In the Café Volpini, a few metres away from the Eiffel Tower, they proposed to the Parisian public the archaic lesson of Pont-Aven, geographically close to Ploërmel.

8 'To his eyes, there is something that lies behind phenomena, something invisible, something which is, so to speak, essential. Nature has kept all its veils for him.' Uhde 1911, pp.38–9.

9 Guillaume Apollinaire, 'Le Douanier', *Les Soirées de Paris*, 15 Jan. 1914, in *Apollinaire II* 1991, p.628. Uhde repeats, in another form, this anecdote of the skeleton-ghost: 'One night, in the wine-hall, they had stood a skeleton among the barrels, and moved it with a piece of string. They had a good laugh at the sight of Rousseau politely conversing with the skeleton and asking it if it was thirsty. Perhaps even today he believed that the skeleton was alive.' Uhde 1911, pp.12–13. We might compare, in passing, the story of this skeleton ghost with the adventures recounted by Gaston Bourgeat, 'Le squelette', *La Vie Mystérieuse*, no. 12, 25 June 1909, pp.178–9.

10 Anon. 'La photographie des fantômes', *La Vie Mystérieuse*, no. 22, 25 Nov. 1909, p.337. We also know that the painter Mérodack-Janeau, who shared a landing with Rousseau at 3 rue Vercingeétorix, put him in contact with the Sar Péladan and the Rosicrucian circles, with which, as Yann Le Pichon shows, 'he devoted himself to spiritualist séances'. Yann Le Pichon, *Le Monde du Douanier Rousseau*, Paris 1981, p.261.

11 On this question, see particularly Andreas Fischer and Veit Loers (eds.), *Im Reich der Phantome. Fotografie des Unsichtbaren*, Ostfildern-Ruit 1997, Richard Petersens (ed.), *Spiritus*, Stockholm 2003; and Clément Chéroux and Andreas Fischer (eds.), *Le Troisième œil. La Photographie et l'occulte*, Paris 2004.

12 The idea of the transmission of thought and its possible visualisation is commented upon in the columns of *La Vie Mystérieuse*: 'Everything in the Universe is vibration; why would one deny the vibrations of thought? Why would one deny our brain, marvellous in its subtlety, the gift of emanating vibrations of thought? Photography – still a "miraculous" discovery – has registered waves passing through the skulls of brains agitated either by violent passions or by tender emotions. It would seem that it is here that the proof of the externalisation of thought resides, along with this truth that is also proven: "ideas are in the air".' Stellata, 'Le chemin occulte', *La Vie Mystérieuse*, no. 3, 10 Feb. 1909, p.43.

13 Arsène Alexandre, 'La vie et l'œuvre d'Henri Rousseau, peintre et ancien employé de l'Octroi', *Comoedia*, Paris, 19 March 1910.

14 'Didn't you see how my hand moved?' he asked. 'That's quite natural, Rousseau, because you were painting.' 'No,' he replied, 'that was my poor wife who was here and guided my hand. Didn't you see or hear her? "Chin up, Rousseau," she said, "you will bring it to a fine conclusion".' Rousseau quoted by Wilhelm Uhde in Uhde 1911, pp.32–3.

15 In the scientific journal *Cosmos*, Professor Reverchon established a complete theory on the 'externalisation of memory', based on a vibratory concept of volitional phenomena. This theory was the subject of a major commentary in the work of Albert de Rochas devoted, in 1895, to *L'Extériorisation de la sensibilité*, Paris 1909, pp.221–2.

16 Frederick William Henry Myers, *The Human Personality and its Survival of Bodily Death*, London 1903.

17 Taine, to evoke the power of the image in hallucinations, chose the example of a ghost that was especially dear to Rousseau: 'Everyone knows the power of the image, particularly when it is strange and terrible … Children and even grown men have fainted in the presence of a mannequin or even a sheet that they thought was a ghost. Coming to, they affirmed that they had seen flaming eyes or an open mouth.' Hippolyte Taine, *De l'intelligence* (1870), Paris 1892, p.87. On this subject, see Paolo Tortonese, 'Taine: art et hallucination', *Relire Taine*, Paris 2001, pp.53–8.

18 Taine 1892, p.85.

19 Dugald Stewart, *Elements of the Philosophy of the Human Mind*, cited in ibid. p.89.

20 'What is a memory? An image. What is a hallucination? An image. And finally, what is an image? A weakened copy of an internal sensation', what Binet calls the 'family connections that unite sensation, hallucination and memory … What distinguishes memory, hallucination and external perception as far as we are concerned, is the secondary states of consciousness that accompany the evocation of an image. In memory, these states of consciousness consist of judgements which locate the image in the past. In hallucination and sensation, these states consist in judgements which locate the image in the external world … Reduced to its simplest expression, and stripped of all these accessories, memory is an image like hallucination.' Alfred Binet and Charles Féré, 'La polarisation psychique', *Revue philosophique*, XIX, 1885, pp.369–402, collected in Binet, *Oeuvres complètes*, I, vol. 2, preface and ed. by Maryse Siksou, Saint Pierre du Mont, Eurédit, 2001, p.240.

21 Alfred Binet and Charles Féré, 'Expériences d'hypnotisme sur les images associées', *Revue philosophique*, XXI, 1886, p.159, collected in Binet 2001, p.299.

22 Paul Max Simon, *Sur l'hallucination visuelle. Preuve physiologique de la nature de cette hallucination*, Paris 1880.

23 In his work beginning with the 'Examen de l'opinion généralement admise sur la manière dont nous recevons par la vue la connaissance des corps' (examination of the generally accepted opinion on the way in which we receive the knowledge of bodies through vision), 1819.

24 Jonathan Crary, '1888: Illuminations of Disenchantment', *Suspension of Perception. Attention, Spectacle and Modern Culture*, Cambridge, Mass. 1999, pp.230–40.

25 Jan Goldstein, 'The Hysteria Diagnosis and the Politics of Anti-Clericalism in Late Nineteenth-Century France', *Journal of Modern History*, Vol. LIV, June 1982, pp.209–32.

26 Henri Hubert and Marcel Mauss, 'Esquisse d'une théorie générale de la magie', *Année sociologique*, 1904, pp.90–91.

27 'When I went to the Trocadéro, it was disgusting. The flea market. The smell. I was on my own. I wanted to go. I didn't leave. I stayed, I stayed. I understood that it was very important: something was happening to me. The masks were not sculptures like the others. Not at all. They were magical things. And why not the Egyptians, the Chaldeans? We hadn't noticed them. Primitive people, not magical.' Picasso, quoted by André, *La Tête d'obsidienne*, Paris 1974, also in the catalogue *Les Demoiselles d'Avignon*, Paris 1988, p.637.

28 Picasso to François Gilot, quoted in ibid. p.637.

29 Georges Didi-Huberman, *L'Invention de l'hystérie. Charcot et l'iconographie photographique de la Salpêtrière*, Paris 1982.

30 J.S. Morand, *Le magnétisme animal. Étude historique et clinique*, Paris 1889.

31 Cornelia Stabenow, *La Jungle de Henri Rousseau*, Paris 1984, p.11.

32 Didi-Huberman 1982, p.36.

33 Charles de Villers, *Le magnétiseur amoureux* (1787), intro. and notes by François Azouvi, Paris 1978.

34 Jaqueline Carroy, *Hypnose, suggestion et psychologie. L'invention de sujets*, Paris 1991.

35 See particularly David Lomas, 'Seduction of Hysteria' in *Haunted Self. Surrealism, Psychoanalysis, Subjectivity*, New Haven 2000, pp.53–93; and our article, 'Eros magnétique. Le surréalisme sous hypnose', in Wernerr Spies (ed.), *La Révolution surréaliste*, Paris 2002, pp.366–75.

36 On this occasion Breton draws on the work of F.W.M. Myers. For Myers, 'far from considering hypnotic hallucinations as the effect of an inhibition, as the expression of a mono-ideism, we see it on the contrary as a dynamogenic manifestation, an intensification of the imagination', Myers 1903, p.46.

37 Blaise Cendrars, 'Le Douanier Rousseau', *Der Sturm*, Berlin, nos. 178–9, Sept. 1913.

38 Louis Leroy, 'Les tableaux magnétisés', *Le Charivari*, 7 May 1863, p.2. I would like to thank Jérôme Poggi for drawing my attention to this text.

39 Stanislaus Stückgold, 'Henri Rousseau', *Der Sturm*, Berlin, 1913, trans. Fernand Corin in Henry Certigny, *Le Douanier Rousseau et son Temps*, Vol. II, Tokyo 1984, p.702.

40 Paul Souriau, *La Suggestion dans l'art*, (1893), Paris 1909, p.2.

41 Salvador Dalí, 'Le phénomène de l'extase', *Minotaure*, nos. 3–4, 1933, p.76.

42 Alexandre in *Comoedia* 1910, p.3.

43 André Breton, *L'Art magique* (1957), Paris 1991, p.75.

44 Gérard Legrand, 'Libre promenade', in ibid. p.16.

45 Just as Rousseau liked to add captions to his paintings, Brauner supplies as a commentary to Hypnochimie a mediumistic analysis that the customs man would not have denied: 'Receptive-emanating agent, medium. In this painting, the immaterial bond of forces of fascination between beings, things, concentrated within this representation, should provide a new impulse to contemplation, so that the deep emotions of the inner life may be reborn.' *Victor Brauner: Espaces hypnotiques*, exh. cat., Galerie Rive Droite, Paris 1961, p.3.

46 Pavlov conceived of hypnosis as a means of access to the understanding of schizophrenia. At the beginning of the 1960s, P. King and M. Bowers presented schizophrenia as a kind of 'self-hypnosis'. See Léon Chertok, *L'Hypnose, Théorie, pratique et technique* (1965), Paris 1989, p.62.

47 Victor Brauner, 'While composing…', Galerie Rive Droite 1961, p.86.

48 'Hypnotic sleep which, like all analogous states, intervenes in dreams concerning rebirth, as elements typical of the intra-uterine state, encourages us to suppose that the nature of hypnosis itself and hypnotic suggestibility may be explained with reference to primitive relationships that bind the child to the mother'. Otto Rank, *Le traumatisme de la naissance. Influence de la vie prénatale sur l'évolution de la vie psycuique individuelle et collective* (1928), Paris 1993, p.17.

List of Works Exhibited

A Note on Titles and Dates

Paintings in the exhibition are listed below in chronological order. It should be noted that dating works that were not exhibited during Rousseau's lifetime is problematic. In all cases we have followed the dates and titles supplied by the owners or lending institutions. French titles are not included here, as many works were originally exhibited with simple titles (for example 'Paysage Exotique'), and have earned descriptive titles more recently.

Dimensions are given in centimetres, height before width, followed by inches in brackets.

Works of art will be exhibited in all venues, with the following exceptions:

*
An asterisk indicates that the work will be exhibited at the National Gallery of Art only.

†
A dagger indicates that the work will be exhibited at Tate Modern only.

**
A double asterisk indicates that the work will be exhibited at Tate Modern and the Grand Palais only.

††
A double dagger indicates that the work will be exhibited at Tate Modern and the National Gallery of Art only.

A triple asterisk indicates that the work will be exhibited at the Grand Palais and the National Gallery of Art only.

A different selection of documentary material has been made for the Grand Palais and the National Gallery of Art.

Works of Art

Promenade in the Forest
c.1886
Oil on canvas
70 x 60.5 (27 ½ x 23 ⅞)
Kunsthaus Zürich
(no.16, p.95)

Carnival Evening
1886
Oil on canvas
117.3 x 89.5 (46 ⅛ x 35 ¼)
Philadelphia Museum of Art.
The Louis E. Stern Collection, 1963
(no.15, p.94)

Rendezvous in the Forest
1889
Oil on canvas
92 x 73 (36 ¼ x 28 ¾)
National Gallery of Art, Washington.
Gift of the W. Averell Harriman Foundation
in memory of Marie N. Harriman 1972.9.20
(no.14, p.93)

Myself, Portrait-Landscape
1890†
Oil on canvas
146 x 113 (57 ½ x 44 ½)
Národní galerie v Praze
(no.2, p.75)

The Customs Post
c.1890
Oil on canvas
40.6 x 32.7 (16 x 12 ⅞)
The Samuel Courtauld Trust, Courtauld
Institute of Art Gallery, London
(no.8, p.81)

Tiger in a Tropical Storm (Surprised!)
1891
Oil on canvas
129.8 x 161.9 (51 ⅛ x 63 ¾)
The National Gallery, London
(no.43, p.146)

The Pont de Grenelle
c.1892
Oil on canvas
20.5 x 75 (8 ⅛ x 29 ½)
Musée du Vieux-Château, Laval
(no.41, p.138)

A Centennial of Independence
1892
Oil on canvas
111.8 x 157.2 (44 x 61 ⅞)
The J. Paul Getty Museum, Los Angeles
(no.18, p.104)

Saw Mill, Outskirts of Paris
c.1893–5
Oil on canvas
25.5 x 45.5 (10 x 17 ⅞)
The Art Institute of Chicago.
Bequest of Kate L. Brewster. 1950.133
(no.31, p.130)

Young Girl in Pink
1893–5
Oil on canvas
61 x 45.7 (24 x 18)
Philadelphia Museum of Art. Gift of
R. Sturgis and Marion B. F. Ingersoll, 1938
(no.10, p.89)

The Artillerymen
c.1893–5
Oil on canvas
79.1 x 98.9 (31⅛ x 38 ¹⁵⁄₁₆)
Solomon R. Guggenheim Museum, New York.
Gift, Solomon R. Guggenheim, 38.711
(no.21, p.108)

War
1894
Oil on canvas
114 x 195 (44 ⅞ x 76 ¾)
Musée d'Orsay, Paris
(no.17, pp.102–3)

Portrait of a Woman
1895
Oil on canvas
160 x 105 (63 x 41⅜)
Musée Picasso, Paris
(no.4, p.77)

Tiger Hunt
c.1895
Oil on canvas
38.1 x 46 (15 x 18 ⅛)
Columbus Museum of Art, Ohio.
Gift of Ferdinand Howald
(no.44, p.148)

Boy on the Rocks
1895–7*
Oil on linen
55.4 x 45.7 (21 ¾ x 18)
National Gallery of Art, Washington.
Chester Dale Collection, 1963.10.63
(no.9, p.88)

Portrait of a Lady
1895–7
Oil on canvas
198 x 115 (78 x 45 ¼)
Musée d'Orsay, Paris. Donation of
Baronne Eva-Gebhard-Gourgaud, 1965
(no.3, p.76)

View of the Fortifications
1896**
Oil on canvas
38 x 46 (15 x 18 ⅛)
Private Collection
(no.7, p.80)

The Orchard
c.1896
Oil on canvas
38 x 56 (15 x 22)
Harmo Museum, Nagano
(no.33, p.132)

*View of the Quai d'Ivry near the Port
à l'Anglais, Seine (Family Fishing)*
1900
Oil on canvas
24.1 x 33 (9 ½ x 13)
The Baltimore Museum of Art. The Cone
Collection, formed by Dr. Claribel Cone
and Miss Etta Cone of Baltimore, Maryland,
BMA 1950.294
(no.30, p.130)

Portrait of the Artist's Second Wife
1900–3
Oil on canvas
23 x 19 (9 x 7 ½)
Musée Picasso, Paris
(no.6, p.79)

Portrait of the Artist with a Lamp
1900–3
Oil on canvas
23 x 19 (9 x 7 ½)
Musée Picasso, Paris
(no.5, p.79)

Painter and Model
1900–5
Oil on canvas
46.5 x 55.5 (18 ¼ x 21 ⅞)
Centre George Pompidou, Paris, Musée
national d'art moderne/Centre de création
industrielle. Bequest of Nina Kandinsky, 1981
(no.1, p.74)

Happy Quartet
1901–2
Oil on canvas
94 x 57.4 (37 x 22 ⅝)
Greentree Foundation, New York
(no.20, p.107)

To Celebrate the Baby
1903
Oil on canvas
100 x 81 (39 ⅜ x 31 ⅞)
Kunstmuseum Winterthur, Inv. Nr. 1103.
Presented by the heirs of Olga Reinhart-
Schwarzenbach, 1970
(no.11, p.90)

House on the Outskirts of Paris
c.1905
Oil on canvas
33 x 46.4 (13 x 18 ¼)
Carnegie Museum of Art, Pittsburgh.
Acquired through the Generosity of the
Sarah Mellon Scaife Family, 1969
(no.37, p.134)

Banks of the Oise
1905
Oil on canvas
45.7 x 55.8 (18 x 22)
Smith College Museum of Art,
Northampton, Massachusetts.
Purchased with the Drayton Hillyer Fund
(no.38, p.135)

The Hungry Lion throws itself on the Antelope
1905
Oil on canvas
200 x 301 (78 ¾ x 118 ½)
Fondation Beyeler, Riehen/Basel
(no.49, pp.154–5)

*Liberty Inviting Artists to Take Part
in the 22nd Exhibition of the Société
des Artistes Indépendants*
1905–6
Oil on canvas
175 x 118 (68 ⅞ x 46 ½)
The National Museum of Modern Art, Tokyo
(no.19, p.106)

The Merry Jesters
1906
Oil on canvas
145.7 x 113.3 (57 ⅜ x 44 ⅝)
Philadelphia Museum of Art. The Louise
and Walter Arensberg Collection, 1950
(no.28, p.122)

Eve
c.1906–7
Oil on canvas
61 x 46 (24 x 18 ⅛)
Hamburger Kunsthalle, Gift of the Stiftung
zur Förderung der Hamburgischen
Kunstsammlungen
(no.52, p.165)

The Repast of the Lion
c.1907
Oil on canvas
113.7 x 160 (44 ¾ x 63)
Lent by The Metropolitan Museum of Art,
Bequest of Sam A. Lewisohn, 1951 (51.112.5)
(no.48, p.153)

*The Representatives of Foreign Powers Coming
to Greet the Republic as a Sign of Peace*
1907
Oil on canvas
130 x 161 (51 ⅛ x 63 ⅜)
Musée Picasso, Paris
(no.22, p.109)

The Snake Charmer
1907
Oil on canvas
169 x 189.5 (66 ½ x 7 ⅝)
Musée d'Orsay, Paris.
Bequest of Jacques Doucet, 1936
(no.51, p.164)

The Flamingos
1907††
Oil on canvas
114 x 165 (44 ⅞ x 64 ¹⁵/₁₆)
Collection of Joan Whitney Payson
(no.24, p.117)

Ivry Quay
c.1907†
Oil on canvas
46 x 55 (18 ⅛ x 21 ⅝)
Bridgestone Museum of Art,
Ishibashi Foundation, Tokyo
(no.40, p.137)

Banana Harvest
1907–10*
Oil on canvas
38 x 46 (14 ¹⁵/₁₆ x 18 ⅛)
Collection of Mr. and Mrs. Paul Mellon,
Upperville, Virginia
(fig.33, p.43)

View of Malakoff, Paris Region
1908††
Oil on canvas
46 x 55 (18 ⅛ x 21 ⅝)
Private Collection. Courtesy Pieter Coray
(no.42, p.139)

The Banks of the Bièvre near Bicêtre
1908
Oil on canvas
54.6 x 45.7 (21 ½ x 18)
Lent by The Metropolitan Museum of Art,
Gift of Marshall Field, 1939 (39.15)
(no.35, p.133)

Fight between a Tiger and a Buffalo
1908**
Oil on fabric
170 x 189.5 (66 ⅞ x 74 ⅝)
The Cleveland Museum of Art.
Gift of the Hanna Fund, 1949.186
(no.45, p.149)

The Football Players
1908
Oil on canvas
100.5 x 80.3 (39 ½ x 31 ⅝)
Solomon R. Guggenheim Museum, New York,
60.1583
(no.13, p.92)

Avenue in the Park at Saint-Cloud
1908
Oil on canvas
46.2 x 37.6 (18 ⅛ x 14 ¾)
Städtische Galerie im Städelschen
Kunstinstitut, Frankfurt am Main
(no.34, p.133)

The Environs of Paris
1909
Oil on canvas
45 x 53.7 (17¾ x 21 ⅛)
Detroit Institute of Arts.
Bequest of Robert H. Tannahill
(no.36, p.134)

Jardin du Luxembourg
1909***
Oil on canvas
38 x 47 (15 x 18 ½)
The State Hermitage Museum, St. Petersburg
(no.32, p.131)

The Equatorial Jungle
1909*
Oil on canvas
support: 140.6 x 129.5 (55 ⅜ x 51)
National Gallery of Art, Washington.
Chester Dale Collection. 1963.10.213
(no.29, p.123)

Two Monkeys in the Jungle
1909
Oil on canvas
64.8 x 50 (25 ½ x 19 ⅝)
John Whitney Payson
(no.26, p.119)

View from the Quai Henri IV
1909
Oil on canvas
32.7 x 41 (12 ⅞ x 16 ⅛)
The Phillips Collection, Washington, D.C.
(no.39, p.136)

Jungle with Setting Sun
c.1910
Oil on canvas
114 x 162.5 (44 ⅞ x 64)
Öffentliche Kunstsammlung Basel,
Kunstmuseum
(no.46, p.150)

*Tropical Landscape – An American Indian
Struggling with a Gorilla*
1910*
Oil on canvas
113.6 x 162.5 (44 ¾ x 64)
Virginia Museum of Fine Arts, Richmond.
Courtesy of Mr. and Mrs. Paul Mellon
(fig.35, p.44)

Horse Attacked by a Jaguar
1910***
Oil on canvas
89 x 116 (35 x 45 ⅝)
The State Pushkin Museum of Fine Arts,
Moscow
(no.47, p.152)

Monkeys in the Jungle
1910†
Oil on canvas
114 x 162 (44 ⅞ x 63¾)
Private Collection
(no.25, p.118)

The Dream
1910
Oil on canvas
204.5 x 298.5 (80 ½ x 117 ½)
The Museum of Modern Art, New York.
Gift of Nelson A. Rockefeller. 252.1954
(no.50, p.162)

Tropical Forest with Monkeys
1910
Oil on canvas
129.5 x 162.5 (51 x 64)
National Gallery of Art, Washington,
John Hay Whitney Collection, 1982.76.7
(no.27, p.121)

The Waterfall
1910
Oil on canvas
116.2 x 150.2 (45 ¾ x 59 ⅛)
The Art Institute of Chicago, Helen
Birch Bartlett Memorial Collection, 1926.262
(no.23, p.116)

Portrait of Monsieur X (Pierre Loti)
c.1910
Oil on canvas
61 x 50 (24 x 19 ⅝)
Kunsthaus Zürich
(no.12, p.91)

Emmanuel Frémiet
Bear Club Hunter
After 1885*
Bronze
241.3 x 154.9 x 132 (95 x 61 x 52)
Krannert Art Museum and Kinkead Pavilion,
University of Illinois, Urbana-Champaign. Gift of
Mrs. Stacy B. Rankin

Gorilla Carrying Off a Woman
1887*
Bronze
205.7 x 121.9 x 162.6 (81 x 48 x 64)
Krannert Art Museum and Kinkead Pavilion,
University of Illinois, Urbana-Champaign. Gift of
Mrs. Stacy B. Rankin

Documentary Material

I

'Documents about
le douanier' Rousseau

Manuscripts

Guillaume Apollinaire
Ode to Rousseau
Handwritten manuscript
27.4 x 21.8 (10 ¾ x 8½)
Musée du Vieux-Château, Laval

Robert Delaunay
Letter to Julia Bernard,
daughter of Henri Rousseau
Handwritten manuscript, 18 March 1911
18 x 13.3 (7⅛ x 5¼)
Musée du Vieux-Château, Laval

Fragments of a biography of Rousseau
Handwritten manuscript c.1911
57 x 20 (22⅜ x 7⅞)
Page 1
Bibliothèque Kandinsky, Centre de
Documentation et de Recherche du Musée
national d'art moderne, Centre Pompidou, Paris

Wassily Kandinsky
Letter to Robert Delaunay
Handwritten manuscript, 20 Oct. 1911
18.5 x 22.5 (7¼ x 8 ⅞)
Bibliothèque nationale de France, Paris

Henri Rousseau
Revenge of a Russian Orphan
Drama in five acts, signed by Yadwigha
Barkowski and Henri Rousseau
Handwritten manuscript, dated 5 Jan. 1889
30 x 19.6 (11¾ x 7 ¾)
Collection Daniel Filipacchi

Receipt of returned consignment from Vollard
Handwritten manuscript, 23 Jan. 1895
18.8 x 11.6 (7⅜ x 4 ½)
Musée du Vieux-Château, Laval

Letter to the Mayor of Laval
Handwritten manuscript, 10 July 1898
17.3 x 11 (6 ¾ x 4 ⅜)
Musée du Vieux-Château, Laval

Letter to the Minister of Public
Instruction and Fine Arts
Handwritten manuscript, 21 April 1901
31 x 20 (12¼ x 7 ⅞)
Centre Historique des Archives nationales
de France, Paris

Letter to Guillaume Apollinaire
Handwritten manuscript, 14 Aug. 1908
13.5 x 10.5 (5 ¼ x 4 ⅛)
Bibliothèque nationale de France, Paris

Letter to the artist's niece
Handwritten manuscript, 2 Jan. 1909
15.5 x 11.3 (6 ⅛ x 4 ½)
Musée du Vieux-Château, Laval

Letter to the dealer Bignou
[on the subject of *The Dream*]
Handwritten manuscript, 20 March 1910
21 x 13.7 (8 ¼ x 5 ⅜)
Musée du Vieux-Château, Laval

Letter [about *The Dream*]
Handwritten manuscript, 8 April 1910
17.3 x 11.3 (6¾ x 4 ½)
Musée du Vieux-Château, Laval

Letter to Guillaume Apollinaire
Handwritten manuscript, 21 June 1910
14.7 x 11.3 (5 ¾ x 4 ½)
Bibliothèque nationale de France, Paris

Letter to Pablo Picasso and Fernande Olivier
Handwritten manuscript, 22 June 1910
17 x 11 (6 ⅝ x 4 ⅜)
Musée Picasso, Paris

Letter to Ambroise Vollard
Handwritten manuscript, 21 June 1910
17.5 x 11 (6 ⅞ x 4 ⅜)
Musée du Vieux-Château, Laval

Invitation to Brancusi
Handwritten note on a business card, undated
6 x 10 (2 ⅜ x 3 ⅞)
Bibliothèque Kandinsky, Centre de
Documentation et de Recherche du Musée
national d'art moderne, Centre Pompidou, Paris

Invitation to 'Mademoiselle Alice'
for a musical soirée
Handwritten manuscript, undated
23.6 x 17.9 (9 ¼ x 7)
Musée du Vieux-Château, Laval

Wilhelm Uhde
Receipt for M. Queval, for the purchase
of a painting and two studies
Handwritten manuscript, 7 Jan. 1911
9.5 x 13.4 (3 ¾ x 5 ¼)
Musée du Vieux-Château, Laval

Documents

**Documents related to
'Le Douanier' Rousseau**
Certificate of good military conduct
for Henri Rousseau, 15 Sept. 1871
Musée du Vieux-Château, Laval

Title page from the waltz 'Clémence',
composed by Henri Rousseau, 1904
27 x 11.4 (10 ⅝ x 4 ½)
Published by Barbarin, Paris
Musée du Vieux-Château, Laval

Certificate of retirement, 25 May 1894
Musée du Vieux-Château, Laval

1908 diary, from the Court of Appeal
in Paris, belonging to Georges Guilhermet,
Rousseau's defence lawyer
14.5 x 10 (5 ¾ x 3 ⅞)
Archives Wildenstein, Paris

Court ruling, 9 Jan. 1909
45 x 30 (17 ¾ x 11 ¾)
Archives de Paris, Paris

Business card
Musée du Vieux-Château, Laval

Business card advertising lessons
in drawing, painting and watercolour
Facsimile

Programme for a musical soirée, in honour of
Max Weber, organised by Rousseau in his studio
Facsimile

Max Weber, Map of Rousseau's studio
in the rue Perrel
Facsimile

Photographs

Anonymous
Portrait of Henri Rousseau
Gelatin silver print
13.5 x 10 (5 ¼ x 3 ⅞)
Bibliothèque Kandinsky, Centre de
Documentation et de Recherche du Musée
national d'art moderne, Centre Pompidou, Paris

*Le Douanier Rousseau painting
Tropical Forest with Setting Sun* 1910
Gelatin silver print
11.8 x 16.2 (4 ⅝ x 3 ⅞)
Musée d'Orsay, Paris

*Photograph of 'The Dream'
dedicated to Queval, 28 March 1910*
Gelatin silver print
17.3 x 22.5 (6 ¾ x 8 ⅞)
Musée du Vieux-Château, Laval

Portrait of Rousseau in his studio
c.1907–8
Facsimile of the original dedicated to Max
Weber by Rousseau

Pablo Picasso
Portrait of Henri Rousseau
1910
Modern print from a negative
Musée Picasso, Paris

Portrait of Henri Rousseau, double exposure
1910
Modern print from a negative
Musée Picasso, Paris

Van Echtelt
'Le Douanier' and friends in his studio
c.1910
Gelatin silver print
11 x 14.6 (4 ⅜ x 5 ¾)
Musée d'Orsay, Paris

Anonymous (Henri Certigny?)
*Four photographs of the 'Cour des
Miracles' and Henri Rousseau's studio*
c.1960
Archives Wildenstein, Paris

Books

Henri Rousseau
War
Lithograph on orange paper
c.1884–5
39.9 x 26 (15 ¾ x 10 ¼)
from *L'Ymagier*, Jan. 1895
Musée du Vieux-Château, Laval

Revenge of a Russian Orphan
Drama in Five Acts
Pierre Cailler, Geneva, 1947
Collection Benoît Lardières, Paris

A Visit to the 1889 Exhibition
Vaudeville in Three Acts
Preface by Tristan Tzara
Pierre Cailler, Geneva, 1947
Private Collection, London

A Visit to the 1889 Exhibition
Vaudeville in Three Acts
Preface by Tristan Tzara
Pierre Cailler, Geneva, 1947
Collection Benoît Lardières, Paris

Guillaume Apollinaire
Aesthetic Meditations: The Cubist Painters
Paris, Eugène Figuière, 1913
Bibliothèque Historique de la Ville de Paris,
Fonds Guillaume Apollinaire

Various
The Blaüe Reiter Almanac
R. Piper & Co, Verlag, Munich, 1912
Bibliothèque Historique de la Ville de Paris,
Fonds Guillaume Apollinaire

**Roch Grey [Alias The Baroness
Hélène d'Oettingen]**
Henri Rousseau
Valori Plastici, Rome, 1924
Private Collection, London

Alfred Jarry
*Gestures and opinions of Doctor
Faustroll, Pataphysicien*
Bibliothèque Charpentier, 1911
Bibliothèque Littéraire Jacques Doucet, Paris

André Salmon
Henri Rousseau, called Le Douanier
Editions Crès et Cie, Paris, 1927
Collection Benoît Lardières, Paris

Philippe Soupault
Henri Rousseau, Le Douanier
Edition des Quatre chemins, Paris, 1927
Private Collection, London

Wilhelm Uhde
Henri Rousseau
Paris, Eugène Figuière, 1911
Bibliothèque Historique de la Ville
de Paris, Fonds Guillaume Apollinaire

Catalogues

Salon des Indépendants 1906
Handwritten note by Apollinaire opposite
Rousseau's entries 'Friend of Jarry'
Bibliothèque Historique de la
Ville de Paris, Paris
Fonds Guillaume Apollinaire

Catalogue of Rousseau exhibition
Galerie Bernheim-Jeune, 1912
Bibliothèque Historique de la
Ville de Paris, Paris
Fonds Guillaume Apollinaire

Preface to Rousseau exhibition
291 Gallery, New York, 1910
Bibliothèque littéraire Jacques Doucet, Paris

Catalogue of the Second
Post-Impressionist exhibition
Grafton Galleries, London, 1912
Victoria and Albert Museum, London

Catalogue of Rousseau exhibition
Lefevre Gallery, London, 1926
Tate Library and Archive, London

Newspapers

Press Cuttings
Book of press cuttings collected
by Henri Rousseau, 1907–8
27 x 21 (10 ⅝ x 8 ¼)
Bibliothèque Historique
de la Ville de Paris, Paris
Fonds Guillaume Apollinaire,
donation Adema

Excerpt from *Comoedia*, 13 March 1910
Bibliothèque Littéraire Jacques Doucet, Paris

Excerpt from *La Gazette de France*,
19 March 1910
Bibliothèque Littéraire, Paris
Jacques Doucet

Excerpt from *L'Intransigeant*,
Bibliothèque Littéraire, Paris
Jacques Doucet

Excerpt from *La Vie artistique*, 1911
Bibliothèque littéraire Jacques Doucet, Paris

Articles
Félix Vallotton
'Beaux arts. L'exposition des Artistes
indépendant', *Le Journal Suisse*, 25 March 1891
Facsimile
Bibliothèque cantonale et universitaire,
Lausanne, Switzerland

Louis Roy
Le Mercure de France, March 1895
Bibliothèque administrative
de la Ville de Paris, Paris

Le Salon d'Automne
L'Illustration, 4 Nov. 1905
Collection Benoît Lardières, Paris

Arsène Alexandre
'The life and work of Henri Rousseau,
painter and former employee of the Octroi'
Comoedia, 19 March 1910
Facsimile

Armendo Soffici
'Henri Rousseau'
La Voce, no.40, 15 Sept. 1910
Bibliothèque Historique
de la Ville de Paris, Paris
Fonds Guillaume Apollinaire

Summary of Exhibition reviews
Camera Work, Dec. 1910
The British Library, London

Fernand Girod
La Vie Mystérieuse, 19 Nov. 1911
Facsimile

Guillaume Apollinaire
'Henri Rousseau'
Les Soirées de Paris, 15 Jan. 1914
(wrongly dated 1913)
Bibliothèque Historique
de la Ville de Paris, Paris

Robert Delaunay
'Henri Rousseau'
L'Amour de l'art, Nov. 1920
Collection Benoît Lardières, Paris

Lucien Boucher
'The Triumph of Le Douanier Rousseau'
L'Art vivant, 15 Dec. 1925
Collection Benoît Lardières, Paris

Sunday Times, 13 Oct. 1926
Tate Library and Archive, London

Observer, 17 Oct. 1926
Tate Library and Archive, London

Various
'Visitors at the Salon d'automne'
L'Illustration, 5 Nov. 1904
Collection Benoît Lardières, Paris

Paris

Photographs

Anonymous
*Bridge at Saint-Cloud
Bridge at Charenton
Port Saint-Nicolas, painter and customs man
Two women on the riverbank
The 'Sunday Painter'*
Five photographs
Contretype
Bibliothèque historique de la
Ville de Paris, Paris

Eugène Atget
Porte d'Arcueil, Boulevard Jourdan
1913
Positive print on albumin paper,
from a silver bromide glass plate
16.8 x 21.5 (6 ⅝ x 8 ½)
Musée Carnavalet – Histoire de Paris, Paris

Jardin du Luxembourg, Delacroix monument
1903
Positive print on albumin paper,
from a silver bromide glass plate
17.2 x 21.5 (6 ¾ x 8 ½)
Musée Carnavalet – Histoire de Paris, Paris

Quai Henri IV
1899
Positive print on albumin paper,
from a silver bromide glass plate
17 x 22 (6 ⅝ x 8 ⅝)
Bibliothèque nationale de France, Paris

Fortifications, Porte Dauphine
1913
Positive print on albumin paper,
from a silver bromide glass plate
16.8 x 21.7 (6 ⅝ x 8 ½)
Bibliothèque historique de la
Ville de Paris, Paris

Clamart, vieille rue
1901
Positive print on albumin paper,
from a silver bromide glass plate
20.5 x 16.2 (8 ⅛ x 6 ⅜)
Bibliothèque historique de la
Ville de Paris, Paris

Jules Girard
A Bridge in Paris
c.1900
Digital print from a glass negative
Ministère de la Culture, Médiathèque de
l'Architecture et du Patrimoine, Paris

Woman in the Bois de Boulogne
c.1914
Digital print from a glass negative
Ministère de la Culture, Médiathèque de
l'Architecture et du Patrimoine, Paris

Village in a Valley
c.1900
Digital print from a glass negative
Ministère de la Culture, Médiathèque
de l'Architecture et du Patrimoine, Paris

Road, House
c.1914
Digital print from a glass negative
Ministère de la Culture, Médiathèque
de l'Architecture et du Patrimoine, Paris

Road, river and bridge
c.1920
Digital print from a glass negative
Ministère de la Culture, Médiathèque
de l'Architecture et du Patrimoine, Paris

Postcards

*Rue de Sèvres, junction with
the Avenue de Breteuil*
Bibliothèque historique
de la Ville de Paris, Paris

*Rue Daguerre
Avenue du Maine
Rue de la Gaîté
Rue Vercingétorix
Rue de Sèvres
Landing stage at the Point du Jour
View of the Point du Jour
The viaduct at Auteuil
The Seine at Passy
The Seine at the Port Saint-Nicolas
The Port Saint-Nicolas
Port de la Tournelle
The Seine at Bercy
Lac Daumesnil, Bois de Vincennes
Bois de Boulogne, The Alley of Acacias
Bois de Boulogne, The great lake*
Collection Benoît Lardières, Paris

III
A World of Sources

Senegal lion devouring an antelope
Stuffed animal display, tanned hide
on wooden frame, built up with wood
shavings, modelled in plaster as a whole
1886
250 x 160 x 130 (98 ⅜ x 63 x 51 ⅛)
Muséum national d'Histoire naturelle, Paris

Bêtes sauvages
Special edition from the department
store Galeries Lafayette
c.1900
Musée du Vieux-Château, Laval

Charles Verlat
Buffalo surprised by a Tiger
19 x 26 (7 ½ x 10 ¼)
Lithograph by Pirodon after
the work by Charles Verlat
Bulla Brothers and Jouy Publishers, Paris
Bibliothèque nationale de France, Paris

Pierre Petit
Football players in the Jardin de Luxembourg
Dec. 1895
Digital print from a glass negative
Ministère de la Culture, Médiathèque
de l'Architecture et du Patrimoine, Paris

Catalogues

*Eugène Delacroix at the Ecole
des Beaux-Arts* 1885
Paris, Galerie des Artistes Modernes,
Ludovic Baschet publications
Bibliothèque Historique de la
Ville de Paris, Paris

The French Primitives
Pavillon de Marsan et Bibliothèque
nationale, 1904
Collection Benoît Lardières, Paris

Newspapers and Journals

'Les Fêtes à Andorre, The Farandole',
Le Petit Journal, 11 April 1891
' In the Jardin d'Acclimatation, Tinan,
young orang-utan', *Le Petit Journal*,
20 Dec. 1896
' In the Jardin d'Acclimatation, the
hothouse of camellias', *Le Petit Journal*,
21 March 1897
'Modern Sport in the Army',
Le Petit Journal, 4 May 1902
'Aeroplane and the Eiffel Tower',
Le Petit Journal, 31 Oct. 1909
'The painter and the Boa', *Le Petit
Journal*, 18 April 1909
'The panthers of Kabak' *Journal des
Voyages*, 16 Aug. 1908
Collection Benoît Lardières, Paris

'Gabon', *Le Tour du Monde*, 1865
'Cannibals', *Le Tour du Monde*, 1889
'Egyptian Lotus', *Le Magasin Pittoresque*, 1834
Musée du Vieux-Château, Laval

Postcards

*Statue of Étienne Dolet, Place Maubert
Panthers in dispute over a gazelle*
Collection Benoît Lardières, Paris

Quai Henri IV
Musée Carnavalet – Histoire de Paris, Paris

Lion pouncing on an Antelope
Bibliothèque Historique de la
Ville de Paris, Paris

IV
Jardin des Plantes

Photographs

Pierre Petit
Interior of the glasshouse c.1885
Photograph
19.5 x 25.7 (7 ⅝ x 10 ⅛)
Muséum national d'Histoire naturelle, Paris

Pond in glasshouse c.1885
Photograph
18.9 x 25.7 (7 ⅜ x 10 ⅛)
Muséum national d'Histoire naturelle, Paris

Henri Olivier
Monkey Palace 1900
Digital print from a double glass negative
Ministère de la Culture, Médiathèque
de l'Architecture et du Patrimoine, Paris

Zoological Gallery, Display of Gorillas 1910
Digital print from a double glass negative
Ministère de la Culture, Médiathèque
de l'Architecture et du Patrimoine, Paris

Zoological Gallery 1910
Digital print from a double glass negative
Ministère de la Culture, Médiathèque
de l'Architecture et du Patrimoine, Paris

Zoological Gallery, Tiger display 1910
Digital print from a double glass negative
Ministère de la Culture, Médiathèque
de l'Architecture et du Patrimoine, Paris

Books, Newspapers, Journals

M. Boitard
The Jardin des Plantes
J.J. Dubochet et Cie, Paris, 1842
Collection Benoît Lardières, Paris

'The new Zoological Gallery at the
Muséum', *La Nature*, Oct. 1889
'The New Glass houses at the
Muséum', *L'Illustration*, 27 July 1889
'Artists studying animals at the Jardin
des plantes', *L'Illustration*, 2 Aug. 1902
Collection Benoît Lardières, Paris

Postcards

*The Monkey Palace
Royal Tiger*
Musée Carnavalet – Histoire de Paris, Paris

*Backwater et Vaquais
The Jardin d'hiver
The Jardin d'hiver, viewed from the grotto
The Great Aviary
Tigers devouring their prey
'The Bear hunter' by Frémiet*
Collection Benoît Lardières, Paris

V
Jardin d'Acclimation Exhibitions, Colonial Exhibition

Photographs

Anonymous
*Amazons and warriors from Dahomey
(now Benin)*
Casino de Paris, 1892
Albumin print
10 x 14.8 (3 ⅞ x 5 ⅞)
Collection Gérard Lévy, Paris

Village on the champ de Mars
1895
Albumin print
12 x 17.5 (4 ¾ x 6 ⅞)
Collection Gérard Lévy, Paris

Henri Olivier
Main hothouse of the Jardin d'Acclimatation
c.1900
Digital print from a double glass negative
Ministère de la Culture, Médiathèque de
l'Architecture et du Patrimoine, Paris

Books

Jean-Camille Fulbert-Dumontiel
*Male and Female warriors from
Dahomey in the Jardin d'Acclimatation*
1891
Booklet published by the Jardin d'Acclimatation
The British Library, London

Edouard Grimard
The Jardin d'Acclimatation
J. Hetzel et Cie, Paris, 1880
Collection Benoît Lardières, Paris

Documents

Fold-out from the Achanti Exhibition
Jardin zoologique d'Acclimatation
1887
Collection Gérard Lévy, Paris

Invitation to the exhibition
of Colonial Ethnography
'150 Dahomeans on the Champ de Mars'
Palais des Arts Libéraux, 24 March 1893
Collection Gérard Lévy, Paris

Fold-out from the Ethnographic exhibition
'Sudanese and Madagascans on the champ
de Mars' 1896
Collection Gérard Lévy, Paris

Abdoulaye
Tiger Hunt
Watercolour on Card
13.6 x 9 (5 ⅜ x 3 ½)
Handwritten annotation 'Senegalese',
signature in French and Arabic
Collection Gérard Lévy, Paris

Abdoulaye
Tiger Hunt
Watercolour on Card
13.6 x 9 (5 ⅜ x 3 ½)
Handwritten annotation 'Senegalese',
signature in French and Arabic
Collection Gérard Lévy, Paris

Abdoulaye
Tiger Hunt
Watercolour on Card
13.6 x 9 (5 ⅜ x 3 ½)
Printed with mark 'Senegalese
Village, porte Maillot'
Collection Gérard Lévy, Paris

'Black Village, the artist'
Portrait of Abdoulaye
Postcard
13.8 x 8.7 (5 ⅜ x 3 ⅜)
Collection Gérard Lévy, Paris

Official invitation to the Colonial Exhibition
Bois de Vincennes, 1907
Postcard
9.1 x 14 (3 ⅜ x 5 ½)
Collection Gérard Lévy, Paris

Postcards

*Jardin d'Acclimatation,
Achanti people: The meal
The Gallas in the Jardin
zoologique d'Acclimatation
Warriors in the Jardin d'Acclimatation
Hindu Village, Jardin d'Acclimatation
Colonial exhibition in the Bois
de Vincennes: Madagascan hut
Colonial exhibition in the Bois de Vincennes:
exhibit on Dahomey (now Benin)
and fetish objects
Colonial exhibition in the Bois
de Vincennes: Saharan encampment*
Collection Gérard Lévy, Paris

*Entrance to the Jardin d'Acclimatation
The Palm-house in the Jardin d'Acclimatation
The great exhibition lawn in the
Jardin d'Acclimatation
Porte Maillot, Senegalese Village, entrance
Porte Maillot, Senegalese Village, dances
Jardin d'Acclimatation, Achanti village: School
Jardin d'Acclimatation, Achanti village:
indigenous dance
Jardin d'Acclimatation, Achanti women
Colonial Exhibition in the Bois de Vincennes:
Pavilion of the Congo and People from
the Ivory Coast*
Collection Gérard Lévy, Paris

Newspapers, Reviews

'Behanzin', *Le Journal Illustré*, 23 Oct. 1892
Collection Benoît Lardières, Paris

VI
World Fairs

Photographs

Anonymous
Eiffel Tower under Construction 1889
*Arab Merchant at the foot of the
Eiffel Tower* 1889
*Women in costume in front of the
Siam Pavilion* 1889
Javanese Village 1889
*Champ de Mars, Eiffel Tower
and Trocadéro* 1889
Eiffel Tower, Brazilian Pavilion 1889
*View of the Seine during the 1889
Paris World Fair* 1889
Interior of the Decorative Arts Pavilion 1889
Austrian palace, interior view 1889
A Cairo Street 1889
Ten digital prints from tinted glass positives, five
in colour
Ministère de la Culture, Médiathèque
de l'Architecture et du Patrimoine, Paris

Newspapers, Journals

'Overview of the Invalides Esplanade',
Le Monde illustré, 22 Dec. 1888
'Overview of the Exhibition', *Le Journal Illustré*,
23 April 1889
'The Eiffel Tower', *Le Journal Illustré*, 5 May
1889
'The Angkor Pagoda', *Le Journal Illustré*,
30 June 1889
'The Invalides Esplanade, The colonial
palace', *Le Journal Illustré*, 7 April 1889
'A Cairo Street: Senegalese Princes',
Journal Illustré, 7 April 1889
'A Cairo Street', *L'Illustration*, 15 June 1889
Collection Benoît Lardières, Paris

VII
Literature, Theatre, Hunting Logs

Books

Adolphe Belot
The Black Venus
Voyage to Central Africa
Librairie Illustrée & Librairie Dreyfus, 1879, Paris
Collection Benoît Lardières, Paris

Paul du Chaillu
The African Forest and Jungle
John Murray, London, 1903
The British Library, London

Rudyard Kipling
The Jungle Book
Macmillan, London, 1894
The British Library, London

Victor Meunier
Adventures on the Great Hunting Grounds of the World 1868
The British Library, London

Louis Noir
In Dahomey, an Amazon from Béhanzin
A. Fayard, Paris, 1892
Bibliothèque nationale de France, Paris

By Lake Tchad, A snake charmer
Fayard Brothers, Paris, 1899
Collection Benoît Lardières, Paris

On the banks of Lake Tchad, Sultan Rabat
Fayard Brothers, Paris, 1899
Collection Benoît Lardières, Paris

On the Nile, Commander Marchand in Fachoda
Fayard Brothers, Paris, 1899
Collection Benoît Lardières, Paris

The red flag of the Niger, flying
Fayard Brothers, Paris, 1899
Collection Benoît Lardières, Paris

Jules Verne
Five Weeks in a Balloon 1874
The British Library, London

The Giant Raft, Eight hundreds leagues of the Amazon
Sampson Low and Co, London, 1881
The British Library, London

Documents, Newspapers, Journals

The Black Venus
Publicity handout for the Show
Théâtre du Châtelet, 1878
Collection Gérard Lévy, Paris

'In Dahomey', *L'Illustration*, 13 Feb. 1892
'Rabah', *L'Illustration*, 9 March 1901
'A wedding in Dahomey', *L'Illustration*, 9 Sept. 1905
'Tourism in Central Africa', *L'Illustration*, 30 Dec. 1905
'A photographic hunter in Africa', *L'Illustration*, 14 July 1906
'Return to civilisation', *L'Illustration*, 22 Jan. 1910
Collection Benoît Lardières, Paris

VIII
Exploration, Colonisation

Photographs

Francis Joaque
Pierre Savorgnan de Brazza, his deputy, their luggage bearers, Group portrait, Gabon 1880
Albumin print pasted on cardboard
13.7 x 20.2 (5 ⅜ x 8)
Société de Géographie, Bibliothèque nationale de France, Paris

Paul Nadar
Carte album
Full-length portrait of Pierre Savorgnan de Brazza 1882
Silver print pasted on cardboard
16.5 x 10.8 (6 ½ x 4 ¼)
Centre des Archives d'Outre-Mer, Archives nationales, Aix-en-Provence, France

Marcel Monnier
Forest edge near Assuakourou (Sanwi)
Binger Mission from the Ivory Coast to the Sudan, 1891–2
Silver print pasted on cardboard
17.5 x 24 (6 ⅞ x 9 ⅜)
Centre des Archives d'Outre-Mer, Archives nationales, Aix-en-Provence, France

*A natural bridge in the forest –
fallen tree crossing a backwater*
Binger Mission from the Ivory Coast to the Sudan, 1891–2
Silver print pasted on cardboard
17 x 23.5 (6 ⅝ x 9 ¼)
Centre des Archives d'Outre-Mer, Archives nationales, Aix-en-Provence, France

Hunters in the Forest
Binger Mission from the Ivory Coast to the Sudan, 1891–2
Silver print pasted on cardboard
17 x 23.5 (6 ⅝ x 9 ¼)
Centre des Archives d'Outre-Mer, Archives nationales, Aix-en-Provence, France

Camp at Dibi (Sanwi)
Binger Mission from the Ivory Coast to the Sudan, 1891–2
Silver print pasted on cardboard
18 x 24.8 (7 ⅛ x 9 ¾)
Centre des Archives d'Outre-Mer, Archives nationales, Aix-en-Provence, France

Tangled Creepers
Binger Mission from the Ivory Coast to the Sudan, 1891–2
Silver print pasted on cardboard
17.5 x 23 (6 ⅞ x 9)
Centre des Archives d'Outre-Mer, Archives nationales, Aix-en-Provence, France

The Forest (Abron)
Binger Mission from the Ivory Coast to the Sudan, 1891–2
Silver print pasted on cardboard
18 x 24.7 (7 ⅛ x 9 ¾)
Centre des Archives d'Outre-Mer, Archives nationales, Aix-en-Provence, France

In the Forest: Palms and Creepers
Binger Mission from the Ivory Coast to the Sudan, 1891–2
Silver print pasted on cardboard
18 x 24.3 (7 ⅛ x 9 ⅝)
Centre des Archives d'Outre-Mer, Archives nationales, Aix-en-Provence, France

Forest backwater
Binger Mission from the Ivory Coast to the Sudan, 1891–2
Silver print pasted on cardboard
17 x 23.5 (6 ⅝ x 9 ¼)
Centre des Archives d'Outre-Mer, Archives nationales, Aix-en-Provence, France

Books

Capitan Binger
From the Niger to the Gulf of Guinea (II)
Librairie Hachette, Paris, 1892
Bibliothèque nationale de France, Paris

Marcel Monnier
Black France
Librairie Plon, Paris, 1894
Collection Benoît Lardières, Paris

Vidal-Lablache
Atlas
Armand Colin, Paris, 1898
Collection Benoît Lardières, Paris

Atlas
Armand Colin, Paris, 1908
Collection Benoît Lardières, Paris

Documents

Charles de Chavannes
Book of topographic sketches
and rough drafts of letters
Graphite and coloured pencil
in an exercise book
18.5 x 22 (7 ¼ x 8 ⅝)
Centre des Archives d'Outre-Mer, Archives nationales, Aix-en-Provence, France

Reviews and Journals

Henry Stanley, 'Across the Mysterious Continent', *Le Tour du Monde*, 1878
Pierre Savorgnan de Brazza, 'West African Journey', *Le Tour du Monde*, 1888
'Henri Stanley', *Journal Illustré*, Nov. 1889
'From the Niger to the Gulf of Guinea', *Journal des Voyages*, 1890
Captain Binger, 'From the Niger to the Gulf of Guinea', *Le Tour du Monde*, 1891
Collection Benoît Lardières, Paris

List of Lenders

Works of Art Lenders

Public Collections
The Art Institute of Chicago
The Baltimore Museum of Art
Bridgestone Museum of Art, Tokyo
Carnegie Museum of Art, Pittsburgh
The Cleveland Museum of Art
Columbus Museum of Art, Ohio
Courtauld Institute of Art, London
The Detroit Institute of Arts
Fonds nationale d'art contemporain, Puteaux
Solomon R. Guggenheim Museum, New York
Hamburger Kunsthalle, Hamburg
Harmo Museum, Nagano
The J. Paul Getty Museum, Los Angeles
Kunsthaus Zürich
Kunstmuseum Basel
Kunstmuseum Winterthur
The Metropolitan Museum of Art, New York
Musée d'Orsay, Paris
Musée du Vieux-Château, Laval
Musée National d'Art Moderne,
 Centre Georges Pompidou, Paris
Musée Picasso, Paris
The Museum of Modern Art, New York
The National Gallery, London
National Gallery of Art, Washington, D.C.
The National Gallery of Prague
The National Museum of Modern Art, Tokyo
Philadelphia Museum of Art
The Phillips Collection, Washington, D.C.
The State Pushkin Museum of Fine Arts, Moscow
Smith College Museum of Art, Northampton
Städelsches Kunstinstitut und Städtische
 Galerie, Frankfurt
The State Hermitage Museum, St. Petersburg
Virginia Museum of Fine Arts, Richmond

Private Collections
Fondation Beyeler, Basel
Greentree Foundation, New York
John Whitney Payson
Private Collection. Courtesy Pieter Coray

And all other private lenders who wish
to remain anonymous

Documentary Material Lenders

Public Collections
Archives de Paris
Bibliothèque Administrative de la Ville de Paris
Bibliothèque Centrale du Museum national
 d'histoire naturelle, Paris
Bibliothèque cantonale et universitaire, Lausanne
Bibliothèque Historique de la Ville de Paris
Bibliothèque Kandinsky, Centre de recherche
 et de documentation, Musée nationale d'art
 moderne, Paris
Bibliothèque Littéraire Jacques Doucet, Paris
Bibliothèque nationale de France, Paris
The British Library, London
Centre des Archives d'Outre-Mer,
 Aix-en-Provence
Centre Historique des Archives Nationales, Paris
Médiathèque de l'architecture et du patrimoine,
 Montigny-le-Bretonneux
Musée Carnavalet, Paris
Musée d'Orsay, Paris
Musée du Vieux-Château, Laval
Musée Picasso, Paris
Muséum national d'histoire naturelle, Paris
Société de Géographie, Paris
Tate Library and Archive, London
Victoria and Albert Museum, London
National Gallery of Art, Washington, Library

Private Collections
Benoît Lardières, Paris
Daniel Filipacchi, Paris
Gérard Lévy, Paris
The Wildenstein Institute, Paris

And all other private lenders who wish
to remain anonymous

Index

A

Abrams, Isaac 203
abstraction 24
academic, Rousseau as 183–9
Adriani, Götz 169
Alexandre, Arsène 24, 49, 144, 192, 194, 202
 interview with Rousseau 30, 32, 41, 45, 52, 53, 99, 111, 112, 184, 188, 189
allegorical subjects 17–18, 87, 99–101, 143, 158, 161, 187–8
Anglers 128, 180; fig.89
animaliers 16, 36, 38; fig.5
anthropozoology 58
Apollinaire, Guillaume 13, 14, 23, 32, 43, 47, 111, 169, 173, 174–5, 191, 192–3; fig.108
 Banquet Rousseau 24, 100, 176
 The Cubist Painters 161
 epitaph on Rousseau's tomb 170
 memoir of Rousseau 24, 29, 30
 poem in honour Rousseau 100, 170, 176
 portraits by Rousseau 49, 73, 174, 175, 199–200, 202
 'The Triumph of Rousseau' 174
Armory Show, New York 179
art nègre 22–3, 144
Artaud, Antonin 179
The Artillerymen 27, 101, 111; no.21
Association Philotechnique 19
Atget, Eugène 62
 Clamart, vieille rue 52; fig.45
 On the Paris Fortifications 72; fig.65
 Porte d'Arcueil, Boulevard Jourdan 51; fig.43
 Avenue in the Park at Saint-Cloud no.34

B

Banana Harvest 43, 112; fig.33
The Banks of the Bièvre near Bicêtre 128; no.35
The Banks of the Oise 125; no.38
Banquet Rousseau 24, 100, 176
Baraduc, Hippolyte
 psychicônes 193
Barker, Robert 61
Barnes, Dr Albert C. 179, 180–1; fig.113
Barnum, P.T. 55
Barr, Alfred 180
 diagram of artists and schools 25–6; fig.14
Bartholdi, Auguste
 The Lion of Belfort 188
Basler, Adolphe 32, 127
Baudelaire, Charles 87
Behanzin, King of Abomey 58; fig.54
Bergson, Henri 201
Bernard, Julie (daughter) 177
Bernheim, Professor 196
Bernier, Camille 186
Bertrand, Alexander 196
Bêtes sauvages 21, 35, 37, 46, 49, 113, 186, 187; fig.11
Biche, Frumence 101
Bignou, Étienne 180
Binet, Alfred 195
Binger, Louis Gustave 63
Blaüe Reiter 173, 176
Boat in the Storm 180
Boitard, Clémence (first wife) 69, 73, 83, 194, 195
Bonnat, Léon 183
Bosc, Ernest
 Glossaire raisonné de la divination, de la magie et de l'occultisme 192
Bouguereau, Adolphe-William 21, 169, 183
Bouret, Jean 181
Bourgeois, Charles Arthur 32
Boy on the Rocks 83, 85; no.9
Braid, James
 Neurhypnologie 201
Brancusi, Constantin 170
Braque, Georges 21, 22, 73
Brauner, Victor 202–3
 la recontre du 2 rue Perrel 202; fig.139
 detail 66
Brazza, Pierre Savorgnan de 63
Breton, André 24, 29, 30, 36, 41, 47, 63, 179, 195, 200
 l'Art Magique 202
Brière, de la 170–1
Brummer, Joseph 23, 144, 180; fig.12
Buffon, Comte de 46
Buguet, Édouard 193

C

Cabanel 183
Carmagnole 98, 99; fig.79
Carnival Evening 17, 86–7, 113, 170–1; no.15
Carolus-Duran 187
cartes de visite 18, 69
Casagemas, Carles 198
Castellani, Charles 61
To Celebrate the Baby 83, 86; no.11
Cendrars, Blaise 111, 201
A Centennial of Independence 18, 49, 98–9, 188; no.18
 detail *182*
Certigny, Henri 180, 181
Cézanne, Paul 25, 178, 183
Charcot, Professor 196, 198
Charton, Edouard 62
Child with a Doll 85, 180; fig.72
Chirico, Giorgio de 24, 47
 Dr Albert C. Barnes fig.113
Claretie, Jules
 Amours d'un interne 200
Clémence (waltz) 86; fig.73
Clément, Félix-Auguste 16, 21, 25, 61, 169, 183–4, 186
Cocteau, Jean 180
collage-like works 21, 37, 42, 49, 50, 57, 85, 100, 129, 158, 179
colonialism, French 15, 32, 35–6, 45, 50, 58, 99, 112, 142–3
colour in Rousseau's works 24, 171, 177
Comment, Bernard 61
Coquiot, Gustave 70
Cotton, M. 141
Coupin, Henri 46, 47
Courbet, Gustave 126
Courmelles, Foveau de 199
Courteline, Georges 180
Courthion, Pierre 52
Crary, Jonathan 196
critical response to Rousseau's works 13, 17, 20, 22, 72, 98–100, 113–14, 141, 143–4, 157, 161, 169–81; fig.76
Cubism 21
The Customs Post 51, 71–2, 202; no.8
 detail *66*
Cuvier, Georges and Frédéric 35

D

Daguerre, Louis 61
Dalí, Salvador 47, 202
Darget, Louis
 psychic photographs 193
Delaborde, Henri 186
Delacroix, Eugène 16, 58, 144
 Tiger and Snake 16; fig.4
Delaunay, Berthe 158, 179, 198
Delaunay, Robert 21, 25, 30, 32, 40, 47, 67, 70, 126, 127, 128, 143, 161, 169–70, 173, 176–8, 180, 189
 The Cardiff Team 177
 The City of Paris 177
 collection of works by Rousseau 176–7
 portrait of Rousseau 70
 writings on Rousseau 177
Delaunay-Terk, Sonia 70, 158
Denis, Maurice 38, 43
Derain, André 22, 43, 142
dioramas 61
Dolet, Étienne 99, 188
Doucet, Jacques 180
The Dream 13–14, 19, 20, 29, 36–7, 38, 40, 72, 157–8, 161, 174, 188, 199, 202; no.50
 details *12, 191*
Dubuffet, Jean 173
Dumas, F.G. 57
Dumont, Santos 51
Dumonteil, Fulbert 54–5
Dupont, Henri 183

E

Eiffel Tower 15–16, 53, 69; fig.3
The Environs of Paris 126; no.36
The Equatorial Jungle 46, 115; no.29
Ernst, Max 63, 187
Ernst, Rodolphe
 Soirée Triomphale 186; fig.120
Eve 20, 160–1; no.52
exhibitions of Rousseau's work 174, 177–80, 183
Exotic Landscape (1908)112; fig.81
Exotic Landscape (1910) 113; fig.83
Expressionism 24

F

fake Rousseaus 181
The Farmyard 176; fig.111
Fauves 142, 176
Fels, Florent 175
Férat, Serge *see* Jastrebzoff, Serge
Fight between a Tiger and a Buffalo 142, 144, 174; no.45
Figuière, Eugène 192
film 85–6, 143, 160; figs.48, 50
The Flamingos 112; no.24
 detail *110*
Folk-art 23–4, 25, 126–7, 143
The Football Players 85, 126, 174, 177; no.13
 detail *82*
Fourcard, de 144
Franco-Prussian War 72, 97, 188
Frémiet, Emmanuel 36
 Gorilla 36, 47, 113, 143; fig.26
The French Republic 188
Furetières 142

G

Gauguin, Paul 37–8, 40, 42–3, 142, 161, 171, 172
George, Waldemar 161
Gérôme, Jean-Léon 16, 21, 25, 49, 61, 85, 169, 183–4
 Innocence 100
 Tiger on the Watch fig.117
 Truth Emerging from a Well to Chastise Humanity 97
Gille, Vincent 127–8
Gillot, Françoise 198
Girard, Jules
 Village in a Valley 52; fig.44
Girod, Fernand 192
Gourmont, Rémy de 173
Green, Christopher 100, 111–12, 176
Grey, Roch (Baronness d'Oettingen) 30, 32, 179
Guggenheim, Mrs Simon 180
Guillaume, Paul 179, 180–1; fig.114

H

Hagenbeck, Carl 55
Hague conference 100
Happy Quartet 100, 128; no.20
history paintings 17–18, 87, 186–7, 188
Hoog, Michel 183
Horse Attacked by a Jaguar 144; no.47
House on the Outskirts of Paris no.37
 detail *124*
Hugo, Victor 54
The Hungry Lion Throws itself on the Antelope 19–20, 29, 30, 33, 37, 38, 40, 43, 49, 114, 127, 142, 143–4, 175–6; no.49
 model for 33, 35; fig.25
hypnosis 195–7, 198–202

I

l'idéoplastic 193
L'Illustration 58; figs.53, 54
image d'Epinal 86, 98, 173
Impressionism 170
industrial subjects 18, 126
Ingres, Jean-Auguste-Dominique 157, 186
La Grande Odalisque 14
Ireson, Nancy 191–2, 193
Italian primitives 24, 29, 144
Ivry Quay 125, 127; no.40

J

Jacquemart, Alfred
 Lion and Corpse 38; fig.29
Jardin coloniale 35–6
Jardin d'Acclimatation 32, 35, 40, 54–5, 57, 58, 60, 63, 113, 114
Jardin du Luxembourg 125, 142; no.32
Jardin des Plantes 21–2, 30–47, 49, 50, 54, 63, 111, 187
 souvenir postcards 32; figs.18, 21, 22, 23, 24
 Tropical House 33, 112; fig.22
 zoo 21–2, 32–3, 35, 36, 37
Jarry, Alfred 23, 42, 43, 86, 98, 169, 173–4; fig.106
 The Gestures and Opinions of Dr Faustroll 98, 173
 Ubu cycle 114, 173
 L'Ymagier 98, 173; figs.75, 105
Jastrebzoff, Serge (Férat) 128, 178
Jungle paintings 13–17, 19–20, 21–2, 23–4, 27, 29–47, 49, 85, 157–61, 172, 187, 199
 the dangerous exotic 141–5
 the peaceful exotic 110–123
 sources 29–47, 49–50, 53–63, 112–15, 143, 174, 186, 187
Jungle with Buffalo Attacked by a Tiger 142; fig.92
Jungle with Setting Sun 37, 45, 46, 49, 143; no.46

K

Kandinsky, Wassily 68, 126, 169, 173, 176, 177, 179
Klimt, Gustav 183

L

The Lady with the Unicorn tapestry 16, 49
Lanchner, Carolyn 176, 183
landscapes 18, 40, 49–53, 63, 86, 125–9, 143, 187
Laurencin, Marie 73, 174, 199
Laval 52, 169, 180
Le Bon, Gustave 202
Le Pichon, Yann 181
Le Senne, Camille 144
Léger, Fernand 21
Lermina, Jules
 Magie passionnelle 194–5
Leroy, Louis 201
Lestrange, Robert 100
Liberty Inviting Artists to Take Part in the 22nd Exhibition of the Société des Artistes Indépendents 100, 188; no.19
Lorde, AndrÈ de
 Théâtre d'épouvante 200
Louvre 179–80
 Rousseau's access as copyist 21, 186
Lumière brothers
 The Baby's Meal 85; fig.71

M

Le Magasin Pittoresque 49
Magic Realism 24
magie passionnelle 194–5
magnetic love 191–2
Malraux, André 198
Manet, Édouard 184
 Déjeuner sur l'herbe 14, 68; fig.61
 Olympia 14; fig.2
Marc, Franz 173, 177
Matisse, Henri 29, 142, 179
Mauclair, Camille 113–14
Mauss, Marcel
 'Sketch of a General Theory of Magic' 197
Méaulle, Fortuné
 La Farandole 49
Méliès, Georges 62, 86
 The Brahmin and the Butterfly 160; fig.98
The Merry Jesters 29, 33, 36, 40, 46, 113, 114, 177; no.28
Mexico 111, 174, 179, 181
Milne-Edwards, Alphonse 33, 35, 40
Miró, Joan 202
Modernism 23, 25, 26, 27, 144, 184
Monet, Claude 183
Monkeys in the Jungle 37, 42, 46, 112–13; no.25
Monnier, Marcel 53–4
 Camp at Dibi fig.82
 Hunters in the Forest 53; fig.47
 In the Forest: Palms and Creepers 53; fig.46
Monot, E. 57
Munro, Thomas 180
Münter, Gabriele 176
murals, proposed 98–9, 188–9
The Muse Inspiring the Poet 73, 174, 199–200, 202
Muséum d'Histoire naturelle 33, 35, 36, 37, 38, 49, 54, 143, 187
Museum of Modern Art, New York 179, 180
Myself, Portrait-Landscape 15–16, 69, 171, 175, 177, 179, 187; no.2

N

Nabis 161, 172
La Nature 47
Negro Attacked by a Jaguar 200
Neuville, A. de 61
Nietzsche, Friedrich
 The Birth of Tragedy 114
Noury, Joséphine (second wife) 67, 69–70, 193–4

O

Ochorowisz, Jules 196
Oettingen, Baronne d' *see* Grey, Roch
Old Junier's Cart 84–5, 126, 180; fig.70
Olivier, Fernand 72, 176, 189
The Orchard 126–7, 129; no.33
Orientalism 16, 19, 187

P

Painter and Model 67–9, 177; no.1
Panorama-Salon 37
panoramas 61
pantograph 20
Papouin, Charlotte 84
Paris 15, 40, 49–53, 63, 69, 125–9
 fortifications 71–2; fig.65
Paris World Fair (1889) 15, 32, 36, 50, 55, 57, 58, 60–1, 69, 86, 114–15, 187, 192, 198, 199
Paris World Fair (1900) 15, 50, 61, 114
Perret, Benjamin 179
Le Petit Journal 19, 49, 58, 60, 113, 143, 160; figs.7, 84, 95
photography 18, 27, 49, 51–3, 62, 69, 83, 84–6, 112
 cinema 85–6, 143, 160; figs.71, 98
 spirit 193–4
physiological psychology 196
Picasso, Pablo 21, 22, 23, 29, 30, 32, 43, 47, 73, 169–70, 175–6, 183, 189
 Banquet Rousseau 24, 100, 176
 collection of works by Rousseau 72, 73, 100, 173, 175–6
 Les Demoiselles d'Avignon 175, 197–8, 199; fig.132
 portrait photographs of Rousseau 29, 46; figs.19, 20
Pissarro, Camille 171
Pol-Neveux 57, 60
The Pont de Grenelle 129, 177, 188; no.41
popular art 25–6, 172–3, 177
Portrait of the Artist with a Lamp 69–70, 176, 177; no.5
Portrait of the Artist's Second Wife 69–70, 73, 176, 177; no.6
Portrait of Joseph Brummer 23; fig.12
Portrait of a Lady 18–19, 73, 83; no.3
Portrait of Monsieur X (Pierre Loti) 85–6; no.12
Portrait of a Woman 18–19, 72, 73, 83, 175–6; no.4
portrait-paysage form 187; no.2
portraits 18–19, 20, 72–3, 83–6, 129, 187
Poussin, Nicolas 24, 126
The Present and the Past (Philosophical Thought) 181, 193–4, 195, 197; fig.128
Primitivism 22–4, 172, 192
Promenade in the Forest 17, 86–7; no.16
 detail *169*
Puvis de Chavannes, Pierre 99, 171–2
 The Balloon 69; fig.62

Q

Quinn, John 180

R

Ralli 183
Raynal, Maurice 72, 176
Régnier, Dr
 Hypnotisme et croyances anciennes 199
Rendezvous in the Forest 17, 86, 113; no.14
The Repast of the Lion 37, 145; no.48
The Representatives of Foreign Powers Coming
 to Greet the Republic as a Sign of Peace
 99–100, 176, 188; no.22
The Revenge of a Russian Orphan (play) 19, 86
Rivera, Diego
 Dream of a Sunday Afternoon in
 the Alameda 179; fig.112
Rogers, Willy 97
Rosenberg, Paul 181
Rousseau, Henri fig.63
 autobiographical statement 189
 birth 52
 children 70, 83, 177
 clientele 18–19, 127
 death and funeral 169–70, 172
 education 25, 27
 employment 16, 17, 19, 70–1
 first marriage 69, 73, 83, 194, 195
 fraud charges against 25, 183
 income 17, 19
 military service 14, 30, 71, 101, 111
 music 19, 86; fig.43
 naïve style 25, 27, 43, 62, 85, 127, 169,
 181, 183–4, 189
 plays 15, 19, 72, 86, 114–15, 187
 poetry 13, 73
 political and social opinions 40, 189
 prices charges for painting 86, 127
 public patronage sought by 18, 25, 70–1,
 98–9, 183, 188–9
 retirement 17, 67, 70, 71
 second marriage 67, 69–70, 193–4;
 nos.21, 23, 55
 soirées 13
 sources used by 29–47, 49–63, 112–15,
 143, 174, 186, 187
 teaching work 13, 19, 186
 tomb 169–70; fig.102
 working methods 18, 52, 143, 184
Rousseau, Jean-Jacques 114
Roussel, Raymond 62
Roy, Louis 98, 172
Rubens, Peter Paul 144
Rubin, William 23, 176, 183

S

Saint-Hilaire, Étinne and Isidore Geoffroy 35, 40
Salmon, André 72, 111, 114, 144, 176, 179, 181
Salon d'Automne 29, 113, 127, 142, 158, 176
Salon des Indépendants 13, 16–17, 29, 50, 58,
 87, 97, 99–100, 142, 169
 Rousseau retrospective (1911) 128, 174, 178
Saw Mill, Outskirts of Paris 126, 129; no.31
La Science populaire 58
Scouts Attacked by Tiger 142, 181; fig.115
Seckel-Klein, Hélène 176
Segalen, Victor 40, 42
self-portraits 15–16, 67–70, 176, 193–4;
 nos.21, 24, 2, 55
Seurat, Georges 16, 171
 Grande Jatte 170
Shattuck, Roger 85
Signac, Paul 172
sketches 18, 32, 112, 184; fig.119
The Sleeping Gypsy 19, 29, 38, 46, 86, 171,
 180, 187, 188; fig.30
The Snake Charmer 20, 29, 32, 37, 40, 158, 160,
 161, 174, 177, 180, 193, 198–9, 202; no.51
 detail 156
Soffici, Ardengo 36–7, 38, 157, 186
Soulié, Eugène 72
Soupault, Philippe 36, 160, 179, 181
Souriau, Paul
 La Suggestion dans l'art 201–2
spiritualist culture and Rousseau's works
191–203
Spitz, Georges
 Banana Carriers 43; fig.34
Stabenow, Cornelia 199
Stein, Gertrude 176
Stevens, Alfred 61
Stewart, Dugald 195
Stieglitz, Alfred 179
Strollers in a Park 180
Struggle for Life 142
Stückgold, Stanislaus 72, 201
'Student on a Spree' 86
Surrealism 24, 29, 36, 179, 183, 191, 195–6,
 200, 202–3
Symbolism 173

T

Taillebois, E. 58
Taine, Hippolyte 196
 De l'intelligence 191, 195
Tarde, Gustave 202
Tiger Hunt 143, 186, 187; no.44
Tiger in a Tropical Storm (Surprised!)
 14–15,16–17, 29, 38, 53, 71, 141, 142,
 143, 172; no.43
Le Tour du Monde 49, 62; figs.56, 57
Tropical Forest with Monkeys 42, 112; no.27
Tropical Landscape – An American Indian
 Struggling with a Gorilla 37, 45, 47, 143,
 200; fig.35
Two Monkeys in the Jungle 113; no.26
Tzara, Tristan 42, 73, 85

U

Uhde, Wilhelm 25, 30, 32, 40, 47, 49, 50, 52, 63,
 72, 73, 83, 86, 87, 100, 112, 125–6, 127, 142,
 158, 160, 176, 178–9, 192, 195, 202
Unpleasant Surprise 181

V

Vallatton, Félix 17, 141–2, 172
Vallier, Dora 100, 181
Valton 183
Vauxcelles, Louis 114, 157
Verlat, Charles 49
View of the Bridge at Sèvres 51, 129; fig.90
 detail 48
View of Brittany 186
View from the Quai Henri IV 127, 185; no.39
 preliminary oil sketch 127; fig119
View of the Fortifications 72, 86, 113; no.7
View of Malakoff, Paris Region 129; no.42
View of the Pont du Jour, Sunset 51
View of the Quai d'Ivry near the Port à l'Anglais,
 Seine (Family Fishing) 86, 126, 127; no.30
Villard, Antoine 180
Villers, Charles de
 Le magnétiseur amoureux 200
A Visit to the 1889 Exhibition (play) 15, 86,
 114–15, 187
Vlaminck, Maurice de 22, 183
Vollard, Ambrose 25, 100, 142, 176, 180, 181

W

War 17–18, 23, 97–8, 172, 173, 180; no.17
 detail 96
 lithograph for L'Ymagier 98, 173; fig.105
The Waterfall 37, 40–1, 45, 111; no.23
Watteau, Jean-Antoine 49
Weber, Max 23, 32, 85, 112, 126, 127, 144,
 158, 176, 179
The Wedding 101, 177; fig.77

Y

Yadwigha 13–14, 19, 63, 72, 199
L' Ymagier 98, 173; figs.75, 105
Young Girl in Pink 83–5; no.10

Z

Zervos, Christian 72, 126